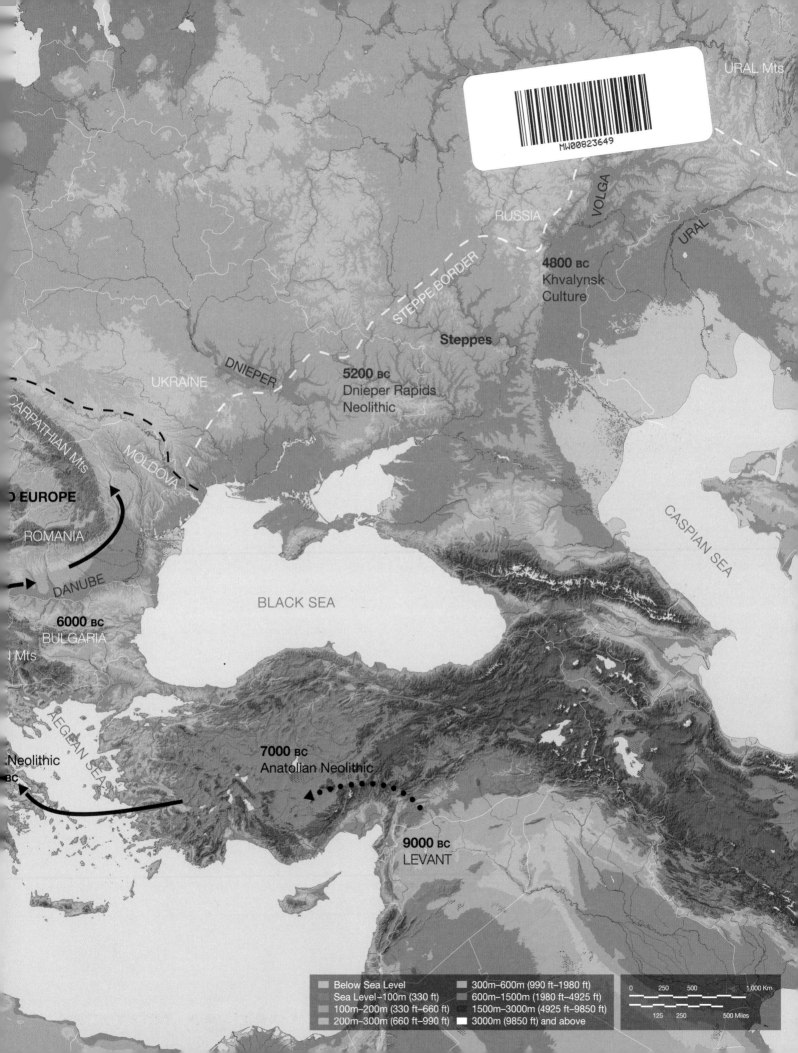

URAL Mts

VOLGA

RUSSIA

URAL

4800 BC
Khvalynsk
Culture

STEPPE BORDER

Steppes

DNIEPER

UKRAINE

5200 BC
Dnieper Rapids
Neolithic

CARPATHIAN Mts

MOLDOVA

O EUROPE

ROMANIA

CASPIAN SEA

DANUBE

BLACK SEA

6000 BC
BULGARIA

l Mts

AEGEAN SEA

7000 BC
Anatolian Neolithic

Neolithic

BC

9000 BC
LEVANT

☐ Below Sea Level	☐ 300m–600m (990 ft–1980 ft)
☐ Sea Level–100m (330 ft)	☐ 600m–1500m (1980 ft–4925 ft)
☐ 100m–200m (330 ft–660 ft)	☐ 1500m–3000m (4925 ft–9850 ft)
☐ 200m–300m (660 ft–990 ft)	☐ 3000m (9850 ft) and above

0 250 500 1,000 Km

125 250 500 Miles

The Lost World of Old Europe
The Danube Valley, 5000–3500 BC

The Lost World of Old Europe
The Danube Valley, 5000–3500 BC

Edited by David W. Anthony

With Jennifer Y. Chi

Including contributions by Douglass W. Bailey, Cătălin Bem, Veaceslav Bicbaev, John Chapman, Cornelia-Magda Lazarovici, Ioan Opriş, Ernst Pernicka, Dragomir Nicolae Popovici, Michel Louis Séfériadès, and Vladimir Slavchev

The Institute for the Study of the Ancient World

at New York University

Princeton University Press

Princeton and Oxford

Published by the Institute for the Study of the Ancient World (ISAW)
at New York University and Princeton University Press

Institute for the Study of the Ancient World
15 E. 84th Street
New York, New York 10028
nyu.edu/isaw

Princeton University Press
41 William Street
Princeton, New Jersey 08540
press.princeton.edu

The exhibition The Lost World of Old Europe: The Danube Valley,
5000–3500 BC (November 11, 2009–April 25, 2010) has been organized by
the Institute for the Study of the Ancient World at New York University
in collaboration with the National History Museum of Romania,
Bucharest, and with the participation of the Varna Regional Museum
of History, Bulgaria, and the National Museum of Archaeology and
History of Moldova, Chişinău.

The exhibition and its accompanying catalogue were made possible
through the generous support of the Leon Levy Foundation.

Managing Editor: Julienne Kim
Copy Editor: Mary Cason
Designer: CoDe. New York Inc., Jenny 8 Del Corte Hirschfeld,
Mischa Leiner, Franck Doussot, Raul Bortolotti
Color Separations and Production: Colorfast, New York, NY
Printer: L.E.G.O., EuroGrafica, SpA, Vicenza, Italy

Library of Congress Control Number: 2009933358
ISBN: 978-0-691-14388-0

The book was typeset in Sabon MT Pro and Helvetica Neue LT W1G
and printed on Condat Silk 150gsm.

Printed and bound in Vicenza, Italy

10 9 8 7 6 5 4 3 2

Contents

Letter from
Roger S. Bagnall

Director, Institute for the Study of the Ancient World, New York University

It is an honor to introduce the second international loan exhibition at the Institute for the Study of the Ancient World, at New York University, a center for advanced research and doctoral education in all disciplines concerned with the antiquity of the entire Old World. It has its roots in the passion that Shelby White and Leon Levy had for the art and history of the ancient world, which led them to envision an institute that would offer a panoptic view of antiquity across vast stretches of time and place. The Institute for the Study of the Ancient World aims to encourage particularly the study of economic, religious, political, and cultural connections between ancient civilizations. It presents the results of the research carried out by its faculty, visiting researchers, and students, not only through scholarly publications and lectures but also through public exhibitions in the galleries in its home at 15 East 84th Street in New York City. It is our intention that these exhibitions should reflect the Institute's commitment to studying cross-cultural connections and significant areas of the ancient world often neglected in research, teaching, and public presentations.

The Lost World of Old Europe takes us in a direction that I could not have envisioned when the Institute began in 2007 but which is profoundly true to our mission. As a student I was taught about the Greek Neolithic, but with no sense of its connections to a larger cultural canvas to the north. And when the transition to metal working in Anatolia and the Near East was taught, Europe was never mentioned; we had no sense of how advanced metallurgy was in that region, nor how rich the Chalcolithic societies were. That is a great and exciting revelation, as I believe it will be for most whose background is Classical or Near Eastern. But equally remarkable is the sense that emerges from these finds of the connectedness of Old Europe to Asia and to the Aegean, as well as to points further north.

The Institute is profoundly grateful to Professor David Anthony of Hartwick College, who functioned as our guest curator for this exhibition, and ensured the timely completion of a scholarly catalogue that reflects the high standards of research conducted at 15 East 84th Street. His multidisciplinary approach to the prehistoric steppe region, particularly that in modern Russia and Ukraine, has much furthered our understanding of the spread of Indo-European languages and the archaeological data that support his argument. Old Europe may retain its enigmatic place within the large dialogue of prehistoric Europe, but we hope that this catalogue will provide scholars, students, and interested persons with a publication that presents the many and varied questions surrounding this discipline.

Letter from
Crişan Muşeţeanu
Director, National History Museum of Romania, Bucharest

Situated in the southeastern part of Europe, Romania is a country with a remarkable cultural diversity as well as an outstanding and varied natural landscape. The major geographic landmarks are represented by the Carpathians, in effect the vertebral spine of the Romanian territory and at the same time an area rich with natural resources; the Danube, which forms the greater part of Romania's southern border; and the Black Sea, situated to the southeast. From early times these features determined a densely populated human habitation, resulting in the archaeological vestiges found on Romania's territory and dating to the Paleolithic. Almost without a doubt, from the historical and archaeological points of view, the most representative epochs are the prehistoric—the Neo-Eneolithic and the Bronze and Iron Ages—as well as that of Greek and Roman classical antiquity.

It is well-known to scholars and the broad public interested in ancient history that a large part of what is now Romania, the kingdom of Dacia, was part of the Roman Empire as early as the second century AD. Less widely known, however, is a more distant epoch of the history of this land, namely, the Neo-Eneolithic period. Thus, the National History Museum of Romania is honored to present, in partnership with other Romanian museums and research institutes, the exhibition *The Lost World of Old Europe*, which had its origins in a very ambitious initiative launched by the Institute for the Study of the Ancient World at New York University in 2008. The first exhibition devoted to the archaeological history of Romania that has been organized as an American-Romanian partnership, it presents objects of exceptional value drawn from the national cultural heritage of Romania.

The cultural artifacts selected to be part of this exhibition offer the public the possibility to reflect upon the amazing, *avant la lettre* modernity of the prehistoric civilizations that existed in the Carpatho-Danubian area more than seven millennia ago. Among

these cultures, the Cucuteni civilization is distinguished by its particular expression of prehistoric art and spirituality, as are the discoveries belonging to the Boian, Gumelniţa, Hamangia, Vădastra, and Vinča cultures, to name just a few of the names that resonate within the Neo-Eneolithic in the Lower Danube area.

The organization of this exhibition created the premise for excellent cooperation between the Institute for the Study of the Ancient World and the National History Museum of Romania, and the results of such an endeavor are now on display for assessment by the public and scholars. We wish to express our deep gratitude for the generous effort undertaken by our partners from the Institute for the Study of the Ancient World, as well as to the Romanian museographers who contributed to the development of this project. Also our great thanks are directed to the Romanian Ministry of Culture, Religious Affairs and National Heritage and the U.S. Embassy in Bucharest, together with other Romanian and American institutions that continually supported and contributed to the positive achievements of this major cultural project. At the same time, we would like to thank the Museum of Cycladic Art in Athens for its interest in presenting this exhibition.

We hope that in the future the national cultural heritage of Romania and the valuable archaeological objects found in the collections of Romanian museums will represent significant arguments for undertaking similar cultural initiatives that aim to offer a dedicated framework for prestigious international activities of cultural diplomacy.

Letter from
Gheorghe Dumitroaia
Director, Neamţ County Museum Complex, Piatra Neamţ

Certainly, within no other museum located in the area once occupied by the tribes of the Cucuteni-Tripol'ye cultural complex, can one better observe the beginnings of their painted ceramics than at Piatra Neamţ. The discoveries from Izvoare and Bodeşti-Frumuşica, which bear a particularly important relationship to the development of the early stages of the Cucuteni A phase, are well represented within the museum's main collection, as are ceramics from Târpeşti, Calu, Răuceşti Ghelăieşti, and Poduri, which outline the later stages of evolution. The collection's anthropomorphic objects, together with the data regarding copper metallurgy, stand as proof that this culture reached the highest levels of both civilization and spirituality.

To those unfamiliar with the History and Archaeology Museum in Piatra Neamţ, one might note that its foundation, development, and growth were closely intertwined with the discovery and investigation of the settlements belonging to the Precucuteni-Cucuteni cultural complex from Moldavia's Peri-Carpathian zone. In addition, the contributions of our institution and its foreign collaborators toward expanding knowledge of the exceptional east Romanian prehistoric heritage are well recognized for the quality of their scholarship.

It has been acknowledged without exaggeration that our museum was the first in Romania devoted exclusively to the Cucuteni civilization, and the institution's inestimable value was acknowledged in 1948 by Prof. Dr. Radu Vulpe: "Nowhere else than here can one better study the numerous and complicated problems of the Cucuteni-Tripol'ye civilization complex, which characterized throughout the Neolithic period the geographical area of Moldavia and Ukraine, thus representing, from the most ancient and anonymous times, Europe's unique artistic glow. Nowhere else, inside no other museum, are these successive and related civilizations so variously and complexly

illustrated, for there are few regions where the Cucutenian Neolithic settlements are so well represented as in Neamț."

The activities carried out during the more than seventy-five years since the museum's foundation, the international recognition of its professionals, and its well-organized administration made possible in 1984 our role as coorganizer of the international conference *La civilisation de Cucuteni en contexte europeene*. At that time a number of well-known scholars gathered to discuss research related to Cucuteni, including M. Gimbutas, L. Ellis (both from the United States), O. Höckman (Germany), J. Nandriș (United Kingdom), M. Petrescu-Dîmbovița, E. Comșa. Z. Szekely, A. Nițu, Al. Bolomey, and D. Monah (all from Romania).

To first exhibit this heritage abroad, in 1997 the Romanian scholars C.-M. Mantu, D. Monah, and I together with A. Tsaravopoulos of Greece produced (within two and half months!) an outstanding catalogue and exhibition at the Archaeological Museum of Thessaloniki, Ο ΤΕΛΕΥΤΑΙΟΣ ΜΕΓΑΛΟΣ ΧΑΛΚΟΛΙΘΚΟΣ ΠΟΛΙΤΙΣΜΟΣ ΤΗΣ ΕΥΡΩΠΗΣ/*The Last Great Chalcolithic Civilization of Europe*. Their efforts in organizing the first Cucuteni-related exhibition outside Romania were well repaid by the public response in Europe's cultural capital.

During 2004 the History and Archaeology Museum in Piatra Neamț hosted two other major events: the international colloquia *Cucuteni: 120 Years of Research; Time to Sum Up* and *The Pre- and Protohistoric Archaeology of Salt*, which brought together interested researchers not only from Romania but also from Austria, Bulgaria, Colombia, France, Hungary, the Republic of Moldavia, Russia, Spain, Turkey, Ukraine, the United Kingdom, and the United States.

The goal of the Cucuteni Culture International Research Center is to unite researchers with relevant archaeological material and financial resources, and to introduce visitors from Romania and abroad to the Cucuteni civilization. The present exhibition, *The Lost World of Old Europe*, allows us to reinforce our ongoing scientific relationships and earlier collaborations with academic institutions and museums interested in the Romanian Chalcolithic, and to extend knowledge of our research to a broader public, thus facilitating a better understanding of the Cucuteni culture.

Letter from
Lăcrămioara Stratulat
Director, Moldova National Museum Complex, Iaşi

Thousands of years ago, one of the greatest civilizations of prehistoric Europe covered a surface of 350,000 square kilometers between the Carpathian Mountains and the Dniester. Known as the Cucuteni-Tripol'ye civilization, it produced closely related cultural manifestations that together formed a wide archaeological complex, one that includes two main cultural zones. The civilization was named after the two places where the first objects of this civilization were discovered: Cucuteni, a village near Iaşi, Romania, the site where the first such archaeological discoveries were made in 1884 and that refers to the territories of Romania and the Republic of Moldova; and Tripol'ye, near Kiev, Ukraine, for discoveries there in 1893. The organizers of this unique exhibition have successfully brought together objects and research that will enrich visitors' understanding of the Cucuteni culture. In this context we would like to express our special thanks to the prestigious Institute for the Study of the Ancient World at New York University, which fulfilled the dream of presenting in the United States an exhibition that highlights Cucuteni culture.

What is it that makes the Cucuteni culture so special? Beautiful painted ceramic ware, displaying an exuberance of spiral motifs and symmetrical and complex compositions, created by specialized craftsmen who were true artists; thousands of small statuettes revealing the effervescence of an extraordinary spiritual life; sanctuaries and altars at each site; large dwellings with massive clay platforms that are even now difficult to interpret—all of these elements have rendered the ancient Cucuteni-Tripol'ye cultural complex one of the most fascinating civilizations of prehistory.

The exceptional achievements of this culture prove the existence of a population with a prosperous and stable way of life, allowing a higher level of organization both within each community and, on a broader scale, within tribal unions. This hierarchy made possible the coordinated collective effort necessary to carry out vast works of site

fortification, entailed the specialization of individuals who carried out particular activities, and explains the existence of organized plans at each site. The prosperity of this population was due primarily to agricultural practices—with specialized tools highly efficient for those times—that not only helped create the surplus of food items necessary to a continuously growing population but also made possible exchanges with communities outside the area.

Beyond this broad understanding of the Cucuteni culture, there remain numerous questions whose answers can only be imagined. Why did these people paint, transforming the vessel walls of enduring supports to illustrate their cosmogonic model? What symbols did they want to express by the painted motifs? Why did they cover vessels with apotropaic motifs, asking protection against unknown forces of evil, and with fantastic animals and strange human beings? Why do the body parts of their clay idols clearly point to a belief in the perpetuation of life while their eyes are empty and vaguely sketched, as are the features of their faces in general? How would the people choose places for founding their sites, and their houses, and what rituals would they practice to mark these events? Beyond everything there remains the greatest mystery: What did they do with their dead, and what was their view on the afterlife?

Despite such questions, we are left admiring the achievements of the Cucutenian world: its stability, creative force, originality, and special aesthetic sense. Before the birth of the great civilization of the Ancient Near East in Mesopotamia and Egypt, while the "Lost Old Europe" was still searching for a means of expression, the Cucuteni-Tripol'ye civilization reached a stage of exceptional accomplishments.

Letter from
Valentin Pletnyov
Director, Varna Regional Museum of History

It was a great honor for the Varna Regional Museum of History to receive an invitation from the Institute for the Study of the Ancient World at New York University to participate in the exhibition *The Lost World of Old Europe*. Ten years ago, in 1998–99, a selection from our collection toured seven major U.S. cities—St. Louis, Fort Worth, San Francisco, New Orleans, Memphis, Boston, and Detroit—in the exhibition *Ancient Gold: The Wealth of the Thracians*. Representatives from our museum were impressed by the American public's keen interest in and appreciation of Bulgaria's prehistoric treasures, and it will be a genuine pleasure for us to visit your great country and stay once more as welcome guests in the nation's largest city, New York.

While the number of objects on view from the Varna Eneolithic necropolis is small, they represent a magnificent illustration of a unique and significant moment in human history—the earliest stage in the hierarchal structure of prehistoric society on the Balkan Peninsula. This newly established social organization appears to have been a direct outcome of the economic evolution that characterized the period, and one that ensued from intensified commercial exchange related to technological innovations introduced in the areas of mining and metallurgy. The differentiation of crafts and proto-commerce from agriculture and stock breeding created favorable prerequisites for shifts in the configuration of society, and toward the end of the fifth millennium B.C. led to a concentration of power and authority in the hands of a rather limited group of people representing a newly formed "elite." Some of this group's most prominent members were buried in Varna's Eneolithic necropolis along with attributes and regalia revealing their high rank in the social hierarchy. Examples of the region's earliest gold-crafted jewelry were uncovered here, as well as a great number of objects made of copper, stone and flint, various minerals, bone, horn, and clay.

Knowledge of the cultural traditions of a particular society has always been a crucial factor for successful dialogue with its members. However, the cultural and historical legacy presented by the findings from the Varna necropolis are not the monopoly of a single nation. This heritage reflects commonly shared human values, and our mission as archaeologists and curators is to explore it and present the results of our research to the public. The present exhibition is an important step toward enhancing awareness of this global legacy, and we hope that it will generate the interest it deserves, bringing the past of "Old Europe" to life before the eyes of visitors in the "New World."

Letter from
Eugen Sava
Director, National Museum of Archaeology and History of Moldova, Chişinău

The Republic of Moldova is a country with a rich and expressive history. Located between the Carpathian-Balkans, Central Europe, and Eurasia—regions with varied historical models—it has harmoniously integrated a multimillennial history of numerous cultural traditions with local customs displaying specific and unique traits. At present about eight thousand historical and archaeological monuments are registered in the territory of the Republic of Moldova, with cultural and historical features that can be viewed within the context of European values.

A plethora of archaeological evidence confirms the existence of humankind in this region from Paleolithic to Mesolithic times. One of the most representative archaeological periods was the Neo-Eneolithic, which in the Prut-Dniester region lasted for five thousand years (seventh–third millennia BC). The Cucuteni-Tripol'ye culture existed for roughly fifteen hundred years on a wide territory extending from the Carpathians to the Dnieper River (late fifth–early third millennia BC), and is remarkable for its high level of material artifacts and the spiritual life reflected through them. The region's archaeological monuments combine elements of the Cucuteni culture with those typical of the cultures of the North Pontic nomads (identified with the Proto-Indo-Europeans), and the populations represented played an important role in the history of the Eneolithic communities. The Giurgiuleşti collection included in this exhibition and its catalogue demonstrates the cultural symbiosis within the region.

The subsequent periods of the Bronze Age, the Iron Age, and the Classical era are characterized by the sequential emergence and spread of bronze objects, burial mounds, the prevalence of a pastoral economy, and the "Hallstattization" process. Significantly, it was during the Hallstattian period that the Getae-Dacian culture was formed and developed, during the sixth through first centuries BC. Beginning around 500 BC, local

inhabitants had established cultural and economic contacts with the population of the North Pontic Greek colonies.

The armed confrontation between the free Dacians (led by their king, Decebal) and the Roman Empire ended in 106 AD, resulting in the creation of the Roman province of Dacia and the acceleration of local Romanization. Following evacuation of the Roman legions from these lands in 271 AD, during the reign of Emperor Aurelian, began "the migration of peoples"—Goths, Huns, Avars, Slavs, Hungarians, Pechenegs, Cumans, and Mongols.

Throughout Europe the Middle Ages coincided with the rise of different ethnic groups to the stage of history, and consequently the appearance of independent states. In the fourteenth century, the present territory of the Republic of Moldova became part of the Principality of Moldova, situated between the Eastern Carpathians and the Dniester River, with Khotyn to the north and the Lower Danube and the Black Sea to the south.

The National Museum of Archaeology and History of Moldova is the principal museum of the Republic of Moldova, known for the importance of its unique collection and its scholarly reputation. The museum's holdings include approximately 303,000 objects organized in separate collections, including archaeology; numismatics; historical documents, photographs, books, and periodicals; arms and armor; textiles; objects of daily life and industrial tools; art objects; and philately. One of the most representative collections contains archaeological artifacts that have been exhibited internationally in Germany (Historisches Museum der Pfalz, Speyer), Italy (Palazzo della Cancelleria, Vatican), and Romania (museums in the cities of Bîrlad, Tecuci, Botoşani, and Iaşi)— and that now are on view in the United States.

Our participation in the important and prestigious venue of *The Lost World of Old Europe*, organized by the Institute for the Study of the Ancient World at New York University, provides a significant opportunity to present the Moldova cultural heritage to the international community. With great pleasure, I would like to thank Roger S. Bagnall, Director of the Institute, and Jennifer Chi, Associate Director for Exhibitions and Public Programs, for this collaboration and the efforts that made possible the participation of our museum.

Foreword
Jennifer Y. Chi

Associate Director for Exhibitions and Public Programs, Institute for the Study of the Ancient World, New York University

For many visitors to *The Lost World of Old Europe: The Danube Valley 5,000–3,500 B.C.*—the second international loan exhibition organized by the Institute for the Study of the Ancient World at New York University—the region and its historical context, as well as its material culture, may be largely unfamiliar. Discussions of Western civilization often move from the Venus of Willendorf to the Lascaux cave paintings and then on to Egypt and Mesopotamia, without ever mentioning the art and culture of what is known as Old Europe, an area corresponding geographically to modern-day southeastern Europe and defined by a series of distinct cultural groups that attained an astonishing level of sophistication in the fifth and fourth millennia B.C. *The Lost World of Old Europe* attempts to redefine commonly held notions of the development of Western civilization by presenting the astonishing and little-known artistic and technological achievements made by these still enigmatic peoples—from their extraordinary figurines, to their vast variety of copper and gold objects, to their stunning pottery types.

Perhaps the most widely known category of objects from Old Europe is the "mother-goddess" figurine. Fashioned by virtually every Old European cultural group, these striking miniaturized representations of females are frequently characterized by abstraction, with truncated, elongated, or emphasized body parts, and a surface decorated with incised or painted geometric and abstract patterns. The figurines' heightened sense of female corporeality has led some scholars to identify them as representations of a powerful mother goddess, whose relationship to earthly and human fertility is demonstrated in her remarkable, almost sexualized forms. The great variety of contexts in which the figurines are found, however, has led more recently to individualized readings rather than to a single, overarching interpretation. The set of twenty-one female figurines and their little chairs from Poduri-Dealul Ghindaru that is central to the exhibition's installation of this category of objects, for example, was found near a hearth in an edifice that has been interpreted as a sanctuary. One widely accepted interpretation based upon its

context, then, is that the figures represent the Council of Goddesses, with the more-senior divinities seated on thrones. Others take a more conservative approach suggesting that the figurines formed part of a ritualistic activity—the specific type of ritual, however, remains open to interpretation.

As *The Lost World of Old Europe* illustrates, the refinement of the visual and material language of these organized communities went far beyond their spectacular terracotta figurines. The technological advances made during this 1,500-year period are manifest in the copper and gold objects that comprise a significant component of this exhibition. The earliest major assemblage of gold artifacts to be unearthed anywhere in the world comes from the Varna cemetery, located in what is now Bulgaria, and dates to the first half of the fifth millennium B.C. Interred in the graves are the bodies of individuals who may have been chieftains, adorned with as much as five kilograms of gold objects, including exquisitely crafted headdresses, necklaces, appliqués, and ceremonial axes. Indeed, it is in Old Europe that one sees the first large-scale mining of precious metals, the development of advanced metallurgical practices such as smelting, and the trade of objects made from these materials.

It is also important to note that these cultures did not live in isolation from one another, but instead formed direct contacts, most clearly through networks of trade. Gold and copper objects were circulated among these cultural groups, for example. The most striking material traded throughout much of southeastern Europe, however, is the *Spondylus* shell. Found in the Aegean Sea, *Spondylus* was carved into objects of personal adornment in Greece from at least the early Neolithic period forward. The creamy-white colored shell is known to have been traded as far as the modern United Kingdom by the fifth millennium B.C. Many of the most-common forms are on display in this exhibition and include elaborate beaded necklaces, tubular bracelets, and pendants or amulets. The shells can perhaps be read as markers of a common origin or as indicators of the owner's elite position within society.

Another thought-provoking group of objects included in *The Lost World* are the "architectural" models. Made of terracotta, with the surface enlivened by both incision and paint, these models reveal an amazing variety of form, ranging from realistically rendered models depicting multiple houses to strongly stylized structures that include equally abstract figurines, sometimes interpreted as representations of a temple and its worshipers. While the precise meaning of these objects is still a matter of debate, their very existence clearly indicates a complex relationship between Old European cultures and both the built and unbuilt spaces that surrounded them.

Within their homes Old Europeans stored an impressive array of pottery that has been methodically studied over the last hundred years by many southeast-European archaeologists. The diverse typologies and complex styles suggest that this pottery was used in household and dining rituals. Bold geometric designs—including concentric circles, diagonal lines, and checkerboard patterns—distinguish the pottery made by the Cucuteni culture, examples of which are featured in this exhibition. Part of the

pottery's allure is the resonance of its composition and design to a modern aesthetic. Indeed, one could easily envision a Cucuteni vessel displayed in a contemporary home.

Exhibitions at the Institute are not only meant to illustrate the connections among ancient cultures, but also to question preexisting and sometimes static notions of the ancient world. With *The Lost World of Old Europe*, it is our desire to show that a rich and complex world can be found when looking beyond traditional and narrow definitions of antiquity, and indeed beyond standard depictions of the development of Western civilization.

Acknowledgments

The Lost World of Old Europe has been a collaborative project involving the exhibition department of the Institute for the Study of the Ancient World at New York University and over twenty museums from Romania, the Republic of Bulgaria, and the Republic of Moldova. In organizing this project, my staff and I received warmth and professional courtesy from all the museums and research institutes with which we collaborated, and we would like to gratefully acknowledge their participation in this exciting project.

In Romania, I extend our warmest thanks to His Excellency Dr. Theodor Paleologu, the Minister of Culture, Religious Affairs, and Cultural Heritage, for his Patronage of this exhibition. His staff members Ms. Mircea Staicu, General Secretary, and Ms. Mihaela Simion, personal counselor of the minister, also provided constant support. The National History Museum of Romania was our organizing partner, and we owe a special debt of gratitude to its Steering Committee: Dr. Crişan Museteanu, the Museum's General Director, provided us with great wisdom and advice; Corina Borş functioned as the project's coordinator and ably handled a myriad of administrative requests; Dr. Dragomir Popovici was the head of the museum's scientific committee and provided us with a wealth of historical information; Dr. Ioan Opriş, a senior researcher and advisor, offered us keen insight into organizational issues. Finally, Marius Amarie photographed in an efficient manner the majority of objects borrowed from Romanian institutions.

During my first trip to Romania, I was able to visit the cities of Piatra Neamţ and Iaşi, both in the Romanian region of Moldavia, where the richest Cucuteni sites can be found. Gheorge Dumitroia, Director, and Dorin Nicola, Deputy Director, of Neamţ County Museum Complex, Piatra Neamţ, welcomed me to view the museum's breathtaking collection and were open to lending us key Cucuteni pieces. I was also honored to meet Dr. Lăcrămioara Stratulat, General Director of the Moldova National Museum Complex in Iaşi, who advised and agreed to many Cucuteni loans from Iaşi's spectacular collection.

Our thanks is extended to other members of the Romanian Honorary Committee, comprised of all those museums who lent to the exhibition: Cristian-Dragoş Căldăraru, Director, Galaţi County Museum, Galaţi; Dr. Ionel Cândea, Director, Brăila Museum, Brăila; Dan Leopold Ciubotaru, Director, Museum of Banat, Timişoara; Dr. Gabriel Custurea, Director, Museum of National History and Archaeology, Constanţa; Ioan Mancaş, Director, "Ştefan cel Mare" County Museum, Vaslui; Dr. Alexandru Matei, Director, County Museum of History and Art, Zalău; Mircea Mămălăucă, Director "Vasile Pârvan" Museum, Bârlad; Dr. Marian Neagu, Director, Lower Danube Museum, Călăraşi; Lucica Pârvan, Director, Botoşani County Museum, Botoşani; Traian Popa, Director "Teohari Antonescu" County Museum, Giurgiu; Florin Ridiche, Director, Museum of Oltenia, Craiova; Dr. Victor Spinei, Director, Institute of Archaeology, Iaşi; Radu Ştefănescu, Director, Braşov County History Museum, Braşov; Dr. Ecaterina Ţânţăreanu, Director, Teleorman County History Museum, Alexandria; and Dr. Dumitru Ţeicu, Director, Museum of Mountain Banat, Reşiţa. The Romanian Scientific Committee provided important curatorial support and included: Maria Diaconescu, Botoşani County Museum, Botoşani; Dr. Cătălin Dobrinescu, Museum of National History and Archaeology, Constanţa; Dr. Florin Draşovean; Museum of Banat, Timişoara; Ciprian Lăzanu, "Ştefan cel Mare" County Museum, Vaslui; Pavel Mirea, Teleorman County History Museum, Alexandria; Dr. Stănică Pandrea, Brăila Museum, Brăila; Valentin Parnic, Lower Danube Museum, Călăraşi; Constantin Preoteasa, Neamţ County Museum Complex, Piatra Neamţ; and Dr. Senica Ţurcanu, Moldova National Museum Complex, Iaşi.

In the Republic of Bulgaria, His Excellency Dr. Vezhdi Rashidov, Minister of Culture, showed his initial and continuous support. I was warmly received at the Varna Regional History Museum twice by Dr. Valentin Pletynov, General Director, Dr. Valeri Yotov, Director, Museum of Archaeology, and Dr. Alexander Minchev, Curator, Museum of Archaeology. All three were always responsive to the many administrative and curatorial questions my staff and I posed throughout the planning stages of the exhibition. Dr. Vladimir Slavchev, Curator, Museum of Archaeology, took time out of his busy schedule to meet with me in Berlin, where he was on a Humboldt fellowship, and agreed to write a thought-provoking essay on the Varna material within a very short time frame. Rumyana Kostadinova Ivanova photographed the objects for this article.

We extend our gratitude to His Excellency Dr. Artur Cozma, the Minister of Culture and Tourism, Republic of Moldova. The National Museum of Archaeology and History of Moldova provided ISAW with the majority of loans from the later period of Old Europe, allowing us to pose important questions regarding the fall of this grand civilization. Dr. Eugene Sava, the Museum's Director, warmly welcomed me and allowed me several fruitful days studying the Museum's fascinating collection. Dr. Vaeceslav Bicbaev spent many hours discussing the collection with me and also graciously agreed to write an article for this catalogue on very short notice. Iulia Postica functioned as the Museum's translator, ensuring a fluid line of communication concerning administrative issues. Jurie Foca and Valery Hembaruc photographed the Museum's material.

This exhibition would not, however, have come to fruition without the dedication and professionalism of ISAW's exhibition team. Irene Gelbord, Exhibitions Administrator, assisted me on a myriad of administrative and programmatic issues and ensured easy communication within our department; Julienne Kim, Managing Editor of Exhibition Publications and Didactics, employed her admirable organizational and aesthetic skills to ensure the production of an exquisite exhibition catalogue; Roberta-Casagrande Kim, Senior Researcher, always responded promptly to a great variety of research questions; and Linda Stubbs, Exhibition Registrar, worked extensively with me on contractual and logistical issues throughout the exhibition's planning phase. David Anthony, of Hartwick College, was invited as our guest curator and spent a semester at ISAW, where he dedicated much of his time to creating a first-rate exhibition catalogue. Dorcas Brown helped produce the catalogue's insightful maps. Exhibition and catalogue design was ably handled by Mischa Leiner, Franck Doussot, and Raul Bortolotti of CoDe Communication and Design. Timely production of special exhibition cases is owed to Scott Hoeffer of Insight Group. Mary Cason was our able copy editor for both the catalogue and exhibition didactics. My department and myself also had the enriching experience of working with Corina Suteu, Director, and Oana Radu, Deputy Director, of the New York branch of the Romanian Cultural Institute, on many aspects of this exhibition's public programming; we would like to thank them for sharing their expertise on modern and contemporary Romanian culture.

The Lost World of Old Europe, therefore, is the product of fruitful international and national collaborations; it is greatly rewarding for me to know that these connections and the many professional relationships formed will continue beyond this show.

Jennifer Y. Chi
Associate Director for Exhibitions and Public Programs
Institute for the Study of the Ancient World at New York University

Note: To facilitate understanding of the material presented, all objects from the Exhibition Checklist that are illustrated in the following essays are reproduced at a scale of 1:2 with the exception of chapter-opening images and illustrations for Chapter 6, where the scale is 1:3. All comparative material in the essays is illustrated in black and white.

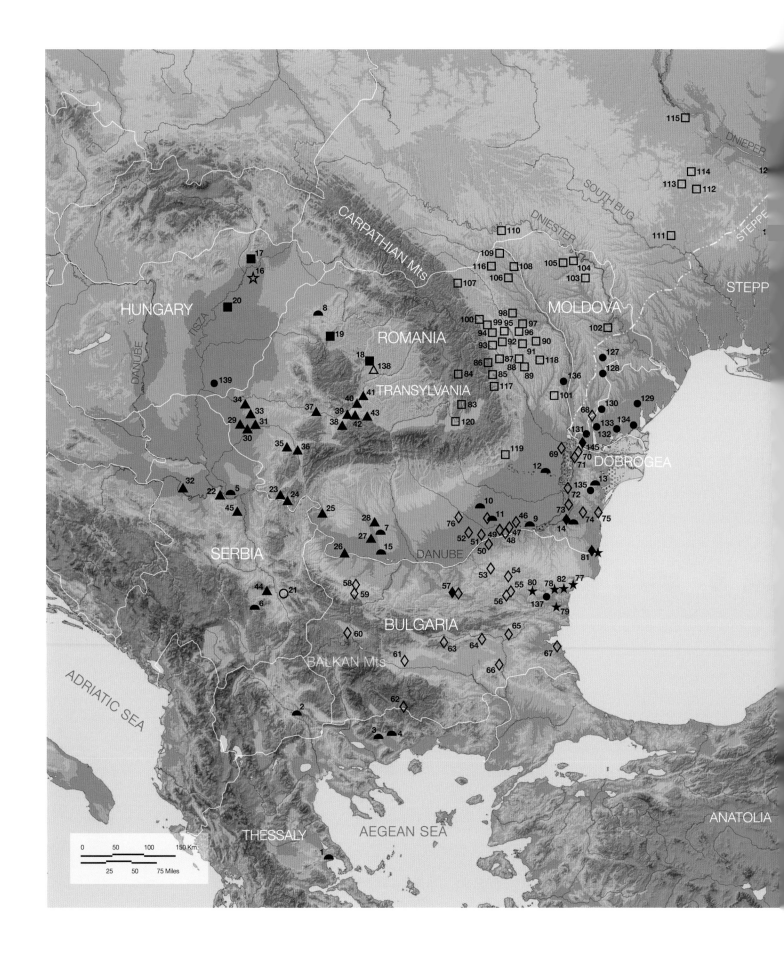

NEOLITHIC CULTURES

Greek Neolithic
1. Sesklo

Macedonian Neolithic
2. Anza
3. Sitagroi
4. Dikili Tash

Starčevo-Criş
5. Starčevo
6. Divostin
7. Cîrcea
8. Zauan

Boian
9. Boian
10. Giuleşti
11. Vidra
12. Liscoteanca

Hamangia
13. Baia Hamangia
14. Cernavoda

Early Vinča Culture
15. Vadastra

COPPER AGE CULTURES

Tiszapolgár
16. Tiszapolgár

Bodrogkeresztúr
17. Bodrogkeresztúr
18. Cheile Turzii
19. Moigrad
20. Tiszaszőlős

Bubanj Hum
21. Bubanj Hum

Late Vinča Culture
22. Vinča
23. Gornea
24. Liubcova
25. Ostrovul Corbului
26. Rast
27. Padea
28. Leu
29. Uivar
30. Parţa
31. Chişoda Veche
32. Gomolava
33. Sânandrei
34. Hodoni
35. Zorlenţa Maru
36. Caransebeş
37. Brănşca
38. Romos
39. Tărtăria
40. Alba Iulia
41. Sântimbru
42. Planu de Jos

43. Petreşti
44. Pločnik
45. Selevac

Gumelniţa/Karanovo
46. Sultana
47. Salcuţa
48. Gumelniţa
49. Căscioarele
50. Ruse
51. Pietrele
52. Tangâru
53. Podgoritsa
54. Târgovişte
55. Ovcharovo
56. Polyanitsa
57. Hotniţa
58. Galatin
59. Krivodol
60. Slatina
61. Yunatsite
62. Yagodina
63. Azmak
64. Karanovo
65. Veselinovo
66. Drama
67. Sozopol
68. Bolgrad
69. Brăiliţa
70. Luncaviţa
71. Carcaliu
72. Hârşova
73. Borduşani
74. Medgidia
75. Taşaul
76. Bucşani
11. Vidra

Varna
77. Varna
78. Devniya
79. Golyamo Delchevo
80. Provadrya
81. Durankulak
82. Strashimirovo

Cucuteni/Tripol'ye
83. Malnaş
84. Păuleni
85. Targu Ocna-Podei
86. Poduri
87. Calu-Piatra Şoimului
88. Traian
89. Brad
90. Scânteia
91. Dumeşti
92. Mărgineni
93. Izvoare
94. Bodeşti-Frumuşica
95. Ghelăieşti
96. Ruginoasa
97. Cucuteni
98. Hăbăşeşti
99. Târpeşti
100. Lunca
101. Bereşti
102. Karbuna

103. Brânzeni
104. Vărvăreuca
105. Putenişti
106. Truşeşti
107. Solca
108. Ripiceni
109. Drăguşeni
110. Polivanov Yar
111. Sabatinovka
112. Maidantets'ke
113. Dobrovodi
114. Tal'ianky
115. Tripol'ye
116. Vorniceni
117. Bodganeşti
118. Poieneşti
119. Sărata Monteoru
120. Ariuşd

Sredni Stog
121. Sredni Stog
122. Kvityana
123. Moliukhor Bugor
124. Dereivka
125. Maiorka
126. Strilcha Skelya

Suvorovo
127. Kainar
128. Kopchak
129. Artsiza
130. Kamenka
131. Giurgiuleşti
132. Utkonosovka
133. Nerushai
134. Suvorovo
135. Casimçea
136. Falcui
137. Devnya
138. Decea Mureşului
139. Csongrád
140. Igren
141. Chapli
142. Petro-Svistunovo
143. Novodanilovka
144. Krivoy Rog

Cernavoda I
145. Orlovka
14. Cernavoda
57. Hotniţa
81. Durankulak

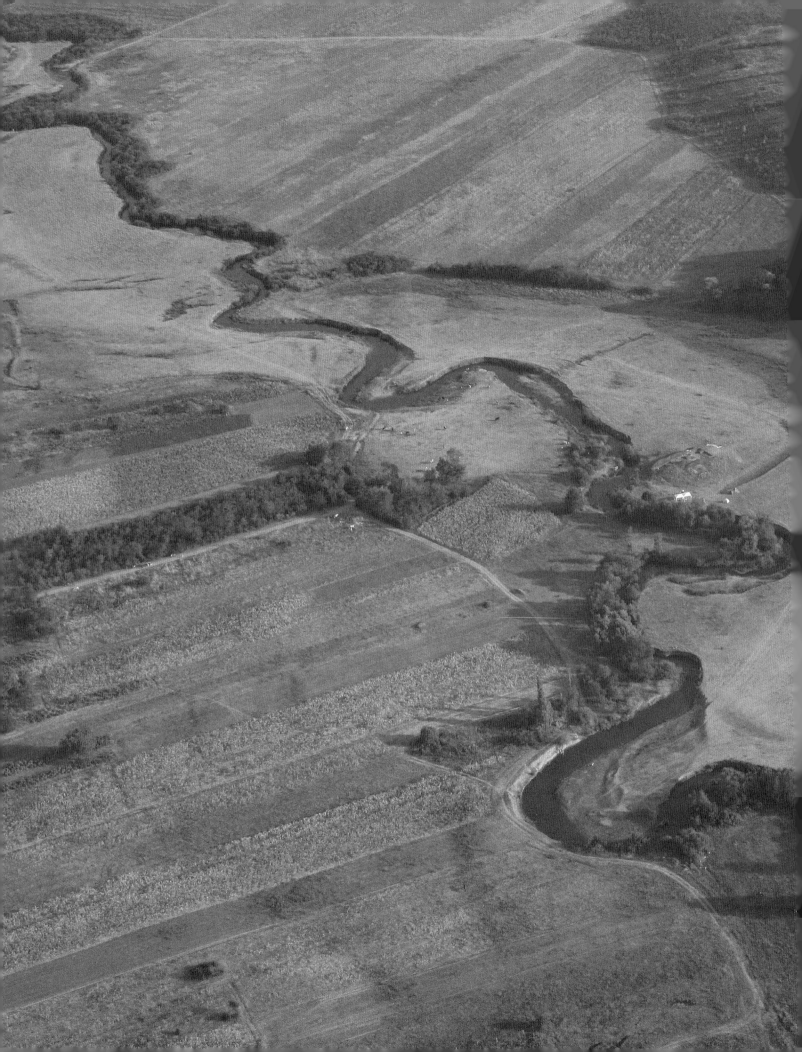

The Rise and Fall of Old Europe
David W. Anthony

Hartwick College

In 4500 BC, before the invention of the wheel or writing, before the first cities were built in Mesopotamia and Egypt, Old Europe was among the most sophisticated and technologically advanced places in the world. The term "Old Europe" refers to a cycle of cultures that thrived in southeastern Europe principally between about 6200 and 4300 BC, then suffered what seems to have been a sudden collapse. Old European customs continued in some regions until about 3500–3300 BC, when there was a final, smaller collapse. At its peak, about 5000–3500 BC, Old Europe was developing many of the political, techno-logical, and ideological signs of "civilization." Some Old European villages grew to citylike sizes, larger than the earliest cities of Mesopotamia. Some Old European chiefs wore stunning costumes gleaming with gold, copper, and shell ornaments—displays of opulence that still surprise and puzzle archaeologists, because there was no equivalent distinction in private houses. Old European metalsmiths were, in their day, among the most advanced metal artisans in the world, and certainly the most active. The metal artifacts recovered by archaeologists from Old Europe total about 4,700 kilograms (more than five tons)

of copper, and over 6 kilograms (13.2 pounds) of gold, more metal by far than has been found in any other part of the ancient world dated before 3500 BC.[1] The demand for copper, gold, Aegean shells, and other valuables created networks of negotiation that reached hundreds of kilome-ters. Pottery, figurines, and even houses were decorated with striking designs. Female "goddess" figurines, found in almost every settlement, have triggered intense debates about the ritual and political power of women. Signs inscribed on clay suggest a system of primitive notation, if not writing.

Old Europe achieved a precocious peak of creativity between 5000 and 3500 BC, but succumbed to a series of crises. Later prehistoric European cultures developed in a different direction, with more widely dispersed populations, greater reliance on stockbreeding, and less investment in houses, pottery, and female symbols. Old Europe was utterly forgotten until it began to be redis-covered by archaeologists in the decades around World War I. In that sense it truly was "lost." The details of its way of life are only now beginning to be clearly recog-nized. For that reason, although much progress has been made, the humanity of Old Europe—its everyday social and political life—remains elusive. Different modern observers have projected quite different visions of the past on the remains of Old Europe.[2] Some of those competing

Aerial image of the Neajlov valley, Romania, a natural habitat rich in Gumelnița prehistoric settlements.

interpretations can be found in this catalogue. But new radiocarbon dates, new discoveries, and new studies of old collections hold out hope for a clearer understanding of Old Europe, Europe's first protocivilization, in the not-too-distant future.

The Meaning of Old Europe

"Old Europe" has a variety of meanings in popular culture, most of them not archaeological. The term was used to refer to the Europe of the pre–European Union, and it was used in the nineteenth century for countries that clung to monarchy and the ancien régime after the revolutions of 1848. These references share the essential meaning of a segment of Europe that resisted change. In archaeology, however, "Old Europe" has a very different history and meaning.

In this volume "Old Europe" is used as it was by Marija Gimbutas in her 1974 book, *Gods and Goddesses of Old Europe* (revised and reissued in 1982 as the best-selling *Goddesses and Gods of Old Europe*, with the genders reversed). Gimbutas' conception of Old European *gods and goddesses* has been both effusively praised and severely criticized,[3] the latter not least by Douglass Bailey in this volume, but her *geographic* and *cultural* concept of Old Europe is useful as a convenient label. It refers to the cultures of southeastern Europe, centered in Bulgaria and Romania, during the Neolithic and Copper Age, beginning about 6200 BC and ending in two stages between 4300 and 3300 BC. The Copper Age, which began about 5000 BC, is called the Eneolithic in southeastern European archaeology, but "Eneolithic" is a term that has multiple meanings. "Copper Age" is simple, conveys a clear meaning, and is comparable to the terms "Bronze Age" and "Iron Age," the other two ages of metal.[4]

The material traits that defined Old Europe at its peak in the Late Neolithic and Copper Age, about 5200–4300 BC, were: first, substantial, heavily built homes framed in timber, roofed with thatch, with walls usually made of mud plaster packed on a core of woven twigs, arranged in nucleated villages (although specific house and settlement types varied, and sun-dried mud brick was used for walls in the southern part of Old Europe); second, technically sophisticated pottery made of fine clays, fired under well controlled conditions, often decorated with complex incised and painted designs (although the shapes and designs varied from region to region); third, figurines that portrayed females, frequently found in houses, occasionally clustered in groups, or deposited broken in rubbish pits connected with houses (although again the shapes and styles varied, and there were also many animal and some male figurines); and fourth, participation in a cycle of long-distance trade that began with the exchange of Aegean *Spondylus* shells and grew to include copper and gold ornaments and cast copper tools and weapons.

Three of these traits—substantial *houses* often with room for visitors; dozens of *different types of pottery* (bowls, jugs, pots, pot stands, storage jars, and so on) made for elaborate service and display at social events; and *figurines* connected with domestic rituals—emphasized the importance of the home as a center of family, social, and ritual life. The house and its household were so important that some houses contained small clay models of houses, and some contained decorated clay panels that could have represented interior room dividers or the gabled ends of houses decorated with animal horns (fig. 1-1, page 90). Two of the listed traits—well fired pottery and the copper trade—resulted from the same sophisticated pyrotechnology. One trait—long-distance trade—was greatly stimulated by the invention and elaboration of metallurgy and mining. Old Europe really was different from other parts of Europe in the persistent recombination and interrelationship of these four customs, and it was the part of temperate Europe where the farming economy began, so the farming way of life truly was "old" there. If we did *not* use a simplifying label like Old Europe, then we would have to use strings of culture names like Gumelniţa-Sălcuţa-Petreşti-Ariuşd-Cucuteni-Tripol'ye (an actual group of related Old European regional archaeological cultures; see table 1-1) to indicate which specific segment of Old Europe we were talking about, a strategy that, while comprehensible to specialists, would make discussion with most people almost impossible.

"Old Europe" is *not* used in this volume as it was used by Carl Schuchhardt in his 1919 book, *Alteuropa*.[5] This early archaeological survey of prehistoric Europe was influenced by the idea that European civilization was

derived from prehistoric northern Europe, an interpretation that had disastrous political consequences and was proved mistaken before World War II.[6] Old Europe, for Schuchhardt, referred to all of prehistoric Europe, including Ice Age hunter-gatherers, so it was synonymous with "prehistoric Europe." Gimbutas used the term with a more specific cultural and geographic meaning, and in this we follow her lead.

The Origin of Old Europe, 6200–5500 BC

Old Europe was different from other parts of Neolithic Europe probably because of how and when the Neolithic farming way of life began in Europe—an accident of history and geography that had substantial consequences. The deeper roots and longer development of Neolithic farming in southeastern Europe affected the role that the latter played in later trade and communication networks.

Pioneer farmers first plunged into the forests of temperate Europe in the Balkans and the Carpathian Basin about 6200 BC (possibly a little earlier), founding the settlements that would eventually evolve into Old Europe (see inside cover map). These farmers came from Greece and Macedonia, and before that, from Anatolia (Turkey).[7] They brought with them seeds of emmer and einkorn wheat, peas, barley, and domesticated sheep and cattle, all intrusive plants and animals that had been domesticated millennia earlier in the Near East and were now imported into the wilderness of Europe. Genetic research shows that the domesticated cows of the Neolithic pioneers were descended purely from long-domesticated mothers that had come from Anatolia.[8] They mated occasionally with wild bulls (traced on the Y-chromosome) of the native European aurochs, huge beasts with horns like today's Texas longhorns, but only the male calves from such unions were retained, perhaps to increase the size of the herd or its resistance to European diseases. Neolithic cows, already kept for their milk (see below), had no wild aurochs-cow genes in their MtDNA (inherited from mother to daughter). Their MtDNA came entirely from domesticated Anatolian cows—perhaps because wild cows were inferior milkers. Wild bulls were a powerful symbol in the art of Neolithic Anatolia, and bulls remained a subject of art and ritual in Neolithic Greece and later in Old Europe, where they were represented in gold at the Varna cemetery (figs. 1-2, 9-8).

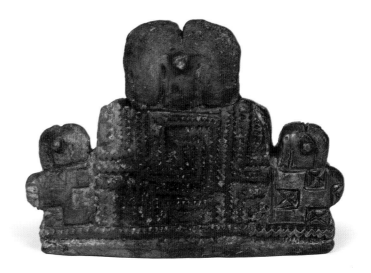

1-1. Possible representation of a house with animal horn gables. Fired clay, Vădastra culture, Vădastra, 5500–5000 BC, MO.

31

cultural break |||||
cultural group ▨

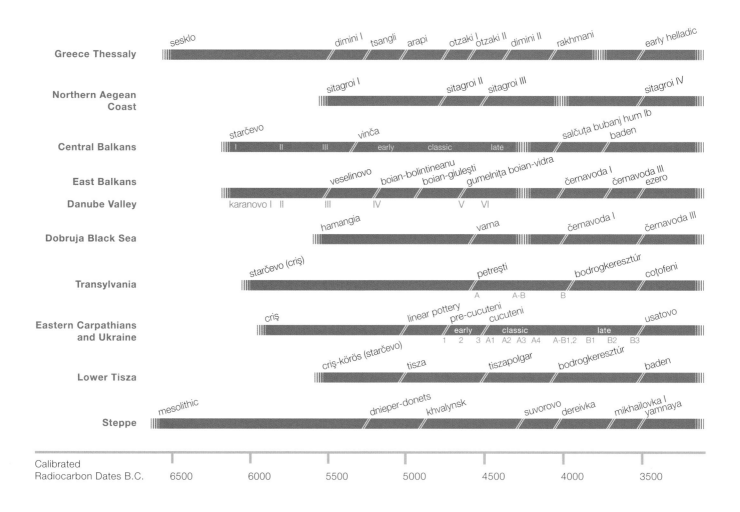

Greece Thessaly

sesklo · dimini I · tsangli · arapi · otzaki I · otzaki II · dimini II · rakhmani · early helladic

Northern Aegean Coast

sitagroi I · sitagroi II · sitagroi III · sitagroi IV

Central Balkans

starčevo · vinča · salčuţa bubanj hum Ib · baden
I · II · III · early · classic · late

East Balkans
Danube Valley

veselinovo · boian-bolintineanu · boian-giuleşti · gumelniţa boian-vidra · černavoda I · černavoda III ezero
karanovo I · II · III · IV · V · VI

Dobruja Black Sea

hamangia · varna · černavoda I · černavoda III

Transylvania

starčevo (criş) · petreşti · bodrogkeresztúr · coţofeni
A · A-B · B

Eastern Carpathians and Ukraine

criş · linear pottery · pre-cucuteni · cucuteni · usatovo
early · classic · late
1 · 2 · 3 · A1 · A2 · A3 · A4 · A-B1,2 · B1 · B2 · B3

Lower Tisza

criş-körös (starčevo) · tisza · tiszapolgar · bodrogkeresztúr · baden

Steppe

mesolithic · dnieper-donets · khvalynsk · suvorovo · dereivka · mikhailovka I / yamnaya

Calibrated
Radiocarbon Dates B.C. 6500 6000 5500 5000 4500 4000 3500

Table 1-1. Chronology of Neolithic and Copper Age cultures by region.
Chronological phases are named after the archaeological sites where
they were defined.

The first Neolithic settlements in Greece were founded about 6700 BC in Thessaly, the richest agricultural land in Greece, probably by colonists who island-hopped across the Aegean Sea from western Anatolia in open boats, carrying seeds, farming tools, and live calves and lambs trussed for transport. Katherine Perlés has convincingly argued that the material culture and economy of the first farmers in Greece were transplanted from Anatolia, and recent archaeological research in western Anatolia has identified Neolithic settlements that probably played a role in the colonizing movement.[9] Material traits and customs carried into Greece from western Anatolia included (in addition to the basic farming plants and animals) Anatolian-like pottery, flint tools, ornaments, bone belt hooks, large-hipped and rod-headed female figurines made of clay, stamps (known as *pintadera*) used to press geometric designs on a variety of media (perhaps including textiles, bread, and human skin), and lip labrets (small, stone, barbell-shaped ornaments pushed through pierced openings in the lower lip, or perhaps in the earlobe). Many of these customs were maintained in Greece and later were carried into Old Europe.

By 6200 BC at least 120 Early Neolithic settlements stood in Thessaly, and a few farming communities had spread up the Aegean coast to Macedonia. But expansion northward stopped at the frontier between the Mediterranean climate and flora of Greece and Macedonia and the colder, wetter, temperate climate and flora of southeastern Europe. About 6200 BC, or perhaps a little earlier, a second wave of pioneers crossed that frontier.

The colonizing farmers brought domesticated sheep and cattle, wheat and barley, female-centered domestic rituals, *pintadera* stamps (figs. 1-3–1-5), lip labrets, and ornaments made of Aegean *Spondylus* shell into the colder, damper climate of temperate Europe for the first time. They leapfrogged from favorable place to favorable place, quickly advancing through the forests from Greece and Macedonia to the middle Danube valley. Their small farming settlements in the middle Danube, in modern northern Serbia and southwestern Romania, are assigned to the Early Neolithic Starčevo and Criş cultures. This central Danubian riverine settlement node produced two streams of migrants that flowed in one direction down

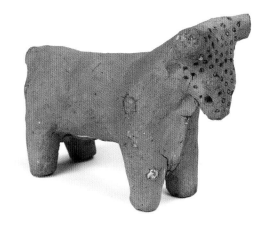

1-2. Bull statuette. Fired clay, Vinča, Padea, 5000–4500 BC (Late Vinča), MO.

1-3. Pintadera. Fired clay, Cucuteni, Ruginoasa, 4500–3900 BC (Cucteni A), CMNM.

1-4. Pintadera. Fired clay, Starčevo-Criş, Poieneşti, 6200–5500 BC, MJSMVS.

1-5. Pintadera in the shape of a left leg. Fired clay, Starčevo-Criş, Zăuan, 6200–5500 BC, MJIAZ.

the Danube, eastward into Romania and Bulgaria, and in the other up the Mureş and Körös rivers, northeastward into Transylvania. Both migration streams created similar pottery and tool types, assigned today to the Criş culture. Their ancestors in Greece had depended largely on sheep for their meat diet, and the Starčevo and Criş pioneers maintained that preference for sheep even though the forests of southeastern Europe were more suitable for pig and cattle keeping. These farmers did, however, consume cow milk, indicated by molecules of milk fat, probably from cows, that were recovered from Starčevo and Criş clay pots.[10]

Archaeologists have long debated the role played by the local indigenous population of hunter-gatherers in the establishment of the first farming communities in southeastern Europe. But only a few places in southeastern Europe contained clusters of Late Mesolithic hunter-gatherer archaeological sites dated after 7000 BC, so the region seems to have been occupied only in patches. One of those patches was located at the transition from the middle to the lower Danube valley, defined by the gorges known as the Iron Gates, where the Danube twisted through steep canyons between the Balkans and Carpathians and the river currents pulled nutrients up from the bottom, feeding large stocks of fish. The indigenous fisher-hunter-gatherers around the Iron Gates, known from famous sites such as Lepenski Vir in Serbia and Schela Cladovei in Romania, interacted with the Neolithic immigrants—Starčevo pottery is found at Lepenski Vir through the entire sequence of hunter-gatherer occupation at the site—but in the end the Mesolithic hunter-fisher-gatherer material culture was replaced by the intrusive economies and material cultures of the Starčevo and Criş immigrants. In the Dobrogea (the peninsula of rocky hills skirted by the Danube delta at its mouth), many Late Mesolithic hunter-gatherer sites have been found near Tulcea south of the Danube River in Romania, and others on the northern side of the estuary at Mirnoe in Ukraine. There is no archaeological evidence of contact between these hunters and the Criş farmers, but the Neolithic Hamangia culture, which emerged later in the Dobrogea, had flint tools that looked like those of the Mesolithic, and its funeral customs might have been influenced by hunter-gatherer burial traditions.[11]

Once established, the Neolithic farming communities of the middle and lower Danube valley diversified and developed into distinct regional cultures. South of the Danube River, on the elevated plain of the Maritsa River in the Balkan Mountains, a settlement was established at Karanovo. This farming village, founded amid a cluster of neighboring Neolithic communities, was almost continuously occupied through the Balkan Neolithic and Copper Age, 6200–4300 BC, and its stratigraphy provides a yardstick for the chronology of Old Europe. Karanovo I was established about 6200–6100 BC, and Karanovo VI, representing the peak of Old European culture, ended about 4300–4200 BC. At the beginning of this sequence, Neolithic settlements of the Karanovo I–III periods in the Balkan Mountains showed some analogies in pottery types with Neolithic communities of northwestern Anatolia (Ilipinar VI and Hoca Çeşme II), so there seems to have been occasional contact between the Balkans and northwestern Anatolia between 6200 and 5500 BC.[12]

As had happened earlier in Greece, the expansion of farming communities into southeastern Europe went only so far and then stopped. The initial phase of rapid, long-distance colonizing movements was followed by consolidation. A frontier was established in Hungary south of Lake Balaton that persisted for at least five hundred years, about 6100–5600 BC.[13] The settling-in process that occurred behind this frontier probably was one of the historical processes that later was responsible for the cultural distinctiveness of Old Europe. When another wave of colonizing migrations began about 5600–5500 BC, carrying the farming and stockbreeding way of life over the Carpathians and into Poland, Germany, and France, the villages of southeastern Europe were already old and well established, and had a history of interconnection. The new pioneers who colonized northern Europe, the Linear Pottery culture (or *Linearbandkeramik*, often reduced to LBK in archaeologists' shorthand) continued to value *Spondylus* shell ornaments, fueling a shell trade that extended from Greece to northern France and Germany between 5500 and 5000 BC (see the essay by Michel Séfériadès in this volume), but in many other ways they grew more and more distinct from the cultures of southeastern Europe.

Old Europe at Its Peak

By 5000 BC the scattered farming hamlets of Bulgaria and southern Romania had blossomed into increasingly large and solidly built agricultural villages of multiroomed houses, some of them two storied, set in cleared and cultivated landscapes surrounded by herds of cattle, pigs, and sheep. Cattle might have been used to pull primitive scratch-plows across the fields (although the evidence for this is contradictory).[14] Fragments of painted plaster suggest that house walls were decorated with the same swirling, curvilinear designs that appeared on pottery. In the Balkans and the lower Danube valley, villages were rebuilt on the same spot generation after generation, creating stratified tells that grew to heights of thirty to fifty feet, lifting the village above its surrounding fields.[15] In other regions, for example at Varna on the Black Sea coast, settlement locations were customarily changed after a few generations, creating thinner archaeological deposits, referred to as "flat" settlements. Marija Gimbutas made Old Europe famous for the ubiquity and variety of its goddesses. Household cults symbolized by broad-hipped female figurines (figs. 1-6, 1-7) were practiced throughout Old Europe, although male figurines also were made and used, occasionally grouped with female figurines (fig. 5-4a), and animal figurines were made in a variety of shapes and sizes (figs. 1-2, 1-8, 1-9). Marks incised on figurines and pots suggest the appearance of a notation system, although the frequency of inscribed signs peaked in the Late Neolithic and declined through the Copper Age,[16] so there is scant evidence for an evolution toward writing. Potters invented two-level kilns that reached temperatures of 800–1100° C. A low-oxygen-reducing atmosphere created black ceramic surfaces that were painted with graphite to make silver designs; alternatively, a bellows-aided high-oxygen atmosphere made a red or orange surface, sometimes painted in white, black, and red.

Pottery kilns led to metallurgy. Copper was extracted from stone, or smelted, by mixing powdered green-blue azurite or malachite minerals (possibly used for pigments) with powdered charcoal and baking the mixture in a reducing atmosphere, perhaps accidentally at first. At 800° C the copper separated from the mineral ore in tiny shining beads. These could be tapped out and separated from the waste slag. The slag was dumped, a sure sign for archaeologists that smelting occurred at that location. The copper was reheated, hammered into sheets, forged, welded, annealed, and made into a wide variety of tools (hooks, awls, and blades) and ornaments (beads, rings, and other pendants). Ornaments of gold (probably mined in the eastern Balkan Mountains and Sakar Mountain near the Turkish border) began to circulate in the same trade networks. The early phase of copper working began before 5000 BC.[17]

Before 5000 BC, Balkan smiths learned that if they heated copper to 1083° C it would turn into a viscous liquid and could be poured into molds, or cast. Attaining this temperature required a bellows-aided kiln, but such kilns were already being used by Old European potters.[18] Working with molten copper was tricky, not only because it required very high temperatures but also because it had to be stirred, skimmed, and poured correctly or it cooled into a brittle object full of imperfections. Well made cast copper tools were used and exchanged across southeastern Europe between about 4800 and 4300 BC in eastern Hungary with the Tiszapolgar culture; in Serbia and western Romania with the Vinča C and D culture; in Bulgaria at Varna and in the Karanovo V–VI tell settlements; in Romania with the Gumelnița culture; and in Moldova and eastern Romania with the Pre-Cucuteni III/ Tripol'ye A through the Cucuteni A3/ Tripol'ye B1 cultures. This period (the Eneolithic in southeastern European archaeology) is referred to as the Copper Age in this volume.

Metallurgy was a new and different kind of craft. Even after being told that a shiny copper ring was made from a green-stained rock, it was difficult to see how. The magical aspect of copperworking set metalworkers apart, and the demand for copper objects increased trade. Prospecting, mining, and long-distance trade for ore and finished products introduced a new era in interregional politics and interdependence that quickly reached across Old Europe and even into the steppe grasslands north of the Black and Caspian Seas, probably through gift exchanges between local elites.[19]

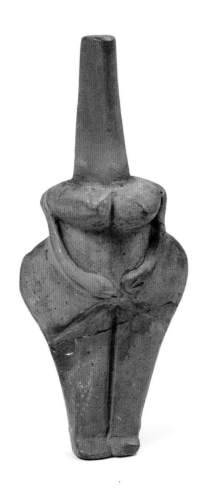
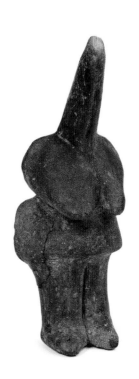

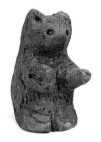

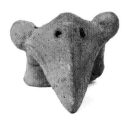

Kilns and smelters for pottery and copper consumed the forests, as did two-storied timber houses and the bristling palisade walls that protected many Old European settlements, particularly in northeastern Bulgaria. It seems likely that many houses were intentionally filled with wood and burned, possibly as a ritual of purification after the death of someone important, then were rebuilt in almost the same place, a cultural practice that added to deforestation.[20] At Durankulak and Sabla Ezerec in northeastern Bulgaria and at Tîrpeşti in Romania, pollen cores taken near settlements show significant reductions in local forest cover.[21] The earth's climate reached its postglacial thermal maximum, the Atlantic period, about 6000–4000 BC, and was at its warmest during the late Atlantic (paleoclimatic zone A3), beginning about 5200 BC. In the uplands majestic forests of elm, oak, and lime trees spread from the Carpathians to the Urals by 5000 BC.[22] But while the climate was mild, farming, mining, and tree felling might have slowly degraded the environments around long-settled villages, leading to increased soil erosion and localized declines in agricultural production.[23]

Trade and Power

A short article published by the anthropologist Mary Helms in 1992 had a profound effect on the archaeological study of long-distance trade.[24] Before this, archaeologists tended to use trade as an indicator of different kinds of political organization: Trade conducted as a series of personal, face-to-face gift exchanges indicated an egalitarian society; trade organized to accumulate valuables for the purpose of enhancing prestige through large-scale gift giving indicated a redistributive chiefdom; and trade that filled locked and labeled storerooms in warehouses to enrich and embellish kings and palaces indicated a centralized state. Helms reminded archaeologists that objects obtained from far away were not just artifacts, but might be tangible symbols of a personal connection with powers and even magic from beyond the known and familiar world. Exotic items suggested not merely wealth, but the owner's power over and intercourse with strange places and beings, possibly including the ghosts of dead ancestors. Engaging in long-distance travel, warfare, and trade gave the participant an aura of the extraordinary. Long-distance trade in Neolithic and Copper Age Europe probably was motivated partly by these ideological and

1-6 (opposite: left). Female figurine. Fired clay, Hamangia, Baïa, 5000–4600 BC, MNIR.

1-7 (opposite: right). Female figurine. Fired clay, Hamangia, Cernavoda, 5000–4600 BC, MNIR.

1-8. Bear statuette. Fired clay, Cucuteni, Ripiceni, 4500–3900 BC (Cucuteni A), MJBT.

1-9. Fragmentary Zoomorphic Statuette. Fired clay, Cucuteni, Epureni 4500–3900 BC, MJSMVS.

imaginative aspects of value, making the trade goods not "commodities" in a modern sense but rather "valuables," symbols of status and recognition.[25]

The oldest long-distance trade in the European Neolithic was the exchange of obsidian, a volcanic glass that was worked into beautiful and razor-sharp stone tools. Obsidian from the Aegean island of Melos was carried across the Aegean Sea on boats.[26] The voyages that distributed Melos obsidian, probably organized as fishing trips, also would have established a pool of knowledge about distances and island crossings that could have facilitated the cross-Aegean colonization of Greece. But obsidian seems to have been just a useful and attractive material, not a symbol of status or power. Another Aegean prize, the shell of the mollusk *Spondylus gaederopus* (fig. 8-1), was traded over even longer distances and carried a significant symbolic weight.

Spondylus shells grew in the Aegean and the Adriatic Seas, and perhaps in other parts of the Mediterranean Sea, but not in the Black Sea. Divers had to pull the spiny shells from submerged rocks at depths of more than four meters. In Greek Neolithic villages, the shells were broken in specific ways and used to make various kinds of ornaments: beads, bracelets, and rings (see the essay by Séfériadès). *Spondylus* ornaments were carried from Greece into southeastern Europe when the first farmers migrated to the Danube valley. Sporadic trade supplied Danubian farmers with these symbols of their Aegean ancestry throughout the Early Neolithic, 6200–5500 BC. The trade in *Spondylus* grew significantly between 5500 and 5000 BC, when a second wave of migration carried the farming economy from the middle Danube valley over the Carpathians into Poland, Germany, and France. North of the Carpathians, the shells took on greater symbolic significance, appearing principally in the graves of mature males, probably as indicators of status in Linear Pottery (or LBK) communities. During this half-millennium, many thousands of shells per year were processed in Aegean workshops at Dikili-Tash, Dimini, and Sitagroi and were traded up the Danube valley, over the Carpathians, and into Linear Pottery farming villages, a distance of more than three thousand kilometers. But after about five hundred years, the stories of Aegean

ancestry seem to have faded away, and the demand for *Spondylus* ceased in central and northern Europe at the transition from Linear Pottery to Lengyel-type communities, about 5000–4900 BC.[27] The *Spondylus* trade contracted to southeastern Europe, but at the same time it began to supply the networks of emulation and competition that defined Old Europe at its peak. In Old Europe *Spondylus* was accumulated and hoarded in unprecedented quantities with new, spectacular kinds of prestige goods made of copper and gold.

Copper metallurgy was invented in southeastern Europe at about the same time that the *Spondylus* trade into central Europe stopped. Smelted copper was a new material and strongly stimulated long-distance trade. But trade connections were no longer very active in the direction of central Europe, where the metal age really began a thousand years later, around 4000 BC; nor was much copper traded into Greece or Anatolia. Metal ornaments *were* quickly included in trade networks that extended eastward into the steppes north of the Black and Caspian seas as far as the Volga-Ural region, a distance of more than eighteen hundred kilometers from the copper mines in Bulgaria that were the source of the traded copper. At the cemetery of Khvalynsk on the middle Volga, dated about 4700 BC, 320 copper ornaments were found in 201 graves. Some objects were made or repaired locally, but most were made of Bulgarian copper, and a handful (rings and spiral bracelets) were made in the same way as the copper ornaments found at Varna, and probably were imported from Bulgaria.[28]

The trade route from Bulgaria to the Volga probably passed through the Old European frontier towns and villages of the Cucuteni-Tripol'ye culture. At the Cucuteni-Tripol'ye settlement of Karbuna, occupied about 4500–4400 BC, a hoard of 444 copper objects was placed in a Tripol'ye A pot with 254 beads, plaques, and bracelets made of *Spondylus* shell, and hidden in a pit under a house floor. Balkan copper like that in the Karbuna hoard was traded eastward into steppe communities, but *Spondylus* shell was not—it remained in Old Europe. Curiously, around 5000 BC steppe chiefs started to wear ornaments made of small boar-tusk plaques about the same size and shape as plaques made of *Spondylus* in Old European hoards.

The boar-tusk plaques could be seen as emulations of *Spondylus* ornaments.

Copper and *Spondylus* were frequently combined in Old European hoards. They occurred together not just at Karbuna, but also in a hoard of more than 450 objects discovered at the Cucuteni-culture settlement of Brad (fig. 1-10) and in another large hoard at Ariuşd in Transylvania (2,034 objects).[29] The hoards seem to have been accumulations of prestige objects—*Spondylus* ornaments, copper and gold ornaments, cast copper hammer-axes, and polished-stone hammer-axes—acquired through long-distance networks of exchange. Similar sets of objects were included in the rich graves at Varna in Bulgaria. A gold-covered *Spondylus* bracelet was worn by the mature male buried with 990 gold objects in Grave 43 at the Varna cemetery, the richest single grave from Old Europe, dated about 4600–4500 BC (fig. 9-11). But no *Spondylus* was included in the Varna cenotaphs (symbolic graves containing no body), which make up about one-sixth of the graves in the cemetery, including four of the five richest graves.

The Varna cemetery was discovered in 1972 on the western outskirts of Varna, Bulgaria, by workers digging a trench for an electric cable, precipitating a multiyear excavation campaign led by Igor Ivanov (fig. 9-1). The gold-filled graves of Varna (see the essays by Vladimir Slavchev and John Chapman in this volume) are the best evidence for the existence of a clearly distinct and distinctive upper social and political rank, probably chiefs and their families, in the Varna culture about 4600–4400 BC. The hoards of similar objects found in other settlements document the extension of this chiefly prestige-trading system to other parts of Old Europe. Occasional wealthy graves, not as rich as those at Varna, probably indicate the burials of lower-level chiefs. Old European society was divided between powerful individuals who possessed metals and Aegean shell (the exotic insignia of long-distance trade) and wore these valuables on their bodies in public events—and those who did not.[30] But the ethos of inequality did not extend to the home. Although a few unusually large houses can be found in a few settlements, they were not significantly different in design or contents from other houses. The people who donned gold costumes for public events while they were alive went home to fairly ordinary houses.

The Lure of the Figurines

One of the most famous aspects of Old Europe, certainly the aspect that Marija Gimbutas made the center of her extensive research, is the abundance of figurines, the majority of them apparently females. The enigmatic female-centered cults of Old Europe have generated sharp disagreement among archaeologists, historians, and feminists. The exhibition that accompanied this catalogue included dozens of elaborately painted and decorated female figures of many kinds and styles, some found in groups sitting on hornback chairs as if in council (figs. 5-1, 5-2), others placed inside ceramic models of houses (fig. 5-5), and others discovered scattered among the ruins of ordinary homes. A strikingly modern male figure from Hamangia, Romania, widely known as "The Thinker," is among the best-known art objects from all of prehistoric Europe (fig. 5-9). But what did they mean?

Gimbutas argued that individual figurine forms and styles could be identified with individual deities in an Old European pantheon. A female figurine might represent the generative Mistress of Nature, or the agricultural, pregnant Goddess of Fertility; the Bird and Snake Goddesses might represent incarnations of the life force; or the old crone the Goddess of Death (sometimes also represented by poisonous snakes and vultures or birds of prey, fig. 1-11). Each of these could take many subsidiary forms. A male figurine might represent the vigorous young partner and Consort of the Goddess; or the old dying Vegetation God (the interpretation Gimbutas assigned to the sorrowful-seeming "Thinker"); or the Master of Animals, the wild Hunter god. Moreover, the prevalence of female images among the anthropomorphic figurines of Old Europe suggested to her that they mirrored a matrilineal and matrifocal Old European social structure, in which women were the dominant figures in social and political life.[31]

Gimbutas followed the theories of James Mellaart, the archaeologist who in the 1960s described the mother-goddesses of Neolithic Çatal Höyük in Anatolia (Turkey) as evidence for an ancient and widespread tradition of

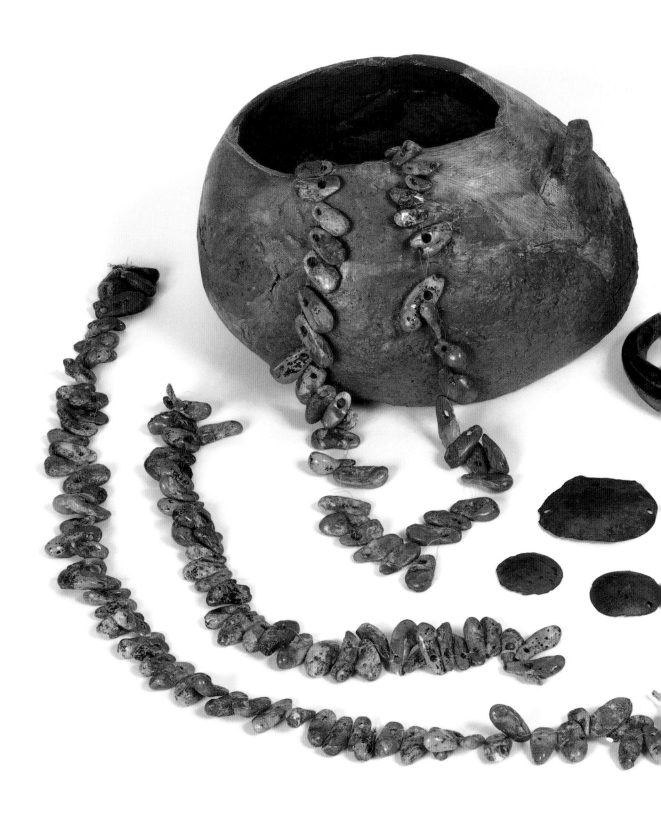

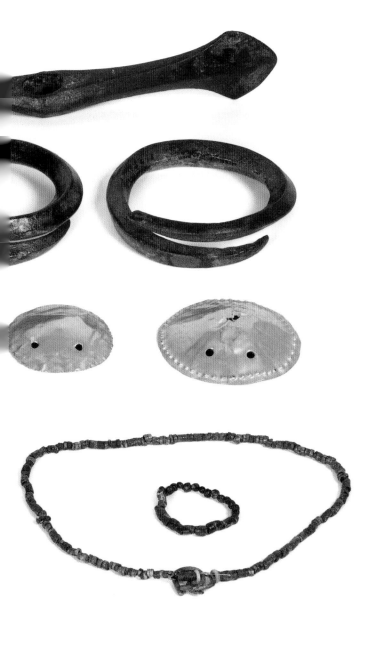

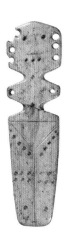

1-10. Brad hoard objects including an Askos, stag-tooth necklace, copper and gold disks, copper axe, copper bracelets, copper necklace, and copper and vitreous-bead necklace. Cucuteni, Brad, 4200–4050 BC (Cucuteni A3), MIR.

1-11. "Goddess of Death" female figurine. Bone, Gumelniţa, Vitănești 4600–3900 BC, MJITR.

multifaceted mother-worship.[32] For Gimbutas, this tradition was rooted in the Paleolithic Ice Age, continued through the Neolithic, and survived into the Bronze Age and the Classical era, although much suppressed at that date by the later cults built around Indo-European male gods (Zeus, Poseidon, Ares, and so on). According to Gimbutas, it was patriarchal Indo-European people who, in a war of the genders, destroyed and replaced the goddess-centered societies of Old Europe. Eastern European scholars have tended to interpret Old European figurines in similar ways, assuming that they are somehow connected with the worship of a Great Mother Goddess and assigning specific cult activities or identities to specific figurines (for a different approach see the essay by Bailey in this volume).[33]

Most of these identifications of specific gods and goddesses depended on analogies with much later rituals and religious traditions derived from Classical Greece or Rome, or even from modern folklore. Mircea Anghelinu criticized her colleagues who depended on what she called the "folk premise"—the assumption that contemporary Romanian peasant traditions about female spirits and witches could be understood as substrate survivals of Copper Age beliefs—but she made this criticism precisely because the practice was so widespread.[34] Gimbutas, who grew up in Lithuania, explicitly cited Baltic folkloric parallels for the "goddess" figurines of Old Europe. The problem, of course, is that modern or even medieval folk traditions are separated from Old Europe by at least five thousand years of intervening history, and in the case of Lithuania, by a significant distance. (Gimbutas bridged the distance by appealing to the prehistoric origins of the Balts among Indo-European tribes that interacted with the societies of Old Europe.) Similarly, Gimbutas' attempt to link specific Copper Age goddesses with Minoan or Greek deities must overcome the problem that Classical Greece and Bronze Age Crete were quite far from Romania or Moldova geographically, and even Minoan Crete flourished at least two thousand years after Old Europe.

Without any question, codes of meaning are contained in Old European figurines, but it is difficult to decipher the codes. Bailey's essay in this volume opens with a description of two almost identical sets of figurines—twenty-one broad-hipped females, twelve large and nine small, accompanied by twelve horn-back chairs in one set and thirteen horn-back chairs in the other—found in two different pots at two settlement sites of the Cucuteni culture about two hundred kilometers apart in Romania (figs. 5-1, 5-2). It strains the imagination to believe that these almost identical sets represent a random coincidence. But what, exactly, was the significance of twenty-one, divided into groups of twelve and nine? If the chairs are for the twelve bigger figurines (which, as Bailey notes, are still small enough to fit in your hand), why didn't the nine smaller figurines get chairs?

In the Tripol'ye settlement of Sabatinovka in western Ukraine, a building identified as a "shrine" yielded sixteen similar figurines found sitting in similar horn-back chairs, set up on a clay bench next to the remains of a full-size clay horn-back chair, presumably for a real person. The entire structure was found to contain sixteen more of these rod-headed, round-hipped figurines, for a total of thirty-two. From other evidence it appears to have been perhaps a communal bakery, or perhaps a storehouse for flour making (there were many grinding stones) and bread-making equipment. Baking could have been an act heavy with ritual significance—baking is incorporated even today into many holiday rituals—but to call the Sabatinovka structure a shrine is to impose our own imagined meaning.[35] In any case, the great majority of Old European figurines have been found in domestic contexts in and around houses. Ordinarily they do not seem to have been separated from the flow of daily activities or segregated in shrines, so looking for shrines is perhaps the wrong way to understand them.

One key to interpreting the figurines is to know their exact archaeological contexts more precisely than has often been possible in the past. If they are regarded as art objects or self-contained symbols whose meaning lay entirely in their shapes and decoration, then their exact archaeological context could be deemed less important. But the Berkeley archaeologist Ruth Tringham has shown that it makes a great deal of difference whether figurines were found above or below house floors, and this can be tricky to determine in the burned and collapsed ruins of a

house made of fired clay, plaster, and timber, frequently found on top of the remains of an older house. At Opovo, a Vinča culture site in Serbia dated about 4400 BC, careful excavation showed that many female figurines found "in" one house actually were placed in foundation deposits as some sort of blessing or protection for a house about to be built, and then were covered by the walls, floors, and even the wall posts of the house as it was built. Most of the figurines at Opovo were found broken and discarded in rubbish pits near the house with broken fragments of stone axes, obsidian chips, bone tools, and miniature clay objects commonly called "amulets."[36] A few were found on a house floor; one of these was an alabaster figurine found with a cluster of perforated shell beads that possibly decorated it. These three very different contexts (buried under floors, broken and discarded in pits, or decorated and placed on the floor) certainly indicate very different ways of using figurines, and perhaps indicate three different kinds of domestic household rituals.

The shape, decoration, and even the clay of the figurines is, of course, another valuable source of meanings. At the Tripol'ye settlement of Luka Vrublevetskaya, dated about 4600 BC, the clay of the figurines was thoroughly mixed with all three kinds of grain (two kinds of wheat and millet) cultivated by the farmers of the village, and flour was added as well. In this case, where fat-hipped female images were made of clay tempered with cultivated grain and flour, we might reasonably accept the interpretation of an agricultural invocation of fertility. The designs on the surfaces of the figurines might contain other kinds of clues (fig. 1-12, page 112), and certainly have inspired many interpretative efforts. Gimbutas thought that M and V signs identified the Goddess, and she interpreted anthropomorphic sculptures decorated with these symbols as invocations of the Goddess (fig. 1-13). Peter Biehl and A.P. Pogozheva conducted statistical analyses of the distribution of particular decorative motifs with body parts, establishing that designs like the lozenge or diamond were associated with the belly and particularly with pregnant-looking bellies.[37] Many of the figurines seem to be wearing masks, or at least their faces are rendered in a very unrealistic, masklike way (fig. 1-14), while others, particularly later Cucuteni-Tripol'ye figurines, have very realistic faces. Even vessels were made in the shape of human figures,

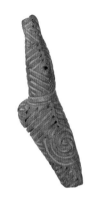

1-12. Figurine. Fired clay, Cucuteni, Săveni, 4200–4050 BC (Cucuteni A3), MJBT.

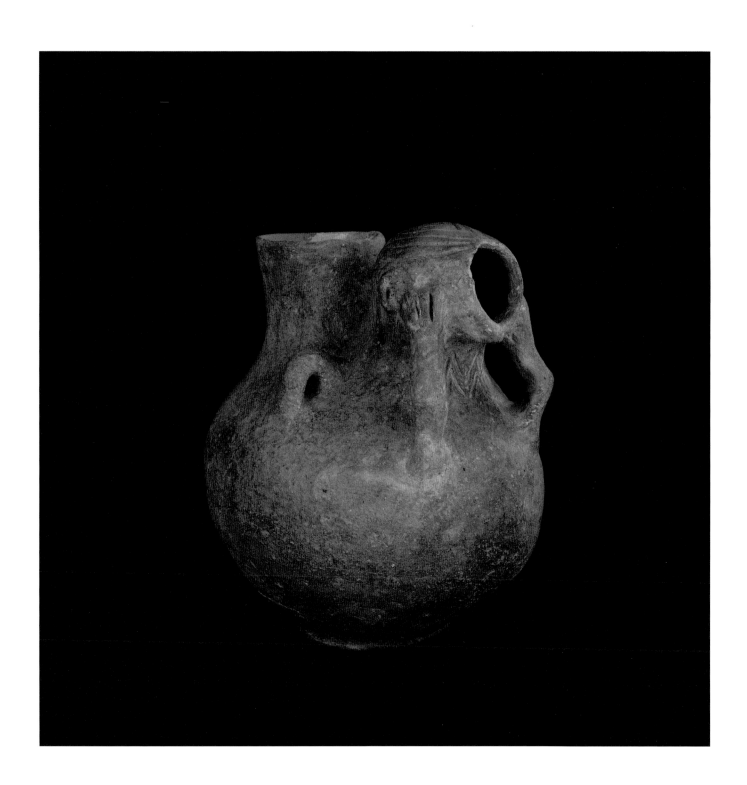

some of them with appended ears, pierced as if for the attachment of ornaments (figs. 1-15, 1-16).

The roles of the genders in Old European society are not accurately reflected in figurines. At the settlement of Golyamo Delchevo in eastern Bulgaria, not far from Varna and connected with the Varna culture, there were no identifiably male figurines in the houses of the excavated town; all of the figurines that could be assigned a gender were female. Yet all of the high-prestige graves in the nearby cemetery, marked by exotic trade goods and metal, belonged to men. The same was true at Varna itself—Grave 43, the richest single grave in Old Europe, was that of a mature male. Although in most sites more than ninety percent of the identifiable human figurines were female, male figurines were also made, and were grouped with females in some cases (fig. 5-4a). Men seem to have controlled external relations involving trade and negotiations with neighboring chiefs, while the rituals represented by female figurines seem to have emphasized the dominant role of women inside the house, and perhaps were connected with ancestor cults centered on their mothers and aunts.

One aspect of Gimbutas' analysis that probably does reflect Old European reality is her recognition that a great many different varieties and kinds of ritual behavior and religious symbolism are represented in the figurines of Old Europe. Figurines had a variety of different cultic uses, and these varied from region to region and changed over time. In spite of the difficulty that this variability raises in interpretation, figurines remain one of the most evocative and compelling aspects of Old Europe.

The Decline of Old Europe
About 4300–4100 BC, more than six hundred tell settlements of the Gumelniţa, Karanovo VI, and Varna cultures were burned and abandoned in the lower Danube valley

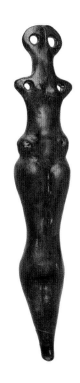

1-13. Anthropomorphic vessel with "M" sign at neck. Fired clay, Banat, Parţa, 5300–5000 BC, MNIR.

1-14. Female figurine. Fired clay, Cucuteni, Vânători-Rufeni, 3700–3500 BC (Cucuteni B1), MNIR.

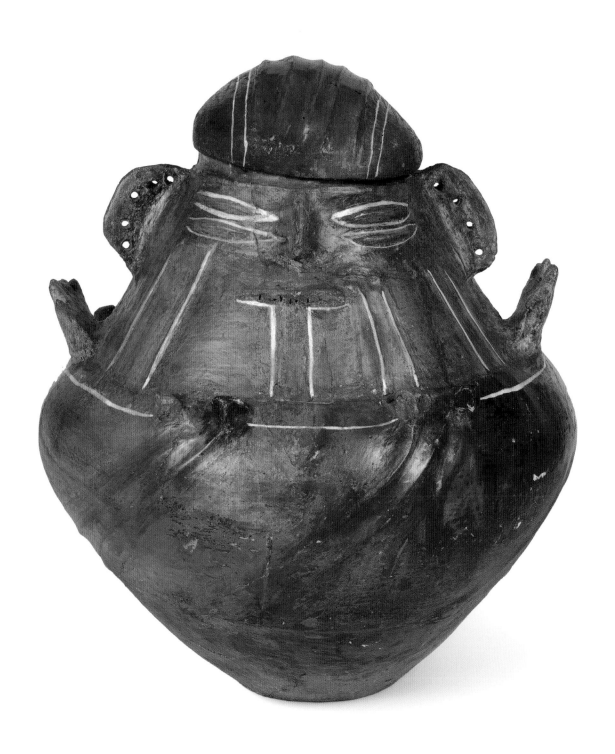

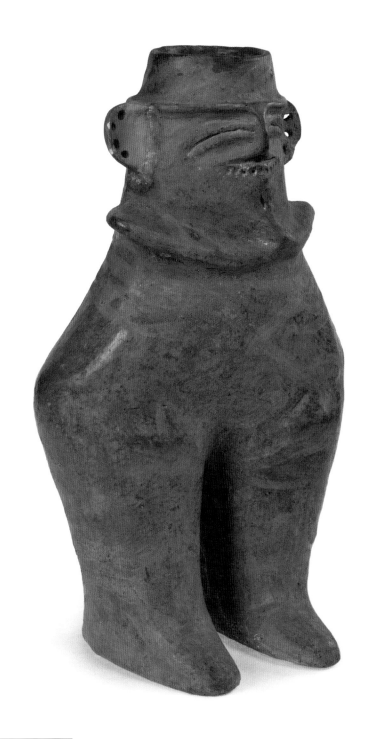

1-15. Anthropomorphic vessel with lid. Fired clay, Gumelniţa, Sultana, 4600–3900 BC, MJITAGR.

1-16. Anthropomorphic vessel. Fired clay, Gumelniţa, Sultana, 4600–3900 BC, MNIR.

and eastern Bulgaria. In a recent compilation of forty radiocarbon dates from the Karanovo VI–phase tell settlements of these three cultures in Bulgaria, the dates are densely clustered between 4800 and 4300 BC, indicating the peak of the Middle and Late Copper Ages, but only a handful of dates fall into the period 4300–4100 BC, and no tell settlement yielded a single date after this. The sudden end of the tell settlements is indicated clearly by the sudden end of the radiocarbon dates.[38] Some of their residents dispersed temporarily into smaller villages like the Gumelniţa B1 hamlet of Jilava, southwest of Bucharest, with just five to six houses and a single-level cultural deposit. But Jilava was burned, apparently suddenly, leaving whole pots and many other artifacts behind.[39] People scattered and became much more mobile, depending for their food on herds of sheep and cattle rather than fields of grain. Pollen cores show that the countryside became even more open and deforested.[40]

Remarkably, archaeological surveys show a blank in the Balkan uplands after this: No permanent settlements can be dated in the Balkans between 3900 and 3300 BC.[41] At Hotnitsa in north-central Bulgaria, the burned houses of the final Copper Age occupation contained human skeletons interpreted as massacred inhabitants. The final Copper Age destruction level at Yunatsite, west of Karanovo, contained forty-six human skeletons, also interpreted as a massacre.[42] Balkan copper mines abruptly ceased production—copper-using cultures in central Europe and the Carpathians switched to Serbian ores about 4000 BC, at the beginning of the Bodrogkeresztur culture in Hungary (fig. 1-17).[43] Metal objects now were made using new arsenical bronze alloys, and were of new types, including new weapons, importantly daggers. People probably still lived in the Balkans, but herds of sheep grazed on the abandoned tells.

In the lower Danube Valley, in contrast, there are many post-Gumelniţa sites, but the people of the Cernavoda I culture that appeared after about 4000–3800 BC left only a few female figurines, no longer used copper spiral bracelets or *Spondylus*-shell ornaments, made relatively plain pottery in a limited number of shapes, did not live on tells, and depended as much on stockbreeding as on agriculture. Metallurgy, mining, and ceramic technology declined sharply in both volume and technical skill. Ceramics and metal objects changed markedly in style. "We are faced with the complete replacement of a culture," Evgeni Chernykh, the foremost expert on Copper Age metallurgy, said. It was "a catastrophe of colossal scope . . . a complete cultural caesura," according to the Bulgarian archaeologist, Henrietta Todorova.[44]

Exactly what happened to Old Europe is the subject of a long and vigorous debate. One possibility is that Old Europe collapsed in a period of intensified raiding and warfare caused by the migration into the lower Danube valley of people who were mobile herders, possibly mounted on horseback, from the steppe grasslands of Ukraine. A migration from the steppes does seem to have happened about the same time as the collapse, but whether it *caused* the collapse is debated.

The intrusive group of graves is usually called the Suvorovo culture by Western archaeologists, after a grave of this period at Suvorovo, Ukraine, north of the Danube delta, where a male was buried with a stone mace head in the shape of a horse.[45] The steppe intrusion is marked only by graves, as no settlements can be ascribed to the Suvorovo immigrants. One of the richest of these intrusive cemeteries, a cluster of five well outfitted burials, was discovered at Giurgiuleşti, at the southern tip of Moldova, north of the Danube delta (see the article by Veaceslav Bicbaev in this volume). A horse was sacrificed above the grave of an adult male at Giurgiuleşti. A human bone gave a date range of 4490–4330 BC (Ki-7037, 5560 ±80 BP). Another grave with a horse-head mace was found at Casimçea in the Dobrogea, south of the delta (fig. 1-18). The grassy plain north of the delta and the rocky Dobrogea south of it seem to have contained the majority of the intrusive graves, but there was another group of intrusive steppe-derived graves at Decea Muresului in Transylvania, dated 4330–4050 BC (KIA-368, 5380±40 BP), and a third cluster appeared near a group of Cucuteni settlements in the Prut-Dniester watershed, including the grave at Kainar, dated 4455–4355 BC (Ki-369, 5580±50 BP). There was a period of several generations, at least, of interaction between Old European cultures and the intruders. During these centuries (perhaps 4400–4200 BC), a significant quantity of Old European copper ornaments and weapons,

made from copper mined in the Balkans, was funneled back into the Ukrainian steppes around the lower Dnieper River, where a cluster of copper-rich graves is called the Novodanilovka group (after the grave at Novodanilovka) or the Skelya group (after the settlement at Stril'cha Skelya).[46] Horses were important in the economies of these steppe settlements, particularly at the settlement of Dereivka, which has been the focus of arguments about the domestication of the horse for many years; but imported copper from the Balkans also played a brief but important role in steppe prestige competition.

Another possible cause for the collapse cited by archaeologists is climate change, and a resulting crisis in agriculture. About 4200–4000 BC the climate began to cool. Solar insolation decreased, glaciers advanced in the Alps, and winters became much colder.[47] According to changes in the annual growth rings in oaks preserved in bogs in Germany and in annual ice layers in ice cores from Greenland, the cold period peaked between 4100 and 3800 BC, with temperatures colder than at any time in the previous two thousand years. Investigations led by Douglass Bailey in the lower Danube valley showed that floods probably occurred more frequently and erosion degraded the riverine floodplains where crops were grown. Agriculture in the lower Danube valley shifted to more-cold-tolerant rye in some settlements.[48] But this change in winter temperatures seems to have peaked after the collapse of Old Europe, and even then it did not make agriculture or village life impossible; both continued in most parts of southeastern Europe, except in the lower Danube valley, the agricultural plain around Karanovo in the Balkans, and the coast around Varna—where tell settlements were most common.

Another possible explanation, taken up by many in the 1990s, was that a sudden rise in the level of the Black Sea could have drowned the fertile plains on the coast and caused an agricultural crisis.[49] But this would not have affected the Balkan uplands at all, and even on the Black Sea coast the entire area inundated since the middle Holocene (extending sixteen to eighteen meters below modern sea level) was only about five to ten kilometers wide in most places, up to a maximum of eighteen kilometers measured from inside today's widest, shallowest

1-17. Anthropomorphic appliqué. Gold, Bodrogkeresztúr culture, Moigrad, 4000–3500 BC, MNIR.

49

1-18. Stone horse-head scepter, flint arrow points, and flint lances.
Indo-European, Casimçea, 4000 BC, MNIR.

bays. Sea-level curves dated by calibrated radiocarbon dates show that the Black Sea rose very rapidly, swallowing the coast, about 5200–4500 BC (the Late Neolithic and Early and Middle Copper Ages in Bulgaria, the early phase of Old Europe), then briefly leveled off or fell back about 4500–4300 BC (the Late Copper Age, the peak of Old Europe in Bulgaria), and rose again about 4200–3600 BC (the Final Copper Age, after the collapse).[50] The earlier rise, the fall, and the subsequent rise had no apparent negative effect on societies of the Late Neolithic and Early and Middle Copper Ages. None of these sea-level rises reached as high as today's coastline.

A late Karanovo VI settlement was found at a depth of five to six meters beneath modern sea level during renovations of the Sozopol harbor. Tree rings from oak pilings used to build the Late Copper Age houses at Sozopol covered a 224-year-long period from the youngest growth ring to the last felled oak, and part of that interval was taken up by the growth of the trees to a harvestable size, suggesting that the settlement was occupied for substantially less time, perhaps only a century. Radiocarbon dates ranged between 4540 and 4240 BC. In spite of the Atlantis-like discovery of this settlement beneath the modern waves, a moment's reflection reveals that Sozopol does not illustrate the drowning of Old Europe. The Sozopol settlement was located on what was in the Late Copper Age dry land surrounded by oak forest. If Sozopol was on dry land at six meters below modern sea level, the Late Copper Age coastline at the time of the collapse probably was even lower, perhaps eight meters below modern sea level. The Sozopol radiocarbon dates are compatible with an occupation at the end of the Karanovo VI phase, and the Karanovo VI phase III ceramic types suggest an occupation after the abandonment of most of the Karanovo VI tells, perhaps even by refugees from the tells. If refugees were moving to coastal Sozopol after the collapse, the cause of the collapse was not danger from the sea. The Sozopol settlement ended in a large fire, the ashes from which still form a thick layer over the settlement in sediments six meters beneath the sea. Fire, not water, destroyed the Sozopol settlement.[51]

Finally, an explanation for the collapse often invoked in Ukraine is that the large settlements of Old Europe degraded the environments around them, leading to ecological ruin and a change in economy from settled, village-based agriculture to mobile stockbreeding.[52] But the evidence for ecological degradation is slight, and the proposed massive shift in economy seems an extreme solution to a problem of localized ecological degradation near settlements. Hundreds of sites were abandoned, and many long-standing traditions were terminated, in crafts, domestic rituals, decorative customs, body ornaments, housing styles, living arrangements, mortuary customs, mining, and metallurgy. The conjunction of so many terminations suggests a catastrophic event, not a gradual evolution.

Region-wide abandonments of large settlements have been documented archaeologically in other areas, notably in the North American southwest (1100–1400 AD) and in Late Classic Maya sites (700–900 AD) in Mesoamerica.[53] In both regions the abandonments were associated with intense warfare. The kind of climate shift that struck the lower Danube valley about 4200–3800 BC would not have made tell settlements uninhabitable. But it might have intensified conflict and warfare.

Settlements of the Cernavoda I type appeared just after the abandonment of the tells in the lower Danube valley. They contain ceramics that exhibit a mixture of steppe technology and indigenous Danubian shapes, and are ascribed to a mixed population of steppe immigrants and people from the tells. It looks like the tell towns of Old Europe fell to warfare, and immigrants from the steppes were involved—somehow. But the primary causes of the crisis could have included climate change and related agricultural failures, or soil erosion and environmental degradation accumulated from centuries of intensive farming, or internecine warfare over declining timber and copper resources, or some combination of all of these.

The Final Flowering of Old Europe
The crisis, however it was constituted, did not immediately affect all of Old Europe. Widespread settlement abandonments occurred about 4300–4100 BC in the lower Danube valley (Gumelniţa, northeastern Bulgaria and the Bolgrad group), eastern Bulgaria (Varna and related cultures), and in the mountain valleys of the Balkans

(Karanovo VI), east of the Yantra River in Bulgaria and the Olt in Romania. The region abandoned was precisely where many hundreds of tell settlements, fixed permanently in an equally stable, fixed agricultural landscape, were concentrated. The focused pattern of land use and communal living that produced tells disappeared.

The traditions of Old Europe survived longer, until about 3500 BC or a little later, in western Bulgaria and western Romania (Krivodol-Sălcuţa IV-Bubanj Hum Ib). Here the settlement system had always been a little more flexible and less rooted—the sites of western Bulgaria usually did not form high tells. Old European ceramic types, house types, and figurine types were abandoned gradually during Sălcuţa IV, 4000–3500 BC. Settlements that were occupied during this Final Copper Age, places like Telish-Redutite III and Galatin, moved to high, steep-sided promontories, but they retained mud-brick architecture, two-story houses, and cult and temple buildings.[54] Many caves in the region were newly occupied, and since herders often use upland caves for shelter, this might suggest an increase in upland–lowland seasonal migrations by herders.

The Old European traditions of the Cucuteni-Tripol'ye culture also survived between 4000 and 3500 BC. In fact they seemed curiously reinvigorated. After 4000 BC, in its Tripol'ye B2 phase, the Tripol'ye culture expanded eastward toward the Dnieper valley, creating ever larger agricultural towns. New relationships were established with the copper-using cultures of eastern Hungary and Transylvania (Borogkeresztúr) in the west and with the tribes of the steppes in the east. Domestic cults still used female figurines, and potters still made fine, brightly painted lidded pots and storage jars one meter high. In Tripol'ye C1 communities, specialized craft centers appeared for flint tool making, weaving, and ceramic manufacture. Painted fine ceramics were mass-produced by specialist potters in the largest towns (Varvarovka VIII), and flint tools were mass-produced at flint-mining villages like Polivanov Yar on the Dniester.[55] A hierarchy appeared in settlement sizes, with two and perhaps three tiers: small sites of less than 10 hectares, medium-sized sites of less than 50 hectares, and large sites of up to 450 hectares. Cucuteni AB/ Tripol'ye B2 settlements such as Veseli Kut (150 hectares), occupied about 4200–3800 BC,

contained hundreds of houses and seem to have been preeminent places in a new settlement hierarchy. These kinds of changes usually are interpreted as signs of an emerging political hierarchy and increasing centralization of power—an important stage in a process that could have led to the evolution of cities. But that is not what happened.

Almost all of the Tripol'ye settlements located between the Dnieper and South Bug rivers were oval in plan with the houses arranged radially, their long axes pointing toward a central plaza. Between about 3700 and 3400 BC, a group of Tripol'ye C1 towns in this region reached sizes of 250 to 450 hectares, two to four times larger than the first cities of Mesopotamia, evolving at the same time. These megatowns were located in the hills east of the South Bug River, near the steppe frontier in the southern forest-steppe ecological zone. They were the largest communities not just in Europe, but anywhere in the world.[56]

None of the three best-documented megatowns, Dobrovodi (250 hectares), Maidanets'ke (250 hectares), and Tal'yanki (450 hectares), contained an obvious administrative center, palace, storehouse, or central temple. Consequently, they are not called cities. They had no surrounding fortification wall or moat, although at Maidanets'ke the excavators Mikahil Videiko and M.M. Shmagli described the houses in the outer ring as joined in a way that presented an unbroken two-story-high wall pierced only by easily defended radial streets. The most thoroughly investigated megatown, Maidanets'ke, covered 250 hectares (fig. 3-5). Magnetometer testing revealed 1,575 structures. Most were inhabited simultaneously (there was almost no overbuilding of newer houses on older ones) by a population estimated at 5,500–7,700 people.[57] The houses were built close to each other in six concentric oval rings, on a common plan, radially oriented toward a central plaza. The excavated houses were large, five to eight meters wide and twenty to thirty meters long, and many were two storied.

Towns this large were difficult to manage and administer (see Chapman in this volume). Videiko and Shmagli detected in the archaeological remains of Maidanets'ke

localized subgroupings of eight to ten houses that they interpreted as kinship groups such as clan segments. If a segment leader represented ten houses, a council of 120 to 150 segment leaders would have made decisions. Since no known building seems to have been built to host and feed town council meetings of 150 or more, the wintertime administrative schedule must have been a socially complicated house-to-house affair more suited to life in smaller villages. It is not clear why they took the trouble to live this way. The megatowns lack obvious temples or palaces and have yielded only a few artifacts that might be seen as record-keeping tokens or counters, which makes it look like they were not religious and administrative centers that taxed and controlled the surrounding agricultural population, unlike the contemporary early cities of the Near East. These megatowns are therefore interpreted by most investigators as defensive concentrations of population at a time of increased conflict. Excavation of sample sections in several megatowns has shown that all of the houses were burned simultaneously when each megatown was abandoned.[58] The excavators acknowledge that the evolution and expansion of a new kind of pastoral economy in the neighboring steppe region was connected in some way with increasing conflict and the end of the megasites, but there is no consensus on the crucial details of who was doing what to whom, and why.

After Maidanests'ke and Tal'yanki were abandoned, the largest town in the South Bug hills was Kasenovka (120 hectares, with seven to nine concentric rings of houses), dated to the Tripol'ye C1/C2 transition, perhaps 3400–3300 BC. When Kasenovka was burned and abandoned, Tripol'ye towns and the customs associated with them simply disappeared from most of the South Bug River valley, a large region that had been densely occupied by Tripol'ye farmers for more than a thousand years. In Romania and Moldova the Cucuteni archaeological typology, with all of its varied styles and substyles, finally comes to an end at about this time or even a little earlier in most of the eastern Carpathian piedmont. The decorated pottery on which it is based was no longer made. Although some painted-pottery craft traditions survived for a few more centuries in the Dniester valley and around Kiev in the middle Dnieper valley, this was the true end of Old Europe. Mobile pastoral herders of the Yamnaya culture, practicing a new and revolutionary pastoral economy that was based on wagons and horseback riding,[59] spread into the South Bug valley and built kurgans on the grassy sites where the megatowns had been; their cousins migrated up the Danube valley into Bulgaria and even Hungary, creating a bigger and more visible archaeological footprint than the smaller-scale Suvorovo migration from the steppes a thousand years earlier.

The Legacy of Old Europe

Old Europe has left us an impressive body of surprisingly modern-looking ceramic art, an astonishing amount of inventive metallurgy, and an enigmatic series of ritual figurines that helped to inspire a modern spiritual revival of reverence for goddesses. Marija Gimbutas, following the studies of Jane Harrison on the evolution of Greek religion, supposed that Old European beliefs survived into the Classical and even Christian eras as substrate bodies of ritual and custom, not confined only to mothers and daughters but as the common cults of the majority of the rural population, designed to propitiate a variety of "vague, irrational, and mainly malevolent spirit-things, ghosts, and bogeys. . . ."[60] If Harrison and Gimbutas were right, then some small ritual acts conducted today, perhaps even those wrapped in the cloth of Christianity, were born long before they were baptized, in Jane Harrison's apt phrase.

The significance of Old Europe is much greater than those small fragments of custom suggest. Bronze Age Greece is generally understood as the first European civilization, but by the time the first foundation for the first citadel at Troy was dug, the gold-filled graves at Varna had been in the ground for fifteen hundred years. Much earlier than is generally recognized, southeastern Europe achieved a level of technological skill, artistic creativity, and social complexity that defies our standard categories and is just beginning to be understood in a systematic way. The end of Old Europe is another problem that has not produced an agreed-upon explanation, but that is rapidly becoming clearer because new radiocarbon dates have sharpened the basic framework of when and how rapidly things happened. In a little more than a century, we have gone from puzzled wonder at the age and origins of the painted

pottery found on hilltops in eastern Europe to a broad understanding of when it originated, how many varieties were made, how they were made, the kinds of houses the pots were used in, the sizes and organization of families and villages, the nature of the subsistence economy, the domestic rituals that the pottery makers conducted at home, the methods of metallurgy they invented in the same kilns, and something of their participation in networks of interregional trade, exchange, and conflict. That is a great accomplishment, but it leaves much more to do.

Notes

1 Pernicka, E., et al., "Prehistoric Copper in Bulgaria," *Eurasia Antiqua* 3 (1997): 41.

2 For some of the major shifts in interpretation, see Barford, P.,"East Is East and West Is West? Power and Paradigm in European Archaeology," in *Archaeologies of Europe: History, Methods, and Theories*, ed. P.F. Biehl, A. Gramsch, and A. Marciniak (Tübingen: Tübinger Archäologische Taschenbücher, 2002): 78–97.

3 Gimbutas, M., *The Gods and Goddesses of Old Europe, 6500–3500 BC: Myths and Cult Images* (London: Thames and Hudson, 1974); and Gimbutas, *The Goddesses and Gods of Old Europe, 6500–3500 BC* (London: Thames and Hudson, 1982). For critics see Meskell, L., "Twin Peaks: The Archaeologies of Çatal Höyük," in *Ancient Goddesses: The Myths and the Evidence*, ed. L. Goodison and C. Morris (Madison: University of Wisconsin Press, 1998): 46–62; Anthony, D.W., "Nazi and Ecofeminist Prehistories: Ideology and Empiricism in Indo-European Archaeology," in *Nationalism, Politics, and the Practice of Archaeology*, ed. P. Kohl and C. Fawcett (Cambridge: Cambridge University Press, 1995): 82–96; and D.W. Bailey in this volume. For praise see Marler, J., ed., *The Danube Script: Neo-Eneolithic Writing in Southeastern Europe* (Sebastopol, CA: Institute of Archaeomythology with the Brukenthal National Museum, Sibiu, Romania, 2008).

4 For good overviews of the history of definitions of the European Copper Age, see Lichardus, J., and R. Echt, eds., *Die Kupferzeit als historische Epoche*, Saarbrücker Beiträge zur Altertumskunde 55 (Bonn: Dr. Rudolf Hebelt Verlag, 1991); and Lichter, C., *Untersuchungen zu den Bestattungssitten des Sudosteuropaeischen Neolithikums und Chalkolithikums* (Mainz: Philip von Zabern, 2001).

5 Schuchhardt, C., *Alteuropa, in seiner Kultur- und Stilenwicktlung* (Strasburg: Trübner, 1919).

6 See Sherratt, A., "V. Gordon Childe: Archaeology and Intellectual History," *Past and Present* 125 (1989): 176.

7 Bogucki, P., "The Spread of Early Farming in Europe," *American Scientist* 84, no. 3 (1996): 242–53.

8 For Y-chromosome data on early European cattle, see Gotherstrom, A., et al., "Cattle Domestication in the Near East Was Followed by Hybridization with Aurochs Bulls in Europe," *Proceedings of Biological Sciences* 272, no. 1579 (2005): 2337–44. For MtDNA see Bradley, D.G., D.E. MacHugh, P. Cunningham, and R.T. Loftus, "Mitochondrial Diversity and the Origins of African and European Cattle," *Proceedings of the National Academy of Sciences* 93, no. 10 (1996): 5131–35; and Troy, C.S., et al., "Genetic Evidence for Near-Eastern Origins of European Cattle," *Nature* 410, no. 6832 (2001): 1088–91.

9 Perles, C., *The Early Neolithic in Greece* (Cambridge: Cambridge University Press, 2001); see also Sagona, A., and P. Zimansky, *Ancient Turkey* (London: Routledge, 2009): 115–17, 121–23, 136–39, for the expansion of farming into Europe. For the initial spread into the Balkans, see Fiedel, S., and D.W. Anthony, "Deerslayers, Pathfinders, and Icemen: Origins of the European Neolithic as Seen from the Frontier," in *The Colonization of Unfamiliar Landscapes*, ed. M. Rockman and J. Steele (London: Routledge, 2003): 144–68. Also see Zvelebil, M., and M. Lillie, "Transition to Agriculture in Eastern Europe," in *Europe's First Farmers*, ed. T.D. Price (Cambridge: Cambridge University Press, 2000): 57–92. The logistics of an open-boat crossing of the Aegean are discussed in Broodbank, C., and T. F. Strasser, "Migrant Farmers and the Colonization of Crete," *Antiquity* 65 (1991): 233–45.

10 For the oldest Criş site in the lower Danube valley, see Nica, M., "Circea, cea mai veche aşezare neolită de la sud de carpaţi," *Studii şi Cercetări de Istore Veche şi Arheologie* 27, no. 4 (1977): 435–63. For a recent excavation at a Starcevo settlement in the plains north of Belgrade, see Greenfield, H., "Preliminary Report on the 1992 Excavations at Foeni-Sălaş: An Early Neolithic Starčevo-Criş Settlement in the Romanian Banat," *Analele Banatului* 3 (1994): 45–93. For residue evidence that Starčevo and Criş cattle were milked, see Craig, O.E., et al., "Did the First Farmers of Central and Eastern Europe Produce Dairy Foods?" *Antiquity* 79 (2005): 882–94.

11 On Lepenski Vir, see Radovanić, I., "Further Notes on Mesolithic-Neolithic Contacts in the Iron Gates Region and the Central Balkans," *Documenta Praehistorica* 33 (2006):107–24; on the Dobrogean Mesolithic, see Paunescu, A., "Tardenoasianul din Dobrogea," *Studii şi Cercetări de Istorie Veche şi Arheologie* 38, no. 1 (1987): 3–22. For zoological analyses see Benecke, N., "Archaeozoological Studies on the Transition from the Mesolithic to the Neolithic in the North Pontic Region," *Anthropozoologica* 25–26 (1997): 631–41. For Mesolithic traits in Hamangia, see Todorova, H., "The Neolithic, Eneolithic, and Transitional in Bulgarian Prehistory," in *Prehistoric Bulgaria*, ed. D.W. Bailey and I. Panayotov, Monographs in World Archaeology 22 (Madison WI: Prehistory Press, 1995): 86.

12 Sagona and Zimansky, *Ancient Turkey* (2009): 136–39.

13 Bánffy, E., "The Late Starčevo and the Earliest Linear Pottery Groups in Western Transdanubiana," *Documenta Praehistorica* 27 (2000):173–85.

14 For the pathologies on cattle bones indicating that they were used regularly for heavy draft, see Ghetie, B., and C.N. Mateescu, "L'utilisation des bovines à la tracation dans le Neolithique Moyen," *International Conference of Prehistoric and Protohistoric Sciences* (Belgrade) 10 (1973): 454–61; and Marinescu-Bîlcu, S., A. Bolomey, M. Cârciumâru, and A. Muraru, "Ecological, Economic and Behavioral Aspects of the Cucuteni A4 Community at Draguşeni," *Dacia* 28, nos. 1–2 (1984): 41–46. For a study that failed to find such pathologies, see Bălăşescu, A., D. Moise, and V. Radu, "Use of Bovine Traction in the Eneolithic of Romania: A Preliminary Approach," in *Cucuteni. 120 ans de recherches; Le temps du bilan / Cucuteni: 120 Years of Research; Time to Sum Up*, ed. J. Chapman et al. (Piatra-Neamţ, 2005): 277–83.

15 For a recent excavation at a tell settlement see Echt, R., *Drama-Merdžumekja: A Southeast Bulgarian Monument of the European Culture Heritage and Its Publication*, in *E-Learning Methodologies and Computer Applications in Archaeology*, ed. D. Politis (Hershey, PA: IGI Global, 2008): 229–51.

16 For the chronological shift in frequency, see Merlini, M., "Evidence of the Danube Script in Neighboring Areas: Serbia, Bulgaria, Greece, Hungary, and the Czech Republic," in *The Danube Script: Neo-Eneolithic Writing in Southeast Europe* (Sebastopol, CA: Institute of Archaeomythology, 2008): 53–60; see also Gimbutas, M., *The Language of the Goddess* (London: Thames & Hudson, 1989); and Winn, S.M.M., *Pre-Writing in Southeastern Europe: The Sign System of the Vinča Culture, ca. 4000 BC* (Calgary: Western Publishers, 1981).

17 Copper tools were found in Early Eneolithic Slatina in southwestern Bulgaria, and copper ornaments and pieces of copper ore (malachite) were found in Late Neolithic Hamangia IIB on the Black Sea coast in the Dobrogea hills south of the Danube delta, both probably dated 5200–5000 BC. For Old European metals in Bulgaria, see Pernicka et al., "Prehistoric Copper in Bulgaria" (1997). For the middle Danube, see Glumac, P.D., and J.A. Todd, "Eneolithic Copper Smelting Slags from the Middle Danube Basin," in *Archaeometry '90*, ed. E. Pernicka and G.A. Wagner (Basel: Birkhäuser, 1991): 155–64. For general overviews see Chernykh, E.N., *Ancient Metallurgy in the USSR* (Cambridge: Cambridge University Press, 1992); and Ryndina, N.V., *Drevneishee Metallo-obrabatyvaiushchee Proizvodstvo Iugo-Vostochnoi Evropy* (Moskva: Editorial, 1998).

18 Ellis, L., The Cucuteni-Tripol'ye Culture: A Study in Technology and the Origins of Complex Society, British Archaeological Reports, International Series 217 (Oxford: Archaeopress, 1984).

19 Anthony, D.W., *The Horse, the Wheel and Language: How Bronze Age Riders from the Eurasian Steppes Shaped the Modern World* (Princeton, NJ: Princeton University Press, 2007): 182–87.

20 On house burnings see Stevanovic, M., "The Age of Clay: The Social Dynamics of House Destruction," *Journal of Anthropological Archaeology* 16 (1997): 334–95; for house destruction in Neolithic Anatolia, see Sagona and Zimansky, *Ancient Turkey* (2009): 63–64.

21 For vegetation changes during the Eneolithic, see Willis, K.J., "The Vegetational History of the Balkans," *Quaternary Science Reviews* 13 (1994): 769–88; Marinesu-Bîlcu, S., M. Cârciumaru, and A. Muraru, "Contributions to the Ecology of Pre- and Proto-historic Habitations at Tîrpești," *Dacia* 25 (1981): 7–31; and Bailey, D.W., et al., "Alluvial Landscapes in the Temperate Balkan Neolithic: Transitions to Tells," *Antiquity* 76 (2002): 349–55.

22 Kremenetskii, C.V., "Human Impact on the Holocene Vegetation of the South Russian Plain," in *Landscapes in Flux: Central and Eastern Europe in Antiquity*, ed. J. Chapman and P. Dolukhanov (London: Oxbow, 1997): 275–87.

23 Dennell, R.W., and D. Webley, "Prehistoric Settlement and Land Use in Southern Bulgaria," in *Palaeoeconomy*, ed. E.S. Higgs (Cambridge: Cambridge University Press, 1975): 97–110.

24 Helms, M., "Long-Distance Contacts, Elite Aspirations, and the Age of Discovery," in *Resources, Power, and Inter-regional Interaction*, ed. E.M. Schortman and P.A. Urban (New York: Plenum, 1992): 157–74.

25 Appadurai, A., "Introduction: Commodities and the Politics of Value," in *The Social Life of Things: Commodities in Cultural Perspective*, ed. Appadurai (Cambridge: Cambridge University Press, 1986): 3–63.

26 Broodbank, C., "The Origins and Early Development of Mediterranean Maritime Activity," *Journal of Mediterranean Archaeology* 19, no. 2 (2006): 199–230.

27 Chapman, J., and B. Gaydarska, "*Spondylus gaederopus/Glycymeris* Exchange Networks in the European Neolithic and Chalcolithic," in *Handbook of the European Neolithic*, ed. D. Hoffman, C. Fowler, and J. Harding (London: Routledge, forthcoming).

28 Anthony, *The Horse, the Wheel and Language* (2007): 184–85.

29 Sztáncsuj, S.J., "The Early Copper Age Hoard from Ariuș (Erosd):" in *Cucuteni*, ed. Chapman et al. (2005): 85–105; Dergachev, V.A., *Karbunskii Klad* (Kishinev: Academiei Științe, 1998).

30 For social hierarchy at Varna, see Renfrew, C., "Varna and the Emergence of Wealth in Prehistoric Europe," in *The Social Life of Things*, ed. Appadurai (1986): 141–67; for doubts about the extent of hierarchy at Varna, see Biehl, P.F. and A. Marciniak, "The Construction of Hierarchy: Rethinking the Copper Age in Southeast Europe," in *Hierarchies in Action: Cui Bono?* ed. M.W. Diehl, Occasional Paper 27 (Carbondale, IL: Center for Archaeological Investigations, 2000): 181–209.

31 Gimbutas, M., *The Civilization of the Goddess: The World of Old Europe* (San Francisco: HarperCollins, 1991): 223–50, 342–44.

32 Meskell, "Twin Peaks" (1998): 46–62.

33 Burdo, N.B., Sakral'nyi svit Trypil'skoi tsivilizatsii (Kiev: Nash Chas, 2008); Monah, D., Plastica antropomorfă a culturii Cucuteni-Tripolie, Bibliotheca Memoriae Antiquitatis 3 (Piatra Neamț, 1997).

34 Anghelinu, M., "The Magic of the Painted Pottery: The Cucutenian and the Romanian Prehistoric Archaeology," in *Cucuteni*, ed. Chapman et al. (2005): 29–38.

35 For Sabatinovka, see Gimbutas, *The Language of the Goddess* (1989): 132–33.

36 Tringham, R., and M. Conkey, "Rethinking Figurines: A Critical View from Archaeology of Gimbutas, the 'Goddess' and Popular Culture," in *Ancient Goddesses*, ed. Goodison and Morris (1998): 22–45.

37 Pogozheva, A. P., *Antropomorfnaya plastika Tripol'ya* (Novosibirsk: Akademiia Nauk, Sibirskoe Otdelenie, 1983); and Biehl, P.F., "Symbols on Anthropomorphic Figurines in Neolithic and Chalcolithic Southeast Europe," *Journal of European Archaeology* 4 (1996): 153–76. See also Hansen, S., *Bilder vom Menschen der Steinzeit: Untersuchungen zur anthropomorphen Plastik der Jungsteinzeit und Kupferzeit in Südosteuropa*, Archäologie in Eurasien 20 (Mainz: Philipp von Zabern, 2007).

38 Boyadzhiev, Y., "Synchronization of the Stages of the Cucuteni Culture with the Eneolithic Cultures of the Territory of Bulgaria According to C14 Dates," in *Cucuteni*, ed. Chapman et al. (2005): 65–74.

39 Comsa, E., "Quelques considerations sur la culture Gumelnitsa," *Dacia* 20 (1976): 105–27.

40 Marinova, E., "The New Pollen Core Lake Durankulak-3: The Vegetation History and Human Impact in Northeastern Bulgaria," in *Aspects of Palynology and Paleontology*, ed. S. Tonkov (Sofia: Pensoft, 2003): 279–88.

41 Nikolova, L., "Social Transformations and Evolution in the Balkans in the Fourth and Third Millennia BC," in *Analyzing the Bronze Age*, ed. Nikolova (Sofia: Prehistory Foundation 2000): 1–8.

42 For the destruction of Eneolithic Yunatsite, see Merpert, N.Y., "Bulgaro-Russian Archaeological Investigations in the Balkans," *Ancient Civilizations from Scythia to Siberia* 2, no. 3 (1995): 364–83.

43 This was when metallurgy really began in western Hungary and nearby in Austria and central Europe. Cast copper objects began to appear regularly in western Hungary with the Lasinja-Balaton culture about 4000 BC; see Bánffy, E., "South-west Transdanubia as a Mediating Area: On the Cultural History of the Early and Middle Chalcolithic," in *Archaeology and Settlement History in the Hahót Basin, South-west Hungary*, ed. B.M. Szőke, Antaeus 22 (Budapest: Archaeological Institute of the Hungarian Academy of Science, 1995): 157–96; see also Parzinger, H., "Hornstaad-Hlinskoe-Stollhof: Zur absoluten datierung eines vor-Baden-zeitlichen Horizontes," *Germania* 70 (1992): 241–50.

44 Chernykh, E.N., *Ancient Metallurgy in the USSR* (Cambridge: Cambridge University Press, 1992): 52; Todorova, H., "The Neolithic, Eneolithic, and Transitional in Bulgarian Prehistory" (1995): 90.

45 The original report on the Suvorovo grave and related graves north of the Danube delta is: Alekseeva, I.L., "O drevneishhikh Eneoliticheskikh pogrebeniyakh severo-zapadnogo prichernomor'ya," *Materialy po Arkheologii Severnogo Prichernomor'ya* (Kiev) 8 (1976): 176–86.

46 Anthony, *The Horse, the Wheel and Language* (2007): 249–58; for a radiocarbon date list, see Kotova, Nadezhda S., *Early Eneolithic in the Pontic Steppes*, trans. N.S. Makhortykh, British Archaeological Reports, International Series 1735 (Oxford: Archaeopress, 2008): 69.

47 Perry, C.A., and K.J. Hsu, "Geophysical, Archaeological, and Historical Evidence Support a Solar-Output Model for Climate Change," Proceedings of the National Academy of Sciences 7, no. 23 (2000): 12433–38; and Bond, G., et al., "Persistent Solar Influence on North Atlantic Climate During the Holocene," Science 294 (2001): 2130–36. For Alpine glaciers readvanced in Switzerland, see Zöller, H., "Alter und Ausmass postgläzialer Klimaschwankungen in der Schweizer Alpen," in Dendrochronologie und Postgläziale Klimaschwangungen in Europa, ed. B. Frenzel (Wiesbaden: Steiner, 1977): 271–81. For indicators of cooling about 4000 bc in the Greenland ice cores, see O'Brien, S.R., et al., "Complexity of Holocene Climate as Reconstructed from a Greenland Ice Core," Science 270 (1995): 1962–64. For climate change in Central Europe in the German oak-tree rings, see Leuschner, H.H., et al., "Subfossil European Bog Oaks: Population Dynamics and Long-Term Growth Depressions as Indicators of Changes in the Holocene Hydro-Regime and Climate," The Holocene 12, no. 6 (2002): 695–706.

48 For the flooding and agricultural shifts, see Bailey, D.W., et al., "Expanding the Dimensions of Early Agricultural Tells: The Podgoritsa Archaeological Project, Bulgaria," Journal of Field Archaeology 25 (1998): 373–96. For overgrazing and soil erosion, see Dennell, R.W., and D. Webley, "Prehistoric Settlement and Land Use in Southern Bulgaria," in Palaeoeconomy, ed. E.S. Higgs (Cambridge: Cambridge University Press, 1975): 97–110.

49 Todorova, H., "The Neolithic, Eneolithic, and Transitional in Bulgarian Prehistory" (1995): 89.

50 Dates taken from fig. 3 in Balabanov, I.P., "Holocene Sea-Level Changes of the Black Sea," in The Black Sea Flood Question: Changes in Coastline, Climate, and Human Settlement, ed. V. Yanko-Hombach, A.S. Gilbert, N. Panin, and P.M. Dolukhanov (Dordrecht: Springer, 2007): 711–30, esp. 718, 722; for a general sea-level curve, see Siddall, M., et al., "Sea-Level Fluctuations During the Last Glacial Cycle, Nature 423 (2003): 853–58.

51 Draganov, V., "Submerged Coastal Settlements from the Final Eneolithic and the Early Bronze Age in the Sea around Sozopol and Urdoviza Bay near Kiten," in Prehistoric Bulgaria, ed. D.W. Bailey, I. Panayatov, and S. Alexandrov (1995): 225–41; Filipova-Marinova, M., "Archaeological and Paleontological Evidence of Climate Dynamics, Sea-Level Change, and Coastline Migration in the Bulgarian Sector of the Circum-Pontic Region," in Yanko-Holmbach et al., The Black Sea Flood Question (2007): 453–81.

52 Rassamakin, Y., "The Eneolithic of the Black Sea Steppe: Dynamics of Cultural and Economic Development, 4500–2300 bc," in Late Prehistoric Exploitation of the Eurasian Steppe, ed. M. Levine, Y. Rassamakin, A. Kislenko, and N. Tatarintseva (Cambridge: McDonald Institute for Archaeological Research, 1999): 59–182; Manzura, I., "Steps to the Steppe, or How the North Pontic Region Was Colonized," Oxford Journal of Archaeology 24, no. 4 (2005): 313–38; Kohl, P.L., The Making of Bronze Age Eurasia (Cambridge: Cambridge University Press, 2007): 132–37.

53 Cameron, C., and S.A. Tomka, eds., Abandonment of Settlements and Regions: Ethnoarchaeological and Archaeological Approaches (Cambridge: Cambridge University Press, 1993).

54 Todorova, H., "The Neolithic, Eneolithic, and Transitional in Bulgarian Prehistory" (1995): 90.

55 Ellis, The Cucuteni-Tripol'ye Culture; and Tsvek, E.V., "On the Problem of Distinguishing Manufacturing Cults among Tripolyan Populations," in Cucuteni, ed. Chapman et al. (2005): 145–56.

56 For the megasites, see Chapman, this volume; Videiko, M.Iu., Trypil's'ki protomista. Istoriia doslidzhen' (Kiev: Tov. Kolo-Ra, 2002); and Videiko, M.Iu., "Die Grossiedlungen der Tripol'e Kultur in der Ukraine, Eurasia Antiqua 1 (1996): 45–80.

57 Emmer and spelt wheats were the most common cereals recovered; barley and peas were found in one house. Cattle (35 percent of domesticated animals), pig (27 percent), and sheep (26 percent) were the principle sources of meat—the remaining 11 percent being equally divided between dogs and horses. About 15 percent of the animal bones were from wild animals, including red deer, wild boar, bison, hare, and birds. The importance of domesticated pigs and wild game indicate forested environments near the settlement. A hardwood forest of only about twenty square kilometers would have provided sustainable firewood for the town. Its abandonment was not clearly related to ecological degradation. See Chernyakhov, I.T., ed., Rannezemledel'cheskie poseleniya-giganty Tripol'skoi kul'tury na Ukraine (Tal'yanki: Vinnitskii Pedagogicheskii Institut, 1990).

58 Videiko, M.Iu., "Looking for Trypillya Culture Proto-Cities," illus. pamphlet (2005): 15.

59 Anthony, The Horse, the Wheel and Language (2007): chap. 13.

60 See Harrison, J.E., Prolegomena to the Study of Greek Religion (1903; Princeton: Princeton University Press, 1991): 7.

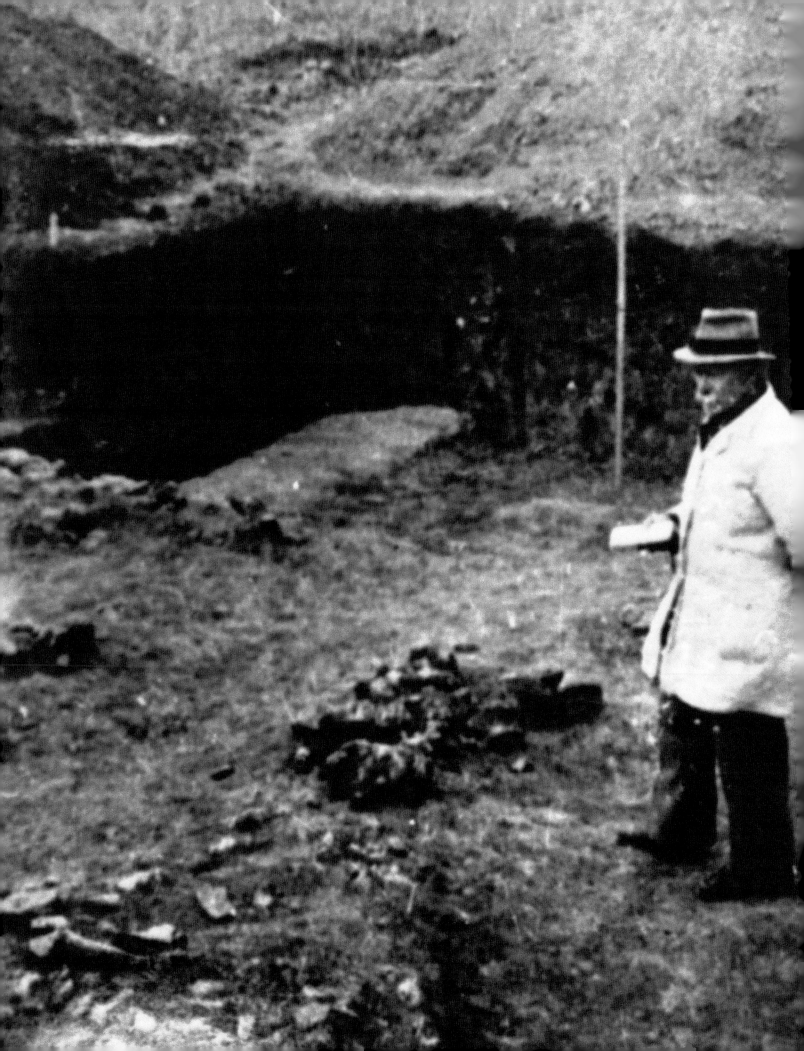

A History of Archaeology and Museography in Romania

Ioan Opriş and Cătălin Bem

National History Museum of Romania, Bucharest

Archaeology is among the oldest and most respected academic disciplines in Romania. Since 1864, when the National Museum of Antiquities was founded in Bucharest, both it and the provincial museums have been dedicated to archaeological research. The first archaeology course was taught by Alexandru Odobescu at Bucharest University in 1874, and each subsequent generation of historians has incorporated archaeology as a central component in historical studies. The first state regulation of archaeological excavations, promulgated in 1892, stabilized excavation procedures and increased their importance. At the dawn of the twentieth century, the Romanian school of archaeology coalesced around specialized university chairs in Cluj, Bucharest, and Iaşi. Today Romania contains a wide diversity of remains from quite different ages and varied histories, and therefore presents a challenge to exhibiting and interpreting the past.

The Formative Period in Romanian Archaeology

In many ways the history of archaeology in Romania is connected with the Cucuteni archaeological site and the Copper Age culture after which it is named. Located on Cetăţuia Cucutenilor, an elevated bluff near the village of Cucuteni in northeastern Romania, not far from the city of Iaşi, the archaeological site was discovered in 1884 by Theodor Burada, and the first trial trenches were excavated one year later by Nicolae Beldiceanu, Dimitrie Butculescu, and Gheorghe Buţureanu. Public interest in the site inspired the founding of the Society of Medics and Naturalists as well as the Scientific and Literary Society in Iaşi in 1886, attracting memberships that included numerous educated people interested in Romania's prehistory. Research of the last two decades of the nineteenth century was still dominated by romanticism, as was evident in the studies of Grigore Tocilescu (1880), Nicolae Beldiceanu (1885), and Alexandru Odobescu (1889–1900). In 1889 at the International Congress of Anthropology and Prehistoric Archaeology in Paris, Odobescu and Buţureanu presented for the first time to the European scientific world the results of their trial excavations at Cucuteni.

Hubert Schmidt (fig. 2-1), an archaeologist from Berlin, was interested in these finds and eventually visited Cucuteni to assess the site. In 1909 and 1910 Schmidt conducted the first systematic archaeological excavations at Cucuteni (figs. 2-2, 2-3). This excavation is usually accepted as the beginning of systematic archaeological research in Romania, although László Ferenc had begun excavations at Ariuşd, a Cucuteni settlement in

Father Constantin Mătasă (1878-1971) visiting an archaeological excavation.

Transylvania, two years earlier (fig. 2-4). Schmidt published his results at Cucuteni in a preliminary report in 1911, but his complete excavation report was published many years later in a volume that defined and described the most spectacular prehistoric culture of southeastern Europe.[1] Schmidt returned to Romania during World War I, overseeing additional archaeological excavations in Walachia while it was occupied by German troops.

Before the beginning of the war, three important archaeological works were published[2] in addition to Schmidt's 1911 preliminary report from Cucuteni, stirring the public's desire for more knowledge about the prehistoric civilizations of Romania. Immediately after the war ended in 1918, and Transylvania, Banat, and Bessarabia became part of modern Romania, systematic excavations began at Neolithic sites across the country, in Banat, Moldavia, Oltenia, Transylvania, and Walachia, largely under the direction of Vasile Pârvan, who set the direction for his successors and emulators, and whose books helped to define Romanian archaeology in the first half of the twentieth century.[3] Also in these postwar years, a series of large-scale excavations commenced at the Neolithic and Copper Age sites of Căscioarele, Sultana, and Vădastra (in the lower Danube valley), as well as at the Cucuteni sites of Ruginoasa and Traian (in the eastern Carpathian piedmont).

Pârvan was the founder of the modern school of Romanian archaeology and archaeological museography, and in 1912 became the director of the National Museum of Antiquities, which in the second half of the twentieth century was the foundation for the Institute of Archaeology (1956) and the National History Museum of Romania in Bucharest (1972). When he began as director, Pârvan was a young professor at Bucharest University and a member of the Commission of Historic Monuments. He not only introduced a systematic approach to archaeological excavations in Romania, but also created new site museums to protect archaeological sites and the collections of objects found there (for example, at Histria in 1915). Before World War I, there were only four local museums with archaeology collections (in Bucharest, Cluj, Iaşi, and Sfântu Gheorghe), but in the following decades many others were added (including those at Alba Iulia, Constanţa, Craiova, Deva, Piatra Neamţ, Tecuci, Timişoara, and Turnu Severin).

During this era, interaction with archaeologists from other countries was facilitated by the establishment of the Accademia di Romania (Rome) and L'École Roumain (Fontenay aux Roses, Paris), while students and disciples of Pârvan developed new strategies that benefited from the favorable situation of an entirely unified country and two decades of progress and stability after 1918. Among the archaeologists who followed Pârvan were Constantin Daicoviciu in Cluj, Vladimir Dumitrescu in Bucharest, and Orest Tafrali in Iaşi, all of whom brought innovative concepts and established regional schools. At the same time, the renowned English archaeologist V. Gordon Childe brought Romanian archaeology to the forefront of European prehistory, arguing forcefully in his widely read books that the Danube Valley was Europe's oldest highway of migration, trade, and communication.[4]

Archaeology in Romania between the World Wars

Dumitrescu's excavations at Sultana (1923), and then at Gumelniţa (1925), revealed the exceptional interest and importance of tell sites north of the lower Danube, in Walachia and Moldavia. Analyzing the geography of Neolithic and Copper Age sites, he suggested they were to be found at specific locations that were rich in wild game and fish and offered copper and gold ore deposits, natural salt deposits, and natural communication paths. He collaborated with his wife, Hortensia Dumitrescu (fig. 2-5), and a series of devoted partners, including Father Constantin Mătasă (figs. 2-6, 2-7, page 58), the founder of the archaeological museum in Piatra Neamţ (1934). Their efforts brought to light the great prehistoric settlements of Bistriţa, the Prut valley, and Siret. At the end of the 1920s and the beginning of the 1930s, archaeological excavations by the Dumitrescus at Ruginoasa and Traian (fig. 2-8), as well as joint projects at Căscioarele (started by Gheorghe Ştefan), Sultana (begun by Ion Andrieşescu), Tangâru and Petru Rareş, Vădastra, and Vidra and Săruleşti, defined the Romanian Neolithic and Copper Age (Eneolithic).

In Bucharest Ion Nestor (1905–1974) pulled together much of this new Copper Age material in his doctoral thesis,[5] which he expanded during a Rockefeller fellowship (1935/36) in Berlin, where he dedicated himself to studying the Cucuteni finds excavated by Schmidt and stored at the Museum fur Vor- und Frühgeschichte. Nestor's excavations at Ariuşd and Sărata Monteoru led to important new discoveries and established a true "archaeological school." During the 1930s a number of other Romanian archaeologists became members of international scientific bodies, thus contributing to broader dissemination of their archaeological finds. This also was the period of the first large-scale research in the eastern area of the Cucuteni culture in Ukraine, where V.V. Hvoiko had defined a new eastern variant of the painted-pottery cultures with his excavations at Tripol'ye in 1893. In the 1930s, when Tatiana Passek systematically organized and interpreted Tripol'ye archaeological sites and artifact types,[6] it became clear that the Cucuteni-type sites near Iaşi and in Transylvania were western expressions of a widespread culture with painted pottery; eastern variants were named after the site of Tripol'ye, on the west bank of the Dnieper River, forty kilometers south of Kiev. These cultures were themselves but one aspect of a broad family of interacting Copper Age cultures that also included the region south of the Danube, where Bulgarian archaeologist R. Popov excavated large tell settlements (Salmanovo, or Kodja-Dermen). The interwar years were a prosperous period for archaeology and archaeological museography in Romania, leading to genuine improvements in understanding the prehistoric and ancient civilizations of this part of Europe.

Archaeology after World War II

The years after World War II brought radical transformations to Romania, but also witnessed archaeological discoveries of great significance. Archaeologists belonging to the older generation remained dedicated to their goals—in spite of ideological restrictions and even in some cases punishment by the communist regime—and Vladimir Dumitrescu became the academic authority who defined research regarding the Neolithic and Copper Age. Archaeology was less visibly affected than most other professions by the ideological detours that turned Romanian society from its proper course. Archaeologists

were able to defy the standard dogma, and promoted interacademic relations and developed professional relationships on a solid scientific foundation that was resistant to political obstruction.

Archaeological excavations now resumed at important Copper Age sites that had first been explored before the war, including Căscioarele, Gumelniţa, and Sultana (of the Gumelniţa culture), and Ariuşd, Cucuteni, and Traian (of the Cucuteni culture). Entire Copper Age settlements were excavated and revealed at Hăbăşeşti and Truşeşti. Excavations also resumed in Bulgaria (at Karanovo and Ruse), in the Republic of Moldova (Darabani and Petreni), in Ukraine (Kolomişcina and Tripol'ye), and Serbia (Starčevo and Vinča). Industrial development in all regions of Romania caused major landscape changes after 1950, and discoveries were made as bulldozers stood by (fig. 2-9). Exceptional objects were uncovered and entered into museum collections, contributing to the development of archaeological museography, and more than fifty regional archaeological museums opened. Fabulous finds fascinated the larger public and were disseminated throughout the world.

After the 1956 revolution in Hungary, the effects of a certain liberalization were visible in respect to Romanian archaeologists and museographers. Romania reaffirmed its adherence to the standards of the International Committee of Historic Studies (1956), and Romanian archaeologists began to travel more frequently abroad, starting with the congresses of history at Lund (1958) and Stockholm (1960). Friendships and scientific communications with foreign archaeologists and historians contributed to the growth of Romanian archaeology. In 1956, after a visit to Romania, Childe proposed the first exchanges of students between Romania and the United Kingdom. Following this proposal, the archaeologists Lucian Roşu (later an eminent scholar at Western Michigan University in Kalamazoo and the University of Michigan in Ann Arbor) and Aurelian Petre were the first to benefit from the program.

The first postwar international congress held in Romania took place in 1960 at a conference of classical studies in Constanţa, and marked the resumption of bilateral

Hubert Schmidt
1864 bis 1933

jüngerer Festungs-
graben

älterer Festungs-
graben

Abb 12. Schnitt B
vom Innern der Ansiedlung gesehen

Balkanforschung.
Bericht
über die Unternehmungen
des Jahres 1910.

A. Ausgrabungen in
Cucuteni.

Die Reise nach Rumänien
musste ich dieses Mal mit
einer Dienstreise verbinden, die
mich im Monat August über
Köln und Brüssel nach der
Dordogne zu den Hauser'schen
Ausgrabungen geführt hatte.
So gelangte ich auf dem Wasser-
wege über Constantinopel und
Constanza am Abend des 31.
August nach Jassy. Da das
aus Berlin erwartete Gepäck
noch nicht da war, konnte
ich einige Tage für die Vorbe-
reitungen zur Übersiedlung
aufs Land verwenden. Reise
und Transport nach Baiceni
fanden am 10. September statt.
Wie im vorigen Jahre, wurde
dort in der casa Dimitriu
Quartier genommen, zugleich
für den nachfolgenden Assistenten

62

2-1 (opposite). Archaeologist Hubert Schimdt (1864-1933).

2-2 (opposite). The excavation campaign undertaken by Schmidt at Cucuteni, 1910.

2-3 (opposite). Front page of a research report from 1910 focusing on the excavations made by Schmidt at Cucuteni.

2-4. Excavation led by László Ferenc at Ariuşd, ca. 1910.

2-5. Left to right: Vladimir Dumitrescu, Hortensia Dumitrescu, Silvia Marinescu-Bîlcu, and M. Cârciumaru at Drăguşeni.

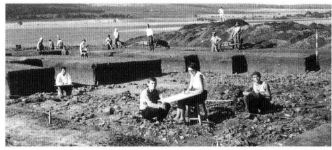

2-6 (opposite). Father Constantin Mătasă (1878–1971), founder of the
Regional Archaeological Museum in Piatra Neamţ.

2-7 (opposite). On-site ceramic restoration supervised by Father
Constantin Mătasă.

2-8. The archaeological team from Traian, including specialists and local
workers.

2-9. The excavations at Târpeşti, ca. 1959–60.

scientific relations with Western countries. Two months earlier Marija Gimbutas, of the American School of Prehistoric Research at Harvard University, visited Romania to study Copper Age collections. In the same year a series of British archaeologists—including J.D. Cowen (University of London), W.F. Grimes, George T.E. Powell (Liverpool University), and M.C. Sanders—visited archaeological sites in Romania, focusing on the settlement of Sărata Monteoru, a stratified site seen as key to understanding the Early and Middle Bronze ages in the lower Danube valley. The year 1960 also witnessed the first Romanian postwar exhibition in the United States, entitled *Folk Art of the Romanians*, which was on view at the American Museum of Natural History in New York and the Smithsonian Institution in Washington D.C., as well as in Philadelphia and Zanesville, Ohio. In 1961 the photographic exhibition *Archaeological Discoveries from Dobrouja* was presented in the United States in response to the interest triggered by spectacular discoveries in that region on the western shore of the Black Sea. In 1962 Hugh Hencken at Harvard University visited a series of archaeological sites in Romania and published an enthusiastic account.

During the 1960s the value of Romanian archaeology began to be recognized in Moscow, where Passek promoted its importance, as well as in New York. Romanian archaeologists were invited to address several symposia at Brooklyn College in 1964, in connection with the International Congress of Prehistory and Protohistory. The following year Constantin Daicoviciu attended the Seventh International Conference of the International Council of Museums at the Metropolitan Museum of Art, leading to scientific exchanges with North American universities. Archaeologist Robert W. Ehrich at Brooklyn College expressed particular interest in the discoveries and contributions of Dumitrescu and Nestor and invited them to a 1968 symposium on "Method and Theory in Archaeological Interpretation." Many other institutions—Barnard College, Boston University, Columbia University, Cornell University, Indiana University at Bloomington, the University of California, Berkeley, Wesleyan University, and others—invited Romanian archaeologists, anthropologists, historians, ethnographers, and art historians for an exchange of ideas and discussion of developments

in Romania. In 1969 Keith Hitchins created the *Journal of Romanian Studies*, which offered a new basis for better knowledge of Romanian historiography.

The publication of major archaeological volumes during the 1970s and 1980s[7] was accompanied by archaeological exhibitions presented abroad during a period of political relaxation: *The Romans in Romania* (1968–69, in Italy and Germany), *The Historic Treasure of Romania* (1969–70, Sweden, France, and Great Britain), *The Dacians and the Illyrians* (1973, Albania), *Archaeological Treasures of the Iron Gates* (1978, Yugoslavia), and *The Civilization of the Geto-Dacians in the Classical Period* (1979–81, which toured eleven European countries). In 1981 an exhibition entitled *The Historical Treasures of Romania* was scheduled to be exhibited at the National Gallery of Art in Washington, D.C., but was banned at the last moment by the Ceauşescu couple.

Academic exchanges continued, however, through the 1980s—the last decade of the communist regime in Romania—when numerous projects and collaborations were supported by American scholars of Romanian history, archaeology, ethnography, and folklore. The names of many remain important today, among them, Linda Ellis, Gail Kligman, Joe Marrant, Paul Mikelson, Jobby Peterson, Katherine Verdery, and Glee Wilson. Through their energy Romanian culture and history, and the interpretations of Romanian historians and archaeologists, received wider recognition by American scholars. The 1990s witnessed the creation of new research centers at the National History Museum of Romania in Bucharest, at the Piatra Neamţ County Museum Complex, in Alba Iulia, and in Târgovişte.

Cucuteni and related Copper Age artifacts were included in an exhibition entitled *7,000 Years of History*, organized in 1993–94 in Germany and the Netherlands, and also were at the center of a 1998 exhibition in Greece, *Cucuteni, the Last Great Eneolithic Civilization of Europe*. Meanwhile exceptional discoveries were made during new excavations at the Copper Age sites of Ariuşd, Borduşani, Bucşani, Cârcea, Grădinile, Gura Baciului, Hârşova, Luncaviţa, Parţa, Poduri, Scânteia, Uivar, and Vităneşti (figs. 2-10–2-12). These projects provided the

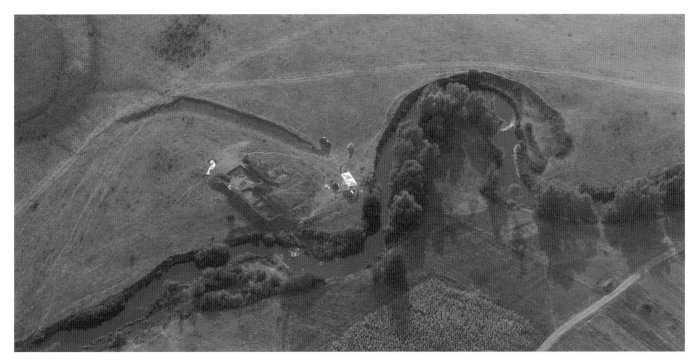

2-10. Aerial image of the excavations of a tell settlement in the Neajlov valley.

2-11. A prehistoric dwelling under excavation at the Bucşani site, Giurgiu county.

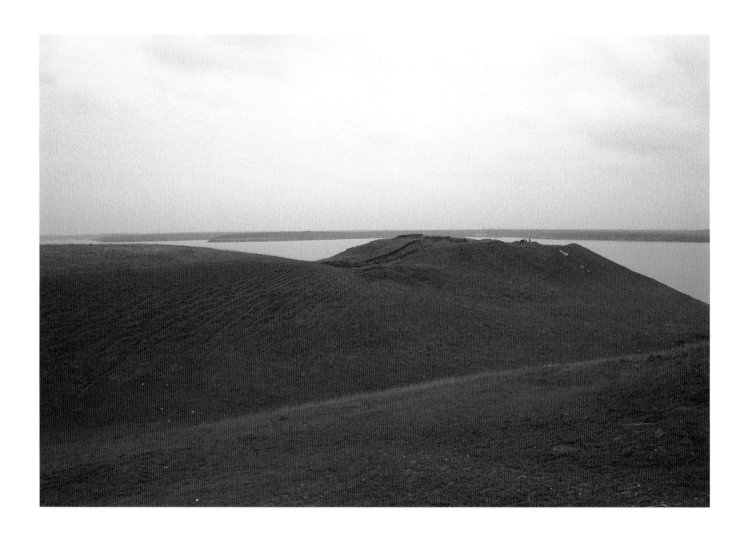

basis for a new appreciation of the Copper Age societies of southeastern Europe and inspired renewed public interest. The importance of salt and its trade, for example, were documented as major factors in the development of prehistoric communities (figs. 2-13, 2-14) through new projects coordinated by V. Cavruc, John Chapman, Gheorghe Dumitroaia, and A. Harding. Today it is widely recognized that the natural salt springs of Moldavia were a critically important resource beginning in the Neolithic era (Starčevo culture) and notably during the Cucuteni period, when there existed specialized facilities for the extractions of salt, an important natural resource in trade and exchange.

Over the last century, three generations of archaeologists and museum professionals have built a foundation for investigating, preserving, and exhibiting the past (Table 2-1). Each generation has added to the base of knowledge and reinterpreted history through new discoveries. In the future multidisciplinary investigations pursued in coordination with museum exhibitions promise to add further subtleties to the multiple meanings of the prehistoric civilizations of Romania.

Translated by Corina Borş

2-12 (opposite). The prehistoric tell settlement from Sultana, Călăraşi county.

2-13. A salty spring currently in operation at Cucuieţi-Slatina Veche, Solonţ commune, Bacău county.

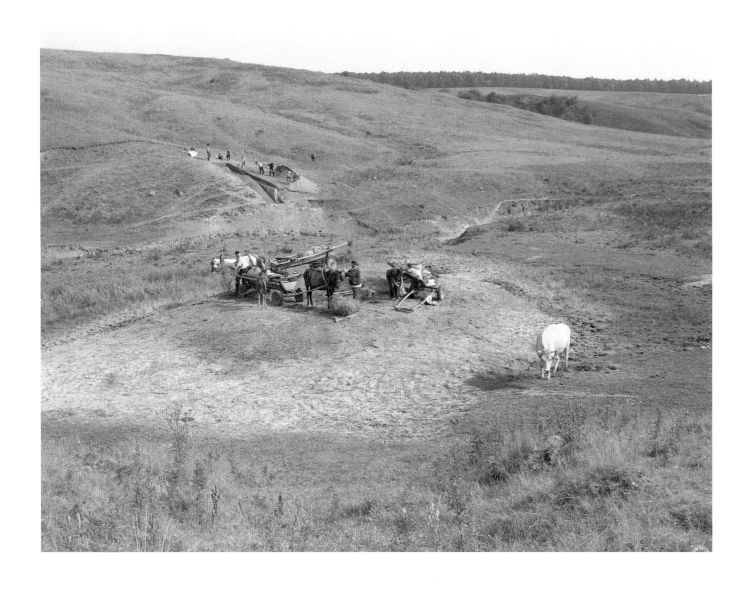

A Selected Chronology of Excavations at Major Neolithic and Eneolithic Sites Now Located in Romanian Territory

Years Excavated	Site Name	Excavator
1907-9, 1911-13, 1925	Ariuşd	László Ferenc
1909-10	Cucuteni	Hubert Schmidt
1923	Sultana	Ion Andrieşescu
1923	Gumelniţa	Vladimir Dumitrescu
1924	Căscioarele	Gheorghe Ştefan
1924	Boian	Vasile Christescu
1926	Ruginoasa	Hortensia Dumitrescu
1926	Glina	Ion Nestor
1926	Vădastra	Vasile Christescu
1936, 1938, 1940	Traian	Vladimir Dumitrescu
1943	Glina	Mircea Petrescu-Dâmboviţa
1949–50	Hăbăşeşti	Vladimir Dumitrescu
1949–51	Corlăteni	Ion Nestor
1951–60	Traian	Vladimir Dumitrescu
1953–54, 1960–61	Hamangia	D. Berciu
1959–60	Târpeşti	Silvia Marinescu-Bîlcu
1960	Gumelniţa	Vladimir Dumitrescu
1961–74	Cucuteni	Mircea Petrescu-Dâmboviţa
1961–68	Căscioarele	Vladimir Dumitrescu
1969–present	Poduri	Dan Monah
1970–present	Drăguşeni	Silvia Marinescu-Bîlcu
1978–present	Parţa	Gheorghe Lazarovici
1985–present	Borduşani	Dragomir Popovici
1985–present	Scânteia	Cornelia-Magda Mantu-Lazarovici
1986–present	Hârşova	Dragomir Popovici
1993–present	Vităneşti	Radian Andreescu
1998–present	Bucşani	Cătălin Bem
1998–present	Luncaviţa	Cristian Micu
2001–present	Sultana	Radian Andreescu
2002–present	Uivar	Florin Draşovean

2-14. Archaeological excavations adjacent to contemporary operations of salty springs at Ţolici-Hălăbutoaia, Petricani commune, Neamţ county.

Table 2-1. A selected chronology of excavations at major Neolithic and Eneolithic sites now located in Romanian territory.

Acknowledgments

We would like to express our gratitude to Dr. Mircea Babeş (Bucharest), Dr. Gheorghe Dumitroaia (Piatra Neamţ), Cătălin Lazăr (Bucharest), Dr. Silvia Marinescu-Bîlcu (Bucharest), and Dr. Vargha Mihály (Sfântu Gheorghe) for permission to reproduce archival photographs in their possession.

Notes

1 Schmidt, H., *Cucuteni in der oberen Moldau* (Berlin-Leipzig: Gruyter, 1932).

2 Marţian, I., "Archäologisch-prähistorisches Repertorium für Siebenbürgen," *Mitteilungen der Anthropologischen Gesellschaft in Wien* 39 (1909): 321–58; Andrieşescu, I., "Contribuţii la Dacia înainte de romani" (Ph.D. diss., Institutul de Arheologie Iaşi, 1912); László, F., *Ásatások az Erösdi östelepen* (Sfântu Gheorghe, 1914).

3 Pârvan, V., *Getica. Începuturile vieţii la gurile Dunării* (Bucureşti, 1923); Pârvan, V., *Dacia: An Outline of Early Civilization of the Carpatho-Danubian Countries* (Cambridge: Cambridge University Press, 1928).

4 Childe, V.G., *The Dawn of European Civilization* (1925; Oxford: Taylor and Francis, 2005); Childe, V.G., *The Danube in Prehistory* (Oxford: Clarendon, 1929).

5 Nestor, I., "Der Stand der Vorgeschichtforschung in Rumänien" (PhD diss., Philipps-Universität Marburg, 1933).

6 Passek, T.S., *La ceramique tripolienne* (Moscow: Académie de l'Histoire de la Culture Matérielle, 1935).

7 Condurachi, E., *Archéologie roumaine au XXe siècle* (Bucharest: Académie de la République Populaire Roumaine, 1963); Marinescu-Bîlcu, S., *Cultura Precucuteni pe teritoriul României* (Bucureşti: Academiei RPR, 1974).

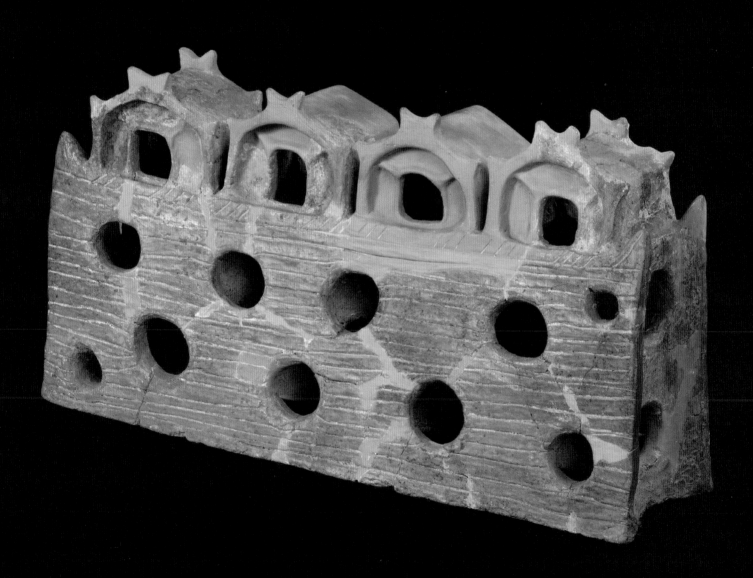

Houses, Households, Villages, and Proto-Cities in Southeastern Europe

John Chapman
Durham University

Introduction

A museum exhibition necessarily removes the objects on display from the contexts of their production and use. In this essay, I seek to reestablish a part of that context by characterizing the pattern of settlement in selected regions of southeastern Europe during two millennia of often dramatic change, 5000 to 3000 BC. I shall concentrate on three remarkable but contrasting social domains: first, the unexpectedly varied range of settlements associated with the spectacular cemetery of Varna and its preceding Neolithic cemeteries near the west coast of the Black Sea; second, the enduring but small-scale tell settlements from a geographically intermediate region, the Lower Danube valley; and third, the surprisingly massive settlements of the Cucuteni-Tripol'ye culture, distributed north of the Danube valley and northeast of the Carpathian Mountains in Moldavia, Moldova, and Ukraine. The regions covered here formed part of what Marija Gimbutas termed "Old Europe"[1]—a distinctive area where people often lived in relatively large, densely occupied, nucleated settlements and produced an abundance of material culture, including spectacular densities of painted pottery, figurines, and miniatures. These three regions not only provide an excellent example of the regional diversity that so typified Neolithic and Copper Age Europe but also challenge us to explain such profound differences.

It is important at the outset to highlight two strong contrasts in the lifeways of the inhabitants of Old Europe. The first concerns areas where the archaeological evidence has been provided primarily by cemeteries, in opposition to areas where most of the evidence is from settlements. Cemeteries formed a focus of ancestral veneration materialized through grave goods, usually in small numbers but occasionally in massive concentrations as, for example, at Varna. The second contrast, which cuts across the first, relates to areas dominated by tell settlements as against areas dominated by flat sites. Tells were settlements where people lived in the same place as their ancestors, slowly creating visually impressive mounds with the remains of their rebuilt houses and discarded household goods in accumulations that eventually elevated a settlement above its surrounding plain.[2] However, densely packed houses built on top of a tell left no space for gardens, animal keeping, outdoor rituals, or pyrotechnic activities such as copper smelting and pottery firing. Flat sites, in contrast, were often divided into "house-and-garden" groupings,[3] where the greater space between structures permitted a much wider range of social practices, although the latter

75

Range of Site Sizes in Old Europe

Culture	Dates	Type	Minimum hectares	Maximum hectares
Vinča	5300-4600 BC	Flat	0.1	100
Vinča	5300-4600 BC	Tell	1	7
Hamangia	5000-4800 BC	Flat	0.1	2.5
Varna	4800-4300 BC	Flat	0.1	4
Varna	4800-4300 BC	Tell	1	5
Gumelniţa	4800-4000 BC	Tell	1	8
Karanovo VI	4800-4000 BC	Tell	1	10
Tripol'ye	4800-2800 BC	Flat	0.5	450
Cucuteni	4600-3500 BC	Flat	0.5	80
Bodrogkeresztúr	4000-3500 BC	Flat	0.1	1

Range of Grave Numbers in Old Europe

Culture	Dates	Minimum	Maximum
Vinča	5300-4600 BC	7	32
Boian	5200-4700 BC	40	350
Hamangia	5000-4800 BC	30	400
Varna	4800-4300 BC	100	900
Gumelniţa	4800-4000 BC	10	100
Tripol'ye	4800-2800 BC	none	none
Cucuteni	4600-3500 BC	none	none
Bodrogkeresztúr	4000-3500 BC	10	100

Table 3-1. Range of site sizes for each culture listed.

Table 3-2. Range of grave numbers for each culture listed.

did not necessarily place the same emphasis on occupying the site of the ancestral dwelling.

The main cultural distributions and geographical regions are indicated on the map on page 26, and the size range of both settlements and cemeteries in tables 3-1 and 3-2. We now turn to the principal area in Old Europe where the mortuary domain is dominant—the western coast of the Black Sea. It is impossible to understand the Varna cemetery without grasping the significance of the long-lasting tradition of cemetery burial in the western Black Sea region, a tradition that started in the Neolithic.

The West Black Sea Coast

Neolithic and Copper Age settlements in the western Black Sea region (the western shore of the Black Sea, including parts of modern Bulgaria and Romania) were established later than those in much of the rest of southeastern Europe. Early farmers in present-day European Turkey, Greece, the former Republic of Macedonia in former Yugoslavia (FYROM), and Bulgaria settled in small flat sites or larger tells (fig. 3-1).[4] Domestic plants and animals provided almost all food and drink;[5] inhabitants depended on a combination of wheats, barleys, and pulses such as lentils and peas, as well as most commonly caprines (sheep and/or goats) rather than cattle or pigs. One of the most significant changes in sixth-millennium settlement in the Balkans was the extension of sedentary agricultural settlements beyond the core areas of early tell dwelling in Bulgaria, through the establishment of flat settlements in the western Black Sea region and northward into Serbia, Hungary, and Romania.

As the western coastline of the Black Sea was then much lower than at present day, some of these western Black Sea Neolithic settlements might now be under water at a substantial distance offshore. Pollen retrieved from sediment cores drilled into the sea floor thirty-five kilometers from the present southeastern Bulgarian coast, as well as pollen identified in the Shabla-Ezerets pollen diagram for the modern land surface near the coast, indicate forest clearance and the establishment of open cultivated fields from 5500 BC[6] Thus the "first" farmers on the present-day western Black Sea coast were part of an inland-oriented settlement shift—perhaps moving to the interior from

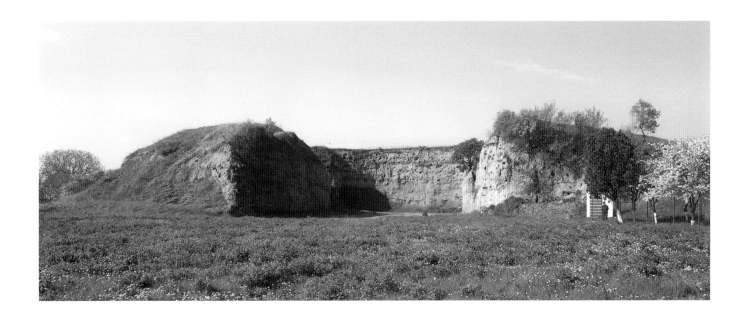

drowned sites now offshore into a dry, often windy continental ecozone with occasionally fertile areas such as Varna. These early western Black Sea farmers (5200–5000 BC) have been termed the Hamangia culture,[7] after a Late Neolithic cemetery in Romania. Their settlements were generally modest in size, with small structures that rarely lasted more than one generation.[8]

The key features in Hamangia landscapes were large cemeteries used over long periods, as at Durankulak (fig. 3-2).[9] The dead of several settlements must have been buried in the cemeteries of their ancestors, whose own burials helped to create and reinforce rules of age and gender differentiation. The fixity of these ancestral places was in tension with community mobility in the Early Hamangia period.

The Late Hamangia phase (5000–4800 BC) witnessed remarkable settlement differentiation, as exemplified at the settlement adjacent to the cemetery at Durankulak. Here an Early Hamangia settlement on the lake-side muds, with wattle-and-daub huts,[10] was abandoned in favor of dwelling on a rocky island, where local stone was used to construct dry-stone-built houses.[11] This shift from

earth-centred lifeways to a symbolic system based on stone differentiated Durankulak from all other known Hamangia settlements, and led to the construction of the largest stone buildings in the Balkans (fig. 3-3). Although the interpretation of the largest structures as "temples" and "palaces" may be exaggerated,[12] there can be no doubt that these were the homes of social elites rather than of "poor" fishermen living on other Hamangia sites, as evidence for craft production and the accumulation of prestige goods was found in these houses.

Similar impressively large stone houses continued to be built in the Late Copper Age, after 4600 BC. The complex Durankulak structures, some of which were two storied, combined everyday activities (flint knapping, grinding, food preparation, and storage), metallurgical production, and sacred or ritual acts (life-size clay figures, pillar altars, and painted wall plaster) concentrated in the largest structures.[13] Opposite the elite residences on the island, burials continued at the cemetery near the lake shore until, by the end of the Copper Age, more than 1,200 bodies had been interred—resulting in the largest known cemetery in Old Europe.[14]

Just one hundred kilometers south of Durankulak, Chalcolithic and Early Bronze Age pottery has been dredged up since the early twentieth century from now flooded sites under the Varna Lakes.[15] Typological

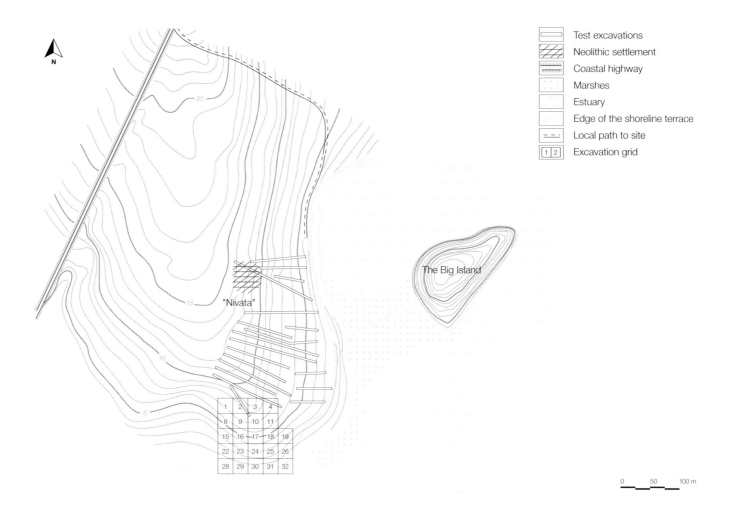

"Nivata"

The Big Island

N

1 2 3 4
8 9 10 11
15 16 17 18 19
22 23 24 25 26
28 29 30 31 32

0 50 100 m

3-2. Plan of Durankulak cemetery (after Todorova, 2002, Karte 4).

dating of Varna Lakes pottery shows that the lake-side zone was colonized and settlements were constructed on then dry land[16] at the same time as the start of burials at the Varna cemetery (4750/4700 BC[17]). One of these small settlements stood just four hundred meters southeast of the Varna cemetery. This "fresh start" may have helped create the conditions for local cultural innovations.

The overall context for the Varna cemetery as a Late Copper Age settlement is poorly documented because of the paucity of large-scale excavations. None of the known sites, whether tells, flat sites, or lake-side sites, was large; they rarely covered more than a few hectares. The large stone houses at Durankulak (Hamangia culture) and

Suvorovo (Varna culture)[18] contrasted with smaller, timber-framed houses on the tells along the western Black Sea coast. Interestingly, the tell settlement at Provadia, in a region of rolling hills and valleys just forty kilometers west of Varna, was located next to one of the richest salt sources in Bulgaria[19]—a resource surely implicated in Varna exchange networks. The splendor of the Varna cemetery has prompted much hyperbole over the nature of the Varna lake-side settlements, which were the residential communities closest to the cemetery. They have been described as economic, social, and metallurgical centers for the region—in effect, proto-cities[20]—and as ritual-administrative centers for Varna and the entire region west of the Black Sea.[21] In fact, none of the criteria for proto-urban settlements has been met at the lake-side sites: They have neither the size nor the internal complexity to qualify as proto-urban centers, nor do they exhibit the required hierarchy of site sizes (village, town, and city).

The groups responsible for the creation of Varna cemetery could have received elite and nonelite burials from communities across the western Black Sea region, if not from the whole of eastern Bulgaria and perhaps even farther afield, actively differentiating their spectacular mortuary riches from the mundane objects of the domestic domain deposited by the Varna lake-side communities. (Note, however, that the article by Vladimir Slavchev in this volume presents a different point of view.) The key question remains: On which dwelling sites were the Varna grave goods produced? Only intensive, systematic field-walking projects in the Varna Lakes area will provide a full answer to the local settlement context for Varna.

The remarkably early[14] radiocarbon dates for Varna, at 4750–4450 BC[22] (tables 3-3, 3-4), highlight the western Black Sea region not as a mature proto-urban center but as a leading innovator that stimulated the early expansion of trade and exchange networks linking the western Black Sea zone to communities on the northern shores and further north, into Moldova, as documented by the Karbuna hoard.[23] Those distinctive features of the Varna elite burial package—shiny, colorful gold and copper, very large flint blades, rings and beads made of imported Aegean shells, painted pottery, beaded necklaces made of pierced red-deer canines, and miniature polished stone axes—began to appear east of the Danube delta after 4700 BC.[24] It was the materialization of social differentiation, the expression of hierarchy and power in material form, that linked Varna to other Late Copper Age cultures of Old Europe, including the eastern part of the Cucuteni-Tripol'ye culture. A defining characteristic in both regions, in what has been termed the Climax Chalcolithic,[25] was the diversification of material culture in a wider range of media than ever before and according to aesthetic principles based upon color and brilliance.[26]

Climax Copper Age Settlement in the Lower Danube Valley[27]

For a millennium (5800–4800 BC), communities in the Lower Danube valley lived in small, mostly dispersed settlements lasting one or two generations.[28] Some hamlets consolidated their kinship links by burying their dead in large corporate cemeteries, such as Cernica, near modern Bucharest.[29] Settlement expansion out of the

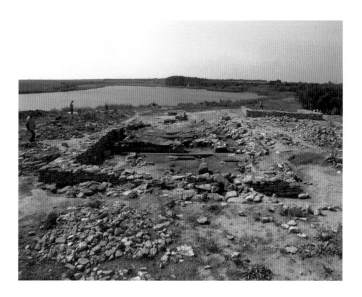

Rich Grave Goods

Burial no.	Lab no.	Radiocarbon age BP	Calibrated to 95.4% probability	
11	13686	5639 ± 32	4543-4370	calBC
43	13685	5720 ± 29	4683-4488	calBC
112	13251	5702 ± 32	4653-4457	calBC
143 (human)	13689	5690 ± 32	4612-4454	calBC
143 (animal)	13690	5700 ± 30	4650-4457	calBC
158	13688	5787 ± 30	4711-4550	calBC
255	13254	5732 ± 33	4686-4496	calBC

Poor Grave Goods

Burial no.	Lab no.	Radiocarbon age BP	Calibrated to 95.4% probability	
10	13687	5569 ± 32	4457-4350	calBC
44	13692	5657 ± 30	4551-4374	calBC
94	13250	5626 ± 31	4526-4366	calBC
121	13252	5672 ± 34	4604-4403	calBC
125	13253	5685 ± 33	4612-4451	calBC
215	13691	5668 ± 32	4591-4402	calBC
225	13693	5660 ± 29	4552-4375	calBC

3-3. House 8, Late Copper Age, Horizon V, Durankulak.

Table 3-3. Calibrated date range for the first fourteen dates for the Varna cemetery, rich grave goods.

Table 3-4. Calibrated date range for the first fourteen dates for the Varna cemetery, poor grave goods.

main river valleys required the utilization of a more diverse range of soil resources for farming, from alluvial soils in the Early Neolithic to alluvial and brown soils and black earths in the Copper Age, leading to variations in productive capacity. One response to the challenges posed by new soils for cultivation was the development of the simple ard-plough, as attested at Vădastra on the basis of cattle long-bone terminals worn by the stress of animal traction.[30]

The beginning of a very stable settlement pattern that eventually would result in the creation of tells can be dated to the early fifth millennium BC in the lower Danube valley. A key area for the study of tells is northeastern Bulgaria, where six tells have been completely excavated, providing an unparalleled opportunity for understanding these highly structured village communities of some 120 to 150 people.[31] There is no consensus on why people settled on tells, but a number of explanations have been advanced: These settlements may have represented a way to avoid floods in periods of increased precipitation; the desire for a highly visual settlement from which the territory could be seen and on which dwellers could be recognized; a means of marking the center of a territory of especially rich arable resources; or a form of settlement that venerated the ancestors who had lived there. The initial size restrictions of tells and, with vertical growth, the progressive reduction in livable area might lead us to expect that the layout of houses and open spaces within a tell settlement was strictly planned. While this did seem to occur on some tells, producing settlement plans of remarkable geometric order (fig. 3-4),[32] many other tell communities rejected the geometric option in favor of a loose ordering of space that resembled the spatial structuring found on nearby horizontal sites.[33] In addition, the contrasting spatial orders of totally excavated tells yielded two different kinds of houses with contrasting implications for the social use of domestic space.[34] Pattern A, found at the loosely ordered tell settlements of Radingrad and Targovishte, revealed simple one- to three-room houses, with a single entrance and one oven and concomitantly simple access pathways throughout the domestic space. In the contrasting Pattern B, found at the geometrically planned tell settlements of Poljanitsa and Ovcharovo, houses had as many as eleven rooms, often with multiple entrances and several ovens. Other characteristics of highly ordered tell settlements included very high ratios of built to unbuilt space that increased over time, cyclical patterns through time in house dimensions (length and width), and markedly similar minimum interhouse spacing. It was inferred that the practices producing this Pattern B were indicative of both spatial and social complexity of a kind not normally found on tells, based upon the differentiation of house space, with larger families more carefully controlling access to rooms and developing specialized uses for them—as sites for hospitality, domestic ritual, food preparation, food storage, tool making, and sleeping. But even the Pattern A social practices of more loosely structured tells betoken a more developed sense of spatial coherence and continuity over time than is apparent on many flat sites.

The regularities in the lengths and widths of houses at these tells indicate the time and effort spent on the careful reproduction of traditional design, based upon ancestral practices materialized in the successive phases of dwelling on the tell.[35] These regularities and the details of house construction suggest a long-term continuity in fundamental principles of geometric order that must have exerted a strong influence on the persons living in these houses.

However, we should not overemphasize the degree of standardization in houses, any more than in objects: Diachronic differences in size, shape, building techniques, and construction materials are well attested.[36] Nonetheless, houses in many different social contexts shared much at the level of overall design principles. On certain tells the combination of ordered village space, carefully observed regularities in both the location of houses and their dimensions, and the division between what was possible and impossible on the tell itself placed strong constraints upon social practices, leading to a well developed sense of the forms of appropriate and inappropriate behavior. The perception of geometric order in the built environment might imply a similarly structured approach to the production of objects. Traditional practices were built into the fabric of tell villages, producing certain kinds of persons who probably would have found living in a less ordered horizontal settlement disorienting and bewildering. However, social relations between neighbors in densely

packed villages must have been subject to negative constraints on potential "polluting" behavior, such as loud music, smelly refuse, and violence. One easily could have found "neighbors from hell" in tightly packed tell communities![37] How did the settlements in the Cucuteni-Tripol'ye culture compare to such high-density living?

Cucuteni-Tripol'ye Settlement Networks and Tripol'ye Megasettlements

The eastward expansion of the Cucuteni-Tripol'ye settlement network[38] marked a vital social change in the lowlands east of the Carpathians. This expansion brought the farming way of life to large parts of the so-called Forest Neolithic zone, characterized by pottery and a low reliance on domestic animals.[39] The Tripol'ye expansion enabled the emergence of fully sedentary life and the first local exploitation of highly fertile black earths.[40]

Settlement information for the two millennia of the Cucuteni-Tripol'ye culture is much richer than that available for western Black Sea cultures such as those at Varna.[41] A comparison of gazetteer results shows a decline in site numbers during Cucuteni A-B, but a recovery during Cucuteni B. While many Cucuteni A-B and B sites covered an area of ten to fifteen hectares, there was considerable divergence in the size of sites in all phases, with an early fourth-millennium population peak in site sizes and a settlement hierarchy whose top level was constituted by settlements covering more than one hundred hectares.[42]

While a small number of special-purpose seasonal sites is known, the vast majority of sites were permanent open settlements. Although many settlements were built on commanding heights, very few, barely three percent, had artificial boundaries such as boundary ditches. The few enclosed/defended sites probably embodied a largely symbolic closure, occasionally overlaid by defensive structures too complex to represent an attempt to ward off any conceivable military attack.[43] They also decreased in frequency with time, as did the proportion of Cucuteni settlements built on steep promontories. There is only one tell settlement known from the entire culture, at Poduri-Dealul Ghindaru, near Moineşti,[44] a local center for salt production and export, supported by seasonal

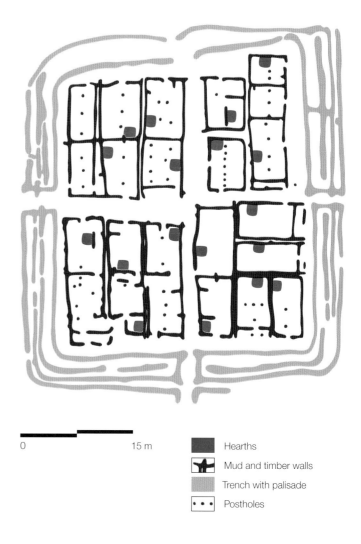

0 15 m

■ Hearths

✈ Mud and timber walls

▨ Trench with palisade

⬚ Postholes

3-4. Plan of Polyanitsa Phase IV (after Todorova, 1982).

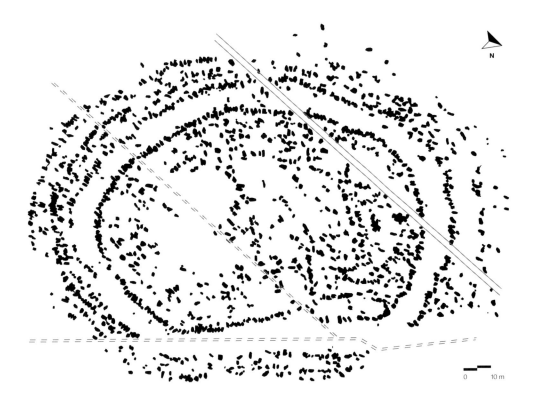

N

0 10 m

satellite sites[45] close to the salt springs that are so plentiful in Moldavia.[46]

The principles of cultural order were expressed in a variety of ways at the community level in terms of settlement coherence. The vast majority of settlements betrayed few signs of deliberate planning. They grew through multiple copies of the same house-and-garden complex, which brought persons, plants, and animals together in an intimate way.[47] The most obvious exception was the concentric principle used to structure many Tripol'ye sites in oval or circular fashion, with houses built around an open central space that might contain one or more structures.[48] These sites seem to have grown by adding further rings of houses. While early forms of the concentric principle were already present in Tripol'ye A sites, an extreme form was reached at the Tripol'ye C site of Maidanets'ke (fig. 3-5).[49] While concentric plans were

always more common than rows or clusters of houses, there is a greater dominance of the concentric principle in the eastern part of the Cucuteni-Tripol'ye distribution,[50] suggesting that those eastern communities used it actively to create a coherent, familiar living space across the full range of site sizes.

Another way of creating a comfortable and secure dwelling space was the design of similar houses with comparable ways of ordering the interiors. From the early fifth millennium, there was a strong Cucuteni-Tripol'ye tradition of erecting the walls of rectangular, one- or two-roomed houses around a thick, clay-covered log platform, as excavated at Scânteia (fig. 3-6). Many everyday household practices, such as sleeping, food storage, grinding, and cooking, were embedded in domestic ritual, as indicated by the figurines often deposited nearby each practice.[51] In the absence of cemeteries, which the Cucuteni-Tripol'ye people did not use, houses may have played an important role in mortuary practices. Bem has interpreted House 9 at the settlement of Scânteia as an ossuary (a place where the bones of the dead were stored), since amid the rich

3-5. Plan of Maidanets'ke Tripol'ye C settlement (after Anthony, 2007, fig. 12.7).

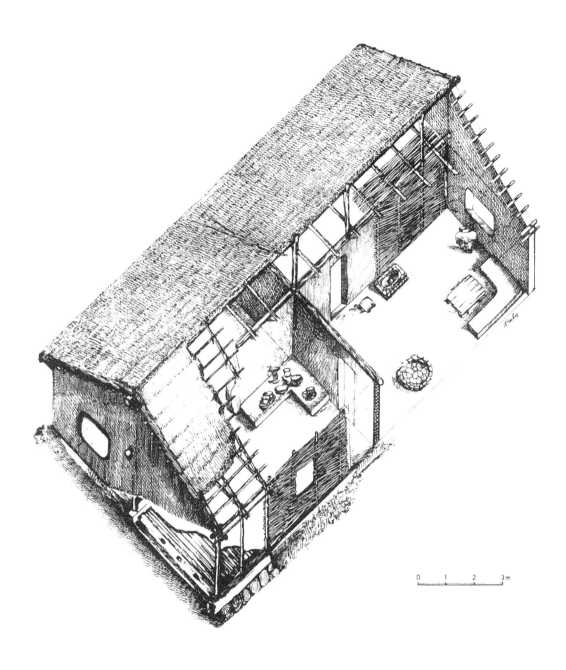

3-6. Reconstruction of a Cucuteni house interior (source: Marinescu-Bîlcu, 1981, fig. 14).

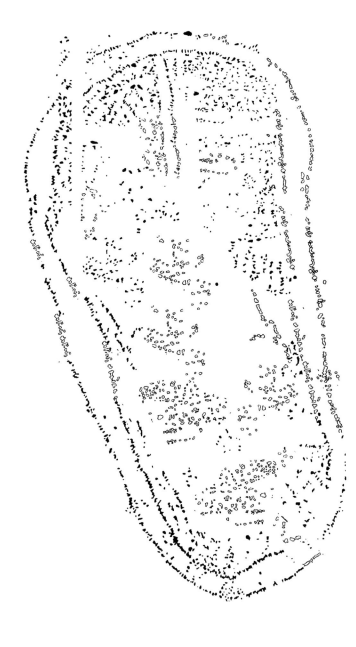

3-7. Plan of the Tripol'ye CI megasite of Talljanky (source: Videiko, 2007, fig. 4).

material culture were 111 human bones/teeth, deriving from a minimum of thirty-three individuals.[52]

Some scholars have maintained that a group of structures containing altars, plinths, or concentrations of figurines indicates not just domestic ritual, but rather formal public "shrines." A large cluster of figurines had been laid on a fired-clay platform at the end of a house at Sabatinovka, Ukraine.[53] Similarly, complete figurines had been regularly placed in large vessels at sites such as Dumeşti,[54] Buznea, and Ghelaeşti[55] as if to signify cardinal points of the Cucutenian world (see fig. 5-5). However, the deposition of standard household materials (animal bones, sherds, and lithics) in these structures suggests that these are instances of unusually intensive ritual practices focused on the household rather than Near Eastern–like public buildings.

There might have been many other uses of Cucuteni-Tripol'ye structures. Smaller buildings have been interpreted as granaries with attached grinding areas, as at Vesely Kut.[56] Larger, perhaps two-storied buildings have been viewed as ceramic workshops for the large-scale production of painted wares, a notion supported by the discovery of raw kneaded clay, kick-wheels, interior kilns, and numerous stacked vessels at sites such as Petreny and Varvarovka VIII.[57]

The megasites of the Tripol'ye culture have been well characterised by M.Y. Videiko as elliptical towns composed of hundreds or even thousands of houses built in concentric ovals around central vacant areas, with regular streets and residential quarters based upon standard planning schemes (fig. 3-7).[58] The earliest megasite currently recognized is Vesely Kut, covering 150 hectares and dating to the Tripol'ye BI/II transition,[59] but the majority of megasites date to the CI phase (3800–3500 BC). At Talljanky more than 2,000 structures are documented by geophysical prospection and limited excavation,[60] while more-intensive excavations at Majdanetskoe led Videiko to reconstruct a three-stage development, with almost all of the 1,575 houses occupied concurrently in Phase 3.[61] It is not surprising to find size-based settlement hierachies in several Tripol'ye phases. The important point to note is that, although megasites were sustained in Phases BI, BII, and CI, there was a decline in site sizes

to only ten to sixty hectares in the transitional BII-CI Phase, suggesting that these extreme populations had a severe effect on local environments. Nonetheless, the renewed growth of megasites in Phase CI, the time of the largest settlements, showed that these problems had been temporarily overcome.

The largest known settlements in fourth-millennium Europe, these "proto-cities" were greater in area than the earliest cities of Mesopotamia—which were being established at about the same time—and they constitute the only exception to the global model of settlement limits established by Fletcher.[62] His model defined two behavioral limits to the size of settlements under premodern tribal conditions:[63] first, limits to the quantity of interaction (in his terms, the I-limit) of 300 to 600 people per hectare, implying that residential densities had to remain at this level or lower to decrease potentially spiralling interaction rates; and second, limits to the size of compact settlement (Fletcher's C-limit) of one hundred hectares, across which communication could function adequately. Not only did the megasites clearly surpass the C-limit, but they appear to have lacked internal settlement divisions, writing, information-storage systems, and other signals of central administration that could have made such problems less intractable. Fletcher considered the megasites as potentially threatening to his global hypothesis of limitations to settlement growth.[64]

The size of the megasites raises logistical issues of provisioning for each resource, whether potting clay (tens of thousands of new vessels were produced each year, rapidly exhausting local clay sources), lithic raw materials for tools (an estimated two tons of flint per year, brought from the Dniester valley, one hundred kilometers to the west[65]), firewood, water, food, and salt. Gaydarska has used computerized geographic information systems (GIS) to model the area of arable land required for growing grain.[66] Her analysis suggests that cultivated fields would have extended seven kilometers from most of the mega-settlements, a distance too great to move grain efficiently, even with ox-carts, and that subsidiary agricultural settlements would have been needed to produce grain for the largest megasites. Chapman and Gaydarska's estimate of the annual salt demand for people and animals at the

megasite of Majdanetskoe—at between 36,000 and 100,000 kilograms per year—implies a massive investment in the salt trade, whether from the eastern Carpathian salt springs or from the *limans* (shallow saltwater bays) of the northern Black Sea coast.[67] The logic of hierarchical order is that the elites who coordinated the trade and supply systems must have relied upon subsidiary communities in the settlement hierarchy for significant amounts of resources, whether food, salt, raw materials, or finished objects. The strategies that could have been used by an elite to coordinate and promote such cooperation, including low-level coercion, the distribution of prestige goods,[68] or a combination of the two, would have intensified and exacerbated major social inequalities—but inequalities are barely hinted at in the Tripol'ye settlements. No palaces, large central temples, large central storage facilities, or even particularly sumptuous houses have been found in the megasites. The absence of a highly evolved set of public mortuary rituals tied to cemeteries is most puzzling, and it would be in Tripol'ye cemeteries coeval with megasites that Varna-style elite funeral rituals might be found to provide evidence for the existence of a social hierarchy. While the absence of cemeteries in the Tripol'ye and the Cucuteni cultures denies us any such evidence, it can hardly be doubted that the concentration of social power in elite families or clans must have gone hand in hand with the creation and maintenance of the megasites, until it reached a level of centralized control that was extraordinary, and perhaps eventually deemed simply unacceptable, for fourth-millennium Europe.

Conclusions

Whether they lived in densely packed, highly regulated tell settlements or in more-open, spacious flat settlements, the occupants of Old European villages and towns seem to have avoided displays of social inequality in their residential architecture. Although some houses were larger than others, few structures stood out as different in style, setting, or architectural elaboration. Wherever the chiefs and elites lived, their homes cannot easily be identified by archaeologists. This suggests that houses were not viewed as appropriate media for the display of social differences. There are two key conundrums of the Copper Age of southeastern Europe: The first concerns the absence of settlement hierachies, or inequalities in settlement size

and function, at the time of the Varna cemetery, with their institutionalized inequalities between people; and the second, the absence of any kind of cemetery evidence, not to mention a highly differentiated form, at the time of the Tripol'ye megasettlements. In each case, the presence of one highly differentiated social arena implies the presence of the other, but evidence that might support the implication is missing. At Varna the production and concentration of spectacular grave gifts indicates not only that the elite controlled considerable craft skills and raw material resources, but also that they had places (but where?) to accumulate and store vast stocks of prestige goods[69] as well as the political and economic means to attract them. With regard to the Tripol'ye megasites, it is impossible to talk of 250- or 450-hectare settlements without invoking the extreme social inequalities that would seem to be required to control effectively the communications and logistics of such centers. It is equally difficult to accept that such inequalities were not materialized through craft and/ or ritual specialization. While it is important to celebrate the achievements of the communities that created Varna and the megasettlements, a more complete understanding of the emergence of these puzzling phenomena is surely a higher priority.

Acknowledgments

I am very grateful to David Anthony for his kind invitation to contribute to this exhibition catalogue, since it allowed me to join two areas of long-standing interest, as well as for his highly skilled editing of successive drafts of this chapter. I should like to thank friends and colleagues in these research areas, without whom it would not have been possible to develop these ideas: in coastal Bulgaria, Henrieta Todorova, Todor Dimov, and Vladimir Slavchev; in Moldavia, Dan and Felicia Monah, Dragomir Popovici, Catalin Bem, Gheorghe Dumitroaia, and Magda Mantu-Lazarovici; in Moldova, Valentin Dergachev; and in Ukraine, Mikhail Videiko, Natalia Burdo, Aleksey Korvin-Piotrovsky, and Yuri Rassamakin. My greatest thanks are, as ever, to Bisserka for inspiration and critical appreciation.

Notes

1 Gimbutas, M., *The Goddesses and Gods of Old World Europe, 6500–3500 BC* (London: Thames and Hudson, 1983).

2 Chapman, J., "The Early Balkan Village," in *Neolithic of Southeastern Europe and Its Near Eastern Connections*, Varia Archaeologica Hungarica 2 (Budapest: Archaeological Institute of the Hungarian Academy of Sciences; Cardiff: School of History and Archaeology, University of Cardiff, 1989): 33–53.

3 Ibid.

4 Kotsakis, K., "Across the Border: Unstable Dwellings and Fluid Landscapes in the Earliest Neolithic of Greece," in *(Un)settling the Neolithic*, ed. D.W. Bailey, A. Whittle, and V. Cummins (Oxford: Oxbow, 2005): 8–16.

5 Colledge, S., and J. Conolly, "The Neolithisation of the Balkans: A Review of the Archaeobotanical Evidence," in *A Short Walk through the Balkans: The First Farmers of the Carpathian Basin and Adjacent Regions*, ed. M. Spataro and P. Biagi (Trieste: Società per la Preistoria e Protostoria della Regione Friuli-Venezia Giulia Quaderno 12, 2007): 25–38; Bartosiewicz, L., "Mammalian Bone," in *The Early Neolithic on the Great Hungarian Plain: Investigations of the Koros Culture Site of Ecsegfalva 23, County Bekes*, ed. A. Whittle, Varia Archaeologica Hungarica 21 (Budapest: Archaeological Institute of the Hungarian Academy of Sciences; Cardiff: School of History and Archaeology, University of Cardiff, 2007): vol. 1, 287–326.

6 Evidence for anthropogenic activities (both arable and pastoral indicators) from Zone *PAZ* BS-8 of the marine core, with a start dating to 4930 +/- 260 uncal. BC (ca. 5500 cal. BC); Filipova-Marinova, M., "Postglacial Vegetation Dynamics in the Coastal Part of the Strandza Mountains, Southeastern Bulgaria," in *Aspects of Palynology and Palaeoecology: Festschrift in Honour of Elissaveta Bozilova*, ed. S. Tonkov (Sofia-Moscow: Pensoft, 2003): 213–31. The presence of cereal grains and weeds of cultivation in Zone Sh-E$_1$ is dated between 4850 +/- 110 uncal. BC and 4040 +/- 100 uncal. BC at Shabla-Ezerets (ca. 5500–4700 cal. BC); Filipova, M., "Palaeoecological Investigations of Lake Shabla-Ezeretz in North-eastern Bulgaria," *Ecologica Mediterranea* 1, no. 1 (1985): 147–58.

7 Berciu, D., *Cultura Hamangia. Noi contribuții* (București: Institutul de Arheologiă al Academiei RPR, 1966).

8 Hasotti, P., *Epocă neolitică în Dobrogea*, Bibliotheca Tomitana 1 (Constanta: Muzeul de Istorie Nationala si Arheologie, 1997); Dimov, T., "Neolithic and Copper Age Sites in the North East Balkans (with Special Reference to Hamangia Culture), in *Early Symbolic Systems for Communication in Southeast Europe*, ed. L. Nikolova, British Archaeological Reports, International Series 1339 (Oxford: Archaeopress, 2003): vol. 2, 459–68.

9 Todorova, H., ed., *Durankulak*, vol. 2, *Die prähistorischen Gräberfelder von Durankulak* (Sofia-Berlin: Deutsches Archäologisches Institut, 2002).

10 Todorova, H., and T. Dimov, "Ausgrabungen in Durankulak, 1974–1987," Varia Archaeologica Hungarica 2 (1989): 291–306.

11 Boyadzhiev, Y., "Stone Architecture from the Chalcolithic Mound on Golemija Ostrov near Durankulak, Dobrich Region," *Starini* (2000–5): 63–74.

12 Todorova, H., *The Eneolithic Period in Bulgaria in the Fifth Millennium BC*, British Archaeological Reports, International Series 49 (Oxford: Archaeopress, 1978): 53.

13 Todorova, H., "Tellsiedlung von Durankulak," *Fritz Thiessen Stiftung Jahresbericht 1995/96* (1997): 81–84; Chapman, J., B. Gaydarska, and K. Hardy, "Does Enclosure Make a Difference? A View from the Balkans," in *Enclosing the Past: Inside and Outside in Prehistory*, ed. A. Harding, S. Sievers, and N. Varnaclová, Sheffield Archaeological Monographs 15 (London: Equinox, 2006): 20–43.

14 Todorova, *Durankulak* (2002): 24.

15 Ivanov, I., "À la question de la localisation et des études des sites submerges dans les lacs de Varna," *Pontica* 26 (1993): 19–26.

16 Ibid.

17 Higham, T., et al., "New Perspectives on the Varna Cemetery (Bulgaria)—AMS Dates and Social Implications," *Antiquity* 81 (2007): 640–54.

18 Ivanov, I., "Spasitelni razkopki na rannoeneolitnioto selishte pri s. Suvorovo," *Archeologicheski Otkritia i Razkopki Prez 1983* 29: (1984): 21–22.

19 Gaydarska, B., "Preliminary Research on Prehistoric Salt Exploitation in Bulgaria," in "Todorova Festschrift," ed. V. Slavchev, *Dobrudzha* 21 (2004): 110–22.

20 Todorova, *Eneolithic Period in Bulgaria* (1978): 55.

21 Raduntcheva, A., "ObshtestVarnao-ikonomicheskiyat zhivot na Dobrudzha i Zapadnoto Chernomorye prez eneolita," *Vekove* 1 (1986): 16–20.

22 Higham et al., "New Perspectives on the Varna Cemetery" (2007): 647 and fig. 3.

23 Chapman, J., "Domesticating the Exotic: The Context of Cucuteni-Tripol'ye Exchange with Steppe and Forest-Steppe Communities," in *Ancient Interactions: East and West in Eurasia*, ed. K. Boyle, C. Renfrew, and M. Levine, McDonald Institute Mononographs (Cambridge: McDonald Institute for Archaeological Research, 2003): 75–92.

24 Haheu, V., and S. Kurciatov, "Cimitirul plan eneolitic de lînga satul Giurgiulești," *Revistă Arheologică* 1 (1993): 101–14; Dergachev, V., *Karbunskii klad* (Chișinău: Tipografia Academiei de Științe, 1998).

25 Chapman, J., *Fragmentation in Archaeology: People, Places and Broken Objects in the Prehistory of South Eastern Europe* (London: Routledge, 2000): 3.

26 Chapman, J., "Dark Burnished Ware as Sign: Ethnicity, Aesthetics and Categories in the Later Neolithic of the Central Balkans," in *Homage to Milutin Garašanin*, ed. N. Tasić and C. Grozdanov (Belgrade: Serbische Akademie der Wissenschaften und Künste, 2006): 295–308; Chapman, J., "The Elaboration of an Aesthetic of Brilliance and Colour in the Climax Copper Age," in *Stephanos Aristeios. Archäologische Forschungen zwischen Nil und Istros*, ed. F. Lang, C. Reinholdt, and J. Weilhartner (Vienna: Phoibos, 2007): 65–74; Chapman, J., "Engaging with the Exotic: The Production of Early Farming Communities in South-East and Central Europe," in *Short Walk through the Balkans*, ed. Spataro and Biagi (2007): 207–22.

27 The two west Balkan cultures represented in the exhibition reveal contrasting settlement characteristics. The most common settlement form in the earlier (Middle–Late Neolithic) Vinča culture was the flat site, with wide fluctuations in size, together with a small number of tells and a very small number of known cemeteries; Chapman, J., The Vinča Culture of South East Europe: Studies in Chronology, Economy and Society, British Archaeological Reports, International Series 117 (Oxford: Archaeopress, 1981). The later, Middle Copper Age Bodrogkeresztúr culture was typified by large cemeteries whose burials must have come from a large number of dispersed homesteads; Patay, P., "Die hochkupferzeitliche Bodrogkeresztúr-Kultur," Bericht der Römisch-Germanisch Kommission 55 (1974): 1–71.

28 Bailey, D.W., et al., "Alluvial Landscapes in the Temperate Balkan Neolithic: Transitions to Tells," Antiquity 76 (2002): 349–55.

29 Comşa, E., and G. Cantacuzino, Necropola neolitică de la Cernica (Bucureşti: Editura Academei Române, 2001).

30 Mateescu, C.N., "Remarks on Cattle Breeding and Agriculture in the Middle and Late Neolithic on the Lower Danube," Dacia, n.s., 19 (1981): 13–18.

31 Chapman, "Early Balkan Village" (1989).

32 Especially Polyanitsa and Ovcharovo; Todorova, H., Kupferzeitliche Siedlungen in Nordostbulgarien, Materialien zur Allgemeinen und Vergleichenden Archäologie 13 (Munich: Beck, 1982).

33 Chapman, "Early Balkan Village" (1989).

34 Chapman, J., "Social Inequality on Bulgarian Tells and the Varna Problem," in The Social Archaeology of Houses, ed. R. Samson (Edinburgh: Edinburgh University Press, 1990): 49–98.

35 Chapman, "Early Balkan Village" (1989).

36 Bailey, D.W., Balkan Prehistory: Exclusion, Incorporation and Identity (London: Routledge, 2000).

37 For such neighbors on Greek Neolithic tells, see Halstead, P., "Neighbours from Hell? The Household in Neolithic Greece," in Neolithic Society in Greece, ed. Halstead, Sheffield Studies in Aegean Archaeology 2 (Sheffield: Sheffield Academic Press, 1999), 77–95.

38 Ellis, L., The Cucuteni-Tripol'ye Culture: A Study in Technology and the Origins of Complex Society, British Archaeological Reports, International Series 217 (Oxford: Archaeopress, 1984).

39 Although Kotova cites small samples of allegedly domestic animal bones, she produces no evidence for their domestic status; Kotova, N.S., Neolithization in Ukraine, British Archaeological Reports, International Series 1109 (Oxford: Archaeopress, 2003). Similarly, the only evidence for domestic plants derives from plant impressions on ceramics, not a valid criterion for local cultivation.

40 Videiko, M., ed., Entsiklopediya Tripil'skoi tsivilizatsii (Kiev: Ukrpoligrafmedia, 2004.)

41 For regional gazetteers, see Monah, D., and Ş. Cucoş, Aşezările culturii Cucuteni din România (Iaşi: Junimea, 1985); Popovici, D.N., Cultura Cucuteni Faza A. Repertoriul aşezărilor (1), Bibliotheca Memoriae Antiquitatis 7 (Piatra Neamţ, 2000); Bodean, S., Aşezările culturii Precucuteni-Tripolie A din Republica Moldova (Kishinev: Pontos, 2001); Bem, C., Traian-Dealul Fântânilor. Fenomenul Cucuteni A-B (Bucureşti: Muzeul National de Istorie a României, 2007): chap. 3.

42 Videiko, M.Y., "Contours and Content of the Ghost: Trypillia Culture Proto-Cities," Memoria Antiquitatis 24 (2007): 251–76.

43 Chapman, J., "The Origins of Warfare in the Prehistory of Central and Eastern Europe," in Ancient Warfare, ed. J. Carman and A. Harding (Stroud: Sutton, 1999): 101–42.

44 Monah, D., et al., Poduri-Dealul Ghindaru. O Troie în Subcarpaţii Moldovei, Bibliotheca Memoriae Antiquitatis 8 (Piatra Neamţ, 2003).

45 Chapman, J., and D. Monah, "A Seasonal Cucuteni Occupation at Silişte-Prohozeşti," in L'exploitation du sel à travers le temps, ed. D. Monah, G. Dumitroaia, O. Weller, and J. Chapman, Bibliotheca Memoriae Antiquitatis 18 (Piatra Neamţ, 2007): 71–88.

46 Weller, O., R. Brigand, and M. Alexianu, "Cercetări sistematice asupra izvoarelor de apă sărată din Moldova," Memoria Antiquitatis 24 (2007): 121–90.

47 For example, at Truşeşti; Petrescu-Dîmboviţa, M., M. Florescu, and A.C. Florescu, Truşeşti. Monografie arheologică (Bucharest-Iaşi: Editura Academiei Române, 1999).

48 Videiko, Entsiklopediya Tripil'skoi tsivilizatsii (2004).

49 Ellis, Cucuteni-Tripol'ye Culture (1984): 192 and fig. 69.

50 Sorokin, V., "Modalitile de organizare a aezrilor complexului cultural Cucuteni-Tripol'ye," Archeologia Moldovei 16 (1993): 69–86.

51 Monah, D., and Monah, F., "Cucuteni: The Last Great Chalcolithic Civilisation of Old Europe," in Cucuteni: The Last Great Chalcolithic Civilisation of Old Europe, ed. C.-M. Mantu, G. Dumitroaia, and A. Tsaravopoulos (Bucharest: Athena, 1997): 15–95.

52 Bem, Traian-Dealul Fântânilor (2007): 252–53.

53 Gimbutas, Goddesses and Gods of Old World Europe (1983).

54 Maxim-Alaibă, R., "Le complexe de culte de la phase Cucuteni A3 de Dumeşti (Dep. de Vaşlui)," in La civilisation de Cucuteni en contexte européen, ed. M. Petrescu-Dîmboviţa, N. Ursulescu, D. Monah, and V. Chirica, Bibliotheca Archaeologica Iassensis 1 (Iaşi: Universitatea Alexandru Ioan Cuza, 1987): 269–86; cf. Buznea "scene": Boghian, D., and C. Mihai, "Le complexe de culte et le vase à décor ornithomorphe peint découverts à Buznea (Dep. de Iaşi)," in ibid.: 313–23.

55 Cucoş, Şt., "Un complex ritual descoperit la Ghelăieşti (jud. Neamţ)," Studii si cercetari de istorie veche si arheologie 24, no. 2 (1973): 207–15.

56 Tsvek, E., "Structure of the Eastern Tripol'ye Culture," in Cucuteni aujourd'hui. 110 ans depuis la découverte en 1884 du site eponyme, ed. G. Dumitroaia and D. Monah, Bibliotheca Memoriae Antiquitatis 2 (Piatra Neamţ, 1996): 89–113.

57 Ellis, Cucuteni-Tripol'ye Culture (1984): 134–35, 162–64.

58 Videiko, "Contours and Content of the Ghost" (2007): 267.

59 Tsvek, "Structure of the Eastern Tripol'ye Culture" (1996).

60 Kruts, V.A., "Planirovka poseleniya u s. Tal'yanki i nekotorye voprosy Tripol'skogo domostroitel'stva," in Rannezemledel'skie poseleniya-giganty Tripol'skoi kul'tury na Ukraine (Kiev: Institut Arkheologii AN USSR, 1990): 43–47.

61 Videiko, M.Y., "Die Grossiedlungen der Tripol'e-Kultur in der Ukraine," *Eurasia Antiqua* 1 (1996): 45–80.

62 Fletcher, R., *The Limits to Settlement Growth* (Cambridge: Cambridge University Press, 1996).

63 Ibid.: 71– 90.

64 Ibid.: 198–200.

65 Mikhail Videiko, conversation with the author, 5 August 2008.

66 Gaydarska, B., "Application of GIS in Settlement Archaeology: An Integrated Approach to Prehistoric Subsistence Strategies," in *Tripol'ye Settlements-Giants*, ed. A. Korvin-Piotorvsky, V. Kruts, and S.M. Rizhov (Kiev: Institute of Archaeology, 2003): 212–16.

67 Chapman, J., and B. Gaydarska, "The Provision of Salt to Tripol'ye Mega-sites," in *Tripol'ye Settlements-Giants*, ed. Korvin-Piotorvsky, Kruts, and Rizhov (2003): 203–11.

68 Cf. the model proposed by Frankenstein and Rowlands for the Early Iron Age of southwest Germany; Frankenstein, S., and M. Rowlands, "The Internal Structure and Regional Context of Early Iron Age Society in South-western Germany," *Bulletin of the University of London Institute of Archaeology* 15 (1978): 73–112.

69 Cf. Olivier's discussion for the Early Iron Age princely grave of Hochdorf; Olivier, L., "The Hochdorf 'Princely Grave' and the Question of the Nature of Archaeological Funerary Assemblage," in *Time and Archaeology*, ed. T. Murray, One World Archaeology 37 (London: Routledge, 1999): 109–38.

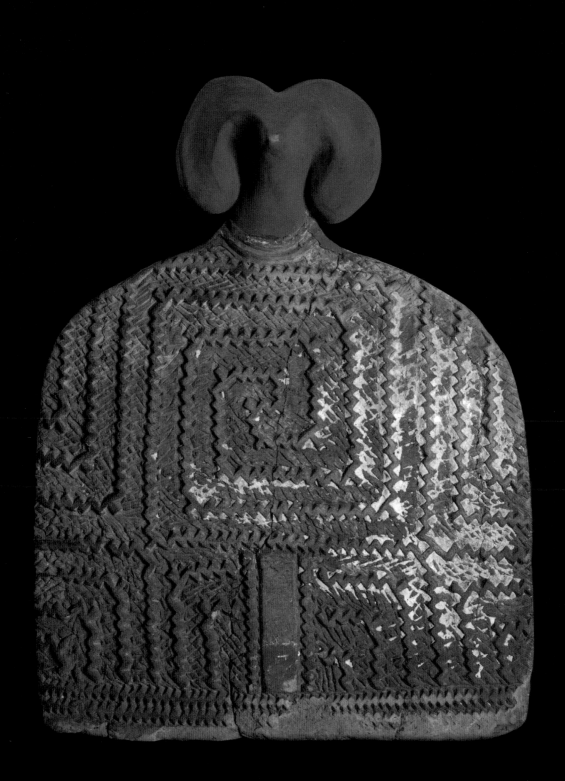

Copper Age Traditions North of the Danube River

Dragomir Nicolae Popovici

National History Museum of Romania, Bucharest

The artifacts in the exhibition that accompanied this catalogue were made and used in Neolithic and Copper Age sites that are today located principally in Romania, north of the Danube River. My object is to describe in a summary fashion the contexts where these objects were found and to outline the new aspects of everyday and spiritual life created by different archaeological cultures starting from a set of common, general features of the Neolithic Age. Below I will analyze the main constitutive elements, including the settlements, houses, workshops, fortifications, and cemeteries of these cultures.

The Settlements

Prehistoric societies thought of their living space as a materialization of a specific vision of the world and its corresponding social structure,[1] the dwelling being ultimately a symbolic model. The symbolic content of built space was expressed in various rituals[2] that once had a particular meaning but today present difficulties in interpretation.

Archaeological excavations have not been distributed uniformly across Romania's territory, nor are all excavations equal, creating disparities in our knowledge of Neolithic and Copper Age settlements and dwellings. The most complete data are derived from the Cucuteni culture, particularly from the three monographic studies dedicated to the sites of Hăbășești, Târpești, and Trușești, which belong to the Cucuteni A phase and have been excavated completely.[3]

Copper Age settlements usually were situated near water,[4] in places with a good view over the surrounding environment, or in mountains, at sites close to important passes. Some settlements were placed near mineral resources (flint, obsidian, salt, and copper)[5] or productive agricultural land, or took advantage of opportunities for fishing and hunting.

The first Copper Age culture of western Romania was the Tiszapolgár, which was distributed in western Romania, on the plains that extend into Hungary, about 4500–4000 BC. About 130 Tiszapolgár settlements are known. A few are tell sites, but most are single-level open settlements, and a few camps have been found in caves.[6] Tiszapolgár houses were rectangular and small, with floors that were either semisunken or on the surface. Tiszapolgár was followed by the Bodrogkeresztúr culture, dated 4000–3600 BC, both being genetically related. A decade ago 53 Bodrogkeresztúr settlements

Anthropomorphic vessel. Fired clay, Vădastra culture, Vădastra, 5500–5000 BC, MNIR.

91

were known.[7] Most were occupied briefly and contained small dwellings erected mostly of wood. These short-term settlements were related to an economy based mainly on cattle breeding, which increased in importance after 4000 BC, as did copper metallurgy (fig. 4-1).[8]

The Boian was a Late Neolithic culture of the lower Danube valley in southeastern Romania. Currently ninety-six Boian settlements are known.[9] Only the late phase of this culture (the Giuleşti) is well known from settlement evidence, thought to be an indication of an increasingly established way of life.[10] In these settlements, houses are arranged either in rows (Piatra Sat–Vadul Codrii and Radovanu) or grouped in clusters called "nests" (Silistea-Conac and Isaccea-Suhat). The only Boian settlement with a large area exposed by archaeological excavation is Radovanu, with four occupation layers.[11] In levels 2 and 3 the dwellings were set in rows.[12] These two models for structuring settlement space persisted during the next phase of the Boian culture (the Vidra phase), at Boian, Glina, and Tangâru.[13] Some tell settlements started during the Vidra phase of the Boian culture, indicating a rapidly accelerating process of sedentarization about 5000 BC. One aspect of this sedentarization was the proliferation of cult objects, particularly figurines and offering tables (fig. 4-2).[14]

The Gumelniţa was the principal Copper Age culture of the lower Danube valley between 4600 and 3950 BC, and its typical settlement type was the tell. About 250 Gumelniţa tell sites are known. Several were constructed on top of earlier Boian tells. These communities preferred locations near rivers, on terraces, and on top of levees. They were able to practice cattle breeding, hunting or fishing, and agriculture, as at the tell site from Bordușani, located on the floodplain of the Danube, on Ialomiţa island. On such tell settlements, the thickness of archaeological deposits is three to six meters, while the diameters vary between forty and sixty meters, measurements that indicate a small village inhabited for a relatively short period of time. Some tells were surrounded by defensive structures of the ditch and bank type, sometimes with a palisade.[15] Detailed field investigations along the Neajlov valley led to the discovery of small tell sites, located two to three kilometers from one another in clusters.[16]

Of great importance for the Gumelniţa A2 stage are the researches from Hârşova and Bordușani (as well as the ones from Pietrele), which indicate that the dwellings were disposed in parallel rows (fig. 4-3).[17]

Information concerning the last stage of the Gumelniţa culture (phase B) is provided only by the tell sites of Bucşani, Căscioarele, and Măriuţa (fig. 4-4).[18] The data are few and demonstrate the persistence of the same two spatial patterns, with some dwellings at Măriuţa set in rows, while at Căscioarele and Bucşani there are clusters or "nests" of houses.

Zoological studies of the animals consumed in Gumelniţa settlements north of the Danube show that hunting remained surprisingly important.[19] At Vitănești (Gumelniţa A2 phase) and Căscioarele (Gumelniţa B1 phase), wild animals accounted for most of the bones in garbage areas, while domesticated cattle were preponderant at Tangâru (Gumelniţa A2 phase) and Vlădiceasca (Gumelniţa B1 phase), as well as at Gumelniţa sites located south of the Danube.[20] For the communities from Bordușani, Hârşova, Luncavița, and Năvodari, fishing and shell gathering were important activities. This economic variability seems to have had no corresponding effect on dwellings, pottery, or artistic objects made of bone or clay, in which we can observe a high level of standardization across different kinds of economies.

The Pre-Cucuteni was the Late Neolithic and early Copper Age culture of eastern Romania. To date, 167 Pre-Cucuteni settlements are known, of which 51 are located in Romania, 74 in Moldova, and 42 in Ukraine.[21] Most Pre-Cucuteni settlements are small, with a surface covering about one hectare. The settlement of Târpești might be considered representative, with only ten structures.[22]

The Cucuteni culture is one of the best-known prehistoric civilizations in Romania. As of 1985, an amazing 1,311

4-1. Axe. Copper, Bodrogkeresztúr culture, Sfârnaş, 4000–3500 BC, MNIR.

4-2. Offering table. Fired clay, Boian-Vidra, Lişcoteanca, 4900–4700 BC, MB.

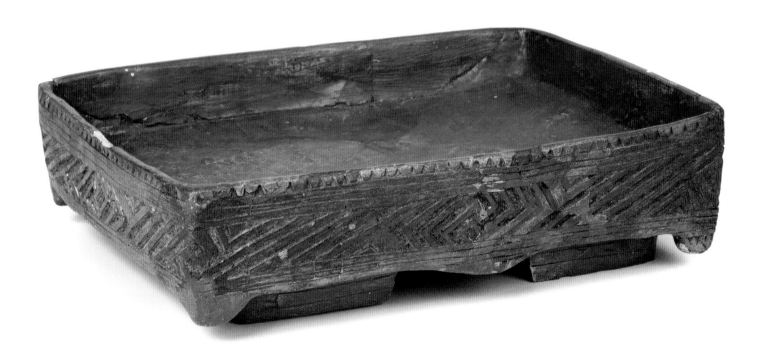

93

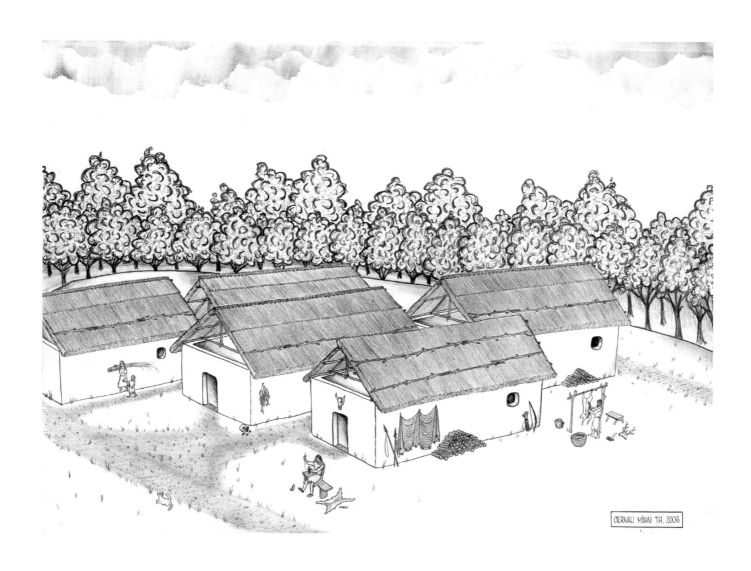

CERNAU MIHAI TH. 2008

4-3. Reconstruction drawing of the northwest section of the Gumelniţa tell site at Borduşani.

4-4 (opposite). General view of the Gumelniţa tell site at Măriuţa.

4-5 (opposite). General view of the Cucuteni settlement at Bodeşti.

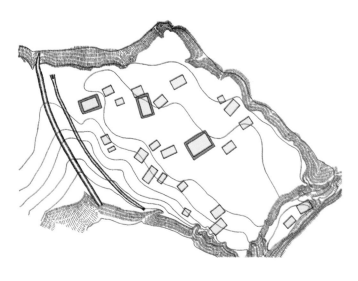

the extraordinary wealth of salt sources.[29] Some places might have been attractive only because there were cult centers or temples in those areas, as was the case at Cãscioarele, Parţa, Poduri, Târgu Frumos, and Truşeşti,[30] where particular constructions with cult places or cult buildings have been discovered.

One way of understanding the quality of life in different Old European settlements is to quantify their degree of crowding. J. Chapman did this by comparing the ratio of built space to unbuilt space. In most cities, for example, there is very little unbuilt space as compared to built space, and the ratio of built to unbuilt space inside a settlement can be used as a standard comparative measure of open space. Chapman observed that, in single-level settlements in western Bulgaria that did not form tells, this ratio varied between 1:3 and 1:13, while at the deeply stratified tell sites of Ovcarovo and Poljanitsa in eastern Bulgaria the ratio was between 6:1 and 1:1, even 8:1 in some phases of the tell.[31]

Cucuteni settlements can also be examined this way.[32] At the stratified settlement of Târpeşti, the Pre-Cucuteni III phase was protected by a defensive ditch, inside which the built-to-unbuilt ratio was 6:1. Later, in the Cucuteni A phase, the settlement was occupied twice. The ratio was 1:9 during the first phase-A occupation—much more open and spread out than in the defended Pre-Cucuteni settlement—and 1:28 in the second phase-A occupation. A similar expansion occurred at the settlement of Hăbăşeşti (fig. 4-6), where the three occupation levels had built-to-unbuilt ratios of 1:8, 1:12.5, and 1:25, showing a change to a more open settlement plan over time.[33] All these data strongly suggest a different model of structuring space.

Open settlements, with more unbuilt space, had houses arranged in clusters, or "nests," with each housing nest[34] separated from the others by open space, which perhaps was used for house gardens. These nests might have represented the houses of the related members of an extended family. This housing pattern is encountered in many Copper Age sites,[35] the major exception being the tell settlements of the Boian, Gumelniţa, Sălcuţa, and Vinča cultures.

sites were assigned to the Cucuteni in Romania.[23] Today that count has increased to 1,848. The zone of most intense habitation was in the area between the Carpathian Mountains and the Siret River (fig. 4-5). Settlements assigned to phase A represent some forty percent of the total number of sites known. Zoological studies show that cattle herds supplied most of the meat diet at Poduri, Scânteia, and Târpeşti,[24] as was the case at most of the communities of this culture. Only a few settlements—such as Bod, Drăguşeni, and Truşeşti[25]—showed hunted wild animals equal to domestic animals. Archaeobotanical studies demonstrate that cultivation was a significant activity for these communities.[26] The average distance between Cucuteni A settlements was about ten kilometers, but this space increased in later phases (A-B and B).[27] Possibly, the high number of phase A sites was caused by shorter occupations and more frequent settlement moves, which would have created a larger number of archaeological sites without any increase in population.

Tiszapolgár and Bodrogkeresztúr communities might have been attracted by access to mineral resources, like salt and copper.[28] A similar density of settlement in the eastern Carpathian piedmont undoubtedly relates to

4-6. General plan of the Cucuteni settlement at Hăbăşeşti, phase I.

The Cucuteni settlement of Drăguşeni is a good example of the "nested" form of house planning. The site is characterized by groups of two to three structures considered to be dwellings, located a distance of one to four meters from one another, and these nests are placed ten to fifteen meters apart.[36] Four or five nests of houses are excavated. In the case of each nest, only one dwelling has a pit-foundation, suggesting that this was the first built, or in other words that this structure represents the first occupational moment of the site. Zooarchaeological study of the animal bones demonstrated that skeletal parts of the same roebuck were discovered inside two different dwellings, presumably indicating that the same game or animal was shared by members of the two households.[37] Stratigraphic analyses showed that the houses in this group were built in a sequence, suggesting that the occupants of these structures probably were successive generations of an extended family.[38] The most important dwelling of this group was probably the first to be built, a two-roomed structure containing a workshop for making flint tools. Another structure in the group probably also contained a flint tool-making workshop. It is possible that a multi-generational family lived here, one that specialized in making flint tools, a craft passed from one generation to the next.

House Architecture and Construction

The construction of houses during the Neolithic was relatively simple. Some houses had floors dug partially into the ground, while others had floors of packed earth on the ground surface. Houses were framed with wood, and had walls made of clay plaster mixed with chopped vegetation and sand. Roofs probably were made of thatch. The Late Neolithic Boian culture in the lower Danube valley exhibited these kinds of houses, rectangular in shape, with both dug-out and surface floors and wood-frame and plaster walls and interiors that measured up to thirty square meters; most of the houses consisted of a single room.[39]

In the Copper Age the same materials were used, but the sizes of the dwellings increased and the timber frame was much stronger, sometimes using whole tree trunks set firmly in foundation ditches. In addition, the thickness of the walls increased to as much as twenty to thirty centi-

meters, making a more comfortable dwelling, one that is known to exist for the Vinča, Boian (Vidra and Spanţov phases), Tisza, Pre-Cucuteni, Petreşti, Cucuteni, and Coţofeni cultures.

In the Late Neolithic and Early Copper Age Dudeşti-Vinča culture, the average dwelling had a single room containing between ten and fifty square meters, larger interiors being rare.[40] Houses of the Tiszapolgár culture at Parţa had foundation ditches with holes for large vertical wall posts.[11] The interior space in Tiszapolgár dwellings varied between twenty and thirty square meters (fig. 4-7).[42] The dwellings of the Coţofeni culture similarly had one or two rooms, a rectangular plan, large timber framing posts, and clay floors. The communities of the Gumelniţa culture built rectangular, two-roomed dwellings, with interiors ranging between forty and sixty square meters. In the tell sites of Borduşani and Hârşova, the entrances were at the ends of each building, and the two rooms partitioning the interior space were unequal in size. The smaller chamber was used for storage, and contained large vessels for provisions and various tools, while the larger chamber was for cooking and sleeping.

Pre-Cucuteni houses usually were one-room dwellings built on the ground surface with a solid timber and log structure, clay plaster being rarely used. The average interior space was thirty to fifty square meters.[43] During the first phase of this culture, the floors were made only of beaten clay, while later a more substantial floor was generally made of wood covered with a layer of clay.[44]

The Cucuteni-culture communities made rectangular surface dwellings with one or two rooms, probably inheriting construction techniques from the Pre-Cucuteni phase. The average interior was between thirty and fifty square meters,[45] with some smaller (ten to twenty square meters) and some much larger (up to one hundred square meters).[46] Cucuteni houses at Hăbăşeşti, Scânteia, Truşeşti, and Poduri were made with floors of logs covered by a thick layer of plastered clay, like the late Pre-Cucuteni floors, which created a very dry and comfortable interior. A fundamentally opposite option seems to characterize the settlements from Drăguşeni and Târpeşti.[47]

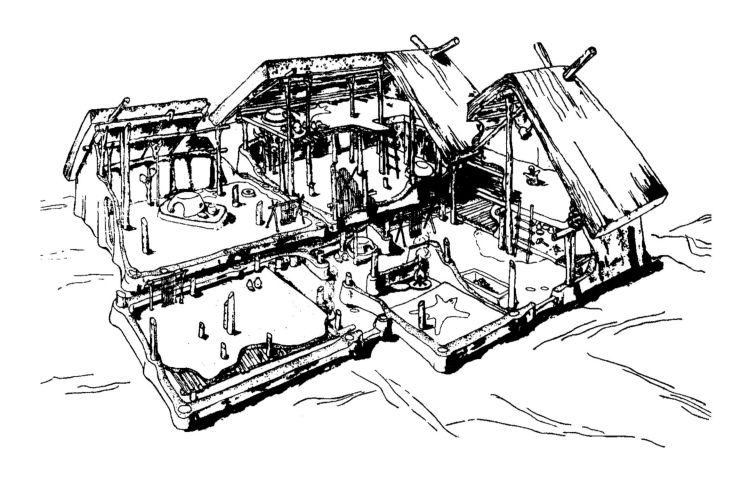

4-7. Reconstruction drawing of a Tiszapolgár cluster of houses at Parţa
(after Lazarovici and Lazarovici, 2006).

For the Gumelnița culture, at Borduşani and Hârşova houses with simple clay floors are the most common dwelling structure, while those with floors made of logs covered by a layer of plastered clay are rare. Stone was used to cover house floors only at a few sites, including the settlements at Cucuteni-Cetăţuia and Dâmbul Morii.[48] This type of floor construction is documented also for the Horodiştea-Erbiceni culture, probably reflecting a Cucuteni tradition.[49]

Some scholars have reconstructed two-story buildings based on their analysis of the collapsed remains of Cucuteni houses, while others disagree with such proposals. Possible examples of two-storied structures might be found at Poduri and Truşeşti.[50]

The Purifying Fire

One of the most puzzling traditions of Copper Age Old Europe apparently was the intentional burning of houses after a period of use as a dwelling. It is not clear why some houses were burned, but possibly homes of important people, perhaps of clan elders or lineage founders, were burned after their death. Fire in general is seen as a form of purification. The archaeological evidence for intentional house burnings, as opposed to accidental burnings or hostile acts of war, is one of the new areas of research in Old European archaeology.[51]

Archaeological research undertaken at the Gumelnița tell settlements of Borduşani and Hârşova (fig. 4-8), together with data gathered since 2000 at the Cucuteni site of Poduri and experiments carried out at Cucuteni in 2004,[52] provided a series of arguments that house fires could have been deliberate. Based on very fine stratigraphic excavation and analysis of the house remains, at the two tell settlements of the Gumelnița culture it was possible to observe that only some of the dwellings that were in the same contemporary occupation level had been set on fire (fig. 4-9). A similar situation exists at Uivar,[53] where only five percent of the dwellings were burned (fig. 4-10). An unusual case was dwelling SL 19 from Hârşova, where a deliberate fire was indicated by the placement of large quantities of combustible materials in the central part of the structure, which was marked by an area of intense burning (figs. 4-11, 4-12). The house was burned fully

equipped with a large quantity of ceramic vessels and objects made of wood, bone, antler, and copper, many placed along the walls. It is possible that the archaeological record is skewed toward the preservation *only* of burned houses, because it can be difficult to observe the vestiges of the houses not set on fire in the areas where chernozem soils are predominant.[54] But even in that case, the number of burned houses is very large.

The majority of these structures set on fire were fully equipped with the artifacts of daily life. My statistical analysis of a series of Gumelnița dwellings set on fire demonstrates that most of them contained a large number of ceramic vessels, often more than eighty. The house was sacrificed with its entire inventory of equipment. At Uivar some of the intentionally burned houses were emptied by inventory.[55] In careful and attentive archaeological excavations of burned Cucuteni houses, I have noticed that, after they were set on fire, pits were dug down through the debris to the hearth or the oven—places where fire had been used in normal daily life—causing its deliberate destruction. Probably only after that final act was the dwelling considered definitively sacrificed. In a few cases these combustion structures (the hearths or ovens) were found preserved entirely, and in these situations one might believe that the house burned accidentally (fig. 4-13).

Research on burned houses has been greatly aided by the experimental construction and intentional burning of Neolithic-type houses under controlled conditions, in an attempt to re-create the kind of burned remains found in archaeological sites. One such experiment took place at Cucuteni, the type site for the Cucuteni culture as noted above; another took place in Calabria, in Italy[56]; and another was made during excavations at the Vinča site of Opovo.[57] In each case the conclusions were the same: The kind of intense burning seen in many Neolithic archaeological sites could only be produced by filling the house with fuel and intentionally setting it on fire, actions that must have been performed "as purifying rituals."[58] Thus, the conclusion of the 1984 campaign at Opovo was that ". . . it is clear that at Opovo there were no houses that were not burned . . . and most likely were burned deliberately," and "such an act might have

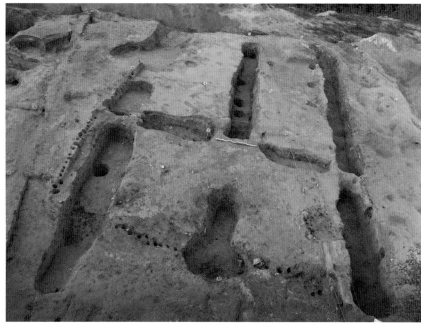

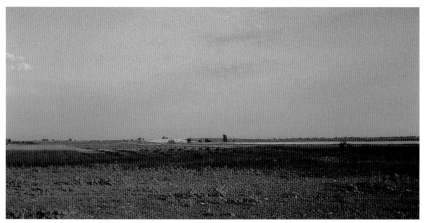

4-8 (top, left). Stratigraphic sequence showing dwellings set on fire and not set on fire, western cross-section of the Gumelniţa tell site at Hârşova.

4-9 (top, right). Foundation ditches of a dwelling not set on fire, Gumelniţa tell site at Borduşani-Popină.

4-10 (bottom). General view of the Neo-Eneolithic tell site of Uivar.

4-11 (opposite: top, left). General view of the floor of a dwelling intentionally set on fire, Gumelniţa tell site at Hârşova.

4-12 (opposite: top, right). Detail of a wall of a dwelling intentionally set on fire, Gumelniţa tell site at Hârşova.

4-13 (opposite: bottom). Household hearth or oven during excavation, Gumelniţa tell site at Hârşova.

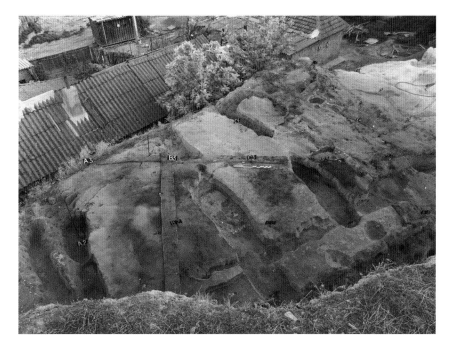

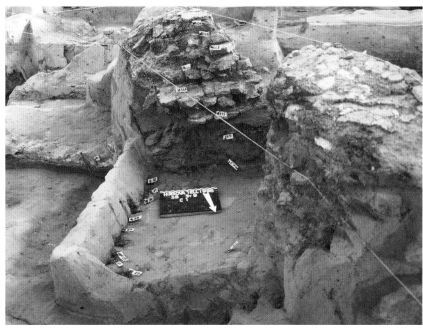

marked symbolically the end of a domestic cycle with the death of the household head."[59]

The early Halaf settlement at Sabi Abyad, in Syria, was probably intentionally burned, yet the hypothesis of a conflict might also be also plausible.[60] In Sweden, at the Skumparberget 2 site, which belongs to the Early Neolithic TRB culture, a minute study of one dwelling indicated a deliberate burning of the structure.[61]

The situations presented above were not identical, and it is possible that house burnings were conducted for a variety of reasons. But it is reasonable to assume that purification was one shared aspect of these acts. In some cases the building was emptied, while in others house equipment was kept inside and destroyed with the house. In spite of regional variability of the specific ritual, which indeed is characteristic of Old Europe, the intentional burning of houses is becoming more frequently identified as part of the recognized traditions of the Copper Age.

The Workshops

Quite a few specialized workshops have been found for the conduct of different crafts and activities. Whether or not the crafts workers were specialists, at least they had in many cases attained the benchmark of providing a special place for crafts to be performed. Such finds are not identified in every settlement, or even in most settlements, perhaps because these structures were often outside or at the margin of the settlement.

Interesting discoveries of pottery workshops are the ones from Zorlenţu Mare (Vinča B1) and Dumeşti (Cucuteni A).[62] The finds from Ghelăieşti (Cucuteni B),[63] Hlăpeşti,[64] and Vărvăreuca VIII and Vărvăreuca XV[65] also suggest the existence inside the settlements of workshops for modeling vessels and outside the settlements for pottery kilns. Kilns for ceramics have been found occasionally inside settlements as well, at Ariuşd, Frumuşica, Glăvăneştii Vechi, Hăbăşeşti, Truşeşti, and Valea Lupului.[66]

Flint-processing workshops inside dwellings were discovered widely in many Neolithic and Copper Age cultures of southeastern Europe, including in the Early Neolithic Starčevo-Criş sites[67]; in a Pre-Cucuteni site

at Târgu Frumos[68]; in many Cucuteni sites (at Copălău,[69] Drăguşeni,[70] Scânteia,[71] and Tîrpeşti[72] in Romania, and at Iabloana I, Putineşti II, and Putineşti III[73] in Moldova); in the Sălcuţa culture at Orlea[74]; and in Gumelniţa sites at Căscioarele.[75]

Workshops for processing deer antler were found in the Cucuteni area at Drăguşeni and Sărata Monteoru,[76] while workshops for polishing stone axes were investigated in a series of Cucuteni settlements (at Preuteşti-Haltă[77]) and Coţofeni settlements (at Şincai-Cetatea păgânului[78]).

Relatively few workshops for metal (copper and gold) processing have been found. One such structure was uncovered in a Bodrogkeresztúr B settlement in Transylvania at Cheile Turzii–Peştera Ungurească/Peştera Caprelor; another was found in a settlement of the Sălcuţa C culture at Cuptoare-Sfogea; and a third was found in a Coţofeni C settlement at Cuptoare-Piatra Ilişovei.[79]

Grinding stones for making flour are often found inside dwellings, but it seems that occasionally this activity was performed in a special structure, perhaps a communal granary. At the tell site of Poduri-Dealul Ghindaru (the Precucuteni III level), inside building no. 44, there were five grinding stones—three of which were fixed on a clay base painted white, surrounded by a clay box for evacuating the flour.[80] Near this installation four clay-lined silos having the shape of a cone's trunk were discovered, forty-five centimeters deep, and inside them were charred cereals. Silo 1 contained barley (*Hordeum vulgare* 68.3% and *Hordeum vulgare nudum* 30.6%); silo 2 contained wheat (*Triticum aestivum* 91.3%); silo 3 contained wheat (*Triticum monococcum* 63.8% and *Triticum dicoccum* 25.2%); and silo 4 contained barley (*Hordeum vulgare nudum* 92.2%).[81] Similar granaries were found in the Gumelniţa culture at Medgidia and in the Celei cultural group at Celei.[82]

Settlement Fortifications

When ditches are found surrounding settlements, or interrupting the approach to settlements located on steep-sided promontories, they are interpreted as defensive in purpose, and indicative of warfare. If they were dug deeply and were long and wide enough to have required the collective

labor of an entire village, one can presume that their role would have been defensive. Secondarily they might also have protected the community from predatory wild animals. The existence or absence of defensive constructions is a key factor in assessing and understanding the character of a settlement and comparing it to others.[83]

The first known fortifications are attested at the end of the early Neolithic, namely for the Starčevo-Criş IV-Vinča A (Gornea-Căuniţa de Sus) horizon, dated before 5000 BC. Other similar sites are those from Vădastra and Parţa-Tell I.[84] At Foeni, a Neolithic settlement in western Romania, excavation uncovered a defensive ditch with a V profile, 5.2 meters wide and 2.3 meters deep. This structure protected the settlement from three sides (east, north, and south), while toward the west the site was bordered by a steep edge of the creek nearby. At Parţa the Tiszapolgár habitation was protected by a defensive system consisting of a ditch and a palisade.[85] No other Tiszapolgár or Bodrogkeresztúr culture sites are known to have been fortified.

Some Pre-Cucuteni settlements were protected by defensive ditches. At Traian-Dealul Viei, the Pre-Cucuteni settlement was protected by a V-shaped ditch about 300 meters long, 4–5 meters wide, and 1.40–1.85 meters deep. This ditch required the removal of about 1,500 cubic meters of earth. At Târpeşti a defensive ditch was maintained for both occupational phases. The ditch built during the Pre-Cucuteni II phase was 98 meters long and had a V-shaped profile, enclosing an occupation area of about 630 square meters, while the Pre-Cucuteni III phase ditch was 129 meters long, about 3 meters wide and 1.50–1.90 meters deep, protecting an occupation area of about 1,200 square meters. The first ditch required the removal of 160 cubic meters, while the second, larger ditch required the excavation of about 440 cubic meters.[86]

Of about 1,200 known Cucuteni settlements, only 40 were documented as having defensive structures, but they were serious defenses.[87] Ditches with a funnel-shaped profile 2–4 meters deep were investigated at Cucuteni-Dâmbul Morii, Sfântu Gheorghe–Cetatea Cocorului, Traian-Dealul Fântânilor, and Truşeşti–Ţuguieta. A ditch and earthen bank was also uncovered at Cucuteni–Cetăţuia

(phase A), Malnaş Băi, and Scânteia.[88] The fortification ditch from Cucuteni had stone veneer,[89] as did the ditches at Malnaş and Ruginoasa. At Hăbăşeşti two V-shaped ditches were found, built at different times.[90] At Ariuşd in Transylvania, there were also a ditch, earthen bank, and palisade that were enlarged over time.[91] The inner, smaller ditch required the excavation of some 970 cubic meters, while the outer, larger ditch required 1,400 cubic meters.[92] It is estimated that about sixty men would have worked for forty days to excavate the ditch.

The Gumelniţa settlements of Geangoeşti,[93] Pietrele,[94] and Vidra[95] were fortified by defensive ditches. Other defensive structures consisting of ditch and earthen bank were discovered at Jilava,[96] Măgurele,[97] Teiu (tell no. 1),[98] Ziduri,[99] and Vidra.[100] The maximum width of the ditches was 6–7 meters, and the maximum depth of 3.4 meters. The palisades were made of rows of partially buried logs, with branches and boards placed between the logs. At Măgurele[101] and Teiu (tell no. 1),[102] the defensive systems were rebuilt and maintained throughout multiple occupations. There were archaeological suggestions of elaborate defensive systems, consisting of an inner "acropolis" and a "civil" settlement at the Cucuteni-culture settlements of Calu, Kazarovici III,[103] Poduri, and Vlădeni, at the Gumelniţa settlement of Pietrele. More precise archaeological data are needed to verify this interpretation.

Fortification works imply a certain level of community organization as well as a hierarchical political structure. The number of fortifications increased from the Neolithic to the Copper Age. It is possible that defensive structures were not built as a planned part of any settlement, but were constructed only for a period of hostilities.

The Funerary Space

In the area of the Tiszapolgár culture in western Romania, 4500–4000 BC, eight cemeteries are known.[104] The characteristic burial rite is inhumation (in a contracted or extended position), the body being oriented west–east, more rarely east–west, north–south, or south–north, the males to the right and the women to the left. The funerary inventory consisted of pottery, weapons, tools, and bracelets made of copper, gold, stone, shells, and bone.

The situation is not very different in the case of the Bodrogkeresztúr culture, 4000–3600 BC, which is genetically linked to the previous Tiszapolgár culture. Two cemeteries are known at Cămin-Podul Crasnei and Ostrovul Corbului–Botul Cliciului. The deceased were inhumed, sometimes with rich inventories of ceramics, ornaments of gold or shells, and food offerings.[105] The Bodrogkeresztúr culture is known for its exploitation of copper and gold, and in addition to rich graves has yielded a number of hoards of copper or golden objects, including the famous hoard of gold idols and ornaments found at Moigrad (figs. 1-17, 7-9, 7-10, page 162).

In the lower Danube valley, the custom of creating special cemeteries for burying the dead had a long history, extending before the Copper Age. Mesolithic hunter-gatherers created cemeteries near the Iron Gates, as at Schela Cladovei, thousands of years before the arrival of Neolithic farmers. The Hamangia culture, centered in the Dobrogea peninsula between the Danube River and the Black Sea, inherited some Mesolithic customs in flint working, and its cemetery burial customs could also have been in some sense influenced by those of the Mesolithic. There are Hamangia cemeteries in both Bulgaria (southern Dobrogea) and Romania (most of the Dobrogea). At Cernavodă in Romania, more than four hundred Hamangia inhumation graves were investigated.[106] The bodies were oriented southeast–northwest. There were clear differences in the richness of the funerary inventory, which included anthropomorphic figurines made of clay and marble, pottery, stone tools, stone ornaments, and bracelets and beads, some made of copper.

The Boian, a very important Late Neolithic culture of the lower Danube valley that influenced the origin of both the Gumelnița and Cucuteni, also practiced cemetery burial. The necropolis from Cernica,[107] with 378 inhumation graves, is the largest known from the north-Danubian area of the Boian culture. The prevailing orientation of the deceased is west–east. In the early phase the body was placed in an extended position, but the last phase of the cemetery from Cernica was characterized by an increase in burials in a contracted or slightly flexed position.[108] About two-thirds of the graves did not contain any funerary inventory. Grave gifts in the other graves consisted of pottery and shell ornaments, but shell ornaments appeared only in children's graves.[109] Four of the deceased were females who died while giving birth.[110] Other Boian cemeteries are known at Popești (16 graves)[111] and Sultana-Valea Orbului (more than two hundred graves).[112]

Human burials are also found inside Boian settlements or on their edges. Graves were discovered inside Boian settlements at Andolina (seven graves, with six adults and a child),[113] Gălățui (three graves),[114] Glina (eight graves),[115] and Vărăști (fourteen graves).[116] This custom was observed also in the Gumelnița-culture tell settlements, where graves are found between or even beneath the dwellings.

The Gumelnița culture also practiced cemetery burial. In Romania three Gumelnița cemeteries have been investigated and published completely: Radovanu (Gumelnița A$_1$, 17 graves),[117] Dridu (Gumelnița A$_2$ or B$_1$, 9 graves),[118] and Vărăști (Gumelnița A$_1$, A$_2$ and B$_1$, 123 graves).[119] Other Gumelnița cemeteries, only partially published, are known at Căscioarele-D'aia Parte (28 inhumation graves, Gumelnița A$_1$ phase),[120] Chirnogi-Șuvița Iorgulescu (62 skeletons),[121] Chirnogi-Terasa Rudarilor (16 graves),[122] and Gumelnița (8 graves).[123] At Vărăști the body was placed in a contracted position, usually on its left side. A very small number were deposited on the right side. The graves were generally arranged in rows. Some graves contained multiple burials.[124] The graves at Dridu contained no grave gifts. Artifacts were deposited in the grave only in 3 graves at Radovanu and 27 graves at Vărăști. Most of the gifts were pottery, flint and stone tools, copper pins (only at Vărăști), and shell ornaments. Grave 54 from Vărăști had a very rich inventory comprising beads and an earring made of gold, and a pendant and two beads made of amber, perhaps indicating the elevated social status of the woman buried in the grave. In 4 graves at Vărăști, there was a large or small quantity of red ochre.[125]

At the tell settlements of Bordușani and Hârșova, human skeletal parts were placed separately in secondary contexts associated with garbage areas (fig. 4-14). Ritual deposits of isolated human skeletal parts were common not only for the Gumelnița culture, but also for a series of other Copper Age cultures in Romania and beyond.[126]

A World without Graves

No cemeteries are known for the Petreşti culture of Transylvania, the Pre-Cucuteni culture, or the Cucuteni culture. In the eastern part of Cucuteni-Tripol'ye, some cemeteries are known but they are assigned to the final phase of this culture.[127] Evidently the dead normally were not buried in these cultures.

In a few settlements isolated inhumation graves have been found, especially of children and adolescents: Cucuteni-Cetăţuia, Scânteia, and Traian-Dealul Fântânilor.[128] At Traian chopped and incomplete skeletons with rich offerings were assigned to rituals of sacrifice.[129] Disparate human bones and skulls were uncovered in a series of settlements, in various habitation complexes, pits, and levels; most of the bones belonged to women, children, and adolescents.[130] The presence of skulls or skull fragments might suggest a skull cult related to veneration of the ancestors. Anthropological analysis documented that most of these remains belonged to females.[131] The discovery of cremated human bones in the debris of an intentionally burned dwelling from Scânteia suggests that cremation might have been employed by Cucuteni communities.[132]

A cemetery of more than a hundred cremation graves was discovered at Suceava-Parcul Cetăţii,[133] finally interpreted as belonging to the Gorodsk culture, a very late and greatly transformed phase of the Tripol'ye culture dated about 3000 BC. Cremated human remains were placed in pits together with pottery fragments, pieces of charcoal, and stone artifacts, all burned in a secondary postcremation ritual.

After the final phase of the Cucuteni culture, about 3300–3000 BC, small communities belonging to the Globular Amphorae culture, with a pastoral economy, infiltrated the Cucuteni region from the north, from Poland, especially between the Carpathians and Siret rivers.[134] The cemeteries belonging to this culture are small, often with multiple bodies placed in stone cist. In the funerary inventory were polished flint axes and chisels, and buckles and daggers made of bone. The grave from Mastacăn had a rich inventory that suggests the existence of social differences in Globular Amphorae communities.[135]

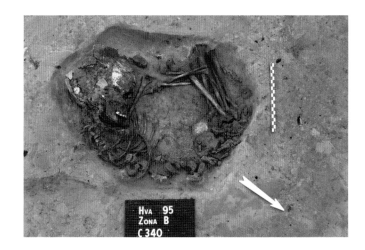

This brief review has traced the evolution of the concepts and behaviors of various Neolithic and Copper Age communities. One trend was a gradual shift from placing burials inside the settlements, between or beneath different structures—a habit that characterizes the early Neolithic—to placing burials in special cemeteries. The development of permanent, sedentary settlements and a more intensive agricultural and stockbreeding economy probably explain the evolution toward the definition of funerary spaces as a new and specialized category of social space during the Middle and Late Neolithic and then in the Copper Age. Yet the absence of cemeteries in the areas occupied by the Foeni cultural group and the Petreşti, Pre-Cucuteni, and Cucuteni cultures is a puzzling exception to this tendency.

The first period discussed here, the Neolithic, is characterized by genesis, diffusion, and contact between a series of cultures. At the initial stage human communities passed through a series of major phases, marked by sedentarization, cattle breeding, and land cultivation. During this period in southeastern Europe, one can observe the intensification of the rhythm of evolution within these societies, the main features being, on the one hand, the diversification of local cultural entities separated by vast distances and, on the other, intense contacts and

4-14. Grave of a child discovered under the floor of a dwelling, Gumelniţa tell site at Hârşova.

exchanges, generating a sort of cultural standardization. It is important to note that the direction of such relations is not only from the south to the north, but also that these interactions included influences and exchanges that spread from north to south, west to east, and east to west. The existence of such exchange systems contributed not only to the circulation of certain objects and raw materials but, in the case of those that were intercultural, to maintaining cultural "unity" by disseminating certain ideas and concepts.

The next period, the Copper Age, was characterized especially by local evolutionary strands, although southern influences continued to exist, as did exchange systems that linked north to south. The splendid civilizations of the Copper Age emerged gradually, still preserving certain fundamental features of the Neolithic. The shared Neolithic heritage is shown in settlements and their locations, the structuring of inhabited space, and the management of resources. But some activities and crafts also showed absolutely new development, like the "mills" from Medgidia and Poduri, the specialization of certain communities in cattle breeding or hunting (as seen in the discoveries from Vitănești), and the emergence of craft specialization in workshops for processing stone and flint (as in the discoveries from Drăgușeni, where we have evidence for a family that specialized in such activities over multiple generations).

The spiritual world was also structured, preserving a series of defining elements deriving from Neolithic practices and beliefs, evolving in the Copper Age into more varied customs. The spiral was the central decorative element through the entire Neolithic, yet differences in the frequency of its use and the variety of its representations defined the main ceramic styles. The divine couple dominated the world of deities venerated by these communities, but various representations marked an individual approach for each culture. Major examples in this sense are the "small basket" vessel from Vădastra, the monumental statue from Parța (Vinča culture), the cult building from Târgu Frumos (Pre-Cucuteni culture), and the "temple" façade from Trușești (Cucuteni culture).

Translated by Corina Borş

Notes

1 Hodder, I., *The Domestication of Europe: Structure and Contingency in Neolithic Societies* (Oxford: Blackwell, 1990): 18.

2 Bromberger, C., "Locuinţa," in *Dicţionar de etnologie şi antropologie*, ed. P. Bonte and M. Izard (Iaşi: Polirom, 1999).

3 Dumitrescu, Vl., et al., *Hăbăşeşti. Monografie arheologică* (Bucureşti: Academiei RPR, 1954); Marinescu-Bîlcu S., *Tîrpeşti: From Prehistory to History in Eastern Romania*, British Archaeological Reports, International Series, suppl. 107 (1981); Petrescu-Dîmboviţa, M., M. Florescu, and A.C. Florescu, *Truşeşti. Monografie arheologică* (Bucureşti and Iaşi: Editura Academiei Române, 1999).

4 Marinescu-Bîlcu, S., *Cultura Precucuteni pe teritoriul României* (Bucureşti: Academiei RPR, 1974); Monah, D., "Aşezări," in *Aşezările culturii Cucuteni din România*, ed. D. Monah and Şt. Cucoş (Iaşi: Junimea, 1985): 41–51; Draşovean, Fl., *Cultura Vinča târzie (faza C) în Banat* (Timişoara: Mirton, 1996); Maxim, Z., *Neo-eneoliticul din Transilvania. Date arheologice şi matematico-statistice*, Bibliotheca Musei Napocensis 19 (Cluj Napoca, 1999); Luca, S.A., *Sfârşitul eneoliticului pe teritoriul intracarpatic al României—Cultura Bodrogkeresztúr*, Bibliotheca Musei Apulensis 11 (Alba Iulia, 1999); Popovici, D., *Cultura Cucuteni Faza A. Repertoriul aşezărilor (1)*, Bibliotheca Memoriae Antiquitatis 7 (Piatra Neamţ, 2000); Lazarovici, C.-M., and Gh. Lazarovici, *Neoliticul*, vol. 1, *Arhitectura neoliticului şi Epocii Cuprului din România*, ed. V. Spinei and V. Mihailescu-Bîrliba (Iaşi: Trinitas, 2006).

5 Cârciumaru, M., D. Popovici, M. Cosac, and R. Dincă, "Spectrographic Analysis of Neo-Eneolithic Obsidian Samples and Several Considerations about the Obsidian Supply Sources," *Annalles d'Université Valachia, Târgovişte, Section d'Archéologie et d'Histoire* 2–3 (2000): 116–26; Popovici, D., "Exchanges during the Eneolithic Period: Case Study of the Cucuteni Culture," *Annalles d'Université Valachia, Târgovişte, Section d'Archéologie et d'Histoire* 2–3 (2000): 87–99; Mareş, I., *Metalurgia aramei în neo-eneoliticul României* (Suceava: Bucovina Istorică, 2002); Weller, O., and Gh. Dumitroaia, "The Earliest Salt Production in the World: An Early Neolithic Exploitation in Poiana Slatinei-Lunca, Romania," *Antiquity* 79, no. 306 (2005): http://antiquity.ac.uk/projgall/weller; Weller, O., et al., "Première exploitation de sel en Europe. Techniques et gestion de l'exploitation de la source salée de Poiana Slatinei à Lunca (Neamt, Roumanie)," in *Sel, eau et forêt. Hier et aujourd'hui*, ed. Weller, A. Dufraisse, and P. Pétrequin, Actes du Colloque International, Saline Royale d'Arc-et-Senans, 3–5 October 2006, Cahiers de la MSH Ledoux 12 (coll. Homme et environnement 1) (Besançon: Presses Universitaires de Franche-Comté, 2008): 205–30.

6 Lazarovici, Gh., "Principalele probleme ale culturii Tiszapolgár în România," *Acta Musei Napocensis* 20 (1983): 3–20; Maxim, *Neo-eneoliticul din Transilvania* (1999); Iercoşan, N., *Cultura Tiszapolgár în vestul României* (Cluj Napoca: Nereamia Napocae, 2002).

7 Luca, *Sfârşitul eneoliticului pe teritoriul intracarpatic al României* (1999): 13–14, 49–59.

8 Ibid.: 48; Iercoşan, *Cultura Tiszapolgár* (2002): 184–86.

9 Pandrea, S., "Câteva observaţii referitoare la periodizarea culturii Boian," *Istros* 10 (2000): 36–57.

10 Comşa, E., "Aşezarea neolitică de la Izvoarele (jud. Giurgiu)," *Buletinul Muzeului "Teohari Antonescu"* 5–6 (1999–2000): 103–4; Neagu, M., "Comunităţile Bolintineanu în Câmpia Dunării," *Istros* 8 (1997): 22; Neagu, M., *Neoliticul mijlociu la Dunărea de Jos* (Călăraşi: Muzeul Dunării de Jos Călăraşi, 2003): 91.

11 Comşa, E., Istoria comunităţilor culturii Boian (Bucureşti: Editura Academiei, 1974).

12 Ibid.: 72.

13 Ibid.: 156.

14 Lazarovici and Lazarovici, *Neoliticul* (2006): 518.

15 Morintz, S., "Tipuri de aşezări şi sisteme de fortificaţie şi de împrejmuire în cultura Gumelniţa," *Studii şi Cercetări de Istorie Veche* 13, no. 2 (1962): 273–84; Marinescu, Fl., "Aşezări fortificate neolitice în România," *Studii şi Comunicări* (Muzeul Brukenthal Sibiu) 14 (1969): 14–17; Comşa, E., *Neoliticul pe teritoriul României* (Bucureşti: Consideraţii, 1987): 133–35; Haşotti, P., *Epoca neolitică în Dobrogea*, Tomitana 1 (Constanţa, 1997): 76–85.

16 Bem, C., et al., "Cercetări arheologice pe valea Neajlovului. Consideraţii generale asupra microzonei Bucşani," *Studii de Preistorie* 1 (2002): 131–45.

17 Popovici, D., B. Randoin, and Y. Rialland, "Le tell néolithique et chalcolithique d'Hârsova (Roumanie)," in *Communautés villageoises du Proche-Orient à l'Atlantique (8000–2000 avant notre ère)*, ed. Jean Guilaine, Séminaire du Collège de France (Paris: Errance, 2001): 119–52; Hansen, S., et al., "Der kupferzeitliche Siedlungshügel Pietrele an der Unteren Donau. Bercht uber die Ausgrabungen in Sommer 2004," *Eurasia Antiqua* 11 (2005): 341–93; Hansen, S., et al., "Pietrele—Eine kupferzeitliche Siedlung an der Unteren Donau. Bericht über die Ausgrabungen in Sommer 2005," *Eurasia Antiqua* 12 (2006): 1–62.

18 Dumitrescu, Vl., "A Late Neolithic Settlement on the Lower Danube," *Archaeology* (New York) 18, no. 1 (1965): 34–40; Dumitrescu, Vl., "Principalele rezultate ale primelor două campanii de săpătură din aşezarea neolitică târzie de la Căscioarele," *Studii şi Cercetări de Istorie Veche* 16, no. 2 (1965): 215–38; Bem et al., "Cercetări arheologice pe valea Neajlovului" (2002).

19 Bălăşescu, A., V. Radu, and D. Moise, *Omul şi mediul animal intre mileniile VII–IV i.e.n. la Dunarea de Jos* (Targoviste: Cetatea de Scaun, 2005): 211–25.

20 Ibid.: 220–21.

21 Bodean, S., *Aşezările culturii Precucuteni-Tripolie A din Republica Moldova* (Kishinev: Pontos, 2001): 3; Zbenovič, V.G., *Siedlungen der frühen Tripol'e-Kultur zwischen Dnestr und Südlichem Bug*, Archäologie in Eurasien 1 (Espelkamp: Marie Leidorf, 1996); Lazarovici and Lazarovici, *Neoliticul* (2006): 546.

22 Marinescu-Bîlcu, *Tîrpeşti* (1981): 24.

23 Monah and Cucoş, *Aşezările culturii Cucuteni* (1985): 178–85.

24 Necrasov, O., and M. Ştirbu, "The Chalcolithic Paleofauna from the Settlement of Tîrpeşti (Precucuteni and Cucuteni A1-A2 Cultures)," in Marinescu-Bîlcu, *Tîrpeşti* (1981): 174–87; Mantu, C.-M., et al., "Un mormânt dublu de înhumaţie din aşezarea cucuteniană de la Scânteia (jud. Iaşi)," *Acta Musei Napocensis* 31, no. 1 (1995): 87–103; information kindly provided by A. Bălăşescu.

25 Bolomey, Al., and G. El Susi, "Animals Remains," in *Drăguşeni. A Cucutenian Community*, ed. S. Marinescu-Bîlcu and Bolomey (Bucureşti: Tubingen, 2000): 159–78; Haimovici, S., "Quelques problèmes d'archéozoologie concernant la culture de Cucuteni," in *La civilisation de Cucuteni en contexte européen*, ed. D. Monah, Bibliotheca Archaeologica Iassiensis 1 (Iaşi, 1987): 157–66; information kindly provided by D. Moise.

26 Cârciumaru, M., Paleobotanica. Studii în preistoria și protoistoria României (Iași, 1996); Monah, F., and D. Monah, Cercetări arheobotanice în tell-ul calcolitic Poduri–Dealul Ghindaru (Piatra Neamț, 2008).

27 Monah and Cucoș, Așezările culturii Cucuteni (1985): 49.

28 Iercoșan, Cultura Tiszapolgár (2002): 17–18; Luca, Sfârșitul eneoliticului pe teritoriul intracarpatic al României (1999): 11; Mareș, Metalurgia aramei în neo-eneoliticul României (2002): 345–46.

29 Ursulescu, N., "Exploatarea sării din saramură în neoliticul timpuriu, în lumina descoperirilor de la Solca (jud. Suceava)," Studii și Cercetări de Istorie Veche și Arheologie 28, no. 3 (1977): 307–18; Ursulescu, N., "L'utilisation des sources salées dans le Néolithique de la Moldavie (Roumanie)," Nature et Culture 1, ed. M. Otte, Colloque de Liège, 13–17 December 1993, ERAUL (Liège) 68 (1995): 487–95; Monah, D., "L'exploitation du sel dans les Carpates orientales et ses rapports avec la Culture de Cucuteni-Tripol'ye," in Le Paléolithique et le Néolithique de la Roumanie en contexte européen, ed. V. Chirica and Monah, Bibliotheca Archaeologica Iassiensis 4 (Iași, 1991): 387–400; Dumitroaia, Gh., "La station archéologique de Lunca—Poiana Slatinii," in La civilisation de Cucuteni en contexte européen, ed. Monah (1987): 253–58; Dumitroaia, Gh., "Depunerile neo-eneolitice de la Lunca și Oglinzi, județul Neamț," Memoria Antiquitatis 19 (1994): 7–82; Weller and Dumitroaia, "The Earliest Salt Production in the World" (2005); Weller et al., "Première exploitation de sel en Europe" (2008).

30 Lazarovici and Lazarovici, Neoliticul (2006): 300–57; Dumitrescu, "Principalele rezultate ale primelor două campanii de săpătură" (1965): 215–38; Ursulescu, N., D. Boghian, and V. Cotiugă, "L'autel peint de l'habitat de Târgu Frumos (dép. de Iași) appartenant à la civilisation Précucuteni (Énéolithique Ancien)," Studia Antiqua et Archaeologica 9 (2003): 27–40; Petrescu-Dîmbovița, Florescu, and Florescu, Trușești (1999): 528–30, fig. 372/6.

31 Chapman, J., "The Early Balkan Village," in "Neolithic of Southeastern Europe and Its Near Eastern Connections," Varia Archaeologica Hungarica 2 (1989): 33–53; Chapman, J., "Social Inequality on Bulgarian Tells and the Varna Problem," in The Social Archaeology of Houses, ed. R. Samson (Edinburgh: Edinburgh University Press, 1990): 49–98; Bailey, D.W., Balkan Prehistory: Exclusion, Incorporation and Identity (London: Routledge, 2000).

32 Popovici, D., "Area Organization, Arrangement and Use in the Cucuteni, Phase A Culture (I)," Cercetări Arheologice 12 (2003): 307, 317.

33 Chapman, "The Early Balkan Village" (1989): 34ff.

34 Marinescu-Bîlcu, S., "Dwellings, Pits," in Drăgușeni: A Cucutenian Community, ed. Marinescu-Bîlcu and Al. Bolomey (București: Tubingen, 2000): 25–48.

35 Lazarovici and Lazarovici, Neoliticul (2006).

36 Marinescu-Bîlcu, "Dwellings, Pits" (2000).

37 Bolomey and El Susi, "Animals Remains" (2000): 160.

38 Marinescu-Bîlcu, "Dwellings, Pits" (2000): 37–38, 46, fig. 5.

39 Neagu, "Comunitățile Bolintineanu în Câmpia Dunării" (1997): 13, pl. IV; Comșa, E., "Complexul neolitic de la Radovanu," Cultură și Civilizație la Dunărea de Jos 8 (1990): 81, fig. 4.

40 Nica, M., and Niță A., "Les établissements néolithiques de Leu et Padea de la zone d'interférence des cultures Dudești et Vinča. Un nouvel aspect du Néolithique moyen d'Oltenie," Dacia, n.s., 23 (1979): 35–41; Nica, M., "Câteva date despre așezarea neo-eneolitică de la Gârlești (com. Mischi, jud. Dolj)," Arhivele Olteniei, n.s., 9 (1994): 4.

41 Lazarovici, Gh., Fl. Drașovean, and Z. Maxim, Parța. Monografie arheologică, Bibliotheca Historica et Archaeologica Banatica 12 (Timișoara: Mirton, 2001): 182–90, figs. 41–48.

42 Ibid.: 182–90; Iercoșan, Cultura Tiszapolgár (2002): 121.

43 Marinescu-Bîlcu, Cultura Precucuteni pe teritoriul României (1974).

44 Ibid.: 25–34; Ursulescu, N., D. Boghian, and V. Cotiugă, "Locuințe de suprafață cu platformă din așezarea precucuzeniană de la Târgu Frumos–Baza Pătule," Codrul Cosminului, n.s., 12 (2006): 22.

45 Monah and Cucoș, Așezările culturii Cucuteni (1985): 49; Petrescu-Dîmbovița, Florescu, and Florescu, Trușești (1999): 186; Sorochin, V., Aspectul cucutenian Drăgușeni-Jura (Piatra Neamț, 2002): 62; Dinu, M., "Principalele rezultate ale cercetărilor arheologice de la Băiceni-Dâmbul Morii, com. Cucuteni (1961–1966)," in Cucuteni 120–Valori universale. Lucrările simpozionului național, Iași 30 septembrie 2004, ed. N. Ursulescu and C.– M. Lazarovici (Iași, 2006): 34.

46 Dumitrescu, Vl., Hăbășești. Satul neolitic de pe Holm (București: Meridiane, 1967): 17; Petrescu-Dîmbovița, Florescu, and Florescu, Trușești (1999): 189.

47 Popovici, "Area Organization, Arrangement and Use in the Cucuteni Phase A Culture (I)" (2003).

48 Petrescu-Dîmbovița, Florescu, and Florescu, Trușești (1999): 195; Petrescu-Dîmbovița, M., and M. Văleanu, Cucuteni-Cetățuie. Săpăturile din anii 1961–1966; Monografie arheologică, Biblioteca Memoria Antiquitatis 14 (Piatra Neamț, 2004): 102–15.

49 Dinu, M., "Quelques remarques sur la continuité de la céramique peinte du type Cucuteni durant la civilisation Horodiștea-Erbiceni et Gorodsk," in La civilisation de Cucuteni, ed. Monah (1987): 138; Levițki, O., R. Alaiba, and V. Bubulici, "Raport asupra investigațiilor arheologice efectuate în anii 1997–1998 la Trinca-Izvorul lui Luca, r. Edineț, R. Moldova," Cercetări Arheologice în Aria Nord-Dacă (București) 3 (1999): 21.

50 Petrescu-Dîmbovița, Florescu, and Florescu, Trușești (1999): 188; Monah, D., "Poduri-Dealul Ghindaru (com. Poduri, jud. Bacău)," in Cucuteni, un univers mereu inedit (Iași: Documentis, 2006): 13.

51 Passek, T.S, Periodizatsiya Tripol'skikh poselenii (III–II tysyachetiletie do n.e.), Materialy i issledovanija po arkheologii SSSR 10 (Moscow: Izdatel'stvo Akademii Nauk SSSR, 1949); László, A., "Așezări întărite ale culturii Ariușd-Cucuteni în sud-estul Transilvaniei. Fortificarea așezării de la Malnaș-Băi," Arheologia Moldovei 16 (1993): 33–50; László, A., "Some Data on House-Building Techniques and Foundation Rites in the Ariușd-Cucuteni Culture," Studi Antiqua et Archaeologica (Iași) 7: 245–52; Petrescu-Dîmbovița, Florescu, and Florescu, Trușești (1999); Marinescu-Bîlcu and Bolomey, eds., Drăgușeni (2000); Bailey, Balkan Prehistory (2000): 164–65.

52 Cotiugă, V., and O. Cotoi, "Parcul arheologic experimental de la Cucuteni," in Cucuteni-Cetățuie, ed. Petrescu-Dîmbovița and Văleanu (2004): 337–50.

53 Schier, W., "Neolithic House Building and Ritual in the Late Vinca Tell Site of Uivar, Romania," in Homage to Milutin Garašanin, ed. N. Tasić and C. Grozdanov (Belgrade: Serbische Akademie der Wissenschaften und Künste, 2006): 325–39.

54 In this respect see the observation made at Trușești by Petrescu-Dîmbovița, Florescu, and Florescu, *Trușești* (1999): 186–97.

55 Schier, "Neolithic House Building and Ritual" (2006).

56 Schaeffer, G.D., "An Archaeomagnetic Study of a Wattle and Daub Building Collapse," *Journal of Field Archaeology* 20, no. 1 (Spring 1993): 59–75.

57 Tringham, R., B. Brukner, and B. Voytek, "The Opovo Project: A Study of Socioeconomic Change in the Balkan Neolithic," *Journal of Field Archaeology* 12 (1985): 425–35; Tringham, R., et al., "Excavations at Opovo, 1985–1987: Socioeconomic Change in the Balkan Neolithic," *Journal of Field Archaeology* 19 (1992): 351–86.

58 Schaeffer, "An Archaeomagnetic Study of a Wattle and Daub Building Collapse" (1993).

59 Tringham et al., "Excavations at Opovo" (1992): 382.

60 Akkermans, P.M.M.G., and M. Verhoeven, "An Image of Complexity: The Burnt Village at Late Neolithic Sabi Abyad, Siria," *American Journal of Archaeology* 99 (1995): 5–32.

61 Apel, J., C. Hadevik, and L. Sundstrom, "Burning Down the House: The Transformation Use of Fire, and Other Aspects of an Early Neolithic TRB Site in Eastern Central Sweden," *Tor* (Uppsala) 29 (1997): 5–47.

62 Lazarovici and Lazarovici, *Neoliticul* (2006): 185; Maxim-Alaiba, R., "Locuința nr.1 din faza Cucuteni A₃ de la Dumești (Vaslui)," *Acta Moldaviae Meridionalis* 5–6 (1983–84): 99; Alaiba, R., "Olăritul în cultura Cucuteni," *Arheologia Moldovei* 28 (2005): 59.

63 Cucoș, Șt., *Faza Cucuteni B în zona subcarpatică a Moldovei*, Bibliotheca Memoria Antiquitatis 6 (Piatra Neamț, 1999): 42–43, fig. 27/1.

64 Ibid.: 43.

65 Marchevici, V.I., *Pozdnie Tripol'skie plemena severnoi Moldavii* (Chișinău, 1981): 128, fig. 95; Ellis, L., *The Cucuteni-Tripol'ye Culture: A Study in Technology and the Origins of Complex Society*, British Archaeological Reports, International Series 217 (Oxford: Archaeopress, 1984).

66 Zaharia, E., D. Galbenu, and Z. Székély, "Săpăturile arheologice de la Ariușd, jud. Covasna," *Cercetări Arheologice* 5 (1981): 3–4; Dumitrescu et al., *Hăbășești* (1954): 58, 192, pl. XIX, fig. 9; Comșa, E., "Caracteristicile și însemnătatea cuptoarelor de ars oale din aria culturii Cucuteni-Ariușd," *Studii și Cercetări de Istorie Veche și Arheologie* 27, no. 1 (1976): 23–26; Ellis, *The Cucuteni-Tripol'ye Culture* (1984): 147; Petrescu-Dîmbovița, Florescu, and Florescu, *Trușești* (1999): 196.

67 Mantu, C.-M., and A. Scorțanu, "Date în legătură cu așezarea Starčevo-Criș de la Poienești, jud. Vaslui," *Studii și Cercetări de Istorie Veche și Arheologie* 43, no. 2 (1992): 149–60.

68 Ursulescu, N., et al., "Târgu Frumos, Baza Pătule," in *Cronica cercetărilor arheologice din România. Campania 2000*, ed. M.V. Angelescu, C. Bors, and I. Oberländer-Târnoveanu (București: CIMEC- Institutul de Memorie Culturală, 2001): 253; Boghian, D., et al., "Târgu Frumos, Baza Pătule," in *Cronica cercetărilor arheologice din România, Campania 2000*, ed. M.V. Angelescu, C. Bem, T. Vasilescu, and B. Tănăsescu (București: CIMeC–Institutul de Memorie Culturală, 2002): 323.

69 Diaconescu, M., "Așezarea cucuteniană de la Razima-Copalău din județul Botoșani," *Hierasus* (Botoșani) 9 (1994): 127.

70 Marinescu-Bîlcu, S., et al., "Cercetări arheologice la Borduşani-Popină (jud. Ialomița). Raport preliminar 1993–1994," *Cercetări Arheologice* 10 (1997): 35–39; Marinescu-Bîlcu and Bolomey, *Drăgușeni* (2000).

71 Mantu, C.-M., M. Știrbu, and N. Buzgar, "Considerații privind obiectele din piatră, os și corn de cerb din așezarea cucuteniană de la Scânteia (1985–1990)," *Arheologia Moldovei* 18 (1995): 115–32.

72 Marinescu-Bîlcu, S., "Un 'atelier' néolithique pour la taille de haches en silex," *Arheologia Moldovei* 17 (1965): 1.

73 Sorochin, V., "Culturile eneolitice din Moldova," *Thraco-Dacica* 15, nos. 1–2 (1994): 67–92; Sorochin, V., "Locuințele așezărilor aspectului regional Drăgușeni-Jura," in *Cucuteni aujourd'hui*, ed. Gh. Dumitroaia and D. Monah (Piatra-Neamț, 1996): 201–31.

74 Nicolăescu-Plopşor, C., "Un atelier neolitic pentru confecționarea vârfurilor de săgeată. Gringul lui Iancu Muşat-Orlea," *Studii și Cercetări de Istorie Veche* 11, no. 2 (1960): 370.

75 Marinescu-Bîlcu, S., "A Few Observations on the Internal Organization of Gumelnița Communities on Lake Cătălui Islet," in "In memoriam Vladimir Dumitrescu," *Cultură și Civilizație la Dunărea de Jos* 19 (2002): 149–50.

76 Dragomir, I.T., "Principalele rezultate ale săpăturilor arheologice de la Berești 'Dealul Bulgarului' (1981), județul Galați," *Memoria Antiquitatis* 9–11 (1985): 95; Marinescu-Bîlcu and Bolomey, *Drăgușeni* (2000), 183, fig. 35; Nestor, I., and E. Zaharia, "Șantierul arheologic Sărata Monteoru," *Studii și Cercetări de Istorie Veche* 6, nos. 3–4 (1955): 499.

77 Ursulescu, N., and S. Ignătescu, *Preuteşti-Haltă. O aşezare cucuteniană de pe valea Şomuzului Mare* (Iași, 2003).

78 Lazăr, V., "Aşezarea Coțofeni de la Şincai (jud. Mureș)," *Marisia* 7 (1977): 35.

79 Lazarovici, Gh., et al., "Balta Sărată. Campaniile 1992–2003 (I. Arhitectura)," *Tibiscum* 11 (2003) 143–98; Radu, A., *Cultura Sălcuța în Banat* (Reșița, 2002): 37.

80 Monah, D., et al., *Poduri-Dealul Ghindaru. O Troie în Subcarpații Moldovei*, Bibliotheca Memoriae Antiquitatis 8 (Piatra Neamț, 2003): 35, 47–48.

81 Cârciumaru, *Paleobotanica* (1996): 103–4.

81 Harțuche, N., and O. Bounegru, "Săpăturile arheologice de salvare de la Medgidia, jud. Constanța, 1957–1958," *Pontica* (Constanța) 30 (1997): 17–104; Nica, M., "Locuirea preistorică de la Sucidava-Celei din perioada de trecere de la neolitic la epoca bronzului," *Oltenia* 4 (1982): 16.

83 Florescu, A.C., and M. Florescu, "Şanțul de apărare," in *Trușești*, ed. Petrescu-Dîmbovița, Florescu, and Florescu (1999): 222–30.

84 Drașovean, Fl., *Cultura Vinca târzie (faza C) în Banat* (Timișoara: Mirton, 1996): 40; Lazarovici and Lazarovici, *Neoliticul* (2006): 113–14.

85 Lazarovici, Gh., and C.-M. Lazarovici, "The Neo-Eneolithic Architecture in Banat, Transylvania and Moldova," in *Recent Research in Prehistory of the Balkans*, ed. D.V. Grammenos, Publications of the Archaeological Institute of Northern Greece 3 (Thessaloniki, 2003): 425.

86 Marinescu-Bîlcu, *Cultura Precucuteni pe teritoriul României* (1974): 21–22; Marinescu-Bîlcu, *Tîrpești* (1981): 24–25.

87 Monah, D., "Istoricul cercetărilor," in Aşezările culturii Cucuteni din România, ed. Monah and Cucoş (1985): 15–24.

88 Lazarovici, Gh., "Über das neo-bis äneolithischer Befestigungen aus Rumänien," *JahrMittDeutsch Vorgeschichte* 73 (1990): 93–117.

89 Florescu, A.C., "Observaţii asupra sistemului de fortificare al aşezărilor cucuteniene din Moldova," *Arheologia Moldovei* 4 (1966): 23–38.

90 Petrescu-Dîmboviţa, M., "Şanţurile de apărare," in *Hăbăşeşti*, ed. Dumitrescu et al. (1954): 203–33.

91 László, F., "Ásatások az erösdi östelepen (1907–1912). Fouilles a station primitive de Erösd (1907–1912)," *DolgCluj* 5 (1914): 279–386; László, "Aşezări întărite ale culturii Ariuşd-Cucuteni" (1993).

92 Petrescu-Dîmboviţa, M., "Şanţurile de apărare," in *Hăbăşeşti*, by Dumitrescu et al. (1954): 203–23.

93 Mihăiescu, G., and A. Ilie, "Tellul gumelniţean de la Geangoeşti (com. Dragomireşti, jud. Dâmboviţa)," *Ialomiţa* 4 (2003–4): 73.

94 Hansen et al., "Der kupferzeitliche Siedlungshugel Pietrele (2005); Hansen et al., "Pietrele" (2006): Abb. 2, 5–9.

95 Rosetti, D.V., and S. Morintz, "Săpăturile de la Vidra," *Materiale* 7 (1960): 75–76.

96 Comşa, E., "Quelques considerations sur la culture Gumelniţa (l'agglomeration de Măgura Jilavei)," *Dacia*, n.s., 10 (1976): 105–27.

97 Roman, P., "O aşezare neolitică la Măgurele," *Studii şi Cercetări de Istorie Veche* 13, no. 2 (1962): 259–71; Marinescu, "Aşezări fortificate neolitice" (1969): 7–32.

98 Nania, I., "Locuitorii gumelniţeni în lumina cercetărilor de la Teiu," *Studii si Articole de Istorie* 9 (1967): 7–23.

99 Mândescu, D., "Tellul gumelniţean de la Ziduri (com. Mozăceni, jud. Argeş)," *Argessis* 10 (2001): 7–20.

100 Rosetti and Morintz, "Săpăturile de la Vidra" (1960).

101 Roman, "O aşezare neolitică la Măgurele" (1962).

102 Nania, "Locuitorii gumelniţeni în lumina cercetărilor de la Teiu" (1967).

103 Marinescu-Bîlcu, *Cultura Precucuteni* (1974); Marinescu-Bîlcu, S., et al., "Cercetări arheologice la Borduşani-Popină (jud. Ialomiţa). Raport preliminar 1993–1994," *Cercetări Arheologice* 10 (1997): 35–39; Cucoş, *Faza Cucuteni B* (1999); Monah, D., "Aşezări," in *Aşezările culturii Cucuteni*, ed. Monah and Cucoş (1985): 41–51.

104 Maxim, *Neo-eneoliticul* (1999): 124; Iercoşan, *Cultura Tiszapolgár* (2002): 158–61.

105 Luca, *Sfârşitul eneoliticului pe teritoriul intracarpatic al României* (1999): 15–16, 36–39.

106 Berciu, D., *Cultura Hamangia. Noi contribuţii* (Bucureşti: Institutul de Arheologiă al Academiei RPR, 1966); Necrasov, O., "Cercetări paleoantropologice privitoare la populaţiile de pe teritoriul României," *Arheologia Moldovei* 13 (1990): 182–85; Haşotti, *Epoca neolitică în Dobrogea* (1997): 28–29.

107 Comşa, E., and Gh. Cantacuzino, Necropola neolitică de la Cernica (Bucureşti: Academiei Române, 2001); Cantacuzino, Gh., "Un ritual funéraire exceptionnel de l'époque néolithique en Europe et en Afrique Septentrionale," Dacia, n.s., 19 (1975): 27–43; Cantacuzino, Gh., "Morminte cu scheletele aşezate pe torace din necropola neolitică de la Cernica şi semnificaţia acestui ritual preistoric," Muzeul Naţional 2 (1975): 224–35; Cantacuzino, Gh., and C. Fedorovici, "Morminte de femei decedate în timpul naşterii din necropola neolitică de la Cernica," Bucureşti 8 (1971): 37–53; Kogălniceanu, R., "Utilizarea testului X2 în arheologie. Studiu de caz-necropola neolitică de la Cernica," Arheologia Moldovei 28 (2005): 288–95.

108 Kogălniceanu, "Utilizarea testului X^2 în arheologie" (2005): 265–302.

109 Ibid.: 276–78.

110 Cantacuzino and Fedorovici, "Morminte de femei decedate" (1971): 37–53.

111 Şerbănescu, D., "Necropola neolitică de la Popeşti, comuna Vasilaţi, jud. Călăraşi," in *Civilizaţia Boian pe teritoriul României*, ed. M. Neagu (Călăraşi: Ministry of Culture, 1999): 14; Neagu, *Neoliticul mijlociu la Dunărea de Jos* (2003): 17.

112 Şerbănescu, D., "Observaţii preliminare asupra necropolei neolitice de la Sultana, judeţul Călăraşi," *Cultură şi Civilizaţie la Dunărea de Jos* 19 (2002): 69–86; Şerbănescu, D., Al. Comşa, and L. Mecu, "Sultana, com. Mănăstirea, jud. Călăraşi. Punct: Valea Orbului," in *Cronica cercetărilor arheologice din România. Campania 2006* (Călăraşi: CIMEC, 2007): 351–52, 473.

113 Comşa, E., "Ritul şi ritualurile funerare din epoca neolitică din Muntenia," *Istorie şi tradiţie în spaţiul românesc* 4 (1998): 21.

114 Neagu, *Neoliticul mijlociu la Dunărea de Jos* (2003): 118–19.

115 Ibid.: 20–21.

116 Comşa, *Istoria comunităţilor culturii Boian* (1974): 206–11; Comşa, "Ritul şi ritualurile funerare" (1998): 21–22.

117 Comşa, E., "Mormintele neolitice de la Radovanu," *Studii şi Cercetări de Istorie Veche şi Arheologie* 49, nos. 3–4 (1998): 265–76.

118 Comşa, E., "Contribuţii la cunoaşterea ritului funerar al purtătorilor culturii Gumelniţa (Grupul de morminte de la Dridu)," *Aluta* 10–11 (1980): 23–32.

119 Comşa, E., "Necropola gumelniţeană de la Vărăşti," *Analele Banatului* 4, no. 1 (1995): 55–189.

120 Şerbănescu, D., "Căscioarele—D'aia parte," in *Cronica cercetărilor arheologice din România, Campania 1997* (Călăraşi: CIMEC, 1998): 14.

121 Bălteanu, C., and P. Cantemir, "Contribuţii la cunoaşterea unor aspecte paleo-demografice la populaţia neolitică de la Chirnogi-Şuviţa Iorgulescu," *Studii şi Cercetări Antropologice* 28 (1991): 3.

122 Şerbănescu, D., "Chirnogi-Terasa Rudarilor," in *Situri arheologice Cercetate în perioada, 1983–1992* (Brăila: Comisia Naţională de Arheologie, Muzeul Brăilei, 1996): 33.

123 Lazăr, C., "Date noi privind unele morminte gumelniţene," *Cultură şi Civilizaţie la Dunărea de Jos* 16–17 (2001): 173–83.

124 Comşa, "Necropola gumelniţeană de la Vărăşti" (1995): 109–10.

125 Ibid.: 101.

126 Bolomey, Al., "Noi descoperiri de oase umane într-o aşezare cucuteniană," *Cercetări Arheologice* (Bucureşti) 8 (1983): 159–73; Lazarovici and Lazarovici, *Neoliticul* (2006); Pandrea, S., "Découvertes d'ossements humains dans les établissement Gumelnitsa situés au nord-est de la Plaine Roumaine," *Acta Terrae Septemcastrensis* 5, no. 1 (2006): 29–43.

127 Bolomey, "Noi descoperiri de oase umane într-o aşezare cucuteniană" (1983).

128 Necrasov, O., "Données anthropologiques concernant la population du complexe culturel Cucuteni-Ariuşd-Tripolie," in *La civilization de Cucuteni en contexte européen*, ed. Monah (1987): 145–56; Bolomey, "Noi descoperiri de oase umane într-o aşezare cucuteniană" (1983); Lazarovici, C.-M., D. Botezatu, L. Ellis, and S. Ţurcanu, "Noi resturi de oase umane în aşezarea cucuteniană de la Scânteia (1994–2003)," *Arheologia Moldovei* 26 (2003): 297–306; Lazarovici, C.-M., D. Botezatu, L. Ellis, and S. Ţurcanu, "New Human Remains in the Cucutenian Settlement from Scânteia (1994–2003)," in *Tripol'skoe poselenie-gigant Tal'ianki. Issledovaniia 2001 g.*, ed. V., Kruts , A. Korvin-Piotrovskiĭ, and S. Ryzhov (Kiiv: In-t arkheologii NANU, 2001); Popovici, D., "Observations about the Cucutenian (Phase A) Communities Behavior Regarding the Human Body," *Analles d'Université Valachia, Târgovişte, Section d'Archéologie et d'Histoire* 1 (1999): 27–35.

129 Dumitrescu, H., "O descoperire în legătură cu ritul de înmormântare în cuprinsul culturii ceramicii pictate Cucuteni-Tripolie," *Studii şi Cercetări de Istorie Veche* 5, nos. 3–4 (1954): 399–429; Dumitrescu, H., "Découvertes concernant un rite funéraire magique dans l'aire de la civilisation de la céramique peinte du type Cucuteni-Tripolie," *Dacia*, n.s., 1 (1957): 97–116; Dumitrescu, H., "Deux nouvelles tombes cucuténiennes à rite magique découvertes à Traian," *Dacia*, n.s., 2 (1958): 407–23.

130 Bolomey, "Noi descoperiri de oase umane într-o aşezare cucuteniană" (1983); Popovici, "Observations about the Cucutenian (Phase A) Communities Behavior" (1999).

131 Ibid.

132 Lazarovici, Botezatu, Ellis, and Ţurcanu, "Noi resturi de oase umane" (2003): 299–302.

133 Ursulescu, N., "Mormintele Criş de la Suceava-Platoul Cimitirului," *Anuarul Muzeului Judetean Suceava* 5 (1978): 81–88; Ursulescu, N., "Apariţia înmormântărilor tumulare şi a incineraţiei la est de Carpaţi," *Memoria Antiquitatis* 19 (1994): 193–99; Ursulescu, N., "Les commencements de l'utilisation du rite de l'incinération dans le monde proto-thrace du nord de la Moldavie," in *The Thracian World at the Crossroads of Civilizations*, ed. P. Roman, Proceedings of the Seventh International Congress of Thracology, Constanţa-Mangalia-Tulcea, 20–26 May 1996 (Bucureşti: Institut Romăn de Thracologie, 1997): 447–64.

134 Dinu, M., "Contribuţii la problema Culturii Amforelor Sferice pe teritoriul Moldovei," *Arheologia Moldovei* 1 (1961): 43–59; Cucoş, Şt., "Cultura amforelor sferice din depresiunea subcarpatică a Moldovei," *Memoria Antiquitatis* 9–11 (1977–79): 141–61; Dumitroaia, Gh., *Comunităţi preistorice din nord-estul României. De la cultura Cucuteni până în bronzul mijlociu*, Biblioteca Memoria Antiquitatis 7 (Piatra-Neamţ, 2000); Mihăilescu-Bîrliba, V., "Mormântul unei tinere căpetenii Mormantul unei tinere capetenii de la inceputul Epocii Bronzului (Mastacan, jud. Neamt–'Cultura Amforelor Sferice')," *Memoria Antiquitatis* 20 (2001): 157–217.

135 Mihăilescu-Bîrliba, "Mormântul unei tinere căpetenii."

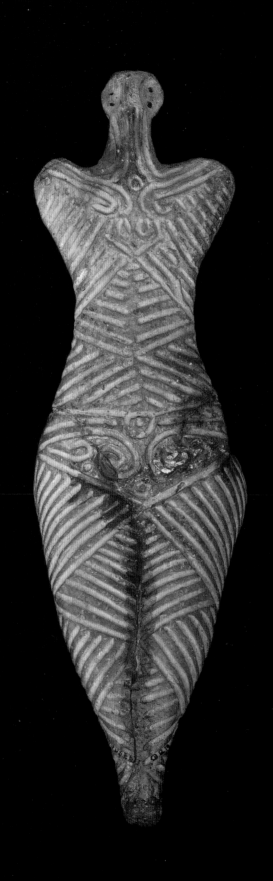

The Figurines of Old Europe
Douglass W. Bailey

San Francisco State University

At the beginning of the fifth millennium BC, in a village in what is now northeastern Romania, near the modern town of Poduri-Dealul Ghindaru, a woman (or a man, it is impossible to tell which) worked balls and slabs of soft clay into a series of small human shapes and tiny chairs. The resulting set of anthropomorphic figurines and furniture is one of the world's most extraordinary assemblages of prehistoric artifacts (fig. 5-1).[1] There are more than twenty figurines and more than a dozen chairs in the group. Twelve large and nine smaller figurines are included, though the term *large* is perhaps confusing as none of the objects is taller than 8.6 centimeters, and thus each of them sits very comfortably in one's hand.

The larger figures have both painted and incised decoration. The painted decoration is red and forms a range of different patterns covering each figure from its ankles up to the shoulders. On some the painted patterns form triangles on the thighs; on others they make up sets of parallel horizontal lines. On a few there is a band of parallel, diagonal lines running around the chest, leaving the rest of the torso empty; on others the entire upper body is covered with parallel lines and curvilinear forms.

Faces are marked simply with short horizontal incisions for the eyes, a pinch of clay for the nose, and a small horizontal incision for the mouth. Sets of incised lines delineate toes, and single incised lines separate the legs and mark the tops of the hips. The nine smaller figurines have little, if any, surface decoration: a few incisions to mark features on the face or to delineate the legs from each other. On all but one figurine, there are no arms modeled; the exception has its left arm raised against the body with the hand held against the side of the face, while the other arm is modeled horizontally across the throat and the hand supports the left elbow.

Cutting across all of this variation in size and surface treatment (with reference to which one could, if one wanted, suggest individual identities) is an overwhelming similarity in form. All of the figurines share a common body position and shape: Heads and necks are very thin; hips and thighs are wide and deep; bodies are bent at the waist (at less than ninety degrees) so that they can sit upright, but as a result they appear to be leaning backward. The inclusion of chairs in the Poduri-Dealul Ghindaru set is important. They are very plain, have no legs or surface decoration, and are made in two or maybe three variations (that is, with a square-shaped, open back, or with a two-pronged back). Under the broad backsides of the larger figurines, the chairs fit well but their sizes

Figurine. Fired clay, Cucuteni, Drăguşeni, 4050–3900 BC (Cucuteni A4), MJBT.

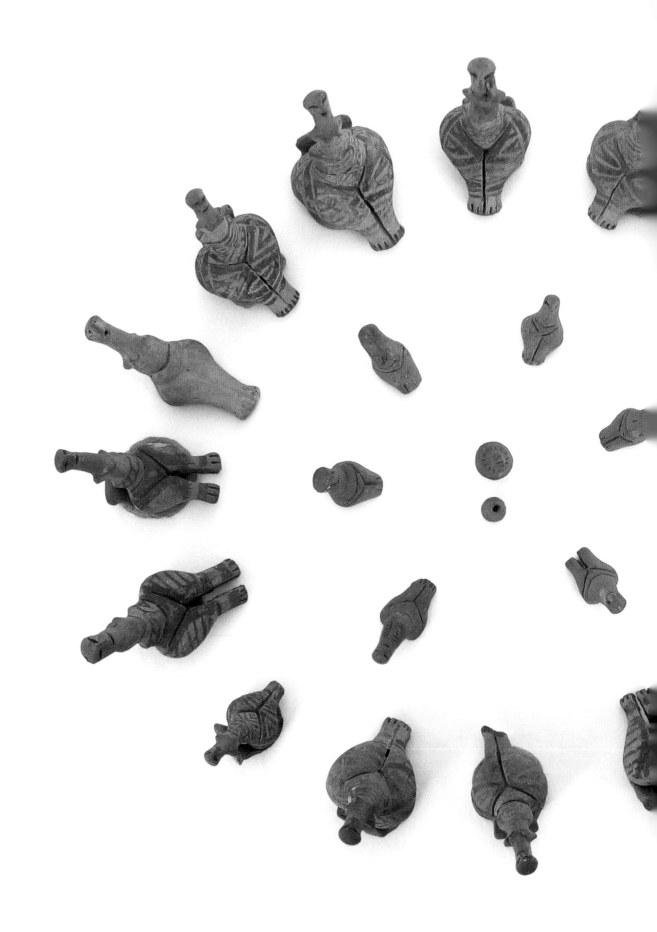

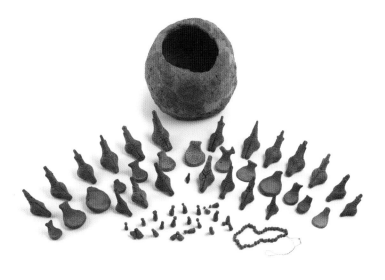

suggest that they were not intended for the smaller figurines in the set. It is not difficult to imagine the Pre-Cucuteni people of Poduri-Dealul Ghindaru placing these larger figurines onto the chairs, and perhaps arranging sets of seated figurines into one or several groups of miniature activities, perhaps with the smaller figurines at the feet or even on the laps of the larger, seated ones. There is a similar set of figurines from the site of Isaiia-Balta Popii, comprising twenty-one figurines (twelve large, eight small, and one tiny), thirteen chairs, and forty-two cylindrical or round clay beads (fig. 5-2).[2]

The Poduri-Dealul Ghindaru figurine set has been interpreted as a cult complex, and the most accessible English-language account calls it "The Council of the Goddess."[3] Similar terms and explanations are offered in the original Romanian reports. Within that primary interpretation, the two-pronged chair is described as a "horned throne of the fertility cult" (its prongs interpreted as symbols of the bull and thus the cult of fertility). This horned throne is assigned to the figurine with hands held to the face, who is designated as the "main goddess," representing a

5-1. (opposite). Set of twenty-one figurines and thirteen chairs. Fired clay, Cucuteni, Poduri-Dealul Ghindaru, 4900–4750 BC (Pre-Cucuteni II), CMJMPN.

5-2. (above). Set of twenty-one figurines, thirteen chairs, and askos. Fired clay, Cucuteni, Isaiia-Balta Popii, 4700–4500 BC (Pre-Cucuteni III), UAIC.

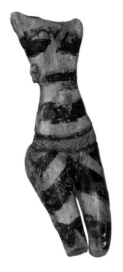

woman who is "dignified," who has borne many children, and whose appearance suggests a "magic, ritual function." Other figurines have been given identities based on particular features of their faces or bodies: One with protruding "firm" breasts, a small head, and a wide open mouth suggests "evil"; another, slimmer than the rest, also with "firm" breasts but with a round mouth, is called the "orant" (because its pose recalls gestures made during prayer). The argument runs that the other chairs are thrones as well, and their varying forms are linked to the particular characters represented by the specific figurines for whom the chairs were made. The excavators contend that the Poduri-Dealul Ghindaru set of figurines and chairs is part of the religious pantheon of the Pre-Cucuteni population.

Both the Poduri-Dealul Ghindaru and the Isaiia-Balta Popii sets of figurines were discovered inside pottery vessels. At Poduri-Dealul Ghindaru, the container was left in a building that the archaeologists have identified as a sanctuary destroyed by fire. In addition to the remarkably similar sets of figurines from these two sites, there are groups of similar figurines from other sites in the region. A house from the village site of Scânteia contained seventy-five figurines (fig. 5-3); a pit from the same site held twenty-four[4]; a bowl from Dumeşti held twelve (figs. 5-4a-b); a model house from Ghelăieşti held seven (fig. 5-5); and one house, called a "temple," from the site of Sabatinovka in Ukraine, produced thirty-two figurines. In addition there are other sites across southeastern Europe, such as at Ovcharovo in northeastern Bulgaria or Platia Magoula Zarkou in northern Greece, where sets of figurines, furniture, or buildings have been uncovered.

I am drawn to these figurines, those from Poduri-Dealul Ghindaru as well as the others, and feel a deep connection with them, but I am not convinced that those long-accepted interpretations, so easily couched in ritual and ceremony, religion and divinity, are legitimate or acceptable in a modern archaeology of the prehistoric past. At a most basic level, these objects challenge me: I want to know what they were used for and what they meant to the people who saw them, who held them, who sat the little bodies on the little chairs. I want to know what roles the objects may have played in the particular day-to-day lives of the people who lived in the community (Poduri-Dealul Ghindaru,

5-3. Figurine. Fired clay, Cucuteni, Scânteia, 4500–3900 BC (Cucuteni A), IAI.

for example) in which they were used. Finally, I want to know how they fit into the broader level of regional and transregional patterns of behavior.

Interpreting the Figurines

Drafting these questions is easier than providing any immediate and worthwhile answers. One could, of course, join the excavators of Poduri-Dealul Ghindaru and quickly find answers in the conventional understanding of prehistoric anthropomorphic figurines as goddesses and gods of cults and religions, or of ceremonies of fertility and fecundity. This indeed is how the late and widely followed scholar Marija Gimbutas scripted her responses to very similar questions. In a series of influential books, she laid out sweeping interpretations on a level that encompassed not only countries and continents, but even the very essence of being human.[5] For Gimbutas the answers were clear: Figurines were representations of divinities or were objects used in special ceremonies of ritual significance, most likely focused on cults of reproduction and death (of plants, animals, and people). For example, flat white female figurines made of bone, with perforated ears perhaps for the attachment of copper rings, are frequently found in the remains of settlements of the Gumelniţa culture in southern Romania (fig. 5-6); Gimbutas designated these figures as the White Goddess of Death.[6] But there is no independent evidence suggesting that the figurines were involved in death rituals.

In large part, Gimbutas' arguments were influential because they were appealing and easy to understand, because she held a significant position at a major research university (the University of California, Los Angeles), and because they appeared in large, glossy volumes produced by mainstream publishers. But as the basis for her arguments, Gimbutas offered little more than anecdotal stories of presumed Copper Age beliefs, based on broad analogies with the documented beliefs and rituals of quite different people who lived thousands of years after the Copper Age. To support her identification of the White Goddess of Death, for example, she invoked analogies with a death goddess from Lithuanian folklore. There was little logical, rational, or scientific reasoning for her conclusions, and independent evidence from the archaeological contexts of discovery did not in fact confirm them.

Over the past decade or so, intense research carried out by a number of scholars working independently has transformed the way in which figurines are studied and interpreted.[7] Even before Gimbutas began to publish books on goddess rituals in Old Europe, some investigators questioned the reality of mother-goddess interpretations.[8] Some of the most important more recent advances have resulted from highly detailed analyses of individual figurines and the patterns with which their body surfaces were decorated (fig. 5-7), such as the work on Bulgarian examples by Peter Biehl.[9] His painstaking study suggested that figurines from the Sălcuţa-Krividol culture were part of communities' transformative acts, through which people transcended the experience and capabilities of being human. In a recent publication, I have examined the broader cognitive frame within which figurines operated, including the role that visual culture (such as representations of the body) plays in societies.[10]

At yet another level, new excavations and approaches have transformed our understanding of the prehistoric societies in which these types of objects were made, used, and discarded.[11] Rigorous syntheses and interpretive work have made important contributions based on multidisciplinary excavations of key sites such as Selevac and Opovo in Serbia[12] and Sitagroi in Greece.[13] At Opovo, a settlement of the Vinča culture, a detailed analysis of the precise locations of figurines and figurine fragments under house foundations, on house floors, and in trash pits raised new questions about how figurines were used (fig. 5-8).[14] The amount and quality of work over the past two decades are significant, and the consequences to our understanding of figurines are important.

Without question, it is no longer acceptable for us to reconstruct life in these early agricultural villages as a life-threatening struggle to survive and wrest an uncertain living from the soil and the farmyard. Indeed there is no longer any support for the idea that the Neolithic settled agricultural life, in which people planted wheat and barley and bred cattle, pigs, sheep, and goats, was easier than a lifestyle based on hunting, gathering, fishing, and foraging. As there was no need for these Neolithic farmers to appeal for divine assistance in gaining their livelihood from cultivation and animal breeding, we have recognized that

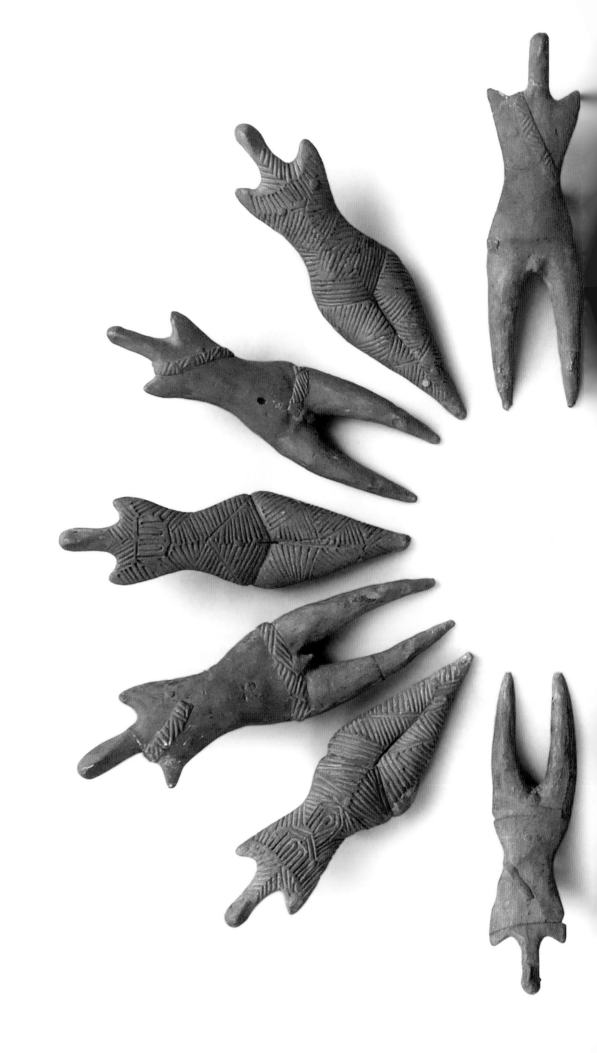

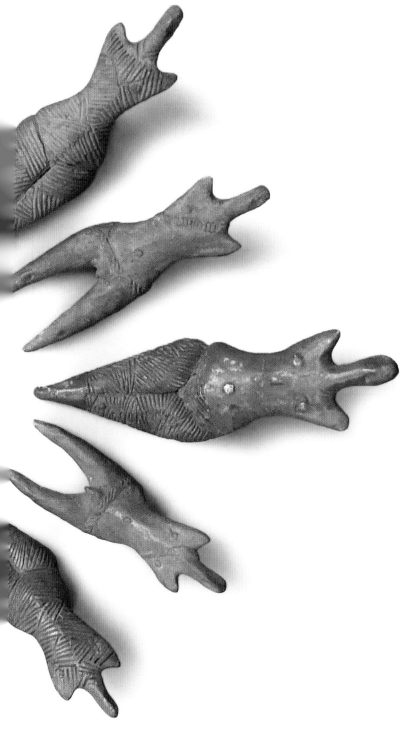

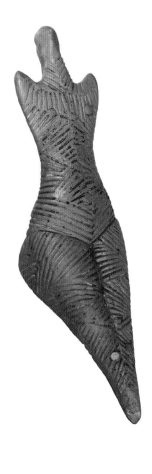

5-4a. Set of twelve figurines. Fired clay, Cucuteni, Dumeşti, 4200–4050 BC (Cucuteni A3), MJSMVS.

5-4b. Figurine from the set.

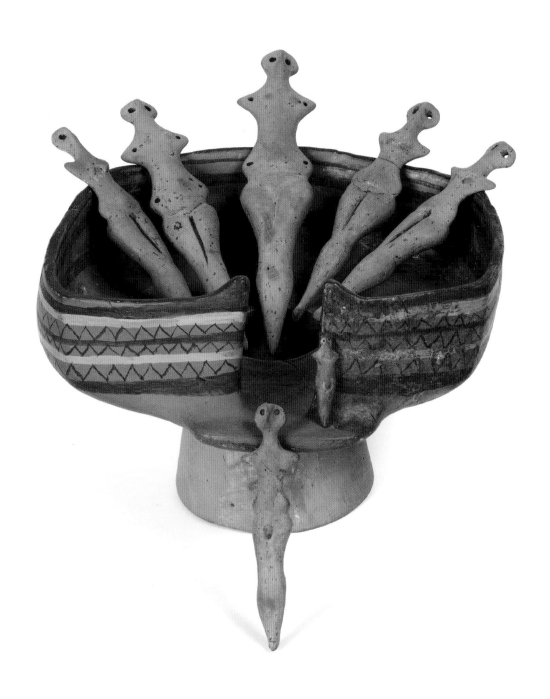

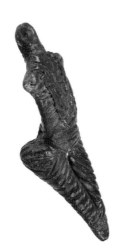
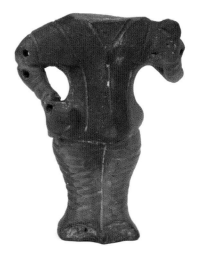

5-5. Architectural model with seven figurines. Fired clay, Cucuteni, Ghelăieşti, 3700–3500 BC (Cucuteni B1), CMJMPN.

5-6. Female figurine. Bone, Gumelniţa, Vităneşti, 4600–3900 BC, MJITR.

5-7. Female figurine. Fired clay, Cucuteni, Truşeşti, 4200–4050 BC (Cucuteni A3), MNIR.

5-8. Figurine. Fired clay, Vinča, Liubcova, 5000–4500 BC (Late Vinča), MBM.

there is no scientific support for the assumption that Neolithic and Copper Age religion was centered on cults of agricultural fertility. One of the most famous human images in European archaeology, a sitting ceramic figurine from the Hamangia culture popularly known as "The Thinker" (fig. 5-9), was dubbed a Vegetation God, but we have no independent archaeological evidence that this designation is even close to being accurate. In fact the figurine was found in a cemetery. As in any discipline, the more work that is carried out in a rigorous manner, the less persuasive are traditional ideals and interpretations. The study of Neolithic and Copper Age figurines is a prime example of this type of academic progress.

A New Understanding

It is one thing (and not an entirely brave or singularly worthwhile undertaking) to reveal the errors in traditional interpretations of Neolithic southeastern European figurines. It is quite another to produce a better under-standing of those same objects. In a longer discussion presented elsewhere, I have offered one possibility.[15] At the core of this new understanding, I redefined figurines in terms of what I recognize as their fundamental charac-teristics: They are miniature, they are representational, and they depict the human form. In this sense, I made no distinction among prehistoric, ancient, or modern miniature, anthropomorphic representations. I assumed (as is justified by our knowledge of human evolution) that the ability to make, use, and understand symbolic objects such as figurines is an ability that is shared by all modern humans and thus is a capability that connects you, me, Neolithic men, women, and children, and the Paleolithic painters of caves.

In my work on the figurines of southeastern Europe from the Neolithic and Copper Age (6500–3500 cal. BC), I sought to understand what it was about these objects that would have made them succeed in their past functions (regardless of whether they were used as votives, toys, portraits, or the representation of divinities). In addition, I tried to understand what made them attractive to us in the present as objects for sale at auction, as material appropriate for exhibition in a museum, or as subjects for an academic essay such as the one that you are reading. Investigating a wide range of modern and historical objects that were miniature, I was intrigued to learn that contemporary psychological studies have shown that something very odd happens to the human mind when one handles or plays with miniature objects. Most simply put, when we focus our attention on miniature objects, we enter another world, one in which our perception of time is altered and in which our abilities of concentration are affected. In a well-known set of experiments, the psychologist Alton Delong showed that when human subjects were asked to imagine themselves in a world where everything was on a much smaller scale than everyday reality, or when they engaged in activities in smaller than normal environments, they thought that time had passed more quickly than in fact it had and they performed better in tasks requiring mental agility.[16] Importantly, the subjects of these studies were not conscious of their altered experience of time or concentration.

By following this line of argument—in other words, that things made miniature affect the ways in which people experience the world—I began to see Neolithic figurines, like those from Poduri-Dealul Ghindaru, in a new light. When the people of that Pre-Cucuteni community looked at their figurines, and when they placed the little bodies onto the little chairs, arranging (and rearranging) them into different scenes and settings, they were entering other worlds. It is entirely possible that these other worlds were spiritual, though I am not convinced that they were of the type that either Gimbutas or the excavators of Poduri-Dealul Ghindaru imagined. It is much more probable that the people who held these objects in their hands, who touched and saw them in their daily activities, were affected in other ways, most likely at a deeper, subconscious level. To understand these interactions and the stimulations effected by the miniature representations of bodies, we need to understand the world in which these people lived.

Life and Death in Old Europe

What do we know of how the people of Old Europe lived their lives? One clear inference that seems well supported by the evidence is that people had particular and strong ideas about community membership. It is apparent from the excavations of their sites that the inhabitants perceived discrete private and public areas, and identified who belonged where and with whom, and who did not belong.

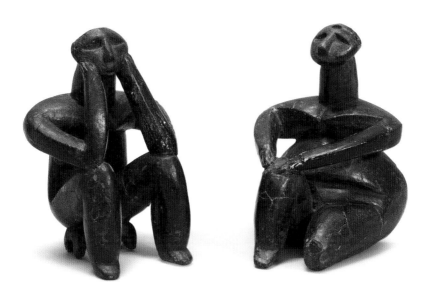

5-9. "The Thinker" from Cernavodă and female figurine. Fired clay, Hamangia, Cernavodă, 5000–4600 BC, MNIR.

Ditches and banks marked out settlement spaces, villages were placed on terrace edges, and features of the natural topography were used to define places of the living. The intentional arrangement of houses and buildings into unambiguously bounded villages reinforced social divisions across the landscape that would have contributed to the emergence of distinctions among groups of people, to the reinforcement of a sense of group membership, and to an equivalent sense of social exclusion.

In some villages, buildings were constructed along obvious patterns, with structures aligned in rows or in circles; in others there was less concern for order or planning. Regardless of the details of building arrangement, one infers a sense of residential coherence at these sites, of living, working, sleeping, and eating within the physically bounded settlement in a shared place that was delineated from the surrounding natural and social worlds. At a reduced scale, within these settlements smaller groups of people lived and worked together and may well have associated more regularly with some groups (for example, within households) than with others.

While the record of Cucuteni settlement is manifest, there is little evidence for funeral rituals. Articulated skeletons are rarely found: Less than a dozen Cucuteni sites have produced full skeletons. Occasionally, individual crania and fragments of skulls were buried under house floors, but these finds are few in number and probably represent special rituals. The majority of human remains are isolated, disarticulated bones found scattered in villages, and even these cannot account for anything but a tiny proportion of the population. In other contemporary Neolithic and Copper Age communities in southeastern Europe, funerals and graves were much more in evidence, and differences in grave wealth allow archaeologists to draw inferences about social structure and status (see the article by Vladimir Slavchev in this volume), but in the Pre-Cucuteni and Cucuteni communities there simply is not enough material to support similar conclusions.

The absence of burials in the Cucuteni tradition is perplexing. One is left without a clear picture of social structure, information about relationships among people, evidence of social hierarchies, or other aspects of social identity that an archaeologist often can gain from analyses of burials. Thus we are forced to search further for the role that might have been played by figurines in their (newly recognized) status as the main representations of human bodies within Pre-Cucuteni and Cucuteni society. The ways in which people perceive and depict the human form within different prehistoric cultures is of vital importance because the human body is one of the most potent components within a community's creation and manipulation of identity. Especially important are the ways in which the body (or more often, its representation, as in the form of a figurine) is part of the everyday activities of peoples' lives, from the special and ceremonial to the more frequent and more mundane. The repeated use of body representations is a central part of those subconscious processes through which a group establishes, slowly and over time, shared ideals of who belongs to one's group and who does not. The classic example from our modern western world is the way in which dolls such as Barbie have had an unintentional effect on how young women have understood their bodies and their positions within industrialized western societies.

The Meaning of Figurines

But how does any of this help us to understand objects like the figurines from Poduri-Dealul Ghindaru, Isaiia, and Dumeşti, or the thousands of other figurines from this period? To begin, let us recognize that these figures were everyday objects that people saw, handled, played with, worshipped, or cursed in their daily existence. From this perspective, it does not matter precisely how each figure (or an entire set) was used. Rather, the function of these objects is to be found at a deeper level of reality, upon which the community constructed and maintained a sense of who one was, what one should look like, and how one was distinct from others.

When we look again at the almost identical sets of figurines from Isaiia and Poduri-Dealul Ghindaru, what do we see and what do we think? If we lived at these sites in Pre-Cucuteni times, and if we handled the figurines, touched them, and walked past them every day, how would their shape and decoration have affected our understanding of the world around us and our place within it? Most observers would accept that the roles played by figurines

in these societies were extraordinarily important. The objects were part of a world in which there were no special social performances centered on the burial of the deceased, and thus a world where there were none of the loud public statements of individual identities and group cohesion that funerals amplified in Neolithic southeastern Europe. How would these figurines and the many others like them have affected the ways that people perceived themselves and their relationships with the people with whom they lived, spoke, ate, and slept? What roles might figurines have played as base lines against which perceptions of others emerged and were consolidated? I contend that none of the thinking that was stimulated by these figurines and these little chairs six thousand years ago (and which is stimulated today) can be contained in the reconstruction of a specific cult or religion or pantheon or deity. Instead, the effects that these objects had were much more subtle, the result of long accumulations of visual and tactile stimulations—accumulations of experiences through which people perceived their appropriate appearance within their communities.

The importance of these objects, therefore, is the way in which they contributed to a shared understanding of group identity; they stated without words, but in always present visual and tactile expression, "this is us." While these figurines were powerful objects, that power rested not in any specific reference to the divine, but rather in their condition as miniature objects, and the ways that miniature objects open up the minds of the people who hold and see them, facilitating deep-seated understandings of what is appropriate in terms of body appearance and membership within a group. Played out across the wider contemporary cultural landscapes of other regions in southeastern and central Europe, one of the most striking impressions created by the figurines of this period is the diversity of representations of the body—the ways in which bodies appear differently in each distinct regional (or chronologically successive) group. Each group maintained an internal coherence in body shape or decoration; each group was distinct from the others.

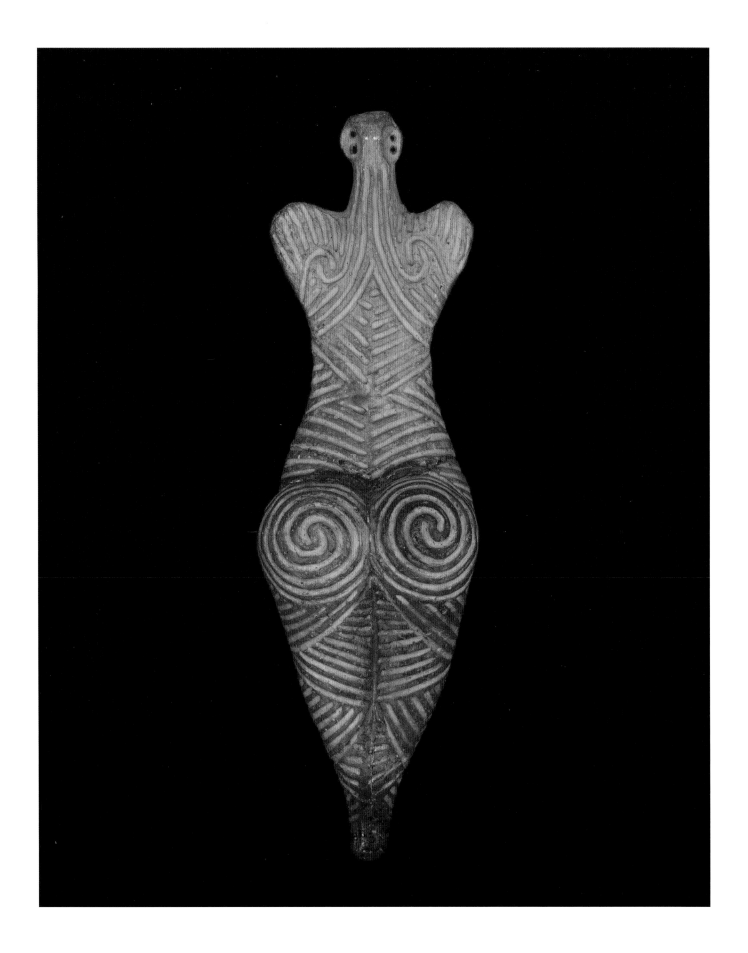

Notes

1 Mantu, C.-M., and G. Dumitroaia, "Catalogue," in *Cucuteni: The Last Great Chalcolithic Civilization of Europe*, ed. Mantu, Dumitroaia, and A. Tsaravopoulos (Thessaloniki: Athena, 1997): 179–81.

2 Ursulescu, N., V. Merlan, and F. Tencariu, "Isaiia, com. Rǎducǎneni, jud. Iași," in *Cronica Cercetǎrilor Arheologice, Campania 2000* (București: CIMeC–Institutul de Memorie Culturalǎ, 2001): 110–11; Ursulescu, N., "Dovezi ale unei simbolistici a numerelor în cultura Pre-Cucuteni," *Memoria Antiquitatis* 22 (2001): 51–69; Ursulescu, N., V. Merlan, F. Tencariu, and M. Vǎleanu, "Isaiia, com. Rǎducǎneni, jud. Iași," in *Cronica Cercetǎrilor Arheologice, Campania 2002* (București: CIMeC–Institutul de Memorie Culturalǎ, 2003): 158–59.

3 Mantu and Dumitroaia, "Catalogue" (1997).

4 Mantu, C.-M., "Plastica antropomorfǎ a așezǎrii Cucuteni A3 de la Scînteia," *Arheologia Moldovei* 16 (1993): 51–67.

5 Gimbutas, M., *The Goddesses and Gods of Old Europe: Myths and Cult Images* (London: Thames and Hudson, 1982); Gimbutas, M., *The Civilization of the Goddess: The World of Old Europe* (San Francisco: HarperCollins, 1991); Gimbutas, M., and M.R. Dexter, *The Living Goddesses* (Berkeley: University of California Press, 2001).

6 Gimbutas, *Civilization of the Goddess* (1991): 240.

7 Tringham, R., and M. Conkey, "Rethinking Figurines: A Critical View from Archaeology of Gimbutas, the 'Goddess' and Popular Culture," in *Ancient Goddesses: The Myths and the Evidence*, ed. L. Goodison and C. Morris (London: British Museum Press, 1998): 22–45; Bailey, D.W., *Prehistoric Figurines: Representation and Corporeality in the Neolithic* (New York: Routledge, 2005).

8 Ucko, P., *Anthropomorphic Figurines of Predynastic Egypt and Neolithic Crete with Comparative Material from the Prehistoric Near East and Mainland Greece* (London: Szmidla, 1968).

9 Biehl, P., "Symbolic Communication Systems: Symbols on Anthropomorphic Figurines in Neolithic and Chalcolithic Southeast Europe," *Journal of European Archaeology* 4 (1996): 153–76; Biehl, P., *Studien zum Symbolgut des Neolithikums und der Kupferzeit in Südosteuropa* (Saarbrücken: Rudolf Habelt, 2003).

10 Bailey, *Prehistoric Figurines* (2005).

11 Whittle, A., *Europe in the Neolithic: The Creation of New Worlds* (Cambridge: Cambridge University Press, 1996); Bailey, D.W., A. Whittle, and V. Cummings, eds., *(Un)settling the Neolithic* (Oxford: Oxbow, 2005); Bailey, D.W., A. Whittle, and D. Hofmann, eds., *Living Well Together: Sedentism and Mobility in the Balkan Neolithic* (Oxford: Oxbow, 2008).

12 Tringham, R., and D. Krstic, eds., *Selevac: A Neolithic Village in Yugoslavia* (Los Angeles: Institute of Archaeology, University of California, 1990).

13 Renfrew, C., M. Gimbutas, and E. Elster, eds., Excavations at Sitagroi, a Prehistoric Village in Northeast Greece, vol. 1 (Los Angeles: Institute of Archaeology, University of California, 1986); Elster, E., and C. Renfrew, eds., The Final Report, vol. 2, Prehistoric Sitagroi: Excavations in Northeast Greece, 1968–1970 (Los Angeles: Cotsen Institute of Archaeology, University of California, 2003).

14 Tringham and Conkey, "Rethinking Figurines" (1998).

15 Bailey, *Prehistoric Figurines* (2005).

16 Delong, A.J., "Phenomenological Space-Time: Toward an Experiential Relativity," *Science* 213, no. 4508 (August 7, 1981): 681–82; Delong, A.J., "Spatial Scale, Temporal Experience and Information Processing: An Empirical Examination of Experiential Reality," *Man-Environment Systems* 13 (1983): 77–86.

5-10. Back view of figurine from page 112.

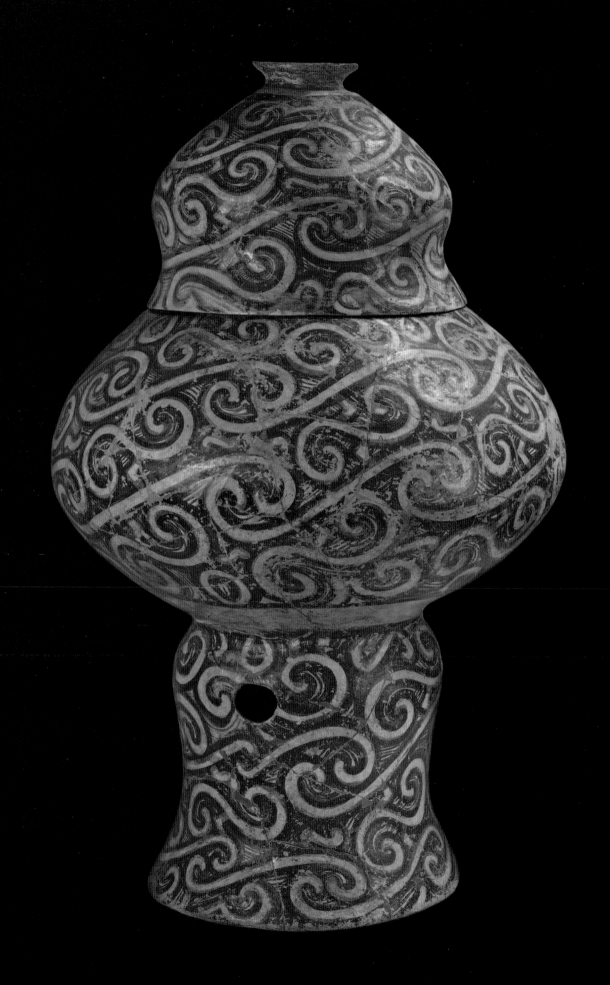

Cucuteni Ceramics: Technology, Typology, Evolution, and Aesthetics

Cornelia-Magda Lazarovici

The Institute of Archaeology, Iaşi

The Cucuteni culture, one of the most important cultures of Old Europe, is named after an archaeological site in northeastern Romania, fifty kilometers northwest of Iaşi, first explored by enthusiastic dilettante archaeologists from 1885 to 1890. On a hilltop outside the small village of Cucuteni, at a site called Cucuteni Cetăţuia, they found rich accumulations of beautifully painted pottery—apparently the oldest painted pottery yet discovered in their country—and in 1889 brought the site to the attention of European archaeologists, including the German Hubert Schmidt, at the International Congress of Anthropology and Prehistoric Archaeology in Paris. Schmidt organized systematic archaeological excavations in 1909 and 1910, with spectacular results,[1] discovering a stratified series of superimposed settlements belonging to a new prehistoric culture, which he named Cucuteni. Schmidt assumed that the oldest occupation layer at Cucuteni represented the beginning of the culture, and gave the designation Cucuteni A to ceramic styles from that level. Field researchers from Izvoare (Neamţ county), led by Radu Vulpe,[2] later showed that Cucuteni A was preceded by an earlier culture distinguished by different shapes and ornamental motifs

on its pottery. Vulpe named this earlier culture Pre-Cucuteni to indicate the close relationship between the two and to mark the evolutionary origin of the Cucuteni culture. The Pre-Cucuteni (in Romanian, *Precucuteni*) culture is divided into phases: I (the oldest), II, and III, the end of which marks the transition to the Cucuteni culture. Current chronological phasing and periodization for the Pre-Cucuteni and Cucuteni cultures reflect as well the contributions of numerous Romanian researchers, especially Vl. Dumitrescu,[3] M. Petrescu-Dîmboviţa, I. Nestor, A. Niţu,[4] S. Marinescu-Bîlcu, I.T. Dragomir, Şt. Cucoş, and D. Monah.

The Pre-Cucuteni (about 5050–4750/4600 BC) and Cucuteni (about 4600–3500 BC)[5] cultures comprise the central part of a vast cultural complex of shared traditions that extended from the forested valleys of Transylvania in the eastern Carpathian Mountains, southwest of the central Cucuteni region, to the rolling plains of western Ukraine as far as the Dnieper River, northeast of the central Cucuteni region. The Transylvanian variant is named after a site located there, Ariuşd, and the variants in Ukraine are named Tripol'ye (in Ukrainian, *Trypillia*) after a site excavated near the Dnieper River in 1896. Russian and Ukrainian archaeologists describe Tripol'ye as one culture with several phases. In contrast, Romanian archaeologists describe Pre-Cucuteni, Cucuteni, and

Globular vessel with lid. Fired clay, Cucuteni, Scânteia-Dealul Bodeşti, 4200–4050 BC (Cucuteni A3), CMNM.

Horodiştea-Erbiceni (the archaeological culture that followed after Cucuteni) as three different civilizations that can be equated with Tripol'ye phases in the following way: Pre-Cucuteni is equivalent to Tripol'ye A; Cucuteni (A, A-B, and B) to Tripol'ye BI-CI; and Horodiştea-Erbiceni to Tripol'ye CII. This essay focuses on the Pre-Cucuteni and Cucuteni cultures in Romania, but it should be remembered that closely related prehistoric communities lived in Ukraine, and the designation Cucuteni-Tripol'ye often is used to refer to the entire cultural tradition.

The Cucuteni-Tripol'ye era covers two periods, the Late Neolithic and the Copper Age. The Pre-Cucuteni culture appeared during the Late Neolithic in Romania.[6] The Late Neolithic was the last time in human history when people depended entirely on tools made of naturally occurring materials, principally stone (for cutting, piercing, and pounding implements) and bone (for needles, weaving tools, handles, points, and a variety of other tools). But starting with the Pre-Cucuteni III phase, copper items are more common, made of naturally occurring native copper. The true Copper Age began during the early Cucuteni culture, when artisans working with high-temperature kilns (intended for pottery manufacture) learned how to smelt natural mineral ores (malachite and azurite) in order to extract pure copper metal from these green and blue rocks. The Pre-Cucuteni and Cucuteni cultures together lasted for 1,500 years (5000–3500 BC), from the Late Neolithic through the Copper Age.

The origin of the Pre-Cucuteni culture is connected with the evolution of other cultures in the Danube valley and the Balkans. It formed at the same time as and was related in some way to the Boian culture (late Giuleşti phase) in the lower Danube valley, and was contemporary as well with Karanovo IV/V and the Marica culture, located in the Balkans. The Pre-Cucuteni culture also retained some decorative techniques derived from a phase of the preceding Linear Pottery culture (called the "music-note" phase, after a decorative motif on pottery that resembles a musical score) in the eastern Carpathian piedmont; and Pre-Cucuteni figurine styles were influenced by the Hamangia-culture figurine tradition on the Black Sea coast.

The Boian and Pre-Cucuteni cultures shared many customs in house architecture and construction (probably derived ultimately from the Vinča culture), female figurine styles, and shapes and design motifs in pottery. During this period, populations in the central part of the Balkans likely began to create closer social relationships, perhaps through migration, with populations to the north and south. In Bulgaria this was the era when the famous settlement of Karanovo was beginning its fifth phase, the Karanovo V period, and there are even some similarities between Karanovo V and Pre-Cucuteni artifacts.[7]

The evolution of the Pre-Cucuteni culture in three phases was described in detail by S. Marinescu-Bîlcu.[8] Recent research at the archaeological sites of Poduri,[9] Târgu Frumos,[10] and Isaiia[11] suggested refinements to her scheme, but the publication of these sites is not yet sufficient to fully define the suggested changes. The three phases of the Pre-Cucuteni culture were not of equal length, nor were they equally expressed geographically. In Transylvania, for example, different cultures appeared after the Pre-Cucuteni I phase. In central and southern Transylvania the Petreşti culture emerged, and in eastern Transylvania the distinctive Ariuşd group of the Cucuteni culture made its appearance. The origin of both cultures is related to southern influences that traveled through the middle Danube region (called the Banat) in southwestern Romania and from there into Transylvania. The southern influences originated in Greece. The Foeni group of the Petreşti culture (in what is now Banat and Transylvania) can be compared with the Dimini culture in central Greece; and from this source came distinctive types of painted decoration on pottery, with white on black, red on white, black on red, channeled, and polished pottery.[12]

Technical and Stylistic Aspects of the Ceramics of the Pre-Cucuteni Culture

The potters of the Cucuteni tradition created the most challenging ceramic vessel shapes and the most elaborate painted designs in the ceramic art of Old Europe. These sophisticated forms and designs evolved slowly, however, from relatively simple beginnings. L. Ellis studied the nature of the clays used to make the pottery of the Pre-Cucuteni period, as well as the tempering materials introduced into the clays and the firing of the finished

vessels.[13] She found that the clay naturally contained a variety of minerals (quartz, feldspar, muscovite, mica, magnetite, and hematite). The tempering agents were broken and pounded ceramic sherds, a material called grog.[14] Ellis's results have been verified by new analyses.[15] The firing of the vessels was mostly in a reducing or low-oxygen atmosphere, which produced surface colors in nuances of gray, black-gray, and brown, although in the Pre-Cucuteni II and III phases there also were vessels made in an oxidizing atmosphere, which produced a reddish or orange surface.

The decoration of pottery vessels in the Pre-Cucuteni I phase was executed without colored paints, probably because the potters had not yet discovered red and black pigments that could survive the firing process without turning brown (figs. 6-1–6-3). Motifs were produced by incisions, excisions (removal of clay from the surface to produce a design in relief), stroked lines made with a bone or wood tool, and flutes (long, shallow furrows made with an instrument that ended in a curve). Pots of semi-fine category were decorated with excisions.[16] The repertory of shapes included goblets, globular vessels, biconical vessels, bowls, jars, pear-shaped (pyriform) vessels, tureens, vessels and cups on pedestals, pedestaled support vessels, handled lids, and others.[17] Many shapes were similar to and perhaps derived from the Boian culture.

The motifs made with the excision technique (triangles, excised and reserved squares, and rhombs) and fluted motifs were similar to the decorative styles of the Boian (Giuleşti phase) and Marica cultures. Fluted designs were combined with incised decorations. Each overall design had a geometric character, sometimes organized in garlands and spirals.[18] The excised motifs sometimes were filled with white paint made of calcium carbonate. The incised motifs included a few very schematic human representations.[19]

During the following phase, Pre-Cucuteni II, the shapes created by potters continued in the same pattern with a variety of goblets of various shapes (fig. 6-4), vessels with bodies that curved out, short cups, small bowls (fig. 6-5), jars, pear-shaped (pyriform) vessels, bowls and tureens, vessels with high pedestals, vessels with lids (fig. 6-6), "fruit dish" vessels, and more.[20] The great variety of shapes

6-1 (top, left). Cup. Fired clay, Cucuteni, Traian-Dealul Viei, 5050–4750 BC (Pre-Cucuteni I).

6-2 (top, right). Tall cup. Fired clay, Cucuteni, Traian-Dealul Viei, 5050–4750 BC (Pre-Cucuteni I).

6-3 (bottom). Vessel with "wolf-tooth" incisions. Fired clay, Cucuteni, Traian-Dealul Viei, 5050–4750 BC (Pre-Cucuteni I).

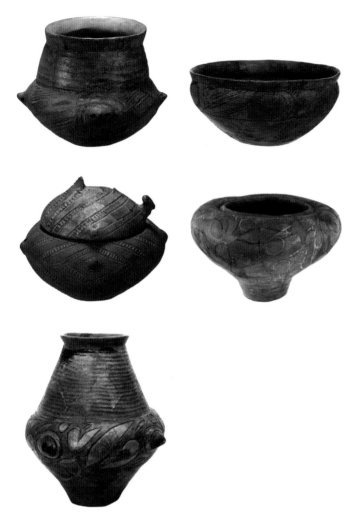

implies that pottery was used not just to contain or to cook, but also to express the mastery of skills and the attainment of status, and the small lidded bowls imply that the serving of food was not merely for nutrition, but included an element of social theater, an unveiling.

Stamped decorative motifs now appeared beside the excised and fluted decoration of the first phase. The flutes were disposed variously (fig. 6-4), in conjunction with other elements of decoration. The strips of incised lines were combined with vertical strokes, stamped designs (fig. 6-6), small prominences, and even protomes (animal and human heads protruding from a vessel). The motifs included spirals and circles, in some cases created through "reserved" decoration (motifs created in the "blank" space between applied decorations; fig. 6-5). Most of the incised and excised patterns were filled with white paint, but a few vessels were painted in red after firing, thus creating multicolored patterns in white, red, and the brown-gray color of the vessels.[21]

During the Pre-Cucuteni III phase, there was an increase in the variety of shapes and forms, almost as if competition between potters was now pushing innovation to new heights. This large variety of ceramic shapes included goblets, cups, globular vessels, small bowls, pyriform vessels (fig. 6-7), biconical bowls, "fruit dish" vessels, pedestaled vessels that seem to have functioned only as supports or presentation stands for other vessels, tureens, lids, strainer vessels, vessels with cylindrical necks (fig. 6-8), storage vessels, and ladles. There also are other forms, including square or rectangular "box" vessels, double "binocular" vessels (in the shape of two connected cylinders),[22] as well as some unusual shapes that resemble a crown, ceramic models of sanctuaries (fig. 6-9), and even miniature clay models of dugout boats.[23]

Fluted and incised decoration maintained its importance. Impressed, excised, and stamped decorations disappeared at the end of the phase. Potters of this period combined incised and stamped decorations (fig. 6-7), while on some pots they used flutes and incisions (organized in curves, circles, and spirals), attached prominences, and applied white paint before firing. Red paint was applied after firing (fig. 6-8) because at this early date Pre-Cucuteni

6-4 (top, left). Beaker. Fired clay, Cucuteni, Isaii-Balta Popii, 5050–4750 BC (Pre-Cucuteni II).

6-5 (top, right). Bowl. Fired clay, Cucuteni, Isaii-Balta Popii, 5050–4750 BC (Pre-Cucuteni II).

6-6 (center, left). Pot with lid. Fired clay, Cucuteni, Isaii-Balta Popii, 5050–4750 BC (Pre-Cucuteni II).

6-7 (center, right). Footed vessel. Fired clay, Cucuteni, Poduri-Dealul Ghindaru, 4750–4600 BC (Pre-Cucuteni III).

6-8 (bottom). Pot decorated with incisions and painting. Fired clay, Cucuteni, Târgu Frumos–Baza Pătule, 4750–4600 BC (Pre-Cucuteni III).

potters had not yet discovered mineral pigments that would retain their red color during firing, particularly in the uncontrolled gaseous atmosphere of the still primitive kilns. However, during this phase potters did begin to use painted slips (a liquid wash containing a fine clay or colored pigment in suspension), which fixed the color to the unfired surface before firing. This method was transmitted to the Cucuteni A_1 period. Decorative motifs were more varied and elaborate than during the previous phases.

The ceramic arts of the Pre-Cucuteni phase are notable for the abundance of different shapes and forms, as well as the exuberance of surface decoration, particularly in the final Pre-Cucuteni III phase. Decorative motifs included both geometric and curving spiral designs, with circular and flowing spiral forms predominating. Fluted surfaces were common features of the decoration during all three phases, particularly on the neck of the vessel, and were retained during the first period of the Cucuteni culture, reappearing again in some local groups starting with the Cucuteni A_4 period. Potters also occasionally portrayed certain stylized anthropomorphic and zoomorphic beings on their pots, as at Traian-Dealul Viei and Isaiia. In most cases decoration occupied the entire surface of a vessel. One of the most striking effects in Pre-Cucuteni decoration was produced by the doubling or reduplicating of motifs, particularly effective with spirals and later used frequently in the Cucuteni culture. Positive and negative ornament, used in the Pre-Cucuteni II phase, was employed on a larger scale during the Pre-Cucuteni III phase, special attention being given to incised "reserved" ornament.[24]

Technical and Stylistic Aspects of the Ceramics of the Cucuteni Culture

Hubert Schmidt defined three principal phases for the Cucuteni culture at the Cucuteni settlement, and each major phase now has its own subphases, defined principally by variations in the decoration of pottery found at many other settlements. The major phases are designated A (with subphases A_1–A_4), A-B (with subphases A-B_1 and A-B_2), and B (with subphases B_1 and B_2). Some subphases are still debated or appeared only in certain regions. The principal innovations that set the Cucuteni period apart from that of the Pre-Cucuteni were improvements in kilns, permitting better control over the evenness of firing

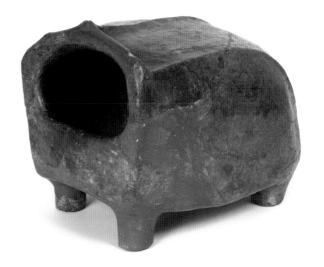

6-9. Architectural model. Fired clay, Cucuteni, Poduri-Dealul Ghindaru, 4750–4500 BC (Pre-Cucuteni III), CMJMPN.

and the gaseous atmosphere during firing; the discovery in nature of manganese minerals that could make a pigment that retained a strong black color during firing; and the development of various kinds of colored slips that could provide a base color of varied hues before firing. These innovations elevated Cucuteni ceramic production from an attractive craft to a specialized skill that produced objects of consummate beauty.

Improvements in the technology and construction of the kilns used for Cucuteni ceramic production probably were connected in some way with the development of an effective metallurgy. Copper metallurgy, the first kind of metal working discovered by humans, also depended on improvements in kilns used to smelt pure copper from malachite and azurite mineral ores (which require a temperature of at least 800°C), and even greater improvements in kilns used to liquefy copper so that it could be poured into molds (which require a temperature of 1083°C). Metal working also witnessed a significant advance about 4700–4600 BC, at the time of the transition from the Pre-Cucuteni to the Cucuteni, initiating the first widespread use of metal tools and weapons in the ancient world. The two technological advances in kilns for copper smelting and for ceramic firing proceeded side by side, perhaps divided by gender, with men probably doing most of the mining, smelting, and trading of metal and women probably doing most of the ceramic decoration and production.[25] In more than a dozen sites of the Cucuteni-Tripol'ye culture, archaeologists have found the remains of kilns used for ceramic firing with one or two superposed chambers, called updraft kilns because the heat rose from the fuel in the lower chamber up to the pots in the top chamber. In these closed kilns, Cucuteni potters could achieve a consistent oxidizing atmosphere that produced a red or yellow-red ceramic body. Reduced-atmosphere, black-bodied pots, typical for the Pre-Cucuteni phase, were almost abandoned. The new kilns produced temperatures ranging from 700–1000°C. Control of the temperature and the firing atmosphere were important for obtaining products of good quality, and this is obvious in comparisons of Cucuteni pottery to that of the Pre-Cucuteni culture.

Most of the pottery was now decorated with various kinds of colorful painted designs. In Romania and Moldova more than seventy-five percent of the ceramic material found in the Cucuteni area was painted, while in the Tripol'ye area in Ukraine the unpainted incised pottery of the Pre-Cucuteni tradition was retained up to the end of the Tripol'ye period.[26]

Potters of the Cucuteni culture used clays that had a high concentration of iron and mica, permitting them to produce ceramics with different variants of red (in oxidizing combustion) or black (in reducing combustion).[27] Such deposits of clay are common both in the area of Moldavia's sub-Carpathians and on the Moldavian Plateau. The presence of the minerals in the clay provided elasticity that made a good material for vessel construction. Ellis noticed that Cucuteni potters used clay that naturally contained mineral inclusions of very small sizes; in other words, minerals were not added as temper but were part of the natural clay, and only clays with very fine mineral inclusions were chosen.[28] During the Cucuteni B phase, clays became even finer, as mineral inclusions became smaller and potters began to use clay with a lighter color, exhibiting a kaolin-like aspect that was preferred for its fine quality and also for providing a lighter background for painting.[29] Utilitarian wares, as well as semifine wares, were tempered with crushed pottery sherds or grog; semifine wares sometimes contained small fragments of calcium carbonates as well. The clay used to make Cucuteni B fine-painted wares was so pure and the mineral inclusions were so small that it is probable the clay was intentionally levigated, or kneaded in water, to remove the coarser fragments.

Cucuteni vessels were built up from bands (coils) of clay, a system used by the majority of prehistoric civilizations. Starting with the Cucuteni A-B phase, a slow wheel (a simple rotating system) probably was introduced, resulting in the standardization of vessel shapes during the Cucuteni B phase. The employment of a slow wheel beginning in Cucuteni A-B is indicated by horizontal parallel striations on the interior of vessel walls, the strong alignment of natural micaceous inclusions in the clay (noticed by Ellis), and archaeological discoveries. Some settlements, notably

Vărvăreuca VIII and Vărvăreuca XV, contained fragments of turntables and/or parts of rotation devices.[30]

Some Cucuteni vessels were covered with slip, a technique of surface treatment that had been used since the beginning of the Neolithic. It produced a smooth surface with various nuances of color, on which painted or other decoration was made after drying. In other cases paint was applied directly to the vessel. The pigments used for paint were derived from minerals: Iron oxides (hematite, goethite, and limonite) could produce red shades, brown, or even black, depending on the firing atmosphere; manganese and ferromanganese oxide produced a black-brown color that was stable even after firing; and calcium carbonate was used to make white paint. Iron oxides could be found on the Moldavian Plateau, where many Cucuteni settlements were located; manganese could have been obtained in the eastern Carpathians or perhaps even from marsh deposits[31]; and calcium carbonate was widely available as a local mineral. Collections of painting materials have been found in certain settlements. The most important discovery was at Dumeşti-Între Pâraie, where two "painting kit" vessels were discovered in the pottery workshop (dwelling no. 3). Each vessel contained a considerable quantity of all three categories of pigments used for painting, as well as clay tools for pottery decoration.[32] Painted decoration first appeared during the Pre-Cucuteni III phase, as was mentioned above, but it was at that time limited to red and white designs. The inspiration for using painted decorative motifs probably came from the Gumelniţa or Petreşti cultures.

Cucuteni A

The variety of different ceramic shapes and forms—made for different aspects of storage, presentation, group meal service, and individual portion service during Cucuteni A—was truly impressive. Public feasts, rituals, and family celebrations must have been elaborately scripted and colorful occasions, surrounded by social expectations concerning what kind of serving or presentation vessel was expected and appropriate for each phase of the event. The predominant forms were cups (figs. 6-10, 6-11) pedestaled vessels (probably just to support or present other vessels; figs. 6-12, 6-13), "fruit dish" vessels (fig. 6-14), spherical vessels, tureens (figs. 6-15, 6-16), bowls, biconical

vessels, small basketlike vessels (fig. 6-17), small altars (fig. 6-18), spoons and ladles (fig. 6-19) anthropomorphic vessels (some shaped like a human body, fig. 6-20); others taking stylized forms that suggest a hora dance (fig. 6-13), binocular vessels, and pyriform vessels (figs. 6-21, 6-22). Some vessels were decorated with anthropomorphic bas-reliefs representing the divine couple (the Great Goddess and a male or androgyne character), couples of goddesses, "dancing" females, and mating representations. All of these motifs reflected and continued images that had appeared earlier in Pre-Cucuteni traditions.[33] Certain cult vessels had zoomorphic protomes, some very suggestive (fig. 6-15), that were well integrated with the vessel body by molding.

Decorative styles and methods evolved considerably during the five to six hundred years of the Cucuteni A phase. During subphase A_1, in addition to fluted and incised decoration many motifs were painted before firing, with white paint (fig. 6-23) or on occasion with red. The surfaces of vessels were brown or red. The decorative motifs were composed of narrow lines and dots. Vessels painted in two colors were rare. During the A_2 subphase, decoration was sometimes excised and bichrome painted (fig. 6-24), but trichrome-painted designs also first appeared. During the A_3 subphase, trichrome painting quickly spread and became the predominant style.

The main decorative motifs were spirals of various forms, placed variously (figs. 6-11, 6-12, 6-14−6-17, 6-21, 6-22, 6-25, 6-26 and page 128) and more rarely, meanders (represented by simplified spirals: figs. 6-10, 6-14, 6-19, 6-22, 6-27). The spiral as well as the chess board (fig. 6-15) and the meander had been common Pre-Cucuteni motifs. Space between motifs was filled with secondary motifs: ends of spirals (figs. 6-16, 6-25 and page 128), oviform decorations (figs. 6-11, 6-12, 6-16, 6-26), straight and arched lines, and dots (figs. 6-16, 6-24). Motifs usually were painted with white color and outlined with brown or black (figs. 6-10−6-12, 6-14, 6-15, 6-19−6-21, 6-25−6-27) to take the place of incisions, used earlier to outline motifs. Space between motifs was filled with red (or sometimes with narrow lines). The two colors used, white and red, had an equal or similar tonal value. The disposition of motifs was tectonic, the vessels having many decorative

registers (figs. 6-11, 6-14, 6-15, 6-21, 6-24, 6-26, 6-27), on occasion delimited by bands. The precise manner in which decorative motifs were made and joined gave a sensation of movement (figs. 6-11, 6-12, 6-21, 6-26 and page 128). Painters repeated motifs in various decorative registers, sometimes with small changes (figs. 6-12, 6-16, 6-21). Toward the end of the A_3 subphase, some potters began to confine the spiral or meander painted motifs to the upper two-thirds of the vessel (fig. 6-26), leaving an undecorated band on the lower third. The harmony of colors and the balanced flow of motifs made some of these vessels true works of art.

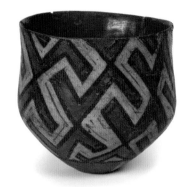

The Cucuteni A_4 subphase (largely confined to the north-eastern part of the Cucuteni area) represents a local aspect of development in the Drăguşeni-Jura (on both sides of the Prut river), where characteristic vessels had fluted, incised, and painted decorations (similar to Pre-Cucuteni traditions; figs. 6-13, 6-16, 6-17) in addition to vessels decorated with paint alone (figs. 6-18, 6-22). Painted decoration was applied in bichrome (figs. 6-13, 6-16, 6-17), sometimes with red paint applied after firing, as well as trichrome (fig. 6-22). The use of flutes and incisions provided an elegant outline for decorative motifs. Decoration was arranged in horizontal registers, sometimes divided into sections or metopes, with a harmonious combination of motifs (lines, spirals, and meanders; fig. 6-22). The Cucuteni A_4 subphase introduced several new ceramic shapes and decorative styles that mark the transition to the Cucuteni A-B phase.[34]

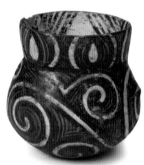

6-10 (top). Cup. Fired clay, Cucuteni, Bodeşti-Cetăţuia Frumuşica, 4200–4050 BC (Cucuteni A3), CMJMPN.

6-11 (center). Cup. Fired clay, Cucuteni, Dumeşti-Între Pâraie, 4200–4050 BC (Cucuteni A3), MJSMVS.

6-12 (bottom). Pot stand. Fired clay, Cucuteni, Scânteia-Dealul Bodeşti, 4350–4150 BC (Cucuteni A3).

6-13 (opposite: top). Pot stand. Fired clay, Cucuteni, Drăguşeni-Ostrov Botoşani, 4050–3900 BC (Cucuteni A4), MJBT.

6-14 (opposite: bottom). "Fruit dish" vessel. Fired clay, Cucuteni, Scânteia-Dealul Bodeşti, 4350–4150 BC (Cucuteni A3).

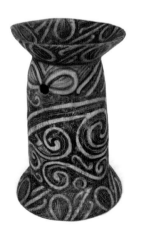

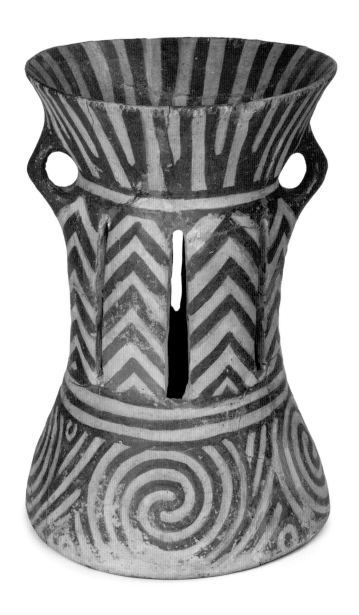

137

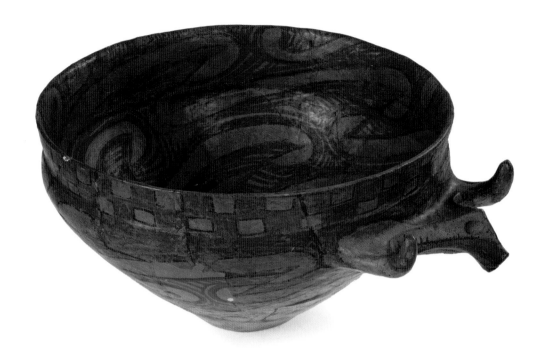

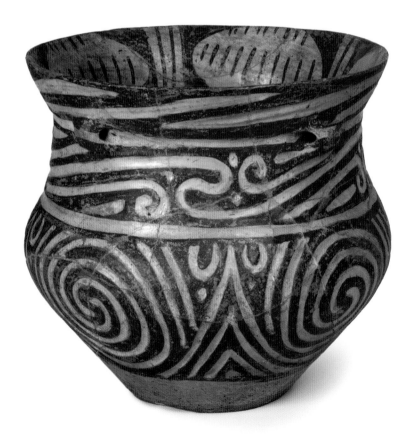

138

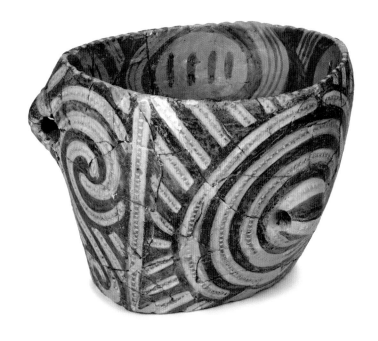

6-15 (opposite: top). Bowl with handle in the shape of a bull's head. Fired clay, Cucuteni, Poieneşti-Dealul Teilor, 4200–4050 BC (Cucuteni A3), IAI.

6-16 (opposite: bottom). Crater. Fired clay, Cucuteni, Drăguşeni-Ostrov Botoşani, 4050–3900 BC (Cucuteni A4), MJBT.

6-17 (top). Vessel. Fired clay, Cucuteni, Drăguşeni-Ostrov, 4500–4100 BC (Cucuteni A4), MJBT.

6-18 (center, left). Offering table/altar. Fired clay, Cucuteni, Drăguşeni-Ostrov, 4050–3900 BC (Cucuteni A4), MJBT.

6-19 (bottom). Ladle. Fired clay, Cucuteni, Truşeşti, 4450–4200 BC (Cucuteni A2), CMJMPN.

6-20 (center, right). Anthropomorphic vessel. Fired clay, Cucuteni, Scânteia-Dealul Bodeşti, 4200–4050 BC (Cucuteni A3), IAI.

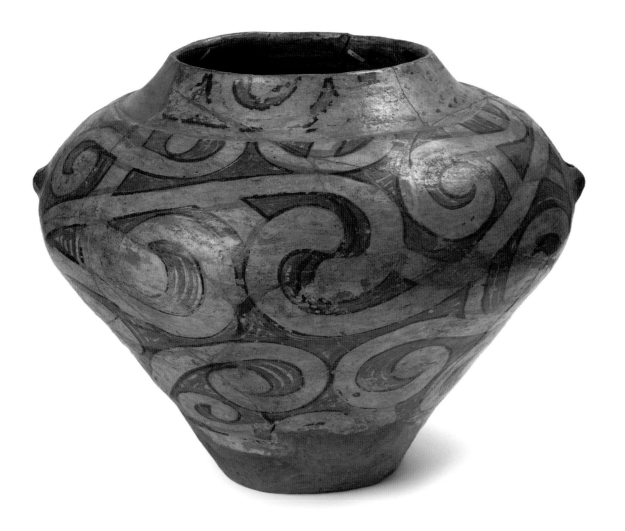

6-21. Biconical vessel. Fired clay, Cucuteni, Truşeşti-Ţuguieta, 4200–4050 BC (Cucuteni A3), CMNM.

6-22 (opposite). Bitronconical vessel. Fired clay, Cucuteni, Drăguşeni-Ostrov Botoşani, 4050–3900 BC (Cucuteni A4), MJBT.

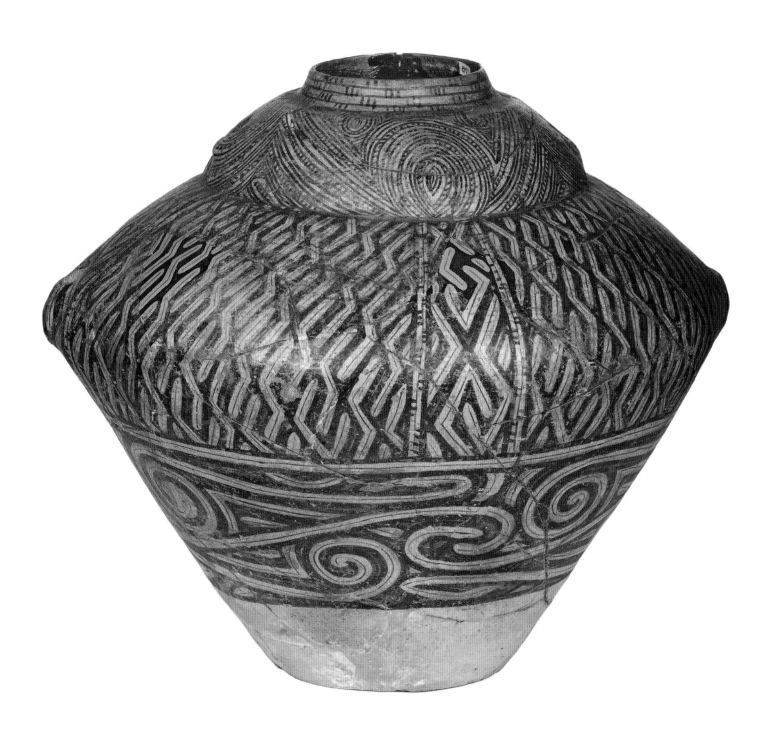

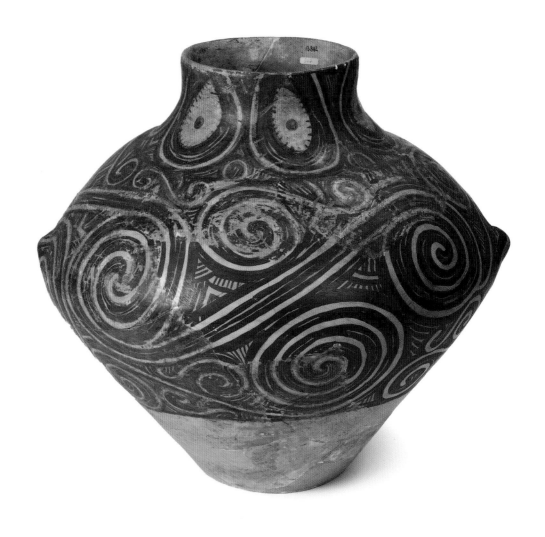

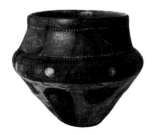

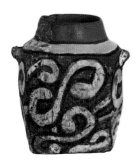

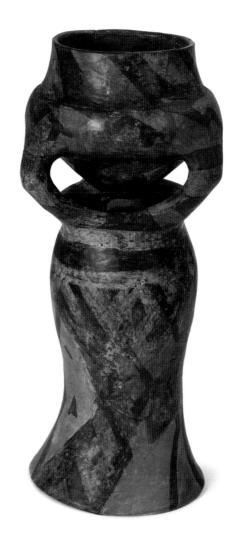

6-23 (opposite: left, top). Askos decorated with incisions and white painting. Fired clay, Cucuteni, Poduri-Dealul Ghindaru, 4600–4550 BC (Cucuteni A1).

6-24 (opposite: left, center). Pot decorated with incisions and white painting. Fired clay, Cucuteni, Izvoare, 4550–4170 BC (Cucuteni A2).

6-25 (opposite: left, bottom). Rectangular painted vessel. Fired clay, Cucuteni, Izvoare, 4550–4170 BC (Cucuteni A2).

6-26 (opposite: top). Bitronconical vessel. Fired clay, Cucuteni, Dumeşti-Între Pâraie, 4200–4050 BC (Cucuteni A3), MJSMVS.

6-27 (above). Stemmed cup. Fired clay, Cucuteni, Poduri-Dealul Ghindaru, 4450–4200 BC (Cucuteni A2), CMJMPN.

Cucuteni A-B

Potters of the Cucuteni A-B phase introduced novel vessel shapes and new roles for color and decoration. Innovative shapes included numerous vessels with bulging and flattened bodies, crater-shaped tureens with wide-open mouths (fig. 6-28), and goblets. Pedestaled support vessels were made more rarely, lids were made in new forms ("Swedish helmet" type; fig. 6-29), and "binocular" vessels were more numerous (fig. 6-30). The shapes of certain vessels reflected influences from traditions and designs of other cultures. For example, figure 6-31 exhibits a lobe-like rim copied from pots of the Bodrogkeresztúr culture in Hungary and western Romania, but it was painted in the Cucuteni manner.

Black and chocolate-brown colors (in various shades) were now used more freely, in some cases covering large decorative zones, a preference that continued into the Cucuteni B phase. Vessels that featured black painting created a distinctive artistic effect in which white paint was used as a border for decorative motifs. The inversion of the roles of these two colors created more possibilities for decoration and, consequently, additional stylistic variants. Motifs still were doubled and redoubled as during the previous phase (figs. 6-28, 6-32). Spiral bands were combined with other motifs (figs. 6-33, 6-34,) such as pills and cells (leaflike figures) that increased the variety of decoration. The meander was frequently used (figs. 6-31, 6-35). Straight and diagonal lines were combined with rounded motifs. Individual motifs alternated rhythmically, creating balanced registers of decoration that was organized geometrically or in spiral forms. Space was measured carefully and planned on the vessel surface before painting to permit a balanced repetition of complex motifs.

During the Cucuteni A-B period, a variety of different decorative styles proliferated, designated ABα, α, β, γ (each with two variants), and δ.[35] The painting styles of Cucuteni A-B$_1$ began to appear in the Cucuteni A$_4$ sub-phase (ABα, α1, α2, δ1, δ1a, and early γ2), but during the A-B$_2$ phase, they evolved into specific stylistic groups (ABα rarely, α1, α2, β1, δ1, δ1a, δ2a, γ groups, and δ2 elements) that were adopted by potters in other regions to the east, southeast, south, and southwest.[36] Sometimes the same vessel contained motifs made in different styles in different registers, demonstrating the contemporaneity of the styles (fig. 6-36, α and β styles; fig. 6-35, γ2 and β1 styles). The ABα style (white and red stripes with equal value, limited by a wider brown line) and the α style (black accents on the vessel's neck; fig. 6-36) were the oldest.[37]

The β group is represented by brown and black stripes, spirals, and meanders on a white background (figs. 6-28, 6-33). The δ group (which survived into the Cucuteni B phase) had the same preference for black colors (fig. 6-34), combined with red and white lines (fig. 6-31). Between design elements the red background was reserved in spaces of various shapes (round, square, and elongated) that were crossed by linear motifs or linear bands (fig. 6-31), creating trichrome patterns.

The γ groups are defined by the use of linear bands as well as meanders and spirals. Trichrome motifs were reduplicated across the vessel. Black linear bands were combined with white bands, as in figure 6-35,[38] which also represents a type of vessel with small handles inserted like metopes, thus interrupting the decorative register. Rows of Xs (which had appeared since the A$_4$ subphase) were common in this group of styles, placed on the vessel shoulder. Stylized horns also appeared, pointing upward or downward, representing a reprocessing of motifs from the Cucuteni A phase (fig. 6-14).

The first painted anthropomorphic representations appeared in this phase, replacing figures made in bas-relief during the previous period. The human silhouette was rendered geometrically, consisting of two triangles joined at the waist, with the head depicted as a circle (fig. 6-35). The body was painted with oblique black bands. Sometimes the hands were rendered with three fingers.[39] Human silhouettes occasionally were framed in metopes (fig. 6-35). The layout of the spiral decoration on certain vessels gives the sensation of an anthropomorphic representation (fig. 6-34). Human images seem to have had a symbolic and cultic role, and were shown in most cases engaged in a perhaps magical dance.

Cucuteni B

During the Cucuteni B phase, some settlements grew to enormous size, particularly in Ukraine, where a few

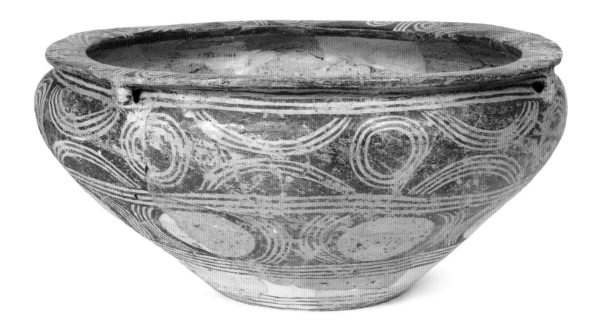

6-28. Bowl/tureen. Fired clay, Cucuteni, Vorniceni-Pod Ibăneasa,
4050–3850 BC (Cucuteni A-B1), MJBT.

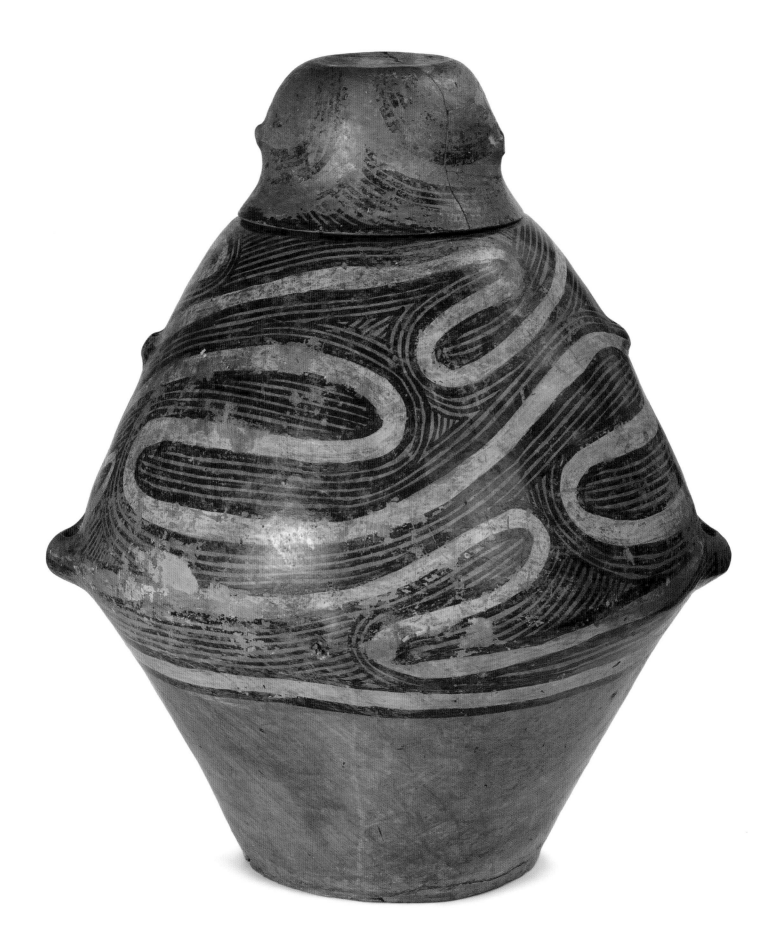

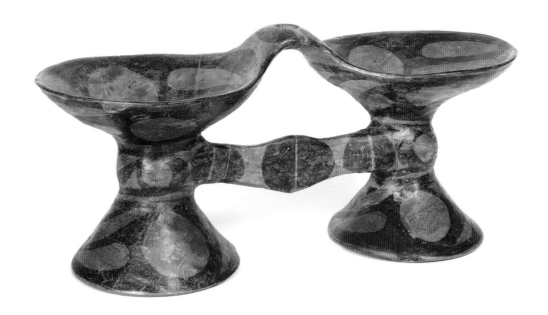

6-29 (opposite). Biconical vessel and lid. Fired clay, Cucuteni, Ghelăieşti-Nedeia, 3700–3500 BC (Cucuteni B1), CMJMPN.

6-30. Binocular vessel. Fired clay, Cucuteni, Ghelăieşti-Nedeia, 3700–3500 BC (Cucuteni B1), CMJMPN.

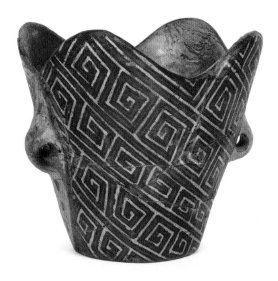

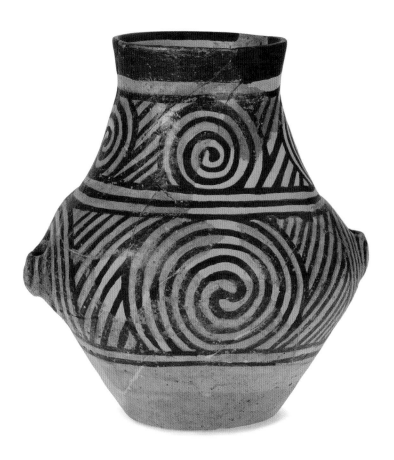

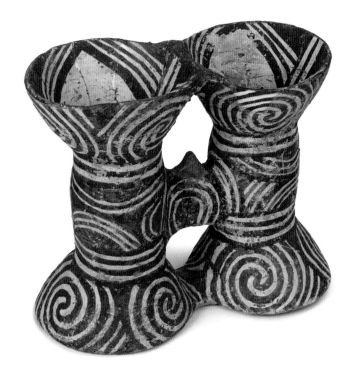

6-31 (opposite: left). Lobate vessel. Fired clay, Cucuteni, Calu-Piatra
Şoimului, 3900–3700 BC (Cucuteni A-B2), CMJMPN.

6-32 (opposite: right). Amphora. Fired clay, Cucuteni, Vorniceni-Pod
Ibăneasa, 4050–3700 BC (Cucuteni A-B1), MJBT.

6-33 (top). Double stand. Fired clay, Cucuteni, Vorniceni-Pod, 4050–3700 BC
(Cucuteni A-B1), MJBT.

6-34 (at right). Amphora with lid. Fired clay, Cucuteni, Rădulenii Vechi,
4100–3800 BC (Cucuteni A-B1).

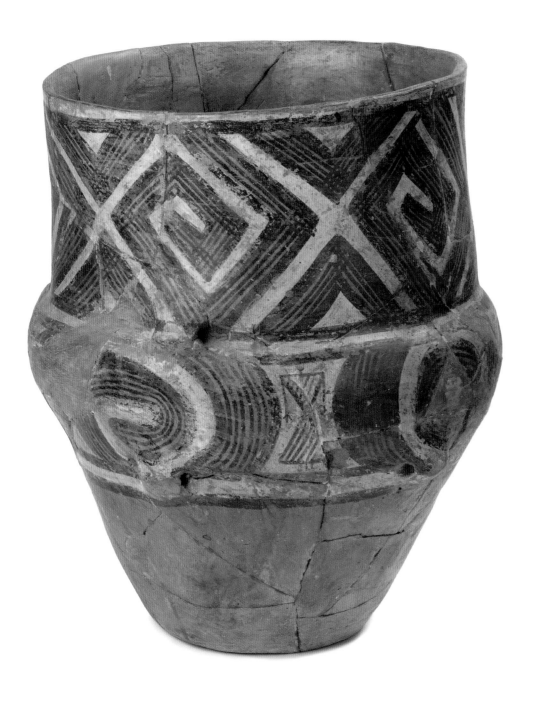

6-35. Crater. Fired clay, Cucuteni, Traian-Dealul Fântânilor, 4050–3700 BC (Cucuteni A-B2), MNIR.

6-36 (opposite). Biconical vessel. Fired clay, Cucuteni, Vorniceni-Pod Ibăneasa, 4050–3850 BC (Cucuteni A-B1), MJBT.

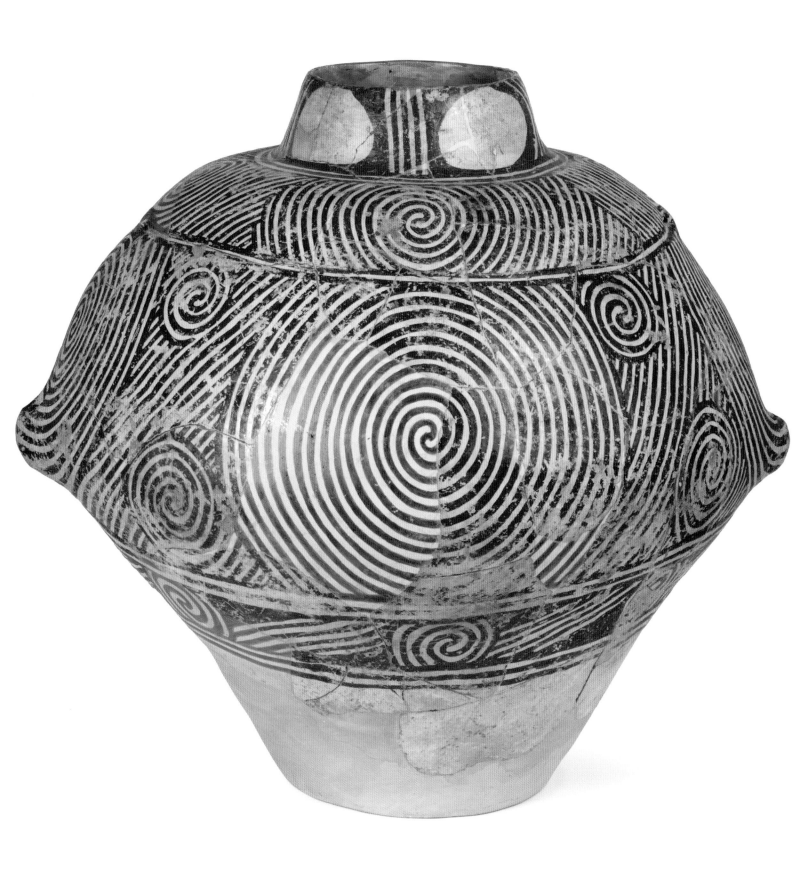

151

Tripol'ye settlements grew to more than two hundred hectares, perhaps as defensive protection against increasing warfare. At the same time there were transformations in the organization of ceramic manufacture. Ceramic shapes became more standardized, a change often associated with a shift to production by specialists. Ellis has argued that specialist ceramic workshops began to operate during this phase, replacing household production in larger settlements such as Petreni and Vărvăreuca VIII, where a ceramic manufacturing workshop was found.[40] The standardization of forms was accompanied by a reduction of the decorated zone, which was restricted to the rim, the neck, and the upper part of the vessel's body (figs. 6-37–6-41). Painted ornaments also became simpler and used fewer colors. Perhaps it was too time consuming to paint the entire surface of every pot in three colors when each specialist potter was producing so many vessels. There was an increase in the number of biconical vessels, while the plates, kraters, and amphoras showed changes in shapes and proportions. Short pedestaled vessels were more elegantly designed, and bowls showed a different profile than those of the previous period. One of the new features was a wide outward flaring rim that appeared on some vessels.[41]

Decoration was arranged on the vessel body much as it had been earlier, in friezes and metopes (figs. 6-37, 6-39–6-44). The background color usually was a light shade of beige, yellow, or white (figs. 6-37–6-43, 6-45) but occasionally was a darker reddish tone (fig. 6-30). The reddish tone appeared mainly in combination with black painted decoration, but also was used with bichrome and trichrome painted designs.[42] Decorative styles specific for this phase are the polychrome δ (fig. 6-37), the polychrome ζ (figs. 6-42–6-44), and the bichrome ε (figs. 6-38–6-41). Colors were used in new ways. In certain subgroups white was used as a background color, while in the ε group it was replaced by a beige background or the color of the vessel's clay, with linear motifs being painted only with black (figs. 6-38–6-41). In the ζ group, polychrome designs were retained (fig. 6-43).[43] The transition from the Cucuteni A-B$_2$ phase (pottery of γ and δ styles) to the B$_1$ (γ, δ, and ε styles) seems now to be expressed best in Moldavia's Subcarpathian zone, with some sites of A-B$_2$ and B$_1$ appearing contemporary.[44]

The decorative motifs used in the Cucuteni B phase showed many changes. The spiral (figs. 6-43, 6-45) and the meander (fig. 6-43) declined, to be replaced by new motifs like crosses, concentric circles, circles with crosses inside (figs. 6-38, 6-43), and small stair motifs. Zoomorphic and aviform motifs were a new decorative element, painted in black (fig. 6-41) or with the body depicted in red but outlined in black (fig. 6-42). Anthropomorphic representations were numerous, but their rendering continued to be schematic and geometric (figs. 6-37, 6-38, 6-40, 6-44). Such images appeared in various ensembles, accompanied by vegetal decorative elements (figs. 6-40, 6-44) as well as zoomorphic (fig. 6-38), natural, and geometric motifs (figs. 6-37, 6-38). Animal motifs seem dynamic, the images appearing in motion within larger friezes or metopes (figs. 6-42, 6-41). These combinations of decorative elements might be interpreted as graphic transmissions of genuine myths,[45] including the "tree of life," which was rendered both schematically and realistically (figs. 6-40, 6-44), and representations of snakes (figs. 6-42, 6-43), which were linked to fertility and fecundity and expressed the cyclic renewal, regeneration, and protection of harvests and households. The representation of bulls, dogs, and stags (figs. 6-42, 6-41) has been interpreted as the expression of fighting groups, also to be found in Mesopotamian glyptics.[46]

Most of the human representations on ceramic vessels are women (fig 6-37), sometimes in dancing positions (fig. 6-40), at other times symbolizing the Great Goddess (Feteşti-La Schit and Sofia VIII).[47] Men's silhouettes were painted infrequently, perhaps representing the Black God[48] wearing a mask.[49] Feminine silhouettes depicted on the vessel from Poduri (fig. 6-37)—divided in two groups (2+2 on the handles' zone and 3+3 on the vessel's body)— as well as six circles on the rim probably were images of a pantheon of goddesses,[50] but also might have encoded concepts of numerology or sacred numbers that some observers have perceived in decorative motifs as early as the Pre-Cucuteni age.

Cucuteni C Ware

In addition to the painted pottery for which they are famous, Cucuteni communities also used coarse unpainted pottery for different household activities. Most coarse

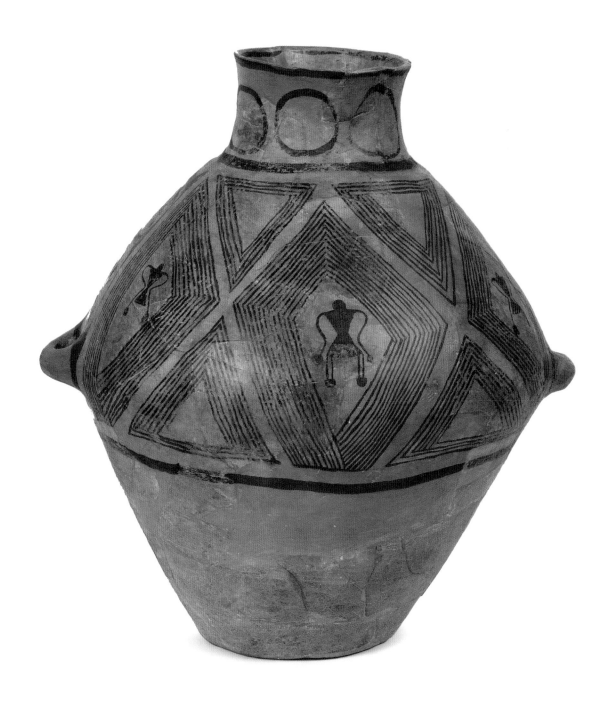

6-37. Amphora with anthropomorphic decoration. Fired clay, Cucuteni, Poduri-Dealul Ghindaru, 3700–3500 BC (Cucuteni B1), CMJMPN.

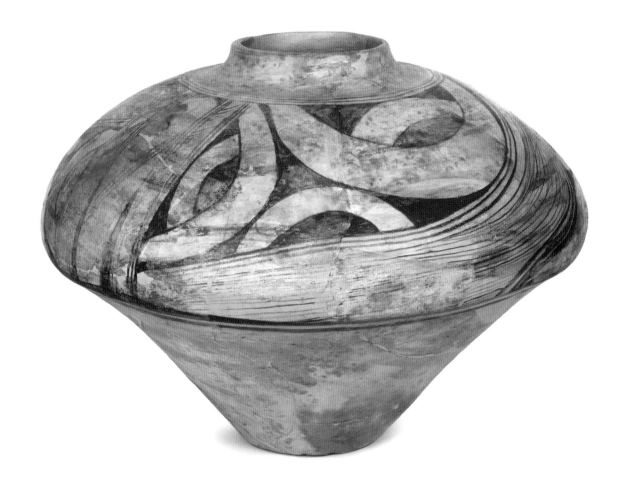

6-38 (at left). Amphora with anthropomorphic decoration. Fired clay, Cucuteni, Sofia VIII, 3800–3500 BC (Cucuteni B2).

6-39 (top). Bitronconical vessel. Fired clay, Cucuteni, Valea Lupului-Iaşi, 3700–3500 BC (Cucuteni B2), CMNM.

6-40 (opposite: bottom, left). Globular pot with vegetal and anthropomorphic decoration. Fired clay, Cucuteni, Brânzeni 3, 3800–3500 BC (Cucuteni B2).

6-41 (opposite: bottom, right). Biconical pot with zoomorphic decoration. Fired clay, Cucuteni, Varvareuca 8, 3800–3500 BC (Cucuteni B2).

6-42 (opposite: top). Crater with zoomorphic decoration. Fired clay, Cucuteni, Valea Lupului, 3700–3500 BC (Cucuteni B2), CMNM.

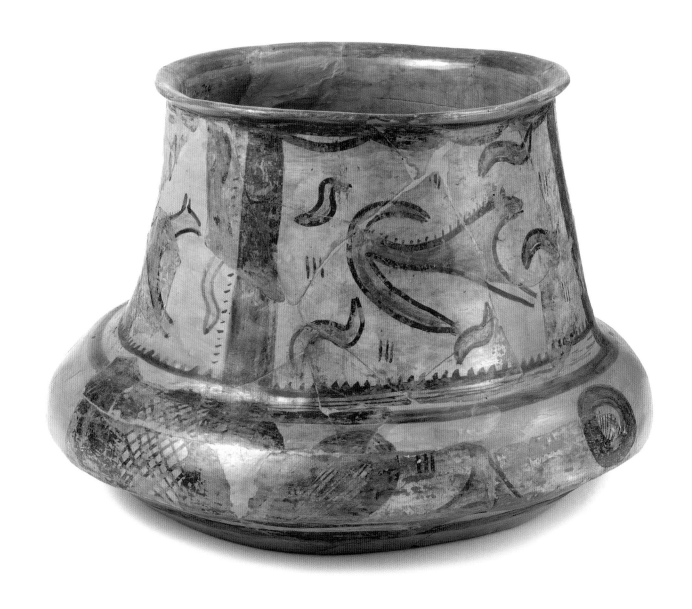

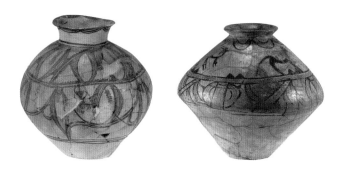

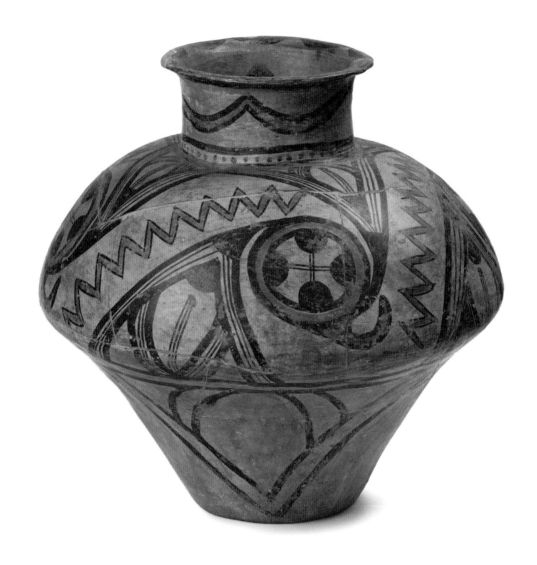

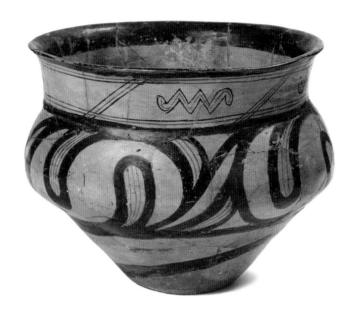

6-43 (opposite). Biconical vessel. Fired clay, Cucuteni, Şipeniţ, 3700–3500 BC (Cucuteni B2), MNIR.

6-44 (at right). Amphora. Fired clay, Cucuteni, Cârniceni, 3800–3500 BC (Cucuteni B2).

6-45 (top). Crater. Fired clay, Cucuteni, Târgu Ocna-Podei, 3700–3500 BC (Cucuteni B2), MNIR.

wares were made in a manner similar to painted wares, with grog-tempered clay paste, in recognizable Cucuteni forms, and featuring incised or fluted decoration. But a subcategory of coarse ware, noticeably distinct from ordinary coarse wares, was designated type C by Schmidt.[51] This ware was made quite differently from standard Cucuteni pottery. First, the clay was tempered with crushed mussel shells or snail shells, and with coarse sand, sometimes in large quantity. Second, the firing of C ware was semioxidizing, not evenly controlled. In the beginning (Cucuteni A_3 subphase), surface decoration on C ware was made with short incised lines, but later (Cucuteni A-B and B phases) there also was a kind of stab-and-drag decoration made with a toothed stamp, together with cord-impressed decoration. Shapes usually were similar to standard Cucuteni types, such as cups and craters. Chronologically, the C ware appeared during the Cucuteni A_3 period and persisted until the end of the Cucuteni culture. It was used in many although not all sites, but never represented more than five percent of the ceramics. Most of the pots had no artistic or aesthetic value, but through time the quality, shape, and decoration of C ware improved. For example, during Cucuteni B some C vessels had clay protomes and bull heads rendered in relief.

Type C ware is important because it was similar in its shell- and sand-tempered clays, its firing, and in some aspects of its decoration to the pottery of the cultures that inhabited the steppe zone of Ukraine and Russia, particularly in the lower Dnieper and Azov steppes north of the Black Sea. The communities that inhabited this region after 4400–4300 BC and until about 3300 BC are known archaeologically as the Sredni Stog, Skelya, and Novodanilovka cultures. As these cultures bordered the Tripol'ye culture, the appearance of C ware in Tripol'ye and Cucuteni settlements is generally thought to indicate a rise in contacts and exchanges with the Sredni Stog or Skelya communities,[52] perhaps through intermarriage. The increasing intensity of such relations through time seems to indicate the great interest and attraction of the wealth of Old Europe during Karanovo VI and the Cucuteni era, and perhaps specifically suggests the powerful attraction of innovative copper metallurgical centers in the Balkans[53] as well as in the Danube valley, the Carpathians (Transylvania), and the eastern Carpathian piedmont (eastern Romania and Moldova).[54]

Conclusion

Cucuteni pottery was brilliantly made in a technical sense, but its outstanding attraction was then and continues to be its elaborate decoration and variety of forms. Improvements in kiln technology and increased control over firing made the Cucuteni ceramic tradition possible, but these developments in pyrotechnology were rapidly shared among most of the pottery traditions across Old Europe, perhaps because they also were connected with advances in the ability to make and work metals. Cucuteni pottery was truly distinctive because of the liveliness of its surface decoration and the ambitious, inventive approach to shapes. The combination of profuse decoration and imaginative shapes made Cucuteni potters the most aesthetically sophisticated ceramic artists of the Copper Age. Cucuteni pots were given as gifts or exported in other ways to surrounding cultures, particularly to Gumelnița communities in the lower Danube valley.

The proliferation of shapes, many of them quite difficult to produce, implies that social events where Cucuteni pottery was used were equally complicated, with different kinds of vessels expected and required for the variety of foods, guests, rituals, and phases of events, much as nineteenth-century Victorian table settings became more complicated when meals provided a stage for the display of prestige, wealth, and knowledge of cultural codes rather than just for sharing food. Some Cucuteni vessels, such as highly decorated, pedestaled stands, served only to elevate and display other, equally highly decorated vessels. Bowls that were an appropriate size for individual servings of food frequently were provided with highly decorated lids, suggesting that the contents were meant to be revealed, not just eaten. Ladles were elaborately painted so that the decoration appeared just as the food was served. Ubiquitous and distinctive pyriform jars (figs. 6-21, 6-22, 6-39) were so top-heavy that they were difficult to fashion out of a medium as soft as clay, yet their proportions were so perfect that they look light and balanced even when the vessels are large. Such complex shapes and forms suggest a rich and perhaps socially competitive world of household and family feasts and rituals that drew potters from different communities together into a web of interaction and emulation.

In decoration a development can be traced from the incised, stamped, and fluted surface designs of the Pre-Cucuteni phase to the complex painted designs of Cucuteni A, A-B, and B. The flowing spirals and meanders that prevailed in many Cucuteni decorative styles demonstrated a precise calculation of the space to be decorated. V. Dumitrescu has noted the symmetrical disposition of motifs around all parts of the vessel, a goal difficult to achieve in the case of polychrome painted decoration, where the potter had to take into account the development and reduplication of the motif, its symmetric composition in the designated space, and the chromatic harmony of the design.[55]

Cucuteni A was the peak period for production of highly decorated trichrome wares,[56] while Cucuteni B was dominated by black painted wares, and Cucuteni A-B refers to the transition from one to the other. Similarly, Cucuteni A-B was divided into three decorative styles and Cucuteni B into three more styles, each designated with a Greek character, but as many as four of the styles can occur on the same vessel. Although clusters of these styles do define regional or chronological groups, the styles as characterized serve best as a grammar of decorative elements, some of which were used together on one pot and some of which were used in different times or places.

In spite of its exuberant variety, many aspects of Cucuteni pottery were similar across a large number of settlements and an enormous territory, demonstrating the existence of powerful local workshops that established traditions that were repeated and followed through many generations. The unity of complex decorative styles over vast spaces emphasized as well an enduring social connection between these innovative centers. When specialized potters began to produce pottery in large quantities during the Cucuteni B phase, some of the most elegant and demanding shapes were produced using highly refined clays and complex kilns, but decorative motifs became simpler and covered only the upper part of the vessel.

At the end of the sequence, the crisis that brought an end to Cucuteni architecture, towns, female figurines, and domestic rituals also brought an end to Cucuteni pottery traditions. Social prestige and power no longer depended on the beauty, inventiveness, and expertise exhibited by vessels that were used to serve feasts or to mediate rituals. Power shifted to other kinds of activities. It was only archaeology that recovered the evidence of this lost tradition. Cucuteni pottery, through its technical expertise in vessel construction and firing and aesthetic inventiveness in the harmonious combination of decorative motifs and colors with vessel shapes, demonstrated the degree of development reached by potters in a dynamic society, one that also achieved significant accomplishments in architecture, metallurgy, and religious life.

Translated by Corina Borș

Acknowledgments

I would like to express my gratitude to Dr. R. Dumitrescu, president of the Cucuteni for the Third Millennium Foundation, Dr. Gh. Dumitroaia (Piatra Neamț), and Prof. Dr. N. Ursulescu (Iași) for allowing me to study the illustrations in their possession to write this essay.

Notes

1 Schmidt, H., *Cucuteni in der oberen Moldau* (Berlin-Leipzig, 1932).

2 Vulpe, R., *Izvoare. Săpăturile din 1936–1948* (București: Academiei RPR, 1957).

3 Dumitrescu, Vl., "Originea și evoluția culturii Cucuteni-Tripolie," *Studii și Cercetări de Istorie Veche și Arheologie* 14, no. 1 (1963): 51–74; no. 2 (1963): 285–305; Dumitrescu, Vl., "În legătură cu periodizarea fazei Cucuteni A-B," *Studii și Cercetări de Istorie Veche și Arheologie* 23, no. 3 (1972): 441–47.

4 Nițu, A., "Criterii actuale pentru clasificarea complexelor ceramicii și periodizarea etapelor culturii cucuteniene," *Cercetări Istorice*, n.s., 9–10 (1979): 93–162; 11 (1980): 135–222; Nițu, A., *Formarea și clasificarea grupelor de stil AB și B ale ceramicii pictate Cucuteni-Tripolie* (Iași: Anuarul Institutului de Istorie și Arheologie "A.D. Xenopol," 1984), suppl. 5.

5 Mantu, C.-M., *Cultura Cucuteni. Evoluție, cronologie, legături*, Bibliotheca Memoriae Antiquitatis 5 (Piatra Neamț, 1998): 111–32.

6 Lazarovici, C.-M., and Gh. Lazarovici, *Neoliticul*, vol. 1, *Arhitectura Neoliticului și Epocii Cuprului din România*, edited by V. Spinei and V. Mihailescu-Bîrliba, Bibliotheca Archaeologica Moldaviae 4 (Iași: Trinitas, 2006): 544–66.

7 Todorova, H., *The Eneolithic Period in Bulgaria in the Fifth Millennium* BC, British Archaeological Reports, International Series 49 (1978): 28–31, pls. I/2–3, 5, pl. II.

8 Marinescu-Bîlcu, S., *Cultura Precucuteni pe teritoriul României* (București: Academiei RPR, 1974).

9 Monah D., et al., "Săpăturile arheologice din tell-ul cucutenian Dealul Ghindaru, com. Poduri, jud. Bacău," *Cercetări Arheologice* 5 (1982): 9–18; Monah, D., et al., "Cercetările arheologice de la Poduri-Dealul Ghindaru," *Cercetări Arheologice* 6 (1983): 3–22.

10 Ursulescu, N., D. Boghian, and V. Cotiugă, "Problèmes de la culture Précucuteni à la lumiére des recherches de Târgu Frumos, Romania," in "Miscellanea in honorem nonagenarii magistri Mircea Petrescu-Dîmbovița oblata," ed. V. Spinei, C.-M. Lazarovici, and D. Monah, *Scripta Praehistorica* (Iași: Trinitas, 2005): 217–60.

11 Ursulescu, N., and F.A. Tencariu, *Religie și magie la est de Carpați acum 7000 de ani. Tezaurul cu obiecte de cult de la Isaiia* (Iași: Demiurg, 2006).

12 Lazarovici and Lazarovici *Neoliticul* (2006): 545.

13 Ellis, L., *The Cucuteni-Tripol'ye Culture: A Study in Technology and the Origins of Complex Society*. British Archaeological Reports, International Series 217 (Oxford: Archaeopress, 1984); Ellis, L., "Analysis of Pre-Cucuteni Ceramics from Târgu Frumos, Romania," in *Scripta Praehistorica*, ed. Spinei, Lazarovici, and Monah (2005): 262–70.

14 Ellis, *Cucuteni-Tripol'ye Culture* (1984): 9, tables 6–7.

15 Ellis, "Analysis of Pre-Cucuteni Ceramics" (2005): 264–65.

16 Marinescu-Bîlcu, *Cultura Precucuteni* (1974): 55.

17 Ibid.: 56, 58–62, figs. 26–34, 38–39, 41, 43, 45, 47.

18 Ibid.: 56–57.

19 Ibid.: 57, fig. 30/1b.

20 Ibid.: 72–75, figs. 38–39, 43, 45, 47.

21 Ibid.: 66.

22 Ibid.: 78–84.

23 Monah, D., et al., *Poduri-Dealul Ghindaru. O Troie în Subcarpații Moldovei*. Bibliotheca Memoriae Antiquitatis 8 (Piatra Neamț, 2003): 153–55, nos. 76, 79, 80, 83, 93.

24 Marinescu-Bîlcu, *Cultura Precucuteni* (1974): 85–87.

25 Wright, R.P., "Women's Labor and Pottery Production in Prehistory," in *Engendering Archaeology: Women and Prehistory*, ed. J.M. Gero and M.W. Cokey (Oxford: Blackwell, 1991): 194–223.

26 Sorochin, V., "Culturile eneolitice din Moldova," *Thraco-Dacica* 15, nos. 1–2 (1994): 79; Mantu, *Cultura Cucuteni* (1998): 123, 126.

27 Dumitrescu, Vl., et al., *Hăbășești. Monografie arheologică* (București: Academiei RPR, 1954): 595–600.

28 Ellis, *Cucuteni-Tripol'ye Culture* (1984): 83, 93–108, 114–119.

29 Ibid.: 93.

30 Marchevici, V.I., *Pozdnie Tripol'skie plemena severnoi Moldavii* (Chișinău, 1981): 127, 129, 130, fig. 39/1–3, 5–7; Ellis, *Cucuteni-Tripol'ye Culture* (1984): 115, fig. 39; Cucoș, Șt., *Faza Cucuteni B în zona subcarpatică a Moldovei*, Bibliotheca Memoria Antiquitatis 6 (Piatra Neamț, 1999): 43.

31 Ellis, *Cucuteni-Tripol'ye Culture* (1984): 84, 120, fig. 11; Mantu C.-M., A.M. Vlad, and G. Niculescu, "Painting Pigments for Ceramic Decoration in the Cucuteni-Tripol'ye Cultural Complex," in *Festschrift für Gheorghe Lazarovici zum 60. Geburtstag*, ed. F. Drașovean (Timișoara: Mirton, 2001): 191–210.

32 Maxim-Alaiba, R.E., "Locuința nr. 1 din așezarea Cucuteni A₃ de la Dumești (Vaslui)," *Acta Moldaviae Meridionalis* 5–6 (1983–84): 99–148; Pântea, C., "Noi date privind tehnica picturală în cultura Cucuteni," *Acta Moldaviae Meridionalis* 5–6 (1983–84): 413–28.

33 Monah, D., *Plastica antropomorfă a culturii Cucuteni-Tripolie*, Bibliotheca Memoriae Antiquitatis 3, (Piatra Neamț, 1997): 173–77, figs. 239, 241/1, 238.

34 Marinescu-Bîlcu, S., and A. Bolomey, *Drăgușeni, a Cucutenian Community* (Bucharest: Enciclopedică, 2000); Marinescu-Bîlcu, S., and C. Bem, "Unde și cum s-a putut realiza trecerea de la faza Cucuteni A la Cucuteni A-B," in *Scripta praehistorica* (2005), ed. Spinei, Lazarovici, and Monah: 299–307, 314, figs. 1–3.

35 Schmidt, *Cucuteni in der oberen Moldau* (1932): 30–36; Dumitrescu, Vl., *Arta culturii Cucuteni* (București: Meridiane, 1979): 41–44.

36 Marinescu-Bîlcu and Bem, "Unde și cum s-a putut realiza trecerea de la faza Cucuteni A la Cucuteni A-B" (2005): 314.

37 Dumitrescu, *Arta culturii Cucuteni* (1979): 43, figs. 35, 37–39.

38 Ibid.: 52–53, figs. 129–31, 134–35.

39 Ibid.: 54, fig. 44.

40 Ellis, *Cucuteni-Tripol'ye Culture* (1984): 207.

41 Dumitrescu, *Arta culturii Cucuteni* (1979): 55–56.

42 Dumitrescu, Vl., *Arta preistorică în România* (Bucureşti: Meridiane, 1974): 44–145.

43 Dumitrescu, *Arta culturii Cucuteni* (1979): 56.

44 Cucoş, *Faza Cucuteni* B (1999): 147.

45 Lazarovici, C.-M., "Semne şi simboluri în cultura Cucuteni-Tripolie," in *Cucuteni 120. Valori universale, Lucrările simpozionului naţional Iaşi, 30 septembrie 2004*, ed. N. Ursulescu and Lazarovici (Iaşi: Sedcom, 2006): 57–100.

46 Niţu, A., "Decorul zoomorf pictat pe ceramica Cucuteni-Tripolie," *Arheologia Moldovei* 8 (1975): 66.

47 Boghian, D., and S. Ignătescu, "Quelques considérations sur un vase Cucuteni B aux représentations anthropomorphes peintes, découvert à Feteşti-La Schit (Dép. de Suceava)," *Codrii Cosminului* 13, no. 23 (2007): 3–12; Bicbaev, V.M., "Litsevye amfory kul'tury Kukuteni-Tripol'e-eneoliticheskie Model'Mira," *Tezisy dokladov VIII mezhdunarodnoj konferentsii, Mezdunarodnye otnoshennja v bassenye Chyornogo Mor'ya v drevnosti i srednie veka* (1996): 16–21.

48 Golan, A., *Prehistoric Religion: Mythology, Symbolism* (Jerusalem, 2003): 391–502.

49 Lazarovici, "Semne şi simboluri în cultura Cucuteni-Tripolie" (2006): 71–72, fig. 15.

50 Monah, *Plastica antropomorfă a culturii Cucuteni-Tripolie* (1997): 182, figs. 252–53.

51 Schmidt, *Cucuteni in der oberen Moldau* (1932): 42, 77, 81.

52 Rassamakin, J.J., *Die nordpontische Steppe in der Kupferzeit. Gräber aus Mitte des 5.Jts. bis des 4.Jts. v. Chr,* Archäologie in Eurasien 17 (Mainz: Zabern, 2004): 216.

53 Videiko, M.J., "Tripol'ye-Pastoral Contacts: Facts and Character of the Interactions, 4800–3200 BC," in "Nomadism and Pastoralism in the Circle of Baltic-Pontic Early Agrarian Cultures, 5000–1650 BC," *Baltic Pontic Studies* 2 (1994): 29–71; Manzura I., and E. Sava, "Interacţiuni 'est-vest' reflectate în culturile eneolitice şi ale epocii bronzului din zona de nord-vest a Mării Negre (schiţă cultural-istorică)," *Memoria Antiquitatis* 19 (1994): 151; Mantu, C.-M., "Cucuteni-Tripol'ye Cultural Complex: Relations and Synchronisms with Other Contemporaneous Cultures from the Black Sea Area," in "In honorem Mircea Petrescu-Dâmboviţa et Marin Dinu," *Studia Antiqua et Archaeologica* (Universitatea Alexandru Ioan Cuza) 7 (2000): 267–84.

54 Mareş, I., *Metalurgia aramei în neo-eneoliticul României* (Suceava: Bucovina Istorică, 2002); Lazarovici, C.-M., and Gh. Lazarovici, *Epoca Cuprului*, vol. 2, *Arhitectura neoliticului şi epocii cuprului din România* (2007): 17–24.

55 Dumitrescu, *Arta culturii Cucuteni* (1979): 90.

56 This observation is based on the fact that more sites belong to Cucuteni A (552 in Romania; 95 in Moldova; 45 in Ukraine), as compared with those of Cucuteni A-B (124 in Romania; 78 in Moldova; 50–70 in Ukraine) and Cucuteni B (308 in Romania; 108 in Moldova; 131–350 in Ukraine).

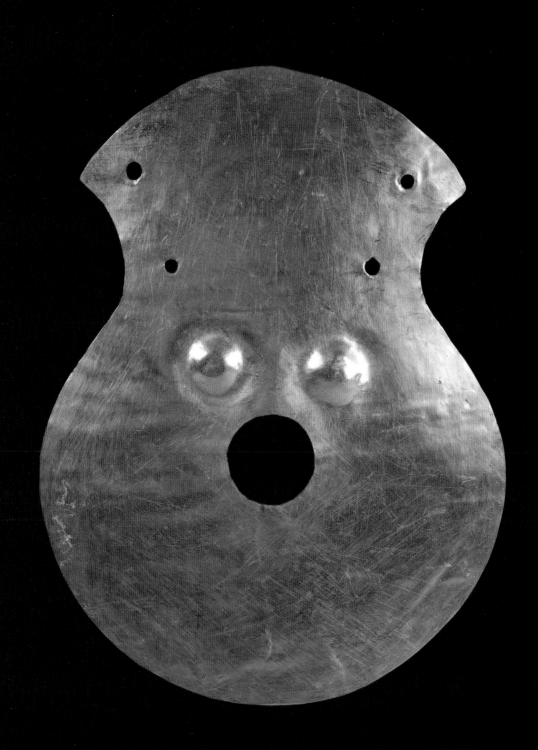

The Invention of Copper Metallurgy and the Copper Age of Old Europe

Ernst Pernicka

Institute for Prehistoric Archaeology, University of Tübingen / Curt-Engelhorn-Center for Archaeometry, Mannheim

David W. Anthony

Hartwick College

The first metal used by humans was copper. From the development of the first tools two million years ago until copper began to be employed, all cutting and piercing tools had been made of naturally occurring materials—stone, antler, or bone. Copper also occurs naturally in the form of metallic nuggets, or native copper, and it was apparently native copper that was used first by experimenters, who heated it and pounded it into sheets with stone hammers as if it were an odd, malleable kind of stone. From a copper sheet it was possible to make, by cutting, bending, hammering, and welding, a wide variety of simple tools (hooks, awls, and blades) and ornaments (beads, rings, and other pendants). But eventually humans discovered that metallic copper was "hidden" inside a variety of bluish and greenish mineral rocks, from which it could be separated and extracted through a process known as smelting that must have seemed almost magical. When that discovery happened true metallurgy began.

The First Experiments: The Use of Native Copper

Present evidence shows that it was in the Near East, particularly in eastern Anatolia and northern Iraq, that humans first used native copper. Several archaeological sites are now known where copper was already used for beads and small objects by the end of the ninth millennium BC (fig. 7-1). Although it was largely native copper that was first utilized, there is evidence that it was exposed to some sort of heat treatment (fig. 7-2),[1] presumably to make it malleable again after cold working (hammering), which makes the copper hard and brittle. In later periods this effect was certainly known and utilized to harden the edges of tools,[2] but in the beginning of metal working there is no evidence for intentional hardening through cold hammering of edges. Nevertheless, although metal was collected like any other stone material, its peculiar properties were recognized and, accordingly, it was formed into awls, fish hooks, rolled beads, and the like by simple cold hammering.

Stone-working techniques like drilling were not useful for working copper. Copper was so malleable that a hole could not be drilled through a nugget of native copper in the normal way that beads were usually made in prehistory, with a natural abrasive like sand and a tubular drill made of reed or a fine flint drill point. Copper beads never were drilled, but instead were made by cutting and rolling a thin sheet of copper. This characteristic of copper is important, because the object long considered to represent the earliest metal find, a corroded pendant from

Anthropomorphic figure. Gold, Bodrogkeresztúr culture, Moigrad, 4000–3500 BC, MNIR.

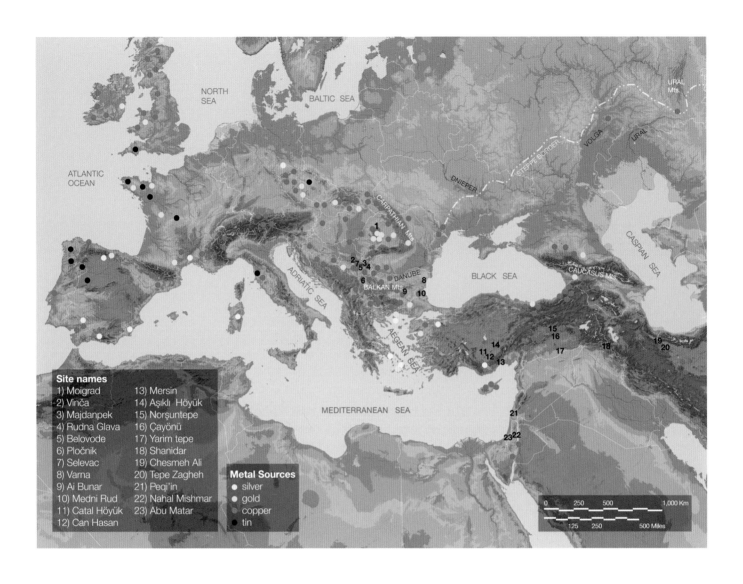

NORTH
SEA

BALTIC SEA

ATLANTIC
OCEAN

URAL
Mts

VOLGA

URAL

STEPPE BORDER

DNIEPER

CARPATHIAN Mts

CASPIAN
SEA

1

2 7 3 4
5
6
DANUBE
8
9 10
BALKAN Mts

BLACK SEA

CAUCASUS Mts

ADRIATIC SEA

AEGEAN SEA

15
16
14
17
11 12
13

18

19
20

MEDITERRANEAN SEA

21

23 22

Site names

1) Moigrad
2) Vinča
3) Majdanpek
4) Rudna Glava
5) Belovode
6) Pločnik
7) Selevac
8) Varna
9) Ai Bunar
10) Medni Rud
11) Catal Höyük
12) Can Hasan

13) Mersin
14) Aşıklı Höyük
15) Norşuntepe
16) Çayönü
17) Yarim tepe
18) Shanidar
19) Chesmeh Ali
20) Tepe Zagheh
21) Peqi'in
22) Nahal Mishmar
23) Abu Matar

Metal Sources
- silver
- gold
- copper
- tin

0 250 500 1,000 Km

125 250 500 Miles

7-1. Locations of metal ores and sites with important copper finds,
8000–3500 BC.

the Shanidar cave in northern Iraq dated to the Upper Palaeolithic,[3] had a round hole resembling the holes drilled in stone beads. Although this object appears to consist of metal that has corroded, it is most likely that the pendant was made from stone, namely, the green copper mineral malachite. It is interesting to note that this seems to be the earliest use of a green mineral for ornamentation. The dominant color for ornament and ritual in the Palaeolithic was red, mostly in the form of red ochre. Even if the find from Shanidar cave does not represent the earliest use of metal, it could yet be an indication of a fundamental change in color symbolism, represented by the choice of green-colored ornaments. Indeed, green stones of all kinds became quite common as ornaments during the first era of agriculture, the pre-pottery Neolithic in the Near East.

The Invention of Metallurgy: Cast or Smelted?

The smelting of mineral copper-bearing ores to extract copper was the decisive step in the invention of metallurgy. But how was it discovered? Was the first step the discovery that native metallic copper would liquify and could be poured into molds if raised to a very high (1083°C) temperature? Or did the first metallurgists accidentally mix powdered azurite or malachite minerals (perhaps granulated to make pigments) with charcoal grains in a reducing atmosphere in a kiln? If they did this, the copper could have smelted out of the mineral grains at about 1000–1200°C (depending on the nature of the ore), producing small but visible prills of metallic copper that could be tapped out of the reduced waste material, called slag, from the ore. It cannot be overemphasized that both phenomena must have made an enormous impression on Neolithic craftworkers. In one case a metallic "stone" would turn into a liquid and harden back into a metal; and in the other a more rocklike "stone" would be transformed into a metal with totally different properties.

Unfortunately, we have as yet no hard evidence about the chronological order of these discoveries, but the hypothesis that melting was discovered before smelting has become rather unlikely. The crucial evidence in favor of melting as a doorway toward smelting was a copper mace head found at the Neolithic settlement of Can Hasan in Anatolia, with a thick central hole that looked like it must

have been drilled or cast,[4] dated to around 6000 BC, and made of very pure copper typical of native copper. It was suggested that this object was cast from native copper—in other words, native copper was melted and poured into a mace-shaped mold.[5] At the time this suggestion was made, the oldest finds of copper slag—the best evidence for the smelting of copper ores—were dated to the late sixth and early fifth millennium BC, later than Can Hasan. However, detailed analysis proved this hypothesis wrong.[6] The mace head from Can Hasan *was* made of native copper, but it was *not* cast. Instead the Can Hasan mace head was hammered around a handle, probably made of wood.

Roughly contemporary with the mace head from Can Hasan is a lead bracelet from Yarim Tepe I in northern Iraq.[7] Unlike copper, lead is extremely rare as a native metal in nature. Therefore, the appearance of lead metal might indicate that a lead ore was smelted to produce lead, perhaps providing the idea for eventual copper-ore smelting. While most researchers agree that it is very unlikely copper was ever smelted accidentally in a fire (the so-called campfire theory) because the temperature in an open fire is not high enough, the accidental smelting of lead is certainly possible.[8] The melting point of lead also is much lower than that of copper, so one might speculate that, indeed, lead ores were cooked in an open

7-2. Metallographic section of a bead showing crystalline structures with so-called twinned crystals, which form after deformation and annealing.

fire and a small amount of lead metal might have been produced accidentally—and it was liquid! Such an observation must have aroused the curiosity if not the fascination of Neolithic craftworkers and could have initiated more experimentation not only with lead ores but also with copper ores.

Such a scenario is not at all far fetched. At the Neolithic settlement of Çayönü in southeastern Anatolia, where some of the earliest copper artifacts were found, pieces of galena (lead sulphide, the most abundant lead ore, black and shiny) were also recorded. Because early stone tool makers often improved the working qualities of stone materials by heating them in fire, it is not unlikely that they also tested copper and lead ores in a similar way. Even if copper ores did not yield a molten metal, they would change colors from green to black and/or red depending on the reduction conditions in the fire. This could have given rise to curiosity and further experimentation. All of these factors might eventually have resulted in the melting of copper or even the smelting of its ores.

The Origins of Metallurgy in the Near East

Smelting permitted craftworkers to make implements not just from occasional stray finds of native copper but also from the much more abundant copper ores, minerals such as azurite and malachite. While these minerals are themselves somewhat restricted in their geographic distribution, in regions where they are found, as in eastern Anatolia west of the upper Euphrates River or in the Balkan Mountains in Bulgaria, they often occur in great quantities (fig. 7-1). The discovery of smelting opened the possibility of extracting many tons of copper metal from such sources, which provided the impetus for the actual mining of malachite and azurite mineral veins. As noted, in a primitive smelting operation the mineral ore probably was first powdered, or pounded into small grains with a stone hammer; then it was mixed with charcoal grains in a small, thick-walled clay vessel or crucible; next the crucible was inserted in a kiln in a reducing (oxygen-reduced) atmosphere; finally the temperature was raised to 1000–1200°C, which can be achieved with blowpipes. In a partial smelt, the copper would have "sweated" out of the ore while the ore matrix was transformed into a bubble-filled slag. The slag would have been crushed to extract the copper prills. In a complete smelt, which required a consistently higher temperature, the copper metal would have flowed out of the slag and formed a layer of copper in the crucible. In both cases the slag and the clay crucible would have been discarded, probably near the place where smelting happened. The best archaeological evidence for smelting is the discovery of the discarded slag, crucibles, and ore fragments together in one site.[9]

Unfortunately, the time and place of the earliest smelting operation is not clear. In the Near East, the earliest evidence for smelting seems to have been found in Anatolia. However, the origin of slaglike material from Çatal Hüyük, level VIA (seventh millennium BC), located in south-central Anatolia and frequently identified as the oldest copper-smelting slag, is disputed.[10] Indications of copper smelting are dated firmly to the late Ubaid period (late fifth millennium BC) in the settlement of Norsuntepe in southeastern Anatolia[11] and also to the late fifth millenium BC in the settlement of Abu Matar in the northern Negev, Israel, dated 4200–4000 BC by radiocarbon.[12] At Abu Matar excavators found arsenic-rich copper prills still embedded in slag, indicating that arsenic-rich copper was smelted at this site.

This brings us to the invention of alloying, or the intentional mixing of two or more minerals to produce a metal not found or quite rare in nature, in order to obtain particular qualities of color or workability. The earliest evidence for this invention probably is at the settlement of Mersin, near Adana in southeastern Anatolia, where in the Middle Chalcolithic levels (XVII–XVI), dated to the early fifth millennium BC, metalworkers began to make simple copper tools—chisels and axes—by pouring molten copper into molds, or by casting, using copper that now can be identified by its chemical properties as having been obtained through the smelting of ores. By the middle of the fifth millennium BC, about the same date as Varna in Bulgaria, metalworkers at Mersin XVI–XIV were producing some cast metal tools made of copper with arsenic at levels of 1.15–4.25 percent,[13] a new metallic material that was harder than pure copper and easier to cast. When molten, pure copper absorbs oxygen from the air, which is released on cooling, thus producing cavities in

the metal. Arsenic in copper can bind the oxygen so that casts of better quality can be produced. Moreover, the presence of several-percent arsenic also reduces the melting point of the mixture and reduces the viscosity of the melt. Since copper ores are often associated with minerals of arsenic, it is possible that this new material was discovered accidentally. Its new qualities may have been recognized and, accordingly, certain ores may have been preferred to others. It was certainly not possible to produce this alloy by adding arsenic to molten copper, because the boiling point of arsenic is much lower (617°C versus 1083°C, the melting point of copper). The arsenic concentration could not be controlled as it varies between 0.5 and 5 percent in arsenical coppers of the fifth and fourth millennia. Nevertheless, alloying, even if it was only by selection of ores or smelted products, was an enormous advance in human control over the qualities of metal.

By the late fifth millennium BC, there were at least four centers of metallurgy in the Near East and Iran. Starting from the east, the first was in highland Iran, west and south of Tehran, where many small tools of copper (probably native copper) were found at Zagheh in an occupation spanning 5500–4600 BC, and slag containing copper prills was found at Cheshmesh-Ali in an occupation dated 4600–4000 BC.[14] The second center was in the mountainous part of southeastern Anatolia drained by the middle Euphrates River, from Malatya to Ergani, including Norsuntepe; the third was in southeastern Anatolia nearer the coast, including Mersin; and the fourth was in the Levant, west of the Jordan valley. It was in the latter region that lost-wax casting appeared earliest, again in the late fifth millennium BC.

Lost-wax casting made it possible to create metal objects in almost unlimited shapes, including sculptural pieces with intricate surface detail. In lost-wax casting, the original model of the object that the craftperson wanted to make out of metal was sculpted out of a mixture of beeswax and resin, possibly with fine surface details of hair and facial features, or with loops and garlands impossible to create by hammering and bending. Fragments of the clay molds still adhering to cast metal objects in Israel indicate that the original wax-and-resin model was enclosed in a very fine clay or marl that picked up all the surface details. This very fine first layer was encased in a rougher second layer of iron-rich clay mixed with quartz sand and vegetal material, and that layer was encased in a third layer of lime plaster or clay mixed with quartz sand and dried manure.[15] Holes were made to allow the wax-and-resin original to flow out when the mold was fired and the wax-and-resin model melted. After the clay mold was fired, molten metal was poured into the void evacuated by the resin and beeswax, and the metal cooled in the form of the lost-wax model. Seven sites west of the Jordan valley have produced arsenical copper artifacts made by the lost-wax process, dated broadly to 4500–3700 BC, the oldest examples of the use of this method. The most famous site is the cave at Nahal Mishmar, where in 1961 a hoard of 442 copper objects was found. Most were made by the lost-wax process and consisted of a curious alloy of copper, antimony, and some arsenic.[16] Other sites with objects cast by the lost-wax process, such as the mace head and standard at Pequi'in cave, are more securely dated by radiocarbon to the two centuries before 4000 BC.

By the last quarter of the fifth millennium BC, perhaps earlier, metalworkers in Anatolia, Iran, and the Levant had invented smelting, casting in simple molds, alloying through the selection of ores, and lost-wax casting. By the early fourth millennium BC, ample and widespread evidence of copper smelting and casting at an advanced level occurred at many different sites in eastern Anatolia—Değirmentepe, Norşuntepe, Tülintepe, and Tepecik—and on a considerable scale.[17] These sites played an important role in the provision of copper to the first cities in the lower Tigris and Euphrates valleys in the middle and late fourth millennium BC.

Interconnections between Early Metal-Working Centers

Not so many years ago, it was generally assumed that European metallurgy was derived from the Near East, whence it spread first to the Aegean and then into the Balkan peninsula. But the initial widespread application of radiocarbon dating in the 1950s and 1960s produced a chronology for the Balkan Copper Age that was much older and began much earlier than had been thought possible. In 1969 C. Renfrew drew together radiocarbon dates showing that the Balkan Copper Age was almost

as old as the oldest copper metallurgy in the Near East, and suggested that the production and use of copper in the Balkans was an indigenous, independent, or nearly independent development.[18] Strong support for this hypothesis was provided by the discovery of the prehistoric copper mines at Rudna Glava[19] and several other sites in Serbia as well as at Ai Bunar in Bulgaria.[20] Exploitation of some of these mines dates back to the middle of the fifth millennium BC, roughly the same time as, or even earlier than, the beginnings of copper smelting in the Near East.

As the data stands now, it would not be unreasonable to suggest that copper smelting began during the late sixth millennium BC in southeastern Europe and, somewhat later, in the first half of the fifth millennium BC, in Anatolia. But this conditional European priority depends on the resolution of the question of the nature of the slaglike material from Çatal Höyük, level VIA, which would give the priority back to Anatolia if it is confirmed as slag; and in any case rapidly changing archaeological discoveries make any claim of priority questionable. It is not at all clear whether the early metal-working centers in Anatolia, the Levant, Iran, and southeastern Europe had any influence on each other in the fifth millennium BC. Arsenical copper objects were made in southeastern Anatolia and the Levant, but were very unusual in Iran and southeastern Europe, where alloying appears to have been almost unknown. Lost-wax casting remained confined to the Levant until later in the fourth millennium BC. Smelting and casting, the only operations shared across all of these emerging metallurgical craft centers in the late fifth millennium BC, could have been invented independently in connection with high-temperature ceramic firing in kilns.

The Early Use of Copper in Southeastern Europe
The rich metal finds discovered in 1972 at the cemetery of Varna in Bulgaria, while excavations were still being conducted at the copper mines of Rudna Glava in Serbia,[21] inevitably directed international attention to the metal resources of southeastern Europe. While I. Ivanov was excavating at Varna, E.N. Chernykh produced the first extensive summary study of Copper Age metal finds and an evaluation of the mining sites in

Bulgaria.[22] H. Todorova followed with a comparative study of Copper Age axes and adzes.[23] Later S. Čochadžiev published new and further finds at Slatino and identified new presumed sources of copper minerals in the Struma Valley.[24] Since the 1980s there have been many studies of the copper artifacts and mines of southeastern Europe.

The Russian metallurgist N.V. Ryndina observed that the oldest use of native copper in southeastern Europe, to make small beads and other simple ornaments, occurred not in the southern regions, where Near Eastern influence would be expected to appear first, but at the northern edge of the Starčevo-Criş geographic distribution, where natural copper minerals occurred and pieces of native copper could be picked up from the earth's surface.[25] Copper awls, fishhooks, and rolled wire beads were the first things made of native copper, examples having been found in nine Starčevo and Criş settlements dated to the final phase of the Early Neolithic period in southeastern Europe. A good example is Selişte, a Late Criş farming hamlet dated 5800–5600 BC (6830±100 BP), where three small beads made of native copper were found in two separate trash deposits in an otherwise ordinary farming settlement in the forested valleys of the eastern Carpathian piedmont.[26] Copper was by no means common in Starčevo-Criş settlements. It remained a local novelty largely limited to areas within easy trading distance of a few major copper mineral outcrops, those that probably had already been found by Early Neolithic explorers in northeastern Serbia and perhaps those in the middle Mureş River valley in western Transylvania.

During the last two decades, it has become increasingly clear that the earliest smelting operations did not take place near the source of the raw material, at the mine or the outcrop, but in living areas or settlements. Copper slag was recently found at Belovode in Serbia, a settlement of the early Vinča period dated about 5400 BC. This seems to be the earliest copper-smelting slag presently known in southeastern Europe.[27] Belovode also contained several large collections or concentrations of malachite lumps, probably the ore that produced the slag; and the lead isotopes in some samples matched those from the deposit at Rudna Glava, where there was a Vinča-era mine. The sixth-millennium BC discoveries at Belovode

are consistent with the discovery of a cast copper chisel in the oldest occupation phase at the early Vinča settlement of Pločnik,[28] dated 5500–4700 BC, and with the presence of many lumps of malachite at Vinča throughout the stratigraphy of the settlement, from the earliest occupation phase to the latest. At Pločnik a feature was uncovered that could be the remains of a smelting oven, although without any identified copper slag. Four hoards of uncertain date, possibly later than the settlement, were found at Pločnik containing forty-five cast copper axe-hammers and chisels. These hoards introduce another aspect of southeastern European copper metallurgy: its abundance.

Southeastern Europe was one of a handful of places in the ancient world where craftworkers were making cast tools of smelted copper during the fifth millennium BC. But it is distinguished from any other early copper-working region by the sheer number and volume of early copper and gold artifacts that have been found, which far exceed the known production of all contemporaneous inventories in any other region. Altogether, the metal finds known today from southeastern Europe, including Hungary, add up to about 4,700 kilograms of copper and more than 6 kilograms of gold. Most of these objects (figs. 7-3, 7-4) date to a 700-year period between 4500 and 3800 BC.[29]

The immense abundance of copper artifacts in southeastern Europe from periods "before the Bronze Age" was evident already in the nineteenth century, leading to the suggestion that a separate period be introduced between the Neolithic and the Bronze Age, namely the Chalcolithic, or Copper Age.[30] Due to the lack of equivalent copper finds in western and northern Europe, this concept never received full acceptance, however, and indeed is disputed even today.[31] Possibly, this is the reason why Eneolithic is nowadays the much more common term in the archaeology of southeastern Europe. It would appear, however, that Eneolithic and Chalcolithic (or Copper Age) are used in the same way and can thus be considered synonymous. They simply denote a chronological stage between the Neolithic and the Bronze Age that is characterized by the more or less regular use of copper.[32] There seems to be a growing consensus, however, that this period in southeastern Europe actually

7-3. Spiral bracelet. Copper, Cucuteni, Ariuşd, 4500–3900 BC, MJIBV.

7-4. Axe. Copper, Gumelniţa, Glina, 4600–3900 BC, MNIR.

represented a specific era of cultural history between the Neolithic and the Bronze Age, with specific modes of food production,[33] social structure as indicated by settlement patterns, burial customs, and the exchange systems of material goods.

Copper Mines in Southeastern Europe

Significant Copper Age copper mines have been excavated by archaeologists B. Jovanović at Rudna Glava in northeastern Serbia and E.N. Chernykh at Ai Bunar in central Bulgaria.[34] But at many other places in southeastern Europe, archaeologists have discovered malachite or azurite mineral outcrops with surface indications of prehistoric mining, particularly in eastern and central Serbia, Transylvania, and southeastern Bulgaria. Copper mineral deposits of different geological ages and origins contain different clusters of lead isotopes, so the study of lead isotopes contained in the copper in Copper Age artifacts can identify and distinguish their geological sources. Studies of lead isotopes conducted by this author (Pernicka) and colleagues showed that 95 percent of the tested artifacts from the Copper Age in Bulgaria and Serbia fell into nine distinct lead-isotope groups, presumably from nine different geological sources.[35] Oddly, none of the Serbian metal objects in the original study could be ascribed to the archaeologically excavated Copper Age mine at Rudna Glava, although many could be ascribed to a nearby, actually much larger copper deposit in the same region, around Majdanpek. Recent studies of samples from the very early Vinča copper-working settlement at Belovode finally did produce a lead-isotope match with Rudna Glava. It is likely that much of the copper used in late Vinča and Bodrogkeresztúr settlements in the central Balkans was supplied by ore deposits from eastern Serbia.

The Ai Bunar mines were located near Stara Zagora in the Balkan Mountains, about thirty-two kilometers west of the well-known tell settlement of Karanovo, in a low knot of hills overlooking the elevated agricultural plain of the Maritsa River, an area where many tell villages were occupied during the Copper Age. The total amount of ore extracted from Ai Bunar in the Copper Age has been estimated to range between 2,000 and 3,000 tons, which might have yielded about 500 tons of copper. Ai

Bunar is in reality a collection of mines that were excavated at eleven different places into a rich vein of malachite contained in limestone, marl, and diorite. The mines were open trenches cut into the rock, ten to eighty meters long and three to ten meters wide. Most of them were two to three meters deep, but in some places they reached twenty or even thirty meters (more than ninety feet) in depth. Abandoned mine trenches were filled by the miners with material dumped from new trenches, as well as a variety of tools, pottery, and even the bodies of three individuals. Tools discarded in the trenches included more than twenty fragmented picks made from red-deer antler, very large hammer stones, and two heavily used cast copper tools, a hammer-axe and an axe-adze. Ceramic sherds from the excavated trenches were all from the Karanovo VI pots, dated about 4800–4300 BC, but copper objects that probably were made from Ai Bunar copper ore have been found in Karanovo V contexts, so the mines likely were operating by about 5000 BC.[36]

It is tempting to relate the Eneolithic copper artifacts in the Balkans to one of these mines, and this is in fact common practice. Chernykh, for instance, distinguished three metallurgical provinces in southeastern Europe and related them to the production centers of Ai Bunar, Rudna Glava, and an unknown center in the Carpathian mountains.[37] From her typological study of Eneolithic axes and chisels, H. Todorova came to similar conclusions but assumed that the geographically nearest mineral sources would have been utilized to make objects of a similar form in a particular region.[38] This basic model can be tested relatively easily with scientific methods by comparing the chemical and/or lead-isotopic composition of the artifacts with those of the supposed source materials. So far this approach has resulted more often in a rejection than a confirmation of the simple geographical-proximity assumption. A typical example, although from a later period, was the finding that the majority of northeast Aegean Early Bronze Age copper and bronze objects do not derive from presently known Aegean ore sources.[39] This conclusion made much less convincing the suggestion that the remarkable cultural development of the Aegean during the early third millennium BC was due to the invention of tin bronze in this region.[40] Actually, for some bronze objects there was, and still is, no ore

deposit known in Anatolia or southeastern Europe that could possibly have yielded their copper. The metal that defined the northern Aegean Early Bronze Age may well derive from very distant regions.

The results of lead-isotope studies have led to similar conclusions in Copper Age contexts in Bulgaria and Serbia.[41] For example, it is clear now that copper ore was carried from the mines to settlements for smelting, rather than being processed at the mine. This practice of transporting ore means that ore from different mines could have been dispersed through trade. Small fragments of malachite ore are frequently found in Copper Age settlements, both in the Vinča culture, as at Selevac, where more than two hundred small lumps were recorded,[42] and in Bulgaria. Lead-isotope analysis shows that a portion of the copper artifacts excavated from sites in Bulgaria could be convincingly related to the ore mined at Ai Bunar, but other Bulgarian objects were made from ores mined near Majdanpek in Serbia and others probably were made from ore mined at or near Medni Rud in southeastern Bulgaria, near Burgas. At the cemetery of Durankulak, on the Black Sea coast of Bulgaria, artifacts made from copper derived from completely different ore sources were found together in the same grave. Surprisingly, no Copper Age artifact in the original study was found to match the Rudna Glava ores, not even those from settlements very near Rudna Glava, so the proximity assumption is shown to be invalid. Unfortunately, no archaeological excavation has yet uncovered a production site with ore, a smelting oven, and slag. In fact, very little slag has been found anywhere in southeastern Europe, and it is thus not possible to identify exactly where smelting occurred, or where the copper tools and ornaments were made. Only the mining sites and the finished objects are well studied; the production process is largely undocumented.

Almost all of the metal artifacts produced in southeastern Europe during the Copper Age were made from rather pure and rich ores, as a rule more than 99 percent copper, as determined by the Württembergisches Landesmuseum in Stuttgart[43] and at the Academy of Sciences in Moscow.[44] Copper with more than 1 percent arsenic has been identified in only 2 out of 190 objects studied that derived from Late Copper Age contexts in Bulgaria, the period

and country where we find the majority of metal artifacts from the Copper Age. One of these was a bracelet from Grave 253 at Varna; the same grave also contained a pure copper bracelet. Copper with elevated arsenic (1.9 and 1.2 percent) was reportedly used to make a bracelet and a ring in the steppe-related graves at Giurgiuleşti, but this was unusual; the other six objects tested from these graves were said to be made of relatively pure copper with trace elements thought to be typical of Bulgarian ores.[45]

The period defined in Bulgarian archaeology as the Late Copper Age (Late Eneolithic) was the peak period of copper production in southeastern Europe, including Romania (fig. 7-5). Radiocarbon dates suggest that it began about 4700–4600 BC and ended about 4300–4200 BC. Subsequently, during the Final Copper Age, there was a hiatus in settlements on the Maritsa plain in the Balkans, near the Ai Bunar mines, and these mines seem to have ceased production. They might have been declining already during the Late Copper Age, as many artifacts from Varna and other sites have lead-isotope signatures that could indicate an ore source in southeastern Bulgaria near the coast, around Rosen, Burgas, and Medni Rud.[46] South of Burgas, occupation continued during the Final Copper Age at the now submerged coastal settlement of Sozopol. Among copper artifacts made during the Final Copper Age (4000–3600 BC) and the following Proto-Bronze Age (3600–3300 BC), more than half exhibit lead-isotope signatures consistent with an ore from near Majdanpek in northeastern Serbia,[47] which seems to have been the most important source of this period (figs. 7-6, 7-7).

Although these developments mark the end of the peak period of copper production, it was not the end of the Copper Age. In western Romania and eastern Hungary, including the territory near the copper-ore sources in western Transylvania, the Bodrogkeresztúr culture evolved around 4000 BC. Bodrogkeresztúr settlement sites were smaller and more ephemeral than the settlements of the preceding Tiszapolgar culture in the Tisza-middle-Danube region, and the Bodrogkeresztúr economy seems to have depended more on cattle breeding; but Bodrogkeresztúr graves and settlement areas were relatively rich in metal finds, including large cast copper tools (fig. 7-8). One of

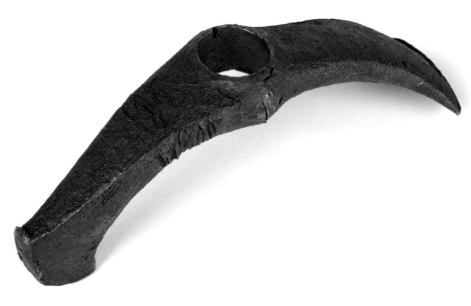

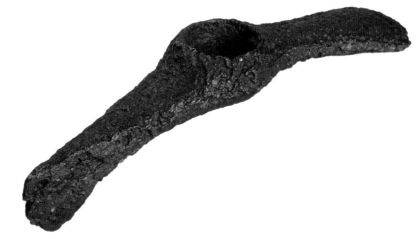

7-5 (top, left). Spiral bracelet. Copper, Cucuteni, Habasesti, 4500–3900 BC (Cucuteni A), MNIR.

7-6 (top, right). Axe. Copper, Cucuteni, Bogdăneşti, 3700–3500 BC (Cucuteni B), CMNM.

7-7 (bottom, left). Dagger. Copper, Cucuteni, Mereşti, 4500–3900 BC (Cucuteni A), MJIBV.

7-8 (bottom, right). Axe. Copper, Bodrogkeresztúr culture, Poiana, 4000–3500 BC, MNIR.

the most interesting Bodrogkeresztúr finds, the Moigrad hoard, contained several unique large gold pieces (figs. 7-9, 7-10, 1-17, page 162). The hoard has a complicated history, having been originally described as a combination of two hoards, one found in Tiszazőlős in Hungary and the other in Moigrad, western Romania, mixed with obviously more recent golden objects from a medieval Sarmatian grave that might have disturbed the Copper Age deposit at Tiszazőlős. J. Chapman provided a good review of the recent arguments about the origins of the hoard and concluded that most of it might have come from a single Bodrogkeresztúr deposit, perhaps a grave, at Tiszazőlős.[48] This would make the gold objects later in date than Varna, which might explain the dissimilarities between the Moigrad and Varna gold objects, but a large golden pendant at Moigrad (page 162) does resemble similar "ring-idols" from the peak Late Copper Age.

The Copper and Gold of Varna

The Late Copper Age cemetery of Varna I was accidentally discovered in 1972 during excavation of a cable trench in an industrial area west of the city of Varna.[49] The keeper of the prehistoric collection of the museum in Varna, Ivan Ivanov, was called in immediately and excavations were conducted under his directorship until 1986. Only thirty-six graves, about 12 percent of all excavated graves at Varna, have been entirely published to date in various articles.[50] It is obvious from the plan of the cemetery that the site has not yet been investigated completely but continues most likely on both the southwest and the northwest.[51]

Archaeologically the cemetery belongs to the so-called Kodžadermen-Gumelniţa-Karanovo VI complex (KGK VI), which covers most of Bulgaria and southern Romania between the delta of the Danube River on the north and the Rhodope Mountains on the south. Varna has aroused great interest because of the exceptional wealth of gold finds,[52] but the graves also contained many copper finds that seem to derive from different ore deposits in various regions.[53] This diversity suggests that the social elite buried there might have drawn on the resources of a larger region.

The gold articles from Varna were studied first by A. Hartmann, who analyzed 137 objects by means of

7-9. Anthropomorphic appliqué. Gold, Bodrogkeresztúr culture, Moigrad, 4000–3500 BC, MNIR.

7-10. Anthropomorphic appliqué. Gold, Bodrogkeresztúr culture, Moigrad, 4000–3500 BC, MNIR.

atomic-emission spectrometry.[54] The Varna gold can be assigned to essentially two gold sources. One, designated gold source B, had no impurities of platinum, and the other, designated gold source BP, had considerable platinum impurities. Both sources were tin-free and had a moderate silver content of approximately 11 percent. Gold derived from source BP, from which about half of the examined gold articles at Varna were manufactured, is limited to sites located in the coastal zone of the Black Sea. Gold derived from source B, according to Hartmann, is found in the entire region of the lower Danube valley and along the coast of the Black Sea. He assumed that the platinum-rich BP source was located east or southeast of the Black Sea, in the South Caucasus, where the gold of Colchis was famous in the later Greek world; and he assigned the platinum-free B source broadly to the eastern Mediterranean area. But recent research has concentrated on much closer sources, particularly on the possibility of gold in the eastern Balkans, not far west of Varna, and in the southern Balkans, near Mount Sakar on the Turkish border. From the Bulgarian side, the alluvial gold deposits of Bulgaria have been investigated by Z. Tsintsov.[55] Ancient gold mining in Bulgarian and Turkish Thrace, which was famous in the ancient world for its gold, has been investigated by A. Jockenhövel and X. Popov.[56] Some of the technological aspects of gold processing and manufacture at Varna were studied further by R. Echt and colleagues.[57]

J. Lichardus and M. Lichardus-Itten proposed a model for the formation of the Copper Age cultures of the Balkans and lower Danube valley that assumed an exchange and mutual influence between indigenous Old European farmers and nomadic stock breeders from the steppes, resulting in a specific type of burial rite.[58] The seemingly rather abrupt end to this prosperous era has long been discussed, but as yet no generally accepted explanation is at hand. Earlier hypotheses of an invasion of nomadic people from the steppe[59] have been widely criticized. Presently the most broadly accepted explanation for this sharp decline, one that includes also the Aegean cultures, is that the environment altered—due to a climatic change—in a way that was unsuitable for the economy of tell settlements.[60]

Notes

1 Technically this is called annealing. Clear evidence for annealing has been identified at Aşıklı Höyük and Çayönü, both in Turkey; see Muhly, J.D., "Çayönü Tepesi and the Beginnings of Metallurgy in the Ancient World," in *Old World Archaeometallurgy*, ed. A. Hauptmann, E. Pernicka, and G.A. Wagner, Der Anschnitt, suppl. 7 (Bochum: Deutsches Bergbau-Museum, 1989): 1–11; see also Yalçın, U., and E. Pernicka, "Frühneolithische Metallbearbeitung am Aşıklı Höyük, Türkei," in *The Beginnings of Metallurgy*, ed. A. Hauptmann, Pernicka, T. Rehren, and Yalçın, Der Anschnitt, suppl. 9 (Bochum: Deutsches Bergbau-Museum, 1999): 45–54.

2 Kienlin, T.L., and E. Pernicka, "Aspects of the Production of Copper Age Jászladány Type Axes," in *Metals and Societies*, ed. T.L. Kienlin and B.W. Roberts, "Studies in Honour of Barbara S. Ottaway," Universitätsforschungen zur prähistorischen Archäologie 169 (Bonn: Habelt, 2009): 258–76.

3 Solecki, R.S., "A Copper Mineral Pendant from Northern Iraq," *Antiquity* 43 (1969): 311–14.

4 French, D.H., "Excavations at Can Hasan: First Preliminary Report, 1961," *Anatolian Studies* 12 (1962): 27–40.

5 Wertime, T.A., "Man's First Encounter with Metallurgy," *Science* 146 (1964): 1257; Wertime, T.A., "The Beginning of Metallurgy: A New Look," *Science* 182 (1973): 875–86.

6 Yalçın, Ü.,"Der Keulenkopf von Canhasan (TR). Naturwissenschaftliche Untersuchung und neue Interpretation," in *Metallurgica Antiqua*, ed. A. Hauptmann, J. Muhly, and Th. Rehren, Der Anschnitt, suppl. 8 (Bochum: Deutsches Bergbau-Museum: 1998): 279–89.

7 Merpert, N.Y., and R.M. Munchaev, "The Earliest Metallurgy of Mesopotamia," *Sovietskaya Arkheologiya* (1977): 154–63.

8 Tylecote, R.F., *Metallurgy in Archaeology* (London: Edward Arnold, 1962).

9 Ottaway, B.S., *Prähistorische Archäometallurgie* (Espelkamp: Marie Leidorf, 1994).

10 Neuninger, H., R. Pittioni, and W. Siegl, "Frühkeramikzeitliche Kupfergewinnung in Anatolien," *Arch. Austriaca* 26 (1964): 52–66; Tylecote, R.F., *A History of Metallurgy* (London: Metals Society, 1976).

11 Zwicker, U., "Investigations on the Extractive Metallurgy of Cu/Sb/As Ore and Excavated Smelting Products from Norsun-Tepe (Keban) on the Upper Euphrates (3500–2800 bc)," in *Aspects of Early Metallurgy*, ed. W.A. Oddy, Occasional Paper 17 (London: British Museum, 1980): 13–26; Hauptmann, A., J. Lutz, E. Pernicka, and Ü. Yalçın, "Zur Technologie der frühesten Kupferverhüttung im östlichen Mittelmeerraum," in *Between the Rivers and Over the Mountains*, ed. M. Frangipane et al., Archaeologica Anatolica et Mesopotamica Alba Palmieri dedicata (Dip. Scienze Storiche Archeologiche e Antropologiche dell'Antichità) (Rome: Universita di Roma La Sapienza, 1993): 541–72.

12 Goren, Y., "The Location of Specialized Copper Production by the Lost Wax Technique in the Chalcolithic Southern Levant," *Geoarchaeology* 23, no. 3 (2008): 374–97, see 376 for the Abu Matar slag; and Burton, M., and T.E. Levy, "The Chalcolithic Radiocarbon Record and Its Use in Southern Levantine Archaeology, *Radiocarbon* 43, no. 3 (2001): 1223–46, see 1231 for the Abu Matar radiocarbon dates.

13 Yener, K.A., *The Domestication of Metals: The Rise of Complex Metal Industries in Anatolia* (Leiden: Brill, 2000); see also Sagona, A., and P. Zimansky, *Ancient Turkey* (London: Routledge, 2009): 139, 205.

14 Matthews, R., and H. Fazeli, "Copper and Complexity: Iran and Mesopotamia in the Fourth Millennium bc," Iran 42 (2004): 61–75.

15 Goren, "The Location of Specialized Copper Production" (2008): 383–86.

16 Tadmor, M., et al., "The Nahal Mishmar Hoard from the Judean Desert: Technology, Composition, Provenance," *Atiqot* 27 (1995): 93–146.

17 Lutz, J., "Geochemische und mineralogische Aspekte der frühen Kupferverhüttung in Murgul/Nordost-Türkei" (Ph.d. diss., Universität Heidelberg, 1990).

18 Renfrew, C., "The Autonomy of South-east European Copper Age," *Proceedings of the Prehistoric Society* 35 (1969): 12–47.

19 Jovanovic, B., *Rudna Glava. Najstarije rudarstvo bakra na Centralnom Balkanu* (Bor: Museum für Bergbau- und Hüttenwesen; Beograd: Archäologisches Institut, 1982).

20 Chernykh, N.E., *Gornoje delo i metallurgija v drevnejsej Bolgarii* (Sofia: Arkheologicheskii Institut i Muzei Bolgarskoi Akademii Nauk, 1978).

21 Ivanov, I., "Les fouilles archéologiques de la nécropole chalcolithique à Varna," *Studia Praehistorica* 1–2 (1978): 13ff.; Jovanović, B., "Rudna Glava—ein Kupferbergwerk des frühen Eneolithikums in Ostserbien," *Der Anschnitt* 28 (1978): 150–57; Jovanović, *Rudna Glava* (1982).

22 Chernykh, *Gornoje delo i metallurgija v drevnejsej Bolgarii* (1978).

23 Todorova, H., *Kupferzeitliche Äxte und Beile in Bulgarien*, Prähistorische Bronzefunde 9 (14) (Munich: C.H. Beck, 1981).

24 Čochadžiev, S.,"Untersuchungen des frühen Äneolithikums im südwestlichen Bulgarien," in *Internationales Symposium über die Lengyel-Kultur* (Nitra: Archäologisches Institut der Slowakischen Akademie der Wissenschaften in Nitra, 1986): 45–52.

25 For Early Neolithic copper artifacts, see Ryndina, N.V., *Drevneishee metallo-obrabatyvaiushchee proizvodstvo iugo-vostochnoi Evropy* (Moskva: Editorial, 1998): 28–32.

26 Dergachev, V., A. Sherratt, and O. Larina, "Recent Results of Neolithic Research in Moldavia (USSR)," *Oxford Journal of Prehistory* 10, no. 1 (1991): 1–16.

27 Radivojevic, M., et al., "The Beginnings of Metallurgy in Europe— Early Smelting Activities in the Vinča Culture," paper presented at "Ancient and Medieval Metalworks: Archaeology-Numismatics-Nuclear Analyses," Second International Symposium, Bucharest, May 2008; Antonović, D., "Copper Processing in Vinča: New Contributions to the Thesis about Metallurgical Character of Vinča Culture," *Starinar* 52 (2002): 27–45.

28 Šljivar, D., "The Eastern Settlement of the Vinča Culture at Pločnik: A Relationship of Its Stratigraphy to the Hoards of Copper Objects," *Starinar* 47 (1996): 85–97.

29 All dates are calendar dates, i.e., radiocarbon dates are dendrochrono-logically corrected.

30 Von Pulszky, F., *Die Kupferzeit in Ungarn* (Budapest, 1884); Much, M., *Die Kupferzeit in Europa und ihr Verhältnis zur Cultur der Indogermanen* (Wien, 1886).

31 Lichardus, J., "Die Kupferzeit als historische Epoche. Eine forschungsge-schichtliche Einleitung," in *Die Kupferzeit als historische Epoche*, ed. Lichardus, Saarbrücker Beiträge zur Altertumskunde 55 (Bonn: Habelt, 1991): 13–32.

32 There exist, however, considerable differences as to which cultures should be summarized under this term. In this article we largely follow the usage in Bulgaria, where the Eneolithic is considered to begin with the first appearance of heavy copper implements, while researchers in former Yugoslavia prefer to speak of the Eneolithic only when copper objects become abundant (e.g., see Tasić, N., Eneolithic Cultures of Central and West Balkans [Belgrade: Draganić, 1995]).

33 Sherrat, A., "Plough and Pastoralism: Aspects of the Secondary Products Revolution," in *Patterns of the Past*, ed. G. de G. Sieveking, I.H. Longworth, and K.E. Wilson (Cambridge, 1983): 261–305.

34 Jovanović, B., "Rudna Glava" (1976); Jovanović, *Rudna Glava* (1982); Chernykh, E.N. "Ai Bunar, a Balkan Copper mine of the IVth Millennium BC," *Proceedings of the Prehistoric Society* 44 (1978): 203–18; Chernykh, E.N., *Ancient Metallurgy in the USSR: The Early Metal Age* (Cambridge: Cambridge University Press, 1992).

35 Pernicka, E., F. Begemann, S. Schmitt-Strecker, and G.A. Wagner, "Eneolithic and Early Bronze Age Copper Artefacts from the Balkans and Their Relation to Serbian Copper Ores," *Prähistorische Zeitschrift* 68 (1993): 1–54; Pernicka, E., et al., "Prehistoric Copper in Bulgaria: Its Composition and Provenance, *Eurasia Antiqua* 3 (1997): 41–180.

36 Gale, N.H., et al., "Recent Studies of Eneolithic Copper Ores and Artefacts in Bulgaria," in *Découverte du métal*, ed. J.P. Mohen (Paris: Picard, 1991): 49–76.

37 Chernykh, E.N., "O jugo-vostochnoj zone Balkano-Karpatskoj metallurgicheskoj provintsii épokhi éneolita," *Studia Praehistorica* (Sofia) 1–2 (1978): 170–81.

38 Todorova, H., "Die kupferzeitlichen Äxte und Beile in Bulgarien," Prähistorische Bronzefunde 9 (14) (München: Beck, 1981).

39 Pernicka, E., et al. "Archäometallurgische Untersuchungen in Nordwestanatolien," *Jahrbuch Romisch-Germanischen Zentralmus* 31 (1984): 533–99; Pernicka, E., F. Begemann, S. Schmitt-Strecker, and A.P. Grimanis, "On the Composition and Provenance of Metal Artefacts from Poliochni on Lemnos," *Oxford Journal of Archaeology* 9 (1990): 263–98; Begemann, F., S. Schmitt-Strecker, and E. Pernicka, "The Metal Finds from Thermi III–V: A Chemical and Lead Isotope Study," *Studia Troica* 2 (1992): 219–39.

40 Renfrew, C., "Cycladic Metallurgy and the Aegean Early Bronze Age," *American Journal of Archaeology* 71 (1967): 2–26; Branigan, K., *Aegean Metalwork of the Early and Middle Bronze Age* (Oxford: Clarendon, 1974).

41 Pernicka, Begemann, Schmitt-Strecker, and Wagner, "Eneolithic and Early Bronze Age Copper Artefacts" (1993); Pernicka, "Prehistoric Copper in Bulgaria" (1997).

42 Glumac, P., and R. Tringham, "The Exploitation of Copper Minerals," in *Selevac: A Neolithic Village in Yugoslavia*, ed. Tringham and D. Krštić (Los Angeles: Institute of Archaeology, University of California, Los Angeles, 1990): 549–66; for malachite in other Vinča sites, see also Antonović, "Copper Processing in Vinča" (2002).

43 Chernykh, E.N., *Istorija drevnejsej metallurgii Vostocnoj Evropy*, Materialy i issledovanija po arkheologii 132 (Moskva and Leningrad: Akademii Nauk, 1966).

44 Junghans, S., E. Sangmeister, and M. Schröder, Kupfer und Bronze in der frühen Metallzeit Europas 1–3 (Berlin, 1968).

45 Ryndina, *Drevneishee metallo-obrabatyvaiushchee proizvodstvo iugo-vostochnoi Evropy* (1998): 165.

46 Pernicka, "Prehistoric Copper in Bulgaria" (1997): 131–33.

47 Ibid.: 136.

48 Chapman, J., *Fragmentation in Archaeology: People, Places and Broken Objects in the Prehistory of Southeastern Europe* (London: Routledge, 2000): 118–20.

49 Ivanov, I., "Razkopki na varnenskija eneoliten nekropol prez 1972 godina," *Izvestija na Narodnija muzej Varna* 11 (1975): 1–17.

50 Ivanov, I., "Les fouilles archéologiques de la nécropole chalcolithique à Varna," *Studia Praehistorica* 1–2 (1978): 13ff.; Ivanov, I., "Das Gräberfeld von Varna," in *Macht, Herrschaft und Gold. Das Gräberfeld von Varna (Bulgarien) und die Anfänge einer neuen europäischen Zivilisation*, ed. A. Fol and J. Lichardus (Saarbrücken: Moderne Galerie des Saarland-Museums, 1988): 49ff.; Ivanov, I. "Der Bestattungsritus in der chalkolitischen Nekropole in Varna," in *Die Kupferzeit als historische Epoche*, ed. Lichardus (1991): 125ff.; Ivanov, I., and M. Avramova, *Varna Necropolis: The Dawn of European Civilization* (Sofia: Agatho, 2000).

51 The untimely death of Ivan Ivanov in 2001 prohibited a complete publication of the cemetery for some time. Presently the new keeper of prehistoric archaeology in the museum of Varna, Vladimir Slavčev, is working on the final publication.

52 Todorova, H., "Die Nekropole bei Varna und die sozialökonomischen Probleme am Ende des Äneolithikums Bulgariens," *Zeitschrift für Archäologie* 12 (1978): 87ff.; Renfrew, C., "Varna and the Social Context of Early Metallurgy," in *Problems of European Prehistory*, ed. Renfrew (Edinburgh: Edinburgh University Press, 1979): 378–88; Chapman, J., "The Creation of Social Arenas in the Neolithic and Copper Age of South East Europe: The Case of Varna," in *Sacred and Profane: Proceedings of a Conference on Archaeology, Ritual and Religion, Oxford, 1989*, ed. P. Garwood, R. Skeates, and J. Toms (Oxford: Oxford Committee for Archaeology, 1991): 152ff.; Marazov, I., "Grave No 36 from the Chalcolithic Cemetery in Varna—Myth, Ritual and Objects," in *Die Kupferzeit als historische Epoche*, ed. Lichardus (1991): 151–55.

53 Gale, N.H., et al., "Early Metallurgy in Bulgaria," in *Mining and Metal Production Through the Ages*, ed. P. Craddock and J. Lang (London: British Museum Press, 2003): 122–73; Marazov, "Grave No 36" (1991).

54 Hartmann, A., *Prähistorische Goldfunde aus Europa II*, Studien zu den Anfängen der Metallurgie 5 (Berlin: Mann, 1982): 5.

55 Tsintsov, Z., "Unique Finds of Golden Articles in Alluvial Placers," *C.R. Acad. Bulg. Science* 45, no. 6 (1992): 59–61; Tsintsov, Z., and Z. Damyanov, "Sperrylite from Struma River Placers, Blagoevgrad Graben, SW Bugaria," *N. Jb. Miner*, Mh. H11 (2001): 528–28.

56 Jockenhövel, A., and Kh. Popov, "B'lgaro-Nemski arkheometalurgichen proekt, 'Zhelyazo i Zlato'—A. po sledite na metalurgiyata ne drevna trakiya," in *B'lgarska arkheologiya 2008. Katalog k'm izlozhba*, ed. Z. Dimitrov (Sofia): 31–33.

57 Echt, R., W.-R. Thiele, and I. Ivanov, "Varna—Untersuchungen zur kupferzeitlichen Goldverarbeitung," in *Die Kupferzeit als historische Epoche*, ed. Lichardus (1991): 633–91.

58 Lichardus, J., and M. Lichardus-Itten, "Nordpontische Beziehungen während der frühen Vorgeschichte Bulgariens," Thracia (Sofia) 11 (1995): 31ff.

59 Gimbutas, M., "The First Wave of Eurasian Steppe Pastoralists into Copper Age Europe," *Journal of Indo-European Studies* 5, no. 4 (1977): 277–338.

60 Todorova, H., "Probleme der Umwelt der prähistorischen Kulturen zwischen 7000 und 100 v. Chr.," in *Das Karpatenbecken und die osteuropäische Steppe. Nomadenbewegungen und Kulturaustausch in den vorchristlichen Metallzeiten (4000–500 v.Chr.)*, ed. B. Hänsel and J. Machnik, Prähistorische Archäologie in Südosteuropa 12 (Rahden: Marie Leidorf, 1998): 65ff.

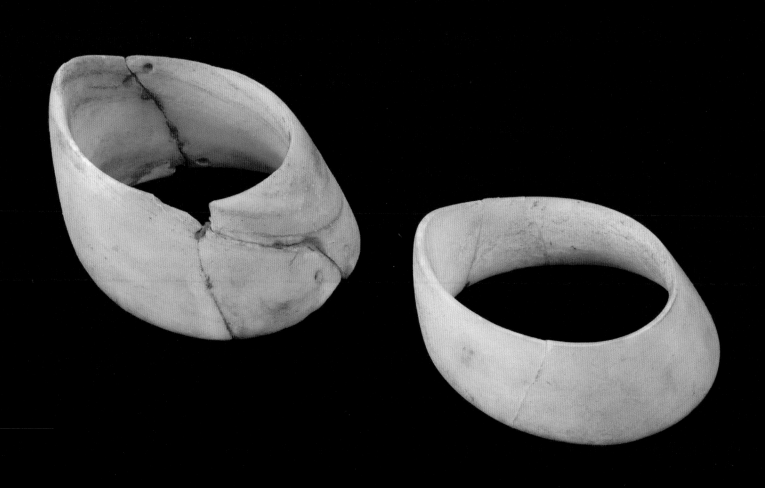

Spondylus and Long-Distance Trade in Prehistoric Europe

Michel Louis Séfériadès

Centre National de la Recherche Scientifique (CNRS)

Long-distance trade routes have always been an object of fascination for geographers and historians, exciting the imagination and stimulating inquiries, for the simple reason that trade routes combine universal concepts of space and time—thus making sense of the human condition in an indelible way. Linking diverse cultures and civilizations, these routes depended upon economic, social, political, cultural, and religious conditions, and reflected the entire array of institutions and ideologies embraced by the individuals who interacted along the way. As a microcosm of the essential problems of the social sciences, trade routes can help to frame the questions we ask in seeking to understand the meaning of social life in the ancient world, as well as the possible answers that we might expect.

I have been interested for a long time in ancient shells, and particularly in the *Spondylus gaederopus*. I discovered a *Spondylus* shell during my first excavation at the archaeological site of Dikili-Tash in Greek eastern Macedonia, not far from the Aegean Sea. The site was occupied from the Neolithic through the Early Bronze

Age, about 5500–3000 BC. Researching books and archaeological reports,[1] I realized that this shell, which grows only in Mediterranean waters, was exported far into Europe and in fact represented the oldest long-distance trade of a specific, identifiable resource on the continent. I also perceived an analogy to much-later trade in other precious natural resources, characterized by a complicated mixture of economic, social, and religious associations, such as the lapis lazuli trade that brought this brilliant blue stone from Afghanistan to Mesopotamia (actually Iraq),[2] or the well-known jade trade that crossed central and east Asia.[3] Similar socioeconomic and religious implications perhaps held for other historically attested exchange systems, such as the circulation of Cowrie shells (*Cypraeidae*) from India to Africa[4] and, at a smaller scale, that of the *Dentalium* shell in North America.[5] I asked why a shell that is, in simple terms, just an oyster would have been traded from the Mediterranean almost to the British Channel, but I was dissatisfied with the answer repeatedly offered, that it was for "prestige." What happened across Europe with the *Spondylus* shell seems to me a much more complicated affair and one that, we shall see, remains surrounded by many mysteries.

Two large bracelets. *Spondylus*, Hamangia, Cernavodă, 5000–4600 BC, MINAC and MNIR.

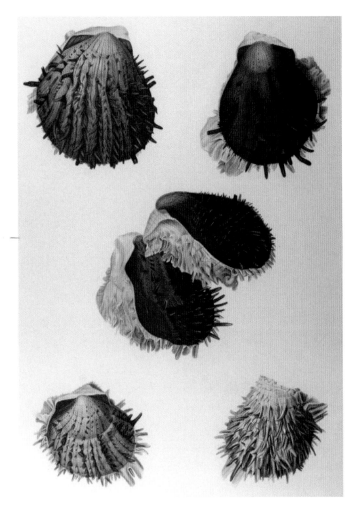

8-1. *Spondylus gaederopus* (source: Chenu, 1842).

The Origin and Distribution of *Spondylus gaederopus* Shells

Bivalves of the genus *Spondylus* (Latin *spondylus*, Greek *sphondulos, spondulos*, vertebra) are mollusks (phylum *mollusca*) of the class Bivalvia (bivalves). The animal lacks filaments (*byssus*) with which to attach itself to the sea floor, but instead cements itself to rocks like the true oyster. The shell is more or less round but with two unequal valves, and on the outside it is brightly colored and furnished with spines and foliaceous blades (fig. 8-1). The two valves are connected with a ball-and-socket type hinge, thick enough to provide the raw material for beads and other ornaments, while the shell itself is a highly colored, very attractive purplish crimson.

There are many species of *Spondylus* around the globe, but all live only in warm seas, at depths from two to thirty meters. The shells are found relatively isolated and strongly attached to rock. As beautiful curiosities they are relatively rare: They lose some of their color if exposed on a beach, so the best specimens for ornaments must be obtained by diving, but they are difficult to find and detach. In ancient Europe the shells were valued both on the Mediterranean coasts and far inland, where they were worked, venerated, and exchanged in many different periods. In Pre-Columbian America they nourished the gods,[6] and in the western islands of the Pacific Ocean they were until recently symbols of institutional power.[7]

The species *S. gaederopus* lives in the waters of the Mediterranean Sea and extends down the northwestern African coast, but does not occur in the Black Sea, primarily due to the temperature and the salinity of its water. Analyses of the oxygen and strontium isotopes in ancient *Spondylus* shells found in Neolithic archaeological sites in Europe have shown that they came from the Mediterranean, and not from old fossil deposits on land or from the Black Sea.[8] As the microstructure of the shell is formed from calcite and aragonite,[9] the large valves of *S. gaederopus* offer an ideal material for working, sculpting, and fine polishing, to produce objects for the adornment of clothing and the body (fig. 8-2). Neolithic ornaments made from *Spondylus* are superbly executed and include pendants made of the whole shell with single or multiple perforations, and the whole shell cut by a

deep notch or V-shaped incision; thin as well as very large bracelets that are round or flattened in section, made from the outer circumference of the shell; beads in the shape of discs and ovoid or rhomboidal cylinders; and occasionally pendants sculpted in the form of anthropomorphic or zoomorphic figures.

In Europe the appearance of *Spondylus* as a valuable item in long-distance trade coincided with the creation of new regional exchange networks that accompanied the introduction of farming economies, precipitating the new economic order that began the Neolithic era. The earliest farming economies in Europe evolved, I believe, as the result of a largely independent process, which took place first in the modern territory of Greece about 7500–6500 BC, whereby local foragers adopted domesticated plants and animals from the Near East.[10] Within this Aegean environment the *Spondylus* was a native shell. In spite of the absence of texts and oral traditions, we can follow the *Spondylus* trade archaeologically over nearly three thousand kilometers—mirroring the trajectory of the spread of domesticated wheat, barley, legumes, cattle, and sheep northward out of Greece extending from the Aegean and the Adriatic Seas, where the shells were harvested, to France, Germany, and Poland, where they are found in the archaeological remains of settlements and cemeteries, in graves, and as isolated finds (fig. 8-3).[11]

In the Mediterranean, the southernmost *Spondylus* beads are found in the Neolithic of Sicily and the archipelago of Malta.[12] In the Aegean region during the Neolithic, as during the Copper Age, worked *Spondylus* ornaments are commonly found in Greece and Thessaly and in Greek Macedonia and Thrace.[13] They also occur south to the Peloponnese in Greece, in contexts related to sites of worship or sacred places such as caves. A small cut-out and contour-perforated pendant representing a bear, possibly pregnant, was found in the cave of Kitsos (Attica) and may be related to neighboring Braurôn, the site of a sanctuary of Artemis and a bear cult (fig. 8-4).

To the north, in Bulgaria, the large Neolithic and Copper Age cemeteries (dated about 4500–4200 BC) of Varna and Durankulak on the edge of the Black Sea have produced many objects fabricated from *Spondylus* with other

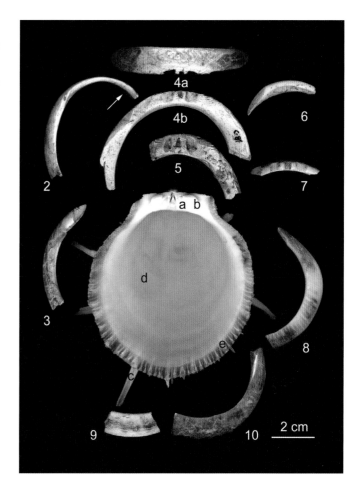

8-2. *Spondylus* shell and representative bracelet fragments. 1. *Spondylus*, inner side of the left valve, a. socket, b. cardinal tooth, c. spine, d. adductor scar, e. ventral margin; 2–10. bracelet fragments; the arrow points to the preserved bottom of the umbonal cavity (source: Dimitrijevic and Tripkovic, 2006, fig. 2).

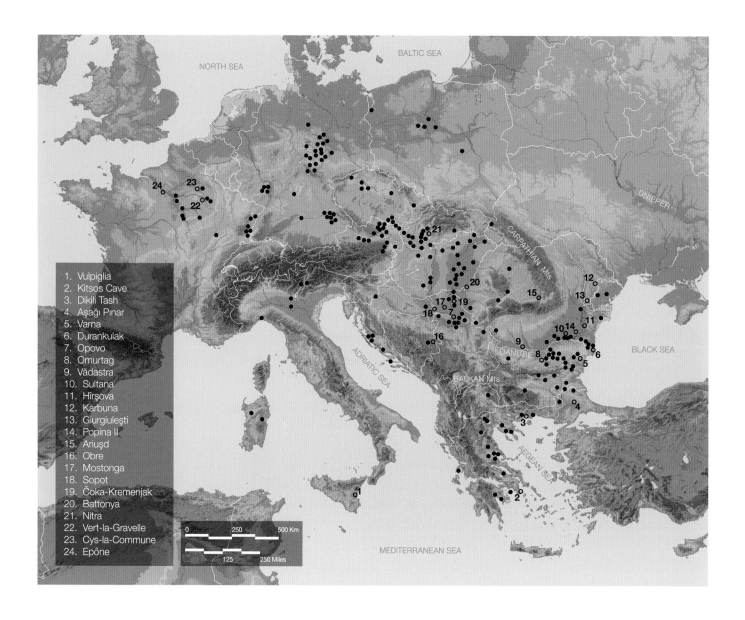

1. Vulpiglia
2. Kitsos Cave
3. Dikili Tash
4. Aşağı Pınar
5. Varna
6. Durankulak
7. Opovo
8. Omurtag
9. Vădastra
10. Sultana
11. Hîrşova
12. Karbuna
13. Giurgiuleşti
14. Popina II
15. Ariuşd
16. Obre
17. Mostonga
18. Sopot
19. Čoka-Kremenjak
20. Battonya
21. Nitra
22. Vert-la-Gravelle
23. Cys-la-Commune
24. Epône

8-3. The pattern of Neolithic diffusion of *Spondylus* artifacts from the Aegean and Adriatic seas to the English Channel.

shells, including *Glycymeris*,[14] as well as with various objects of cut and polished stone and bone, copper, and gold (figs. 8-5, 8-6). In northeastern Bulgaria the "treasure" of the tell of Omurtag, preserved in a vase from the Copper Age culture of Karanovo VI, includes fragments of *Spondylus* bracelets, cut and polished stone tools, bone artifacts, the incisors of a pig, and a grindstone.[15]

North of Bulgaria, *Spondylus* artifacts are found in great numbers in Romania, the territory of the former Yugoslavia,[16] Hungary, Slovakia, and the Czech Republic (Bohemia and Moravia). The tombs of old men—the richest graves—have yielded *Spondylus* artifacts in Slovakia and the necropolis of Nitra (Bandkeramik Neolithic culture, about 5500–5000 BC), and in southern Poland, where artifacts are found that combine *Spondylus* with cut and polished stone.[17] During the Neolithic and Copper Age periods in Romania, *Spondylus* artifacts are present not only in the south of the country—in the Danubian areas corresponding with the cultures of Criş, Dudeşti, Hamangia, Boian, Gumelnitsa, Cernavoda I, and Cernavoda II—but also in the Carpathian Basin, Transylvania, and Banat (figs. 8-7–8-10).

In northeastern Romania, however, in the region of the Cucuteni-Tripol'ye culture, *Spondylus* artifacts appear absent, with no obvious explanation. The single known exception is the unique hoard of Karbuna, found in Moldova, south of Chisinau.[18] The Karbuna hoard contained 444 copper objects as well as 270 ornaments and unfinished pieces of *Spondylus* shell hidden in a Tripol'ye A pot probably dated about 4500 BC—an exceptional indication that *Spondylus* was traded into Cucuteni-Tripol'ye societies.

Even farther north, in Austria, Bavaria, the Rhenish regions, and northwestern France, *Spondylus* artifacts also are found, usually in Neolithic graves. The farthest northwestern find was a large cylindrical *Spondylus* bead serendipitously discovered at Epône, northwest of Paris. Further west the acid nature of the soil probably did not favor the preservation of the shells, but one may wonder whether *Spondylus* artifacts could have reached Brittany and consequently the Atlantic coast. Curiously, the farther one moves away from the Adriatic-Aegean,

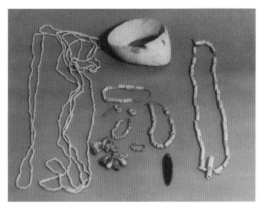

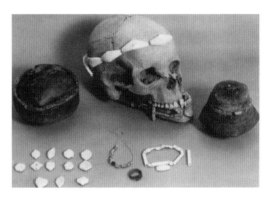

8-4. Small *Spondylus* pendant representative of a bear from the cave of Kitsos, Attic, Greece (after D. Vialou, Musée Nationale d'Histoire Naturelle).

8-5. Necklace and bead bracelets made from *Spondylus*, and other objects made from the canine teeth of deer, from the cemetery of the later Hamangia culture at Durankulak, Bulgaria (after H. Todorova and M. Avramova, National Museum of History, Sofia).

8-6. Diadem and bead bracelet made from *Spondylus*, and other objects made of copper, from the cemetery at Durankulak, Bulgaria (after H. Todorova and M. Avramova, National Museum of History, Sofia).

the native habitat of the *Spondylus*, the more frequently *Spondylus* artifacts appear to abound! This apparent paradox stimulates a number of questions concerning the underlying reasons for the astonishing diffusion.

The Organization and Meaning of the *Spondylus* Trade

Most of the *Spondylus* artifacts found in Europe were initially processed and then finished on the Aegean and Adriatic coasts or in farming communities not far from the sea, principally in modern Greece, Albania, Montenegro, and Croatia. *Spondylus* shells usually were not traded in a fresh or growth state or as separate unworked valves. Nevertheless, abraded valves apparently collected on beaches are found in some of the areas farthest away from the Aegean, as illustrated by discoveries at Vadastra in Romania. In fact there is more evidence for the circulation of unworked or minimally worked shells in a natural state than has been realized. Evidence of the circulation and exchange of these shells in a natural state is of two types: first, from the limited excavations of settlements, and second, from workshops often located far from their native marine habitat. In the latter category are sites like Asagi Pinar (Turkish Thrace), Orlovo (southeast Bulgaria), Obre (Bosnia), Sopot (the Middle Danube), Battonya (southeastern Hungary), and Hîrsova (Romania; fig. 8-11), all dated about 5500–4000 BC. Unfinished objects occur to a small extent almost everywhere from the Carpathians to Bavaria. In addition, the typology of *Spondylus* objects reveals a great variety of forms, subtypes, and alternatives that vary from place to place, and often are specific to particular cultures and "facies" of the Neolithic and Copper Age over nearly three thousand years, 6500–3500 BC.[19] This local variability in time and space suggests that the shells often were modified and reworked locally as they followed trade routes.

The pattern of diffusion of *Spondylus* artifacts through much of Europe along a southeastern to northwestern axis probably reflects distribution at the most densely inhabited places during the Neolithic and Copper Ages. The trade among these places presupposes a network of access routes and a social framework of elaborate exchange systems—including bartering, gift exchange,

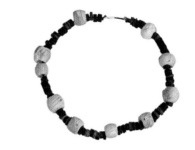

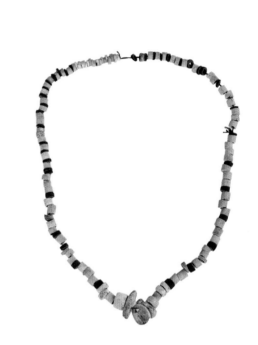

8-7 (top). Necklace. *Spondylus* and copper, Gumelniţa, Brăiliţa, 4600–3900 BC, MBR.

8-8 (bottom). Necklace. *Spondylus* and copper, Foltesti, Vadul Catagatei, 4000–3900 BC, MBR.

8-9 (opposite: top). Necklace. *Spondylus*, Hamangia, Limanu, 5000–4600 BC, MINAC.

8-10 (opposite: bottom). Necklace. *Spondylus*, Hamangia, Limanu, 5000–4600 BC, MINAC.

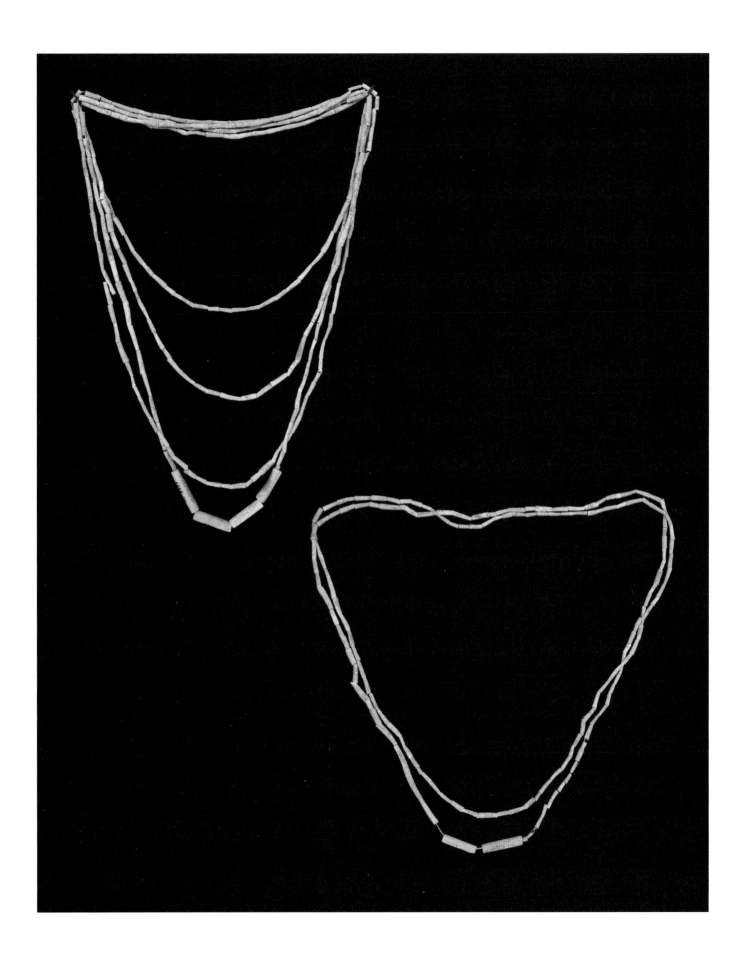

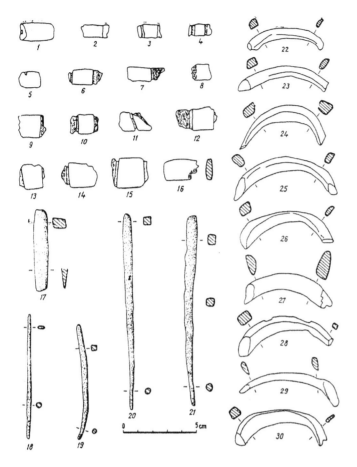

8-11. Fragments of *Spondylus* bracelets, beads in the course of manufacture, and copper tools from the workshop of Hîrsova, Romania (after Comsa, 1973).

and reciprocity—such that these shells even reached somewhat isolated places, including high mountain valleys in the Carpathians. In the absence of any texts or oral histories and in spite of a growing number of extensive excavations, it still is not possible to identify particular localities as centers of concentration or redistribution.

Why was there such a desire for these shells that, once deeply transformed (the red color seldom being preserved) and after having traveled, must have lost much of their original beauty? *Spondylus* artifacts are associated in most archaeological reports with concepts of wealth and prestige.[20] The creation of chiefs, figures of authority, small potentates, "princes," and revered elders at the top of the social hierarchy (depending upon the form of social stratification), and their accumulation of these shells, reinforced the capacity to aggregate possessions of a variety of objects ranging from rare raw materials (honey-colored flint from Madara in Dobrogea, obsidian from the Carpathians and perhaps the Aegean Islands, marble, malachite, jadeite, rock crystal, and carnelian) to valuable artifacts (polished stone axes, adzes, and mace heads) and metal (copper and gold).[21] When *Spondylus* shells are found in graves, they are often together with these kinds of valuables in accumulations that suggest they were regarded as a kind of wealth or a sign of prestige.

However, these simple concepts of wealth and prestige appear inadequate to explain the deep interest in *Spondylus* artifacts exhibited by Neolithic and Copper Age Europeans. More-fundamental reasons for such a passion cannot be understood without recourse to the comparative ethnographic literature. For example, in a similar manner and until relatively recently, the Yurok Indians and the Salish of western North America were unaware of the maritime source of shells such as *Dentalium*, which they obtained via the Chilcotin Indians of the Pacific coast. Likewise, in the European Neolithic and Copper Age, people living far from the Mediterranean coastline also may have been unaware of the maritime source of *Spondylus* artifacts;[22] perhaps the objects were part of a halo of mysteries, an ensemble of beliefs and myths aimed mainly at providing an account of the supernatural origins of the shells.

Such beliefs also might help explain the omnipresence of objects made from *Spondylus* across Europe beginning in the oldest Neolithic (seventh–sixth millenia BC). Trade and interest in these objects was still growing in the Copper Age, only to disappear suddenly at the beginning of the Bronze Age, when in the middle of the fourth millennium BC there was apparently a total social discontinuity with the preceding millennia as other cultures appeared—the new civilizations originating mainly in the Pontic steppes. *Spondylus* shells were linked to the traditions and customs of the European Neolithic and Copper Age in such a strong way that, after the end of Neolithic traditions and the inception of the Bronze Age, *Spondylus* was no longer desired or valuable.

The great archaeologist V. Gordon Childe noted, "The Danubians seem to have brought with them from the south a superstitious attachment to the shells of a Mediterranean mussel, *Spondylus gaederopus*, which they imported even into central Germany and the Rhineland for ornaments and amulets."[23] Childe here referred to the fact, borne out by recent archaeological research, that the first farming cultures of southeastern Europe ('the Danubians") came originally from Greece and the Aegean, so that the desire for *Spondylus* was in one sense "brought with them" from their Aegean homeland. But *Spondylus* artifacts were much more important in interior Europe than they ever were in Greece, so there must have been another element that made *Spondylus* attractive, which Childe labeled a "superstitious attachment."

In connection with possible beliefs of the prehistoric European people discussed here, it is difficult not to evoke shamanism, "one of the great systems imagined by the human spirit, in various areas of the world, to give a direction to events and to act on them," a concept to be understood as "a social fact that relates to the totality of society and its institutions, a fact that at the same time can mark the symbolic system, the economic, the political, and the aesthetic."[24]

Prehistory is endowed with representations of shamans[25]— at least we attribute this interpretation to rare silhouettes of characters with their arms raised to the sky, dancing or masked, painted or carved onto the walls of vases. The varied miscellany of objects often associated with *Spondylus* artifacts—recovered from sites such as Dikili Tash in Greece, Omurtag in Bulgaria, Sultana "Malu Rosu" in Romania, Giurgiulesti and Karbuna in Moldavia, and Csoka-Kremenjak in Hungary—are variously called by archaeologists "treasures," "deposits," "magic-kits," and even "tool-kits" (!) and are probably the many accoutrements or ritual accessories of shamans.[26] The "treasure" of Ariusd in Romania is composed of *Spondylus* artifacts, bone, objects made from copper and gold, and canine teeth of red deer (cervids),[27] which were used as beads and ornaments at the close of the Paleolithic period and during the Mesolithic. These hunting and gathering cultures form a cultural subcontext of the European processes of Neolithization, to which in the Neolithic are added *Spondylus* artifacts that represent a new reality layered on top of old myths.

The *Spondylus*-decorated plate of Popina II (southeastern Romania), the multiperforated valves of Battonya (Tisza culture, Hungary; fig. 8-12), and the complex pectoral pendant reconstructed from the Vert-la-Gravelle tomb (Marne, France; fig. 8-13) can be regarded as elements of the costume of the shaman. However, the V-shaped notched *Spondylus* shells present only in Central Europe (fig. 8-14) and in the Paris Basin could be interpreted as representations of vulva, as has been postulated for some motifs of the Paleolithic period in both parietal and mobiliary art in Russia and in France.[28]

Shamanism remains the best explanation for why certain objects made of *Spondylus* were transmitted from generation to generation while others, including anthropomorphic and zoomorphic figurines, were intentionally broken and/or burned.[29] The multiperforated pendant of the Gumelnitsa at Popina II (Bralia, Romania) is deeply worn, as are the pendants and beads found in the tomb of Cys-la-Commune (Aisne, France), which also are associated with the bone of a crane—a migratory bird that may symbolize the concept of eternal return.[30] In contrast to these worn and used examples, a broken bracelet sized for a child in the richest burial of the necropolis of Varna was repaired by means of two gold fasteners. Thus we have "the inversion of the two Worlds," a component of ancient beliefs, behaviors, and religious rites characteristic

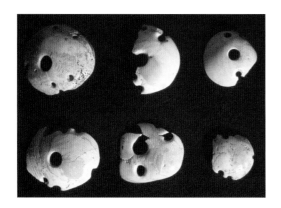

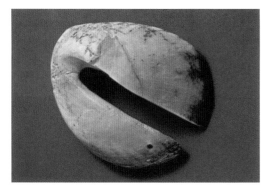

of shamanic thought and, consequently, of the Neolithic and Chalcolithic people, who were engaged in an eternal dialectic between man and nature: What is good here is bad up there, and vice versa. Perhaps if the bracelet had remained intact, the individual buried at Varna, whether a child or an adult, could not have carried it to the other World.[31]

Patterns incised on a valve of a *Spondylus* pendant found in the Neolithic burial of a woman in Mostanga in Voïvodine (Serbia; fig. 8-15),[32] although difficult to interpret, appear to represent a boat and stars—expressions of the symbolic system encompassing this shell. They reflect the synergy that related this woman to both the Earth and the universe through the ever present dialogue between nature and culture that is an eternal expression of life's joys and anguishes.

Translated by A.G. Brown, PhD

8-12 (opposite: top, left). Multiperforated *Spondylus* shell from Battonya, Tisza culture, Hungary (after Kalicz, 1989).

8-13 (opposite: right). Reconstruction of a necklace and pectoral made of *Spondylus* and an open-weave shawl based upon discoveries at Vert-la-Gravelle burial, Marne, France (after Chertier, 1988).

8-14 (opposite: bottom, left). Notched *Spondylus* shell from the cemetery of Nitra, Slovakia (after Pavuk, 1972).

8-15. Mythical forms engraved onto a *Spondylus* pendant found in the burial of the woman of Mostanga IV, Voïvodine, Serbia (after Karmanski, 1977).

Notes

1 Vencl, S., "Spondylove šperky v podunajskem neolitu," *Archeologické rozhledy* 11, no. 5 (1959): 699–741; Willms, C., "Neolithischer Spondylus schmuck. Hundert Jahre Forschung," *Germania* 65, no. 2 (1985): 331–43.

2 Hermann, G., "Lapis-Lazuli: The Early Phase of Its Trade," *Iraq* 30 (1968): 21–57; Sarianidi, V., "The Lapis Lazuli Route in the Ancient Near East," *Archaeology* 24 (1971): 12–15; Deshayes, J., "À propos des terrasses hautes de la fin du IIIe millénaire en Iran et en Asie Centrale," in *Le plateau Iranien et l'Asie Centrale des origines à la Conquête Islamique*, ed. Deshayes (Paris: Centre National de la Recherche Scientifique, 1977): 95–111.

3 Chen-chiu, W., *Jades chinois* (Taipei: Hilit, 1991; France: Ars Mundi, 1994).

4 Le Fèvre, J.-Y., and G. Cheikh, *La magie africaine. Les cauris: paroles des dieux* (Paris: Rocher, 1995).

5 Levi-Strauss, C., *Histoire de lynx* (Paris: Plon, 1991).

6 Paulsen, A.C., "The Thorny Oyster and the Voice of God: Spondylus and Strombus in Andean Prehistory," *American Antiquity* 39 (1974): 597–607; Bussy, M., "Le *spondylus* au Pérou et en Equateur à l'Epoque préhispanique" (master's thesis, Université de Paris I Panthéon-Sorbonne, 1996–97); Séfériadès, M., "*Spondylus gaederopus*: Some Observations on the Earliest European Long Distance Exchange System," in *Karanovo III. Beiträge zum Neolithikum in Südosteuropa*, ed. S. Hiller and V. Nikolov (Vienna: Phoibos, 2000): 423–37.

7 Malinowski, B., *Argonauts of the Western Pacific* (London: Routledge, 1922); Damon, F.H., "Modes of Production and the Circulation of Value on the Other Side of the Kula Ring, Woodlark Islands, Muyuw" (Ph.D. diss., Princeton University, 1978).

8 Shackleton, N.J., and C. Renfrew, "Neolithic Trade Routes Realigned by Oxygen Isotope Analyses," *Nature* 228 (12 December 1970): 1062–65; Shackleton, J.C., and H. Elderfield, "Strontium Isotope Dating of the Source of Neolithic European *Spondylus* Shell Artifacts," *Antiquity* 64 (1990): 312–15.

9 Zavarei, A., *Monographie des Spondylidae actuels et fossiles* (Orsay: Centre d'Études et de Recherches de Paléontologie Biostratigraphique, 1973).

10 Séfériadès, M., "Complexity of the Processes of Neolithization: Tradition and Modernity of the Aegean World at the Dawn of the Holocene Period (11–9 kyr)," in "IGCP 521: Black Sea–Mediterranean Corridor during the Last 30 KA; Sea Level Change and Human Adaptation," ed. N. Catto, V. Yanko Hombach, and Y. Yilmaz, *Quaternary International* 167–68 (2007): 177–85.

11 Séfériadès, M., "*Spondylus gaederopus*: The Earliest European Long Distance Exchange System; A Symbolic and Structural Archaeological Approach to Neolithic Societies," *Porocilo o raziskovanju paleolitika, neolitika in eneolitika v Slovenia* 22 (1995): 233–56.

12 Chilardi, S., L. Guzzardi, M.R. Iovino, and A. Rivoli, "The Evidence of Spondylus Ornamental Objects in the Central Mediterranean Sea: Two Case Studies, Sicily and Malta, in *Archaeomalacology: Molluscs in Former Environments of Human Behaviour*, ed. D. Bar-Yosef Mayer, Proceedings of the Ninth ICAZ Conference, Durham, 2002 (Oxford: Oxbow, 2002): 82–90.

13 Tsuneki, A., "A Reconsideration of Spondylus Shell Rings from Agia Sofia Magula, Greece," *Bulletin of the Ancient Orient Museum* (Tokyo) (1987): 1–15; Karali, L., *Shells in Aegean Prehistory*, British Archaeological Reports, International Series 761 (Oxford: Archaeopress, 1999).

14 Todorova, H., Durankulak, vol. 2, Die prähistorischen Gräberfelder von Durankulak (Sofia-Berlin: Deutsches Archäologisches Institut in Berlin, 2002).

15 Gaydarska, B., et al., "Breaking, Making and Trading: The Omurtag Eneolithic Spondylus Hoard," *Archaelogia Bulgarica* 8 (2004): 11–34.

16 Dimitrijević, V., and C. Tripković, "Spondylus and Glycymeris Bracelets: Trade Reflections at Neolithic Vinča–Belo Brdo," *Documenta Praehistorica* 33 (2006): 1–16.

17 Pavuk, J., "Neolithisches Gräberfeld in Nitra," *Slovenska Archéologia* 20 (1972): 5–105; Müller, J., A. Herrera, and N. Knossalla, "*Spondylus* und *Dechsel*. Zwei gegensätzliche Hinweise auf Prestige in der mitteleuropäischen Linearbandkeramik?" in *Prestige—Prestigegüter—Sozialstrukturen. Beispiele aus dem europäischen und vorderasiatischen Neolithikum*, ed. J. Müller and R. Bernbeck, Archäologische Berichte 6 (Bonn: Habelt, 1996): 81–96.

18 Dergachev, V.A., *Kerbunskii klad* (Chişinău: Tipografia Academiei de Ştinţe,1998).

19 Comşa, E., "Parures néolithiques en coquillages marins découvertes en territoire roumain," *Dacia* 17 (1973): 61–76; Séfériadès, M., "Note sur l'origine et la signification des objets en spondyle de Hongrie dans le cadre du Néolithique et de l'Enéolithique européens," in *Morgenrot der Kulturen. Frühe Etappen der Menschheitsgeschichte in Mittel- und Südosteuropa; Festschrift für Nandor Kalicz zum 75 Geburtstag*, ed. N. Kalicz, E. Jerem, and P. Raczyy (Budapest: Archaeolingua, 2003): 353–73.

20 Müller, Herrera, and Knossalla, "*Spondylus* und *Dechsel*" (1996); Siklósi, Z., "Prestige Goods in the Neolithic of the Carpathian Basin: Material Manifestations of Social Differentiation," *Acta Archæologica Academiæ Scientiarum Hungaricæ* 55 (2004): 1–62.

21 Séfériadès, M., "Pierre taillée et métallurgie," in *Découverte du métal*, ed. J.-P. Mohen and C. Eluère (Paris: Picard, 1991): 325–30; Ivanov, I.S., "Les objets métalliques de la nécropole chalcolithique de Varna," in *Découverte du métal* (1991), ed. Mohen and Eluère: 9–11.

22 Levi-Strauss, *Histoire de lynx* (1991).

23 Childe, V.G., *What Happened in History* (1942; Harmondsworth: Penguin, 1976): 61.

24 Perrin, M., *Le chamanisme* (Paris: Presses Universitaires de France, 2001); my translation.

25 Clottes, J., and D. Lewis-Williams, *Les chamanes de la préhistoire* (Paris: Roches, 2001).

26 Lot Falk, E., *Les rites de chasse chez les peuples sibériens* (Paris: NRF Gallimard, 1953).

27 Sztancsuj, S.J., "The Early Copper Age Hoard from Ariusd (Erosd)," in *Cucuteni. 120 ans de recherches; Le temps du bilan / Cucuteni: 120 Years of Research; Time to Sum Up*, ed. J. Chapman, et al., Bibliotheca Memoriae Antiquitatis 16 (Piatra- Neamţ, 2005): 85–105.

28 Kozlowski, J., *L'art de la Préhistoire en Europe Orientale* (Paris: Centre National de la Recherche Scientifique, 1992): 59, fig. 58 (from Kostienki 1, after P.P. Efimienko).

29 Chapman, J., and J. Gaydarska, *Parts and Wholes: Fragmentation in Prehistoric Context* (Oxford: Oxbow, 2007).

30 Walter, P., *Arthur. L'ours et le roi* (Paris: Imago, Diffusion PUF, 2002).

31 Kharitidi, O., Entering the Circle (San Francisco: Harper, 1996).

32 Karmanski, S., *Katalog antropomorfne i zoomorfne plastike iz okoline Odzaka* (Odzaci: Arheoloska Zbirka, 1977).

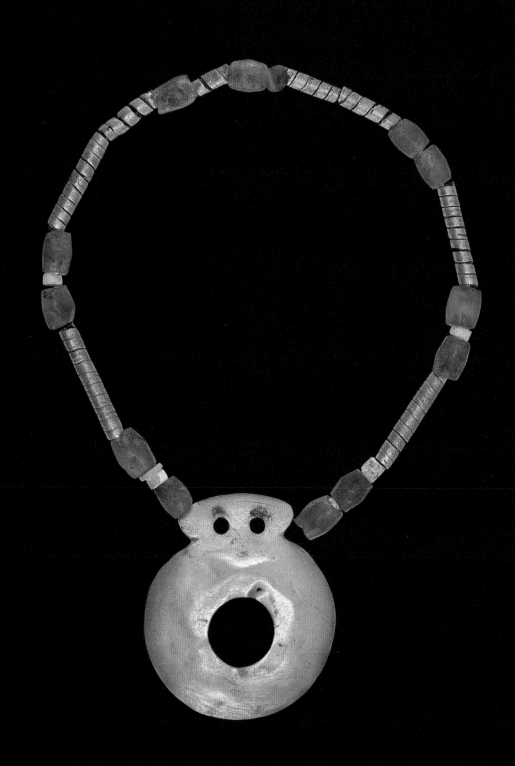

The Varna Eneolithic Cemetery in the Context of the Late Copper Age in the East Balkans

Vladimir Slavchev

Varna Regional Museum of History

The Varna Eneolithic (or Copper Age) cemetery was found by accident in the autumn of 1972 during excavation work in the western industrial zone of the coastal city of Varna, Bulgaria. The cemetery was situated approximately 400 meters north of modern Varna Lake, which during the Copper Age was a bay connected to the Black Sea. The burial ground occupied a terrace that sloped gently southward toward the water's edge, at an elevation of twelve to eighteen meters above modern sea level. Archaeological excavations were conducted under the direction of Ivan Ivanov, to whom we owe the precise excavation, documentation, and explanation of this exceptional site.[1] The cemetery was created about 4400 BC by a society, today known as the Varna culture, that buried its leaders with many weapons and ornaments, including stunning quantities of gold. Varna is the oldest cemetery yet found where humans were buried with abundant golden ornaments. The richness and variety of the Varna grave gifts in a cemetery of such an early date was a surprise to the global archaeological community, including Ivanov. What follows is a brief account of the discovery of Grave 36 at Varna, the objects from

which were exhibited at the Institute for the Study of the Ancient World in New York in 2009–10.

The Discovery of Grave 36

After the first rich graves were discovered in 1972, the second excavation season at the Varna cemetery, in 1973, did not provide any special finds, and the number of excavated graves was comparatively small—twenty graves in eleven months of intensive work with few breaks. The third excavation season began on June 19, 1974. The efforts of Ivanov, the project's leader, were focused on investigating the territory to the south and west of the area already explored. Still not knowing the size of the cemetery, he tried to define its boundaries. He worked with seventeen prisoners from the District Prison of Varna who were serving sentences of fifteen to twenty-five years. They were supervised by prison guards and by officers of the Ministry of Internal Affairs, who guarded the area because it had been declared a monument of national cultural importance.

By the end of July 1974, nine Copper Age graves had been found and excavated, but only six additional graves were discovered in August and September. The last grave was reburied by the collapse of the excavation following heavy rain, and its re-excavation required an additional week. Discouraged and trying to turn his bad

Necklace with pendant. Gold and quartz, Varna culture, Varna, Grave 97, 4400–4200 BC, Varna Museum.

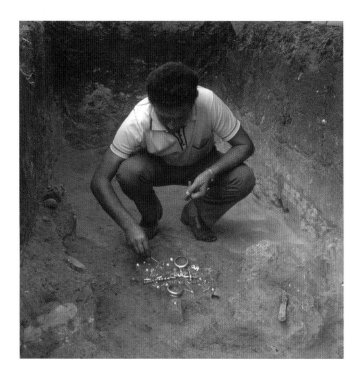

luck, Ivanov started to explore the southeastern part of the cemetery. On September 23, at a depth of 0.93 meter, the workers discovered a small copper axe. Work stopped, the excavated soil was sieved, and forty-four golden beads were found. The grave was given the number 36, and work resumed very carefully (fig. 9-1). After three days of slow and assiduous excavation, it became clear that the grave pit was a cenotaph, or symbolic grave, and contained no human bones. Three groups of artifacts were clearly discerned on the grave floor. The northern and the southern groups yielded copper and flint tools, a bone figurine (fig. 9-2), ceramic vessels, and *Dentalium* shell beads. The central group comprised a multitude of gold artifacts.

Bulgarian National Television and a crew from the Popular Science Film Studio arrived on September 26 and filmed the sensational discovery, which was featured that evening on the central news broadcast. A timber shed was erected above Grave 36 to protect it from the weather until all of the finds were planned and photographed in

situ. Meanwhile rich burials in Graves 41 and 43 were discovered, and the team turned its attention to excavating and documenting them before cold weather set in. For this reason the burial objects were not removed from Grave 36 until October 26, a full month after their discovery. Only then did it become clear that the gold artifacts in the central group had been deposited in four stratigraphic layers, which yielded a miniature diadem, a gold scepter (fig. 9-3), a gold sickle (fig. 9-4), a gold sheep knuckle-bone (or astragal, commonly used in the ancient world as dice; fig. 9-5), and two gold bull figurines together with gold bracelets (fig. 9-6), rings, and appliqués (fig. 9-7) and strings of gold beads.

Grave 36 presented several features that made its interpretation difficult. It contained a greater number and a greater variety of gold artifacts than Grave 4, the richest that had been found before the discovery of Grave 36, although the total weight of gold artifacts in Grave 4 exceeded the weight of those in Grave 36 because there were more solid-gold objects in Grave 4. The gold bull figurines of Grave 36 were particularly interesting—their horns being curved back in a manner similar to those of a water buffalo (*Bubalus bubalis*) (fig. 9-8). Only one other bull figurine was found in the Varna cemetery (in Grave 26), and it was smaller and not so finely made. To date no parallels have been found outside the Varna cemetery.[2] The small size of the gold objects, such as the miniature diadem, also was unusual (fig. 9-9). Although miniature ceramic vessels were not uncommon in the Late Copper Age graves at Varna, other kinds of artifacts placed in the grave pits usually were not miniaturized, leading Ivanov to suggest that Grave 36 was the cenotaph or symbolic grave of a child. Subsequently, another interpretation suggested that the objects in Grave 36 were insignia of power that were buried when new ones were made for a new chieftain. According to this theory, a chieftain was chosen for a certain period of time, and after exhausting his vigor he was no longer able to provide fertility and abundance for the community. Thus in a ritual partly preserved in Grave 36, the old chieftain was deprived of the symbolic attributes of his power, as it was these and not his physical body that were socially meaningful. Stripped of his attributes, the ruler no longer existed. The old insignia that represented his past are

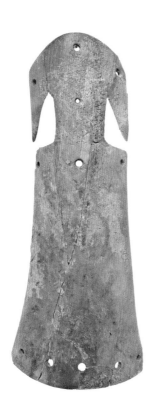

9-2. Idol figurine similar to a poorly preserved one from Grave 36. Bone, Varna culture, Varna, Grave 41, 4400–4200 BC, Varna Museum.

9-3. Scepter. Gold, Varna culture, Varna, Grave 36, 4400–4200 BC, Varna Museum.

9-4 (top, left). Implements. Gold, Varna culture, Varna, Grave 36, 4400–4200 BC, Varna Museum.

9-5 (top, right). Astragal. Gold, Varna culture, Varna, Grave 36, 4400–4200 BC, Varna Museum.

9-6 (center). Bracelets. Gold, Varna culture, Varna, Grave 36, 4400–4200 BC, Varna Museum.

9-7 (opposite: bottom, left). Animal-head appliqués. Gold, Varna culture, Varna, Grave 36, 4400–4200 BC, Varna Museum.

9-8 (opposite: top). Zoomorphic "bull" figurines. Gold, Varna culture, Varna, Grave 36, 4400–4200 BC, Varna Museum.

9-9 (opposite: bottom, right). Diadem. Gold, Varna culture, Varna, Grave 36, 4400–4200 BC, Varna Museum.

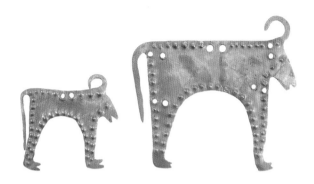

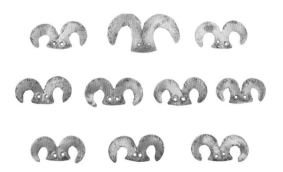

interpreted to have died in his stead and were buried in Grave 36. New insignia were then made for the subsequent, young ruler.[3]

The Varna Cemetery

Excavations were conducted at Varna over a period of twenty years (1972–91) and exposed an area of 7,500 square meters containing 310 graves of the Late Copper Age Varna culture. The area of the cemetery also contained seven Early Bronze Age garbage pits, one Roman garbage pit, three other nonmortuary archaeological deposits, and seventy-six isolated artifacts (fig. 9-10).[4] Among the Late Copper Age graves, 105 were disturbed and the skeleton and/or the grave goods damaged to some extent. The disturbances were of different kinds—resulting from animal holes, tree roots, later graves (dating to a subsequent phase of the Late Copper Age and the Early Bronze Age), agricultural activity, modern excavation work, and so forth. Human bones were poorly preserved due to high soil acidity.

Only 5 graves contained no grave goods at all. The most common finds were ceramic vessels; only 11 of the undisturbed graves yielded no pottery. Flint tools or weapons were found in 140 graves; polished stone axes, chisels, adzes, or polishers were found in 58; copper tools and weapons were placed in 78; and bone or antler tools and implements occurred in 76 graves. More than eighty percent of the graves yielded ornaments made from nonlocal, imported materials: gold, copper, various minerals, and the Aegean *Spondylus* and *Dentalium* shells.

Some kinds of objects tended to be placed near particular parts of the body. Ceramic vessels were placed around the skull or on the upper part of the chest. Tools and weapons were found in this area or beside the arms. Ornaments were placed on those parts of the body where they would have been worn by the deceased during his or her life—for example, the diadem was on the head, bracelets on the arms, and rings on the fingers.

No surface monuments, mounds, or markers were preserved over the Varna graves. The grave pits were rectangular with rounded corners. The graves in the central and southern part of the cemetery were found deeper in the soil, usually at 1.40–1.50 meters from the modern surface, although there are even deeper graves.

The graves can be divided into two main groups: graves containing human remains and cenotaphs, or graves containing no such remains. The bottom of the grave pit of each cenotaph was covered with some organic matter—fur, fabric, or matting—decorated with red paint. Similar floor deposits also were found in the very rich graves with bodies.

Graves containing human remains are divided into two subgroups depending on the position of the skeleton—extended position and contracted position. Because of disturbances it is not always possible to reconstruct the original position of the body, but in 160 of the cases at Varna it can be defined. Among these, ninety-three skeletons were in extended position and sixty-seven in a contracted position. In the extended burials, the legs were sometimes crossed at the ankles. The arms were most often tightly folded at the elbows, and the hands placed at the upper chest.

In graves where the skeleton was preserved well enough to determine gender, three-fourths of the extended graves were those of males. The bodies in extended position usually were provided with a battle-ax or a small clay vessel. Grave 43, the burial of a forty- to forty-five-year-old male, with gold artifacts weighing more than 1.5 kilograms, is especially remarkable (fig. 9-11). The exceptional abundance of grave goods included ritual attire ornamented with gold appliqués, gold and carnelian beads; a hat decorated with gold lamellae; earrings, necklace, and bracelets made from gold rings; *Spondylus* shell bracelets; spears with copper and flint points; a bow and a quiver lined with gold; stone and copper axes; and a scepter—a stone axe whose shaft was lined with gold—suggesting that the grave belonged to the chieftain of this community. Apparently, he had religious as well as military power.

9-10. Plan of the Varna cemetery: a = extended inhumations; b = contracted inhumations of the right side; c = contracted inhumations of the left side; d = symbolic graves (cenotaphs); e = destroyed/damaged burials, f = collective deposits (garbage pits or groups of artifacts).

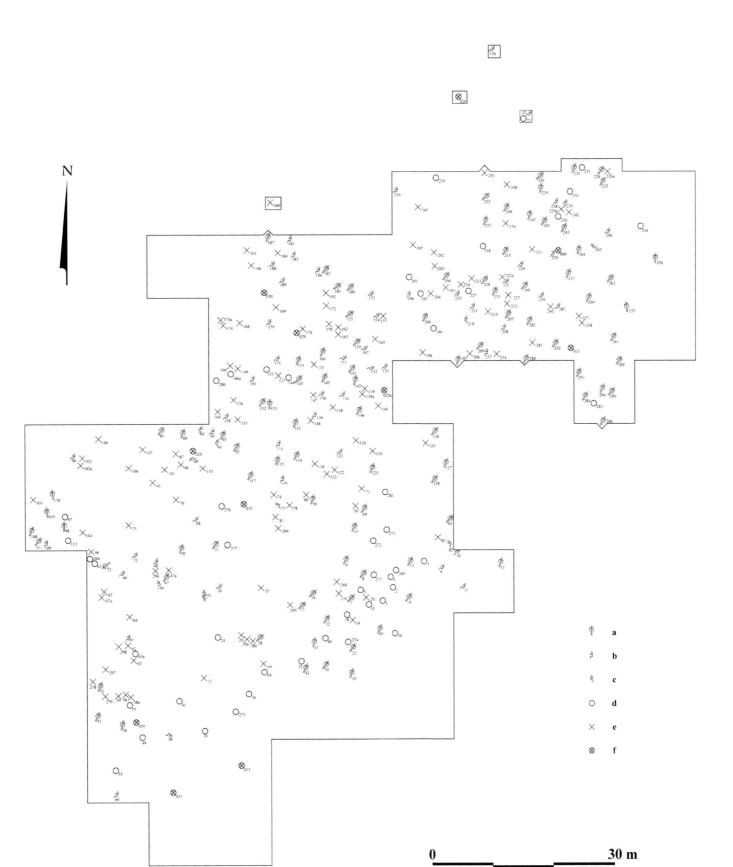

N

	a
	b
	c
	d
	e
	f

0 30 m

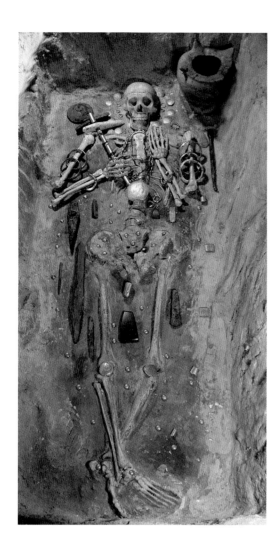

At this stage of the research, the sex and the age of only sixty-two individuals have been defined.[6] Similar to the rest of the cemeteries of the Varna culture, males in most cases were buried in extended position on the back and females in a contracted position on the right side. However, deviations from this rule were more common in the Varna cemetery than in contemporary cemeteries excavated in the western Black Sea region. Among extended burials, 26.47 percent at Varna were female. Equally unexpectedly, 46.15 percent of the burials in a contracted position at Varna were male. Outside of the Varna culture, no male contracted burials on the right side have been discovered in contemporary burial sites on adjacent territories.

The deceased were buried with the head pointing to the northeast. The deviations from this mortuary practice were few—only eleven cases—and it was confirmed that the two east-oriented burials contained remains of people of the Gumelniţa culture, from the Danube valley. Graves oriented to the southwest and at least two oriented to the northwest are dated to the Early Bronze Age.[7]

A surprising aspect of the Varna cemetery was the high number of graves, forty-seven (including Grave 36), that yielded no human remains. Cenotaphs usually are interpreted as symbolic graves of community members who perished far away. It seems probable that religious beliefs in the Copper Age demanded a ritual burial in the community cemetery strictly observing all funerary rituals aimed at sending the soul of the deceased to the underworld, where it would meet the members of its family. Three cenotaphs (Graves 2, 3, and 15), situated about one meter from each other, contained life-size images (masks) of human faces made of unbaked clay and located where the head of the deceased would have been. Gold objects mark some of the features—a rectangular strip at the location of the mouth, round dots at the location of the eyes. Each of these "people" wore numerous ornaments: a gold tiara at the forehead, tiny gold "nails" piercing the lips, several gold-ring earrings on the ears, and a bead necklace made from *Spondylus* and *Dentalium* shell or various minerals (lignite, ultrabasite, and carnelian) with gold pendants shaped as highly stylized female bodies. No battle-axes or large copper artifacts were

Individuals buried in a contracted position were usually on the right side. Only three of sixty-seven contracted burials were on the left side, and eleven more displayed different variants.[5] The contracted burials generally contained fewer grave goods than the extended ones, and metal artifacts were rare. In most cases, in addition to ceramic vessels these graves contained various elements of dress and ornaments, including necklaces made from beads of different materials (gold, minerals, and shells), amulets, bracelets, and appliqués.

Because of the poor preservation of bones, information about the sex and the age of the deceased is incomplete.

9-11. Reconstruction of Varna Grave 43.

found in these three cenotaphs, although each yielded a copper pin, a flint knife, and a spindle whorl, a tool for spinning thread, suggesting that the three graves were those of females, real or deified; it has been proposed that images of the deities worshiped by the local population were buried in these symbolic graves.[8]

The size of the grave pit and the location of the grave goods of the forty-four other cenotaphs were the same as those of "standard" graves, but they yielded no clay masks or human remains. This group of symbolic graves is quite diverse. Some contained few grave goods and no ornaments, while others contained an abundance of grave goods. Three (Graves 1, 4, and 36) contained gold objects that together accounted for more than half of the total weight of all gold grave goods yielded by the cemetery. A scepter, symbol of a supreme secular or religious authority, was discovered in each of these three graves (fig. 9-3).

The Role of Varna Cemetery in Our Knowledge of the Late Copper Age in the Balkans

Numerous Late Copper Age cemeteries have been investigated in the western Black Sea region south of the Danube River, the northeastern area of the Balkans.[9] Varna was richer than the other cemeteries affiliated with the Varna culture, such as Devnya[10] and Durankulak.[11] For that reason, thirty years after it was discovered the Varna cemetery still attracts the attention of researchers who seek an explanation for the "Varna phenomenon."

Interest in this unique burial site is due, of course, to the abundance and the variety of grave gifts, especially the gold artifacts, which number more than 3,000 and whose total weight exceeds six kilograms. Their allocation in the graves is remarkably unequal: Sixty-two graves yielded some gold objects, but the weight of gold in just four graves (1, 4, 36, and 43) accounted for more than five kilograms. Three of these (1, 4, and 36) were cenotaphs. Such a concentration of gold artifacts has not been recorded elsewhere in the fifth millennium BC. The weight and the number of gold finds in the Varna cemetery exceeds by several times the combined weight and number of all of the gold artifacts found in all excavated sites of the same millennium, 5000–4000 BC, from all over the world, including Mesopotamia and Egypt. This fact, as well as

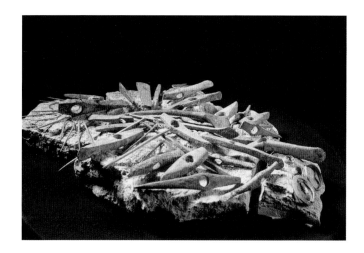

the presence of a number of artifact types[12] not found at other sites, indicates that a center for the manufacture and distribution of gold objects must have been located in the Varna region.[13] A large-scale project carried out by the Varna Regional Museum of History, the Eberhard Karls University of Tübingen with the Curt Engelhorn Center for Archaeometry, and Sofia University was designed to establish the probable sources of the gold and copper. Preliminary data suggest that the gold dust was extracted from the beds of rivers rising from the eastern spurs of the Stara Planina Mountains and, probably, from Sakar Mountain near the Turkish border. After extraction, the gold dust was delivered to Varna and smelted.

The large number of copper artifacts, more than 160 pieces (fig. 9-12), is also evidence for the existence of a metal production center.[14] Just as the Varna cemetery yielded an unsurpassed weight and number of gold artifacts, no other site of the same age has yielded such a concentration of copper objects (figs. 9-13–9-16).[15] Some are unique types, found only in the Varna region.[16] Analysis of the proportion of lead isotopes in the copper proves that 55.1 percent of the copper in the Varna cemetery came from ore sources in the southern part of the west Pontic coast, in the vicinity of Burgas, about 120 kilometers south of Varna; 38.8 percent of the copper came from mines such as Ai Bunar that have been explored by archaeologists near Stara Zagora in

9-12. Copper artifacts found in the Varna cemetery.

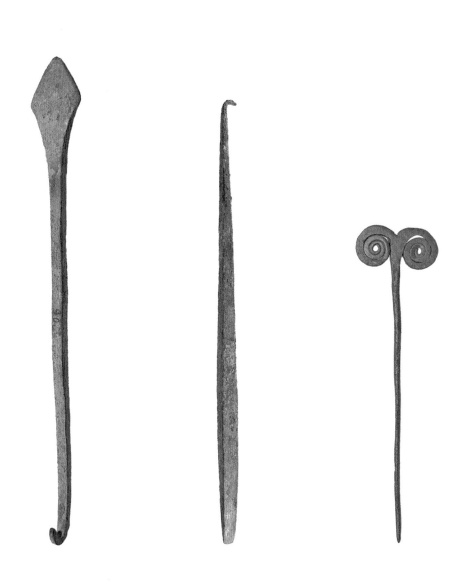

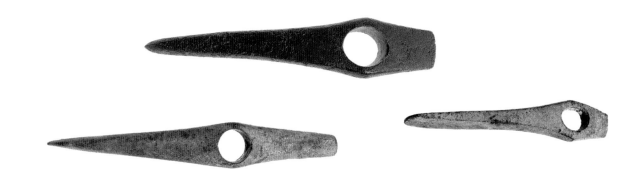

the Balkans, about 200 kilometers southwest of Varna; and only 6.1 percent of the copper came from other sources.[17]

More than 230 flint artifacts were found in the Varna cemetery. The most impressive are long blades (fig. 9-17), some more than thirty centimeters long, with a few extending to forty centimeters. They were made of high-quality flint quarried in the Ludogorie region not far from the town of Razgrad on the Beli Lom River.[18] The graphite used for decorating pottery probably came from mineral deposits in the same region.

The graves yielded more than ninety polished stone artifacts, predominantly axes and adzes (fig. 9-18), as well as over 650 ceramic vessels. Approximately 1,100 *Spondylus* shell ornaments, bracelets, beads, and appliqués (figs. 9-19, 9-20), and more than 12,200 *Dentalium* shells also were found. Both of these shell species came to the Varna region from the northern Aegean coast or the Aegean islands (see the essay by Michel Séfériadès in this volume).

Many more ornaments made of different minerals also were found. The most probable source of red carnelian used for making beads was the area of the Akheloy (Achelous) River estuary about seventy kilometers south of Varna (fig. 9-21).[19] The source of the serpentinite, frequently used for beads in the Varna cemetery, is still undetermined. Sources of serpentinite rock are located on the southern slopes of the Stara Planina Mountains in southeastern Bulgaria and on the northern slopes of the Rhodopes, as well as in adjacent regions.[20]

The clear distinction in the type and the quality of the grave goods,[21] determined by the social rather than the material status of the deceased,[22] is proof of social stratification in the Late Copper Age in the Balkans, a result of the emergence of new elements in social and economic development—mining, metallurgy, and the related increase in long-distance trade and exchange. The separation of crafts and proto-trade from farming and agriculture provided conditions for the concentration of power in the hands of a restricted group of community members—those buried with abundant and numerous grave goods. From this point of view the Varna cemetery illustrates the early stage of the emergence of a class-segregated society, a kind of social and political structure properly named a "chiefdom" by Renfrew.[23] As attributes designating the social status of their owners, gold objects were sacred and symbolic rather than indicators of wealth. This conclusion is applicable to the rest of the finds as well. For example, most of the long flint blades and copper battle-axes were not actively used weapons but instead prestige objects, symbols of power that indicated the social significance of their owners.[24] The gold-decorated handles of copper shaft-hole axes in Graves 4 and 43 suggest that these objects served as scepters. The ornaments made of rare minerals and Aegean mollusk shells can be interpreted from the same perspective. Although some of the ornaments (or similar ones) might have been part of everyday attire, their placement in burial pits suggests that they were indicators of the social status and not the wealth of their owners.

The assumption that these artifacts were luxury goods that could be acquired only by a newly emerging aristocracy is a tempting idea, but excavated Late Copper Age settlements in the Eastern Balkans have yielded no archaeological evidence of essential differences either in the sizes of the houses or the types of objects in them, suggesting that the newly surfacing hierarchical social relations did not have a strong impact on everyday life in this period. This conclusion contradicts current opinion that burial rituals tend to be more conservative and thus are a *delayed* reflection of the real processes taking place in society. In the Varna cemetery and again at the related Durankulak cemetery not far away, rapid changes in funeral customs were instead *leading* indicators of change, while the structure of daily life in the settlements seems to have changed little, if at all.

9-13 (top, left). Spear head. Copper, Varna culture, Varna, Grave 97, 4400–4200 BC, Varna Museum.

9-14 (top, center). Chisel. Copper, Varna culture, Varna, Grave 151, 4400–4200 BC, Varna Museum.

9-15 (top, right). Hair pin. Copper, Varna culture, Varna, Grave 167, 4400–4200 BC, Varna Museum.

9-16 (bottom). Three axes. Copper, Varna culture, Varna, Graves 227, 36, and 229, 4400–4200 BC, Varna Museum.

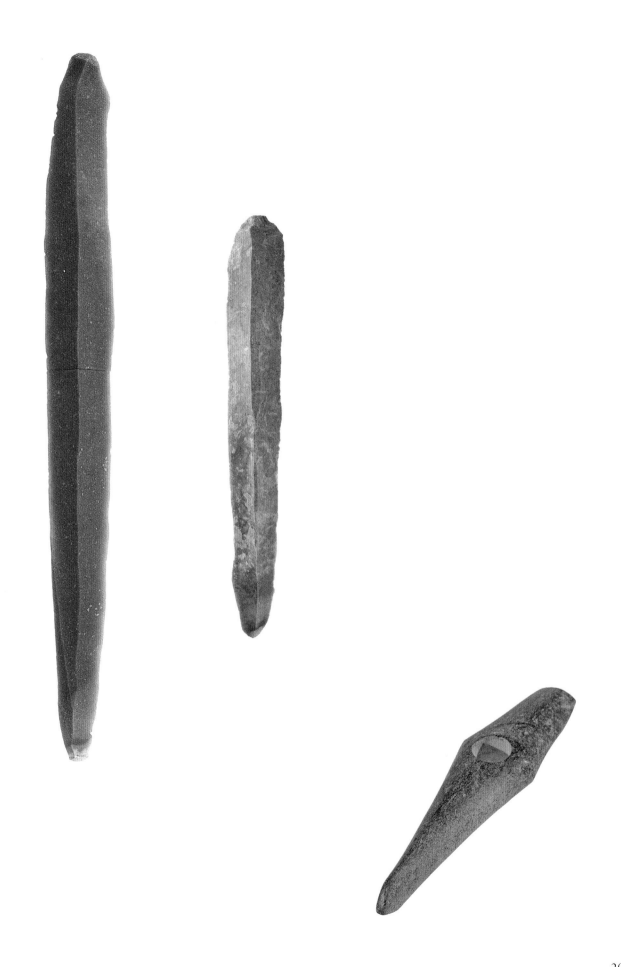

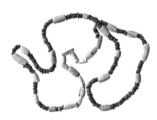

9-17 (opposite: left). Two lamellae. Flint, Varna culture, Varna, Graves 63 and 209, 4400–4200 BC, Varna Museum.

9-18 (opposite: right). Axe head. Stone, Varna culture, Varna, Graves 236, 4400–4200 BC, Varna Museum.

9-19 (top). Three bracelets. *Spondylus*, Varna culture, Varna, Graves 97 and 158, 4400–4200 BC, Varna Museum.

9-20 (bottom, left). Necklace. *Spondylus* and copper, Varna culture, Varna, Grave 154, 4400–4200 BC, Varna Museum.

9-21 (bottom, right). Strand of beads. Carnelian, Varna culture, Varna, Grave 41, 4400–4200 BC, Varna Museum.

Some researchers have attempted to explain the extraordinary wealth of the Varna cemetery by supposing that it was a cult place for burying the chiefs of different tribes or groups united by a large intertribal alliance whose territory covered the entire eastern part of the Balkan Peninsula.[25] However, it seems more probable that the cemetery was one of the burial sites of the local community then inhabiting the shore of the Varna Bay, which later turned into the present-day Varna Lake.[26] This community is represented by eight synchronous settlements situated today at the bottom of the lake.[27] The distance between the settlements is 2.5 to 3 kilometers, and each of them measures at least 350 by 80 meters. This represents a high density of farming communities; no comparable concentration of population has been recorded elsewhere in the Balkans during the period. The dredging activities at the lake bottom brought to light numerous artifacts, among which were copper tools as well as pieces of copper slag, a waste product from copper smelting, indicating that copper was worked in these communities. The Varna cemetery is located approximately 400 to 450 meters northeast of one of these submerged settlements. The same orientation is recorded for the Devnya cemetery, also of the Varna culture, which is similarly located about 400 meters northwest of another settlement.

The territorial range of the Varna culture was limited, on the one hand, by the geographic conditions of this part of the Balkan Peninsula—where agricultural land is constricted between mountains and the sea—and on the other by its neighbors, who experienced a considerable demographic increase. This compelled the farming communities of the west Pontic region to seek the most effective strategies for using available resources as well as new avenues for further development. It seems that the community that created the Varna cemetery used a wide range of raw materials imported from almost the entire Balkan region. Beyond any doubt, the community exercised strong control over the processes of extraction, delivery, and manufacturing as well as control over the network of transport and distribution. The existence and functioning of such a developed network is indicated by the locations of the copper sources that provided raw materials for the manufacture of copper objects.

Analysis of the relationship between the shapes of copper artifacts and the metal sources from which they were made reveals that tool types found only in the Varna culture region were cast from copper that came from mines in the west Pontic region, near Burgas, suggesting that the entire production chain—from ore deposit to mining to artifact manufacturing—was controlled locally. Ore extraction, smelting, and metal manufacturing were accomplished by a limited number of people organized in a manufacturing group, a workshop that specialized in ore and metal extracting and artifact manufacturing. These studies also suggest that the Varna production center completely controlled the west Pontic sources and used them preferentially. The Varna workshop also manufactured copper artifacts made of metal from the Ai Bunar mines in the Balkans that was acquired in the form of copper ingots.[28]

It seems that high social status and power in Late Copper Age communities inhabiting the Varna region were based on control by leading members of society not only over external trade and exchange relations, but also over the local distribution of traded goods. It is worth repeating that in addition to numerous ornaments, the rich graves contained various weapons—bows, arrows, spears, and battle-axes—an indication of how control was maintained by the elite and a direct testament to the connection between power and military leadership. There is a clearly expressed tendency toward increased militarism in the eastern part of the Balkans: The number of weapons deposited in cemeteries increases from west to east—the further east the cemetery is situated, the greater the number of weapons found in graves. The number of artifacts that were acquired through long-distance trade—those made of metal, Aegean mollusk shells, rare minerals, and so forth—increases proportionally as well.

Although the Varna community played an important role in trade and exchange relations, the relatively small number of rare and luxurious goods found as imports outside the Varna culture area (they are very rare even in the Gumelniţa culture sites) also supports the hypothesis that the bearers of the Varna culture were the final consumers. The manufacturing of these goods was in fact aimed at meeting the community's own

needs. The inhabitants of Varna were self-supplying clients rather than mediators involved in buying and reselling goods. From this perspective the exchange cannot be defined as a standard type of trade. The development of technologies and the accumulation of goods aimed at exchanging probably had not yet reached the critical point of satisfying Varna's own needs, and consequently there was little surplus to trade to neighbors.[29] It remains difficult to confirm this hypothesis since the Varna system did not survive. Instead the northeastern part of the Balkan Peninsula became an arena of significant changes in the late fifth millennium BC.

The Rise and Fall of the Late Copper Age Community of the Northeastern Balkans

In the mid-fifth millennium BC, the communities inhabiting the coastal regions west of the Black Sea—the west Pontic coast and Dobruja—became the leading societies not only in the northeastern Balkans, but in all of Europe (see map on page 26). The Varna culture emerged in the southern part of the Dobrudja, the plateau of limestone and sandstone rocks and coastal marshes tucked between the Danube River on the west and north and the Black Sea coast on the east, the northern part of which lies in Romania (*Dobrogea* in Romanian).[30] On the adjacent territories to the west, north, and northwest, in the broad valley of the lower Danube River, the Gumelniţa culture emerged. A variant of the latter, found between the Stara Planina Mountains and the Danube in northwestern Bulgaria, is known as the Kodzhadermen culture, and another Gumelniţa variant, the Bolgrad group, occupied the lake region to the north of the Danube estuary.[31] These three communities—Gumelniţsa, Cucuteni-Tripol'ye, and Varna—shared a common genesis. Their development was based on the earlier Boian, Pre-Cucuteni– Tripol'ye A, and Hamangia cultures. The Boian culture was the principal Late Neolithic/Early Copper Age culture of the lower Danube valley and inland Dobrudja, and had a strong influence on the formation of the Gumelniţsa culture; the Hamangia culture strongly influenced cultural development along the Black Sea coast in coastal Dobruja and along the coast to the south, leading to the Varna culture; and both the Danube valley and Dobruja were influenced by the Pre-Cucuteni–Tripol'ye A culture.[32]

In spite of differences in settlement structures, architecture, and mortuary practices, the three cultures belonged in their early stages to one cultural complex, during the first phase of the Late Copper Age.

The Varna and the Gumelniţa cultures displayed quite different features in spite of their similar economies based on farming and stockbreeding. The most significant distinction between Varna and other cultures was in mortuary practices. The people of the Gumelniţa culture buried the deceased in a crouched position to the left side, the head pointing to the east. In the Varna-culture cemeteries, males usually were buried in an extended position on the back, and females in a crouched position on the right side; in both cases the head pointed to the north or northeast. The grave goods in the graves of the Gumelniţa culture usually were placed near the lower part of the body, while in the graves of the Varna culture gifts were placed around the head. Most of the clay vessels in the cemeteries of the west Pontic coast were poorly fired and usually represented copies that were three times smaller than normal household vessels. This type of pottery was made especially for funerals.[33] In contrast, ceramic vessels analogous to the ones used in everyday life were used for the funerals in the Gumelniţa culture.

At the end of the fifth millennium BC, the Late Copper Age community inhabiting the northeastern Balkans started to disintegrate. The reasons that led to the disappearance of permanent agricultural communities from this territory, as well as from the lower Danube valley (Gumelniţa) and northern Thrace (Karanovo), are still debatable. The explanation suggested by Gimbutas, that the development of these Copper Age cultures was interrupted by an invasion of nomadic tribes from the north Pontic steppes,[34] recently has been criticized. There is an ongoing debate related to reconsidering the evidence for or against a migration of people from the steppes.[35]

The concept of an invasion of tribes coming from the steppes into the Balkans at the end of the Late Copper Age is based on several pieces of evidence. One is the stratigraphic and chronological rupture between the Late Copper Age and the Early Bronze Age in the eastern Balkans,[36] reflected in the abandonment of settlements

without reoccupation about 4200–4000 BC, which in some regions continued for up to 800 years.[37] The number of settlements in the eastern part of this territory gradually decreased, and they ceased functioning and were abandoned,[38] while the number of settlements in the western Balkans increased and continued to function during one more phase, which is variously labeled the Transitional Period or the Final Copper Age.[39] The latest Copper Age building levels of tell settlements testify to the violent death of their inhabitants.[40] However, concrete evidence for an external military invasion into the territory of present-day Romania and Bulgaria is scarce and rather uncertain, consisting of secondary evidence rather than direct proof. In the eastern part of the Balkan Peninsula in the Early Bronze Age (3200–2500 BC), the presence of a steppe population is undeniable, but the evidence at the end of the Late Copper Age is less clear.[41] In either period, however, the steppe element might not have appeared as the result of an "invasion." In recent years there has been an increase in the number of researchers considering the idea of a peaceful penetration of groups of people from the steppes and their gradual cultural infiltration.[42] New data are available about significant climatic changes in the entire territory of Europe in the late fifth to the first half of the fourth millennium BC. Global warming during that period increased the world sea level, and settlements situated along the coast of the Varna Bay at that time were flooded, the water table increased, and large areas of arable land turned into marshes and swamps.[43] Most probably a combination of factors such as hostile neighbors and climatic changes were the principal causes that forced inhabitants of the northeastern Balkans to abandon their homes. They migrated at first to the southern Balkans, where settlements dated about 4000 BC, slightly later than the Varna cemetery, were found at Kableshkovo[44] and Sozopol[45] near Burgas, and at Starozagorski mineralni bani[46] and Yunatsite in the Upper Thrace lowland,[47] as well as at other sites. These sites witnessed the last attempts of the bearers of this bright culture to retain their old customs on the peninsula. But ongoing climate deterioration forced them either to migrate or to change their way of life completely. The beginning of the fourth millennium BC brought an end to a sophisticated society that had briefly achieved a level of political and aesthetic brilliance unrivaled elsewhere. It disappeared from the historical stage and remained unknown until it was discovered by archaeologists six thousand years later.

Translated by Tatiana Stefanova

208

Notes

1 Ivanov, I.S., *Sakrovishtata na Varnenskiya halkoliten nekropol* (Sofia: Septemvri, 1978); Ivanov, I., and M. Avramova, *Varna Necropolis: The Dawn of European Civilization* (Sofia: Agatho, 2000).

2 The objects have become symbols not only of the cemetery, during numerous presentations at dozens of exhibitions, but of the *Varnenski Arheologicheski Muzey* as well, and for the past twenty years representative objects have been reproduced on the cover of each issue of the museum's annual.

3 Marazov, I., "Grave No 36 from the Chalcolithic Cemetery in Varna—Myth, Ritual and Objects," in *Die Kupferzeit als historische Epoche*, ed. J. Lichardus, Saarbrücker Beitrage zur Altertumskunde 55 (Bonn: Habelt, 1991): vol. 1, 151–55; Marazov, I., *Mitologiya na zlatoto* (Sofia: Hristo Botev, 1994): 24–37.

4 The excavations have not yet been completed, as approximately one-fourth of the territory presumed to belong to the cemetery has not been excavated. Damaged and destroyed graves are also included in the total number of graves.

5 Most of the burials are dated back to the Early Bronze Age and are related to the synchronous settlement situated nearby.

6 Preliminary results were published in Yordanov, Y.A., "Anthropologic Study of Bone Remains from Persons Buried in the Varna Eneolithic Necropolis," *Studia Praehistorica* 1–2 (1978): 50–59, and in Marinov, G., and Y. Yordanov, "Preliminary Data from Studies of Bone Material from the Varna Chalcolithic Necropolis during the 1972–1975 Period," *Studia Praehistorica* 1–2 (1978): 60–67.

7 Two other burials did not yield grave goods.

8 Todorova, H., "Zur Frage der s. g. 'Symbolischen Gräber' des kupferzeit-lichen Gräberfeldes Varna I," in *Hommage à Nikola Tasić à l'occasion de ses soixante ans*, ed. M. Garašanin and D. Srejović, Balcanica 23 (Belgrade: Académie Serbe *des* Sciences et *des* Arts, 1992): 255–70.

9 Comşa, E., "Considérations sur le rite funéraire de la civilisation de Gumelniţa," *Dacia* 4 (1960): 5–30; Ovcharov, D., "Eneoliten nekropol do s. Lilyak, Targovishko" *Arkheologia* 5, no. 1 (1963): 53–56; Todorova-Simeonova, H., "Kasnoeneolitniyat nekropol krai gr. Devnya," *Izvestiya na Narodniya Muzei—Varna* 7 (1971): 3–40; Todorova, H., et al., *Selishtnata mogila pri Golyamo Delchevo*, Razkopki i prouchvaniya 5 (Sofia: Izdatelstvo na BAN, 1975); Raduntcheva, A., *Vinitsa. Eneolitno selishte i nekropol*, Razkopki i prouchvaniya 6 (Sofia: Izdatelstvo na BAN, 1976); Ivanov, T., *Radingrad. Selishtna mogila i nekropol* (Sofia: Septemvri, n.d.); Angelova, I., "A Chalcolithic Cemetery Near the Town of Tărgovište," in *Die Kupferzeit als historische Epoche*, ed. Lichardus (1991): vol. 1, 101–5; Todorova, H., ed., *Durankulak*, vol. 2, *Die prähistorischen Gräberfelder von Durankulak* (Sofia: Anubis, 2002).

10 Todorova-Simeonova, "Kasnoeneolitniyat nekropol krai gr. Devnya" (1971).

11 Todorova, *Durankulak* (2002).

12 Thirty-eight types of gold artifacts are defined.

13 Ivanov, I., "Varnenskiyat nekropol i negovoto myasto v praistoriyata na Iztochnoto Sredizemnomorie," in *Balgaria v sveta ot drevnostta do nashi dni*, ed. D. Kosev (Sofia: Nauka i izkustvo, 1979): vol. 1, 97.

14 Ivanov and Avramova, *Varna Necropolis* (2000): 6–7.

15 The weight of the copper artifacts discovered in Grave 43 alone exceeds the total weight of all copper objects yielded by the Durankulak cemetery, where 1,204 graves have been excavated.

16 Todorova, H., Die Kupferzeitliche Äxte und Beile in Bulgarien, Prähistorische Bronzefunde 9 (14) (Munich: Beck, 1981): 39–42, 50–52, and Taf. 9–10, 18.

17 Dimitrov, K., *Mednata metalurgiya po Zapadnia briag na Cherno more (sredata na V–nachaloto na IV hil. pr. Hr.)* (Sofia: Autoreferat, 2007): 46–49.

18 Manolakakis, L., *Les industries lithiques énéolithiques de Bulgarie*, Internationale Archäologie 88 (Rahden/Westf.: Marie Leidorf, 2005): 263–83.

19 Kostov, R.I., and O. Pelevina, "Complex Faceted and Other Carnelian Beads from the Varna Chalcolithic Necropolis: Archaeogemmological Analysis," in *Geoarchaeology and Archaeomineralogy*, ed. R.I. Kostov, B. Gaydarska, and M. Gurova (Sofia: St. Ivan Rilski, 2008): 67–72.

20 Kostov, R.I., "Mineralogichni osobenosti na antigoritoviya serpentinit kato surovina sred neolitnite I halkolitnite artefakti ot teritoriata na Balgaria," in *The Varna Eneolithic Necropolis and Problems of Prehistory in Southeast Europe*, ed. V. Slavchev, Acta Musei Varnaensis 6 (Varna: Abagar, 2008): 75–84.

21 Ivanov, "Varnenskiyat nekropol i negovoto myasto" (1979): 99.

22 Renfrew, C., "Varna and the Emergence of Wealth in Prehistoric Europe," in *The Social Life of Things: Commodities in Cultural Perspective*, ed. A. Appadurai (Cambridge: Cambridge University Press, 1986): 141–68; Chapman, J., "Social Inequality on Bulgarian Tells and the Varna Problem," in *The Social Archaeology of Houses*, ed. R. Samson (Edinburgh: Edinburgh University Press, 1990): 49–98.

23 Renfrew, C., "Monuments, Mobilization and Social Organization in Neolithic Wessex," in *The Explanation of Culture Change*, ed. Renfrew (Gloucester: Duckworth, 1973): 539–58; Renfrew, C., "Varna and the Social Context of Early Metallurgy," in *Problems of European Prehistory*, ed. Renfrew (Edinburgh: Edinburgh University Press, 1979): 382–83.

24 Manolakakis, *Les industries lithiques énéolithiques de Bulgarie* (2005): 279.

25 Ivanov, I., "Le chalcolithique en Bulgarie et dans la nécropole de Varna," in *Ancient Bulgaria*, ed. A.G. Poulter (Nottingham: Nottingham University Press, 1983): vol. 1, 163; Raduntcheva, A., "ObshtestVarnao-ikonomicheskiyat zhivot na Dobrudza i Zapadnoto Chernomorye prez eneolita," *Vekove* 1, no. 1 (1986): 15–19.

26 The present-day sea level is approximately six meters higher than that of the Late Chalcolithic.

27 Ivanov, I., "À la question de la localisation et des études des sites submergés dans les lacs de Varna," *Pontica* 26 (1993): 19–26.

28 Dimitrov, *Mednata metalurgiya po Zapadnia briag* (2007): 51–52.

29 The situation in the Middle Copper Age (4600–4400 BC) was distinctly different. The role of the coastal communities at that time was to supply *Spondylus* and copper to their neighbors (see Todorova, H., "Bemerkungen zum frühen Handelsverkehr während des Neolithikums und des Chalcolithi-kums im westlichen Schwarzmeerraum," in *Handel, Tausch und Verkehr im bronze- und früheisenzeitlichen Südosteuropa*, ed. B. Hänsel, Prähistorische Archäologie in Südosteuropa 11 [Munich: Südosteuropa-Gesellschaft, Seminar für Ur- und Frühgeschichte der Freien Universität, 1995]: 53–66). A good proof of this is the famous Kărbuna hoard that was hidden in a Tripol'ye A settlement located more than 120 miles from Dobruja during the last phase of the Pre-Cucuteni–Tripol'ye A culture. In addition to the other artifacts, it included 444 copper objects and 270 *Spondylus* shell ornaments. See Sergeev, G.P., "Rannetripol'skii klad u s. Karbuna," *Sovetskaia arkheologiya* 7, no. 1 (1963): 135–51; Dergachev, V.A., *Kerbunskii klad* (Chişinău: Tipografia Academiei de Ştinţe, 1998): 29–43, 45–47.

30 Todorova, H., "Das Spätäneolithikum an der westichen Schwarzmeer-küste," Studia Praehistorica 1–2 (1978): 136–45.

31 Subbotin, L.V., "O sinkhronizatsii pamyatnikov kultury Gumelnitsa v Nizhnem Podunavie," in *Arkheologicheskie issledovania Severo-Zapadnogo Prichernomoria*, ed. V.N. Stanko (Kiev: Naukova Dumka, 1978): 36–41; Subbotin, L.V., *Pamyatniki kultury Gumelnitsa Iugo-Zapada Ukrainy* (Kiev: Naukova Dumka, 1983): 36–41. Different researchers give various names to the latter: Gumelnitsa-Ariusd aspect (Dumitrescu, Vl., "Consideration et données nouvelles sur le problème du synchronisme des civilisations de Cucuteni et de Gumelniţa," *Dacia* 8 [1964]: 53); Stoicanj-Aldeni cultural group (Dragomir, I., *Eneoliticul din sud-estul României. Aspectul cultural Stoicani-Aldeni*, Biblioteca de Arheologie 42 [Bucharest: Academiei RSR, 1983]: 9–15); Bolgrad-Aldeni culture (Chernysh, E.K., "Eneolit Pravoberezhnoi Ukrainy i Moldavii," in *Eneolit SSSR*, ed.V.M. Masson and N.Y. Merpert, Arkheologia SSSR 3 [Moscow: Nauka, 1982]: 253–56).

32 Slavchev, V., "Precucuteni Influences on Pottery of the Final Phase of Hamangia Culture," in *Cucuteni. 120 ans de recherches; Le temps du bilan/Cucuteni: 120 Years of Research; Time to Sum Up*, ed. J. Chapman et al., Bibliotheca Memoriae Antiquitatis 16 (Piatra- Neamţ, 2005): 53–54.

33 Todorova calls them "funeral pottery"; Todorova, H., "Die Sepulkral-keramik aus den Gräbern von Durankulak," in *Durankulak*, ed. Todorova (2002): 81–116.

34 Gimbutas, M., "The First Wave of Eurasian Steppe Pastoralists into Copper Age Europe," *Journal of Indo-European Studies* 5, no. 4 (1977): 277–338.

35 Dergachev, V., "The Migration Theory of Marija Gimbutas," *Journal of Indo-European Studies* 28, nos. 3–4 (2000): 257–339; Manzura, I.V., "Vladeyushie skipetrami," *Stratum plus, no.* 2 (2000): 237–95.

36 Todorova, H., "Der Übergang vom Äneolithikum zur Bronzezeit in Bulgarien. Die Ethnogenese der Thraker," in *Dritter Internationaler Thrakologischer Kongress zu Ehren W. Tomascheks*, ed. A. Peschew et al. (Sofia: Swjat, 1984): vol. 1, 117.

37 For further details on problems related to chronology, see Boyadziev, Y., "Chronology of Prehistoric Cultures in Bulgaria," in *Prehistoric Bulgaria*, ed. D.W. Bailey, I. Panayotov, and S. Alexandrov, Monographs in World Archaeology 22 (Madison, WI: Prehistory Press, 1995): 173–74.

38 Todorova, H., *Kamenno-mednata epokha v Balgaria. Peto Khilyadoletie predi Novata Era* (Sofia: Nauka i Izkustvo, 1986): 87–89 and fig. 16.

39 Georgieva, P., "Ethnocultural and Social-Economic Changes during the Transitional Period from Eneolithic to Bronze Age in the Region of Lower Danube," *Godišnjak na Akademija nauka i umetnosti Bosne I Hercegovine. Centar za balkanološka ispitivanja* 28, no. 26 (1990): 241; Boyadziev, "Chronology of Prehistoric Cultures" (1995): 173.

40 See the data on tell Hotnitsa: Angelov, N., "Selishtnata mogila pri s. Hotnitsa," in *Izsledvania v chest na akad. Dimitar Dechev po sluchai 80-godishninata mu*, ed. V. Beshevliev and V. Georgiev (Sofia: Bulgarian Academy of Sciences Press, 1958): 393; Angelov, N., "Zlatnoto sakrovishte ot Hotnitsa," *Arkheologia* 1, nos. 1–2 (1959): 39–40. On tell Yunatsite: Matsanova, V., "Intramiralni 'pogrebenia' ot kasnia halkolit v selishtnata mogila pri Yunatsite, Pazardzhishko," in *Trakia i sasednite raioni prez neolita i halkolita*, ed. V. Nikolov (Sofia: Agatho, 2000): 121–23. On tell Ruse and tell Kubrat: Todorova, *Kamenno-mednata epokha v Balgaria* (1986): 74–75; Matsanova, "Intramiralni 'pogrebenia' ot kasnia halkolit" (2000): 124.

41 Panayotov, I., Yamnata kultura v balgarskite zemi, Razkopki i prouchva-niya 21 (Sofia: Bulgarian Academy of Sciences Press, 1989); Georgieva, P., "Nadgrobna mogila krai gr. Shabla (problemi na hronologiyata i kulturnata prinadlezhnost),"Arkheologia 33, no. 1 (1991): 1–10.

42 Manzura, "Vladeyushie skipetrami" (2000); Georgieva, P., "Za zoomorfnite skiptri i poslednite etapi na kasnoeneolitnite kulturi Varna, Kodzhadermen-Gumelnitsa-Karanovo VI i Krivodol-Salkutsa," in *Stephanos Archaeologicos—In Honorem Professoris Ludmili Getov*, ed. K. Rabadjiev (Sofia: Sofia University Press, 2005: 156).

43 Todorova, H., "Die geographische Lage der Gräberfelder. Paläoklima, Strandverschiebungen und Umwelt der Dobrudscha im 6.–4. Jahrtausend v. Chr.," in *Durankulak*, ed. Todorova (2002): 20–22.

44 Georgieva, P., "Za kraiya na eneolita v Zapadnoto Chernomorie," in *Festschrift für Dr.habil. Henrieta Todorova*, ed. V. Slavchev, Sbornik Dobrudja 21 (Varna: Sitronik, 2004): 215–24.

45 Draganov, V., "Submerged Coastal Settlements from the Final Eneolithic and the Early Bronze Age in the Sea around Sozopol and Urdoviza Bay near Kiten," in *Prehistoric Bulgaria*, ed. Bailey, Panayotov, and Alexandrov (1995): 233–36.

46 Georgieva, "Za zoomorfnite skiptri" (2005): 152.

47 Georgieva, "Za kraiya na eneolita" (2005): 221.

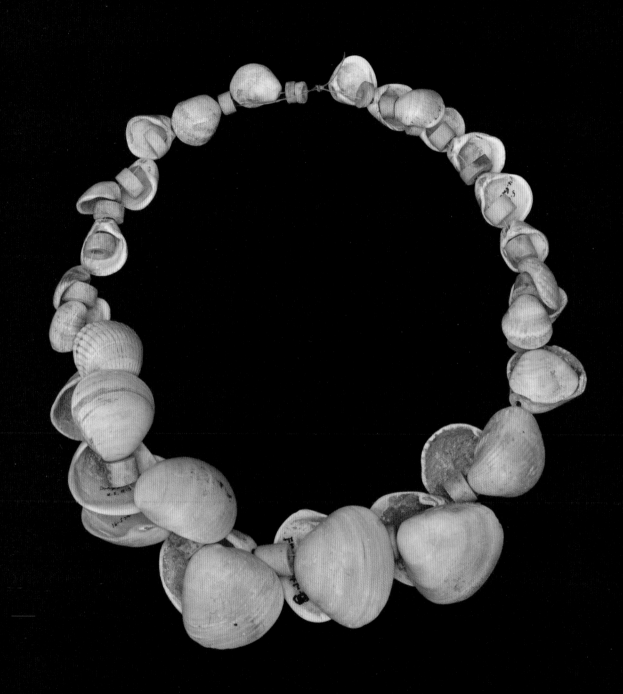

The Copper Age Cemetery of Giurgiuleşti

Veaceslav Bicbaev

The National Museum of Archaeology and History of Moldova, Chişinău

The Copper Age cemetery of Giurgiuleşti was discovered in 1991 during the rescue excavation of a pair of kurgans (burial mounds) at the edge of the village of Giurgiuleşti by the Institute of Archaeology and Ancient History of the Academy of Sciences, Republic of Moldova. Giurgiuleşti is located in the Cahul district in the Lower Prut region of Moldova. The excavations were directed by V. Haheu and S.I. Kurciatov, who also authored the research report and the first publication of the cemetery.[1]

The cemetery is situated on a high plateau on the left (eastern) bank of the Prut River at the southernmost point of Moldova, close to where the Prut flows into the Danube River. The plateau has a commanding view over the flat marshes and plains of the lower Danube River valley and across it to the distant rocky hills of the Dobrogea to the south (fig. 10-1). The region on the north side of the Danube is an extension of the steppe grasslands to the north and east, characterized by flat-bottomed valleys and rolling grassy ridges that in this region rarely surpass elevations of one hundred meters. The Prut River was an important avenue of communication that connected the Danube valley with the settled agricultural landscapes of the region between the Carpathians and the Dniester River, where rainfall agriculture was much more reliable than in the coastal steppes, and where many agricultural Cucuteni settlements existed during the Copper Age. The cemetery site was 130 kilometers west of the Black Sea coast.

The coastal lowlands northwest of the Black Sea receive insufficient rainfall for the growth of trees except in river valleys, where the elevated water table near the river supports ribbons of gallery forest. Outside of the river valleys the vegetation is steppe grassland. The Bugeac steppes, as they are named in this part of the Black Sea lowland, form the western end of a steppe corridor that extends across the Eurasian continent to Mongolia. This was the environment through which tribes of nomad shepherds, assumed to have been the bearers of the Proto-Indo-European language, began to move from the Pontic-Caspian steppes into the Danubian territory at the end of the early Copper Age[2] (the second half of the fifth millennium BC) from the steppes east of the Black and Caspian seas. At that time the lower Danube valley was inhabited by the sedentary agricultural communities of the Gumelniţa culture and its local variants, including the Bolgrad group. The first phase of the intercultural dialogue between the sedentary population and the nomadic peoples occurred during the chronological phase

Karanovo VI-Gumelniţa-Varna, when the mining and production of copper and gold flourished in Old Europe, as can be seen particularly at the rich cemetery of Varna (see Vladimir Slavchev's essay in this volume).[3] It was also a time when the Cucuteni-Tripol'ye culture flourished, a culture perhaps best known for its elaborate and sophisticated pottery. Contact with the steppe nomads began during the Pre-Cucuteni III phase and continued through Cucuteni A4, or about 4500–4000 BC.

What appears to have been at first peaceful interactions changed in a relatively short period of time. Steppe nomads appear to have invaded from the north into the Carpathian-Balkan region about 4300–4100 BC. The first real invasion occurred at the chronological level of the Cucuteni A3 and A4 phases, with a catastrophic outcome for many of the Balkan cultures.[4]

The Suvorovo-Novodanilovka Culture

The steppe culture that migrated into the lower Danube valley is known as the Novodanilovka culture or as the Suvorovo-Novodanilovka culture.[5] It can be divided into three regional groups of graves. No settlements are known, perhaps because the people were mobile pastoralists who left very little in the way of settlement remains. About thirty-five to forty cemeteries are assigned to the Suvorovo-Novodanilovka culture as a whole.

One regional group, the most important for the purposes of this volume, was centered in the lake-studded steppes north of the Danube delta (including the sites of Suvorovo and Giurgiuleşti), with a few additional graves that filtered southward down the coast of the Black Sea to Varna (Casimcea, Devnya), and a few more that followed the steppe river valleys upstream toward the Cucuteni settlements (Kainar, Kopchak). The type site for this group is the Suvorovo tumulus, or kurgan (Suvorovo cemetery II kurgan 1). It was thirteen meters in diameter and covered four Copper Age graves.[6] Stones measuring a meter tall formed a retaining wall or cromlech around the base of the mound. Grave 7 was the double grave of an adult male and female buried supine with raised knees, heads to the east. The floor of the grave was covered with red ochre, white chalk, and black fragments of charcoal. A magnificent polished stone mace shaped like a horse head lay on the pelvis of the male. Belts of *Unio*-shell disc beads draped the female's hips. The grave also contained two copper awls made of Balkan copper, three lamellar flint blades, and a flint end-scraper.

South of the Danube River in the Dobrogea at Casimcea, an adult male was buried in an ochre-stained grave on his back with raised knees, accompanied by a polished stone horse-head mace, five triangular flint axes, fifteen triangular flint points, and three lamellar flint blades (see fig. 1-18).

Farther south down the Black Sea coast, another Suvorovo-Novodanilovka grave was placed in the Varna-culture cemetery at Devnya, near Varna. This single, ochre-stained grave contained an adult male on his back with raised knees, accompanied by thirty-two golden rings; a copper axe; a copper decorative pin; a copper square-sectioned penetrating instrument twenty-seven centimeters long, perhaps a poniard-like dagger or the point of a javelin; a bent copper wire 1.64 meters long, perhaps a trade ingot; thirty-six flint lamellar blades; and five triangular flint points.

The second group of intrusive graves appeared in Transylvania. The migrants there left cemeteries at Decea Mureșului in the Mureș valley and at Csongrad in the plains of eastern Hungary. At Decea Mureșului, near important copper deposits, there were fifteen to twenty graves, the bodies on their backs with the knees probably originally raised but fallen to the left or right, colored with red ochre, with *Unio*-shell beads, long flint blades (up to twenty-two centimeters long), copper awls, a copper rod "torque," and two four-knobbed mace heads made of black polished stone. A radiocarbon date from Grave 12 at Decea Mureșului (KIA-368: 5380 ± 40 BP) gave a calibrated true age of 4330–4170 BC.[7]

The third regional group was located more than 550 kilometers to the east, in the steppes around the lower Dnieper River, perhaps the region of origin for the immigrants. In this arid steppe region, Novodanilovka graves are distributed across the same territory as graves and settlements designated as belonging to the Sredni Stog II culture, and many aspects of grave ritual and lithics are identical. Y. Rassamakin has designated the copper-rich graves of the Novodanilovka type as belonging to a new entity that he designated the Skelya culture.[8] The Novodanilovka elite were buried with copper spiral bracelets, rings, and bangles, copper beads of several types, and copper awls, all of which contained Balkan trace elements and were made technologically, like the objects at Giurgiuleşti and Suvorovo.[9] The grave floors were strewn with red ochre or with a chunk of red ochre. The bodies were positioned on the back with raised knees and the head oriented east or northeast. Surface markers were a small kurgan or stone cairn, often surrounded by a stone circle or cromlech.

The main characteristics of the Suvorovo-Novodanilovka culture are: a lack of settlements; the use of flat graves without a covering tumulus as well as kurgan graves with a single covering tumulus; grave pits of rectangular shape, in some cases with stone slab walls or with the pits covered with stone slabs; and finally a standard burial position on the back with the head oriented to the east, knees raised, arms stretched along the body, and hands, in most cases, on the ground. The body and the base of the pit are usually abundantly covered with red ochre. Grave inventories almost always include flint objects, predominantly triangular spear or arrow points and blades, of a high quality. Frequently, the right or left hand holds a large flint blade, often retouched on the edges. A specific element is the deposit of large quantities of unfinished or semifabricated flint pieces. Some burials contain a large number of simple or spiral bracelets made of copper, copper pendants, strands of *Unio*-shell or seashell beads, and crescent-shaped pendants made of boar tusks. Stone chisels, flint blades, and weapons are also occasionally present in the graves. Stone clubs and maces, notably maces with a stone head shaped like a horse head, also form part of many inventories. It is interesting to note that ceramics are rarely found, and when they do occur, they frequently were borrowed from another culture, as in Grave 2 at Giurgiuleşti, which contained a pot of the local Gumelniţa culture. Similarly, a Tripol'ye B1 beaker was found in the Kainar kurgan, between the Prut and the Dniester;[10] and a late Gumelniţa vessel in the Kopchak kurgan, situated forty-four kilometers northeast of the Giurgiuleşti cemetery. Gold objects, while not frequent, were found in some of the richest Novodanilovka graves, such as those at Devnya in Bulgaria, Krivoj Rog in Ukraine, and Giurgiuleşti in Moldova.[11]

The copper from Suvorovo-Novodanilovka graves helps to date them. Trace elements in the copper from Giurgiuleşti and Suvorovo in the lower Danube, and from Chapli and Novodanilovka in the Dnieper steppes, are typical of the mines in the Bulgarian Balkans (Ai Bunar and/or Medni Rud) that abruptly ceased production when Old Europe collapsed. The eastern-European copper trade shifted to chemically distinctive Serbian ores that probably came

from mines near Majdanpek during Tripol'ye B2, after 4000 BC.[12] Therefore, the Suvorovo-Novodanilovka graves must be dated before that. The earliest side of the chronological frame is defined by the fact that the Suvorovo kurgans replaced the settlements of the Bolgrad group north of the Danube delta, which were still occupied during early Tripol'ye B1, or after about 4400–4300 BC. These two bookends (after the abandonment of Bolgrad, before the wider Old European collapse) restrict Suvorovo-Novodanilovka to a period between 4300 and 4000 BC.

The Giurgiuleşti Graves

The Copper Age cemetery at Giurgiuleşti was discovered in the process of investigating kurgan 2, a large burial mound built by people of the Early Yamnaya culture, probably about 3000 BC. The Yamnaya kurgan mound covered and preserved, apparently by accident, the much older Copper Age cemetery.

The cemetery was created between 4490 and 4330 BC, according to a single radiocarbon date on human bone from one of the graves (Ki-7037, 5560±80 BP). Radiocarbon dates from related sites agree generally with the date from Giurgiuleşti: The steppe-related grave at Kainar, Romania, is dated to about 4455–4355 BC (Ki-369, 5580±50 BP); and the steppe-related graves at Decea Mureşului in Transylvania are dated a little later, 4330–4050 BC (KIA-368, 5380±40 BP).[13]

The Giurgiuleşti cemetery contained five graves distributed over roughly 200 square meters (figs. 10-2–10-6). Graves 1–3 contained the remains of children, while Grave 4 was an adult male, and Grave 5 an adult individual without age or sex determination. In four of the five graves, the bodies were positioned on the back with raised knees (Grave 2, containing disarticulated bones, had been robbed). The grave floors were painted with red ochre. Two children (Graves 1 and 3) and the adult (Grave 5) together wore nineteen copper spiral bracelets and five boar-tusk pendants, one of which was decorated with copper beads. Grave 2 contained a late Gumelniţa pot.

Between the graves was a cult place, with special arrangements for performing complex funerary ceremonies, preparation of the funerary structures, and animal

10-2. General plan of the Giurgiuleşti cemetery (after Haheu and Kurciatov, 1993).

10-3 (opposite: top). Grave 3, plan and section (after Haheu and Kurciatov, 1993).

10-4 (opposite: bottom, left). Grave 4, a. plan of the upper part of the grave pit (shaft) with bones of sacrificed cattle and horse; b. general plan of the grave (after Haheu and Kurciatov, 1993).

10-5 (opposite: bottom, center). Grave 4. Section. a = filling of the grave shaft, with charcoal, small calcined bones and animal skulls in its upper part; b = filling of the burial chamber with a cupola-shaped construction of pure yellow clay; c = niches for wooden ceiling of burial chamber; d = burial chamber with filling of clay; e = layer of silt on the chamber bottom, covered with red ochre (after Haheu and Kurciatov, 1992).

10-6 (opposite: bottom, right). Grave 5, plan and section (after Haheu and Kurciatov, 1993).

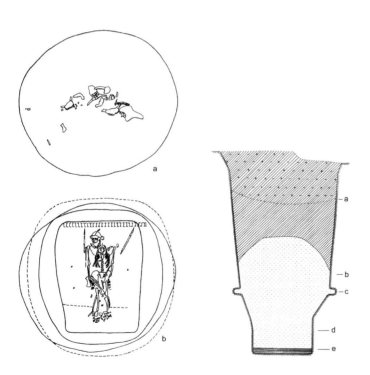

sacrificial rites. The sacrificial place was defined by a rectangular platform surrounded by ditches (Cult structure 1) with a round fireplace altar within, and a pit to the south of the platform (Pit 1) which, in the upper part of its filling, contained the remains of five animal skulls, including cattle and goats.[14] Above Grave 4 was a second sacrificial deposit that contained the skulls of five animals, including an unspecified number of cattle and at least one horse skull. Graves 1–4 and the sacrificial pit formed a compact semicircular group in the southern and southeastern part of the Cult structure, while Grave 5 had an isolated position ten meters south of the structure. Around two thousand objects were discovered in the five graves.

Grave 1 was an oval pit with a small side-niche, or semi-catacomb. The deceased was a child, approximately three years old, laid on the back with knees bent, the head oriented southeast. The grave inventory included: six *Unio* shells without perforations; nine flint blades made from Dobrogea flint, one of them—a knife—introduced in the palm of the right hand; one (incomplete) strand of three white beads (unidentified material) and an uncounted number of black beads (unidentified material), all found in the zone of the neck; two boar-tusk pendants (one perforated for the attachment of copper beads, fig. 10-7, bottom), found on the chest; two fossil shells (*Cardium edule* Reeve), used as pendants;[15] one strand of 75 copper beads found on the chest; a second strand of 420 copper beads; and eight copper spiral bracelets.

Grave 2 was an oval pit with a small side-niche, or semi-catacomb, with a child burial, destroyed by robbing. The skeleton was unarticulated, placed in a pile, and the age was undetermined. The grave inventory included a ceramic vessel of Gumelniţa type; one stone axe; nine rectangular plaques made of *Margaritifera* (freshwater pearl) shells; the remains of a strand of twenty-six cylindrical beads of white marble; thirty-five fossil shell beads (twenty-four of *Cardium Edule*, eleven of *Mactra carolina*), that probably composed a single necklace (see page 212); one *Unio*-shell with no trace of processing; the remains of small roundish unidentified shells; one copper hook; and four copper beads.

Grave 3 was a pit of catacomb type with an oval shaft and an oval-rectangular mortuary chamber with a niche (fig. 10-3). The deceased was a child, two to three years old, laid on the back with knees bent, head oriented southeast, right hand stretched along the body, and left hand with the palm on the pelvis. The grave inventory included: one conical flint nucleus beside the head (fig. 10-8, top), two flint scrapers; one flint blade (knife); one polished stone axe; two boar-tusk pendants (fig. 10-7, top); one strand of two cylindrical marble beads and nine fossil shells; one strand of ten deciduous deer teeth; one necklace of fossil shells; two copper temple rings; one necklace of two strands of beads (one strand containing 106 copper and 3 marble beads, the other 100 copper and 3 marble beads, fig. 10-9); one strand of 158 copper beads (fig. 10-10) and six copper bracelets.

Grave 4 was a very deep shaft grave, five meters deep, roundish in the upper part and rectangular at the bottom (figs. 10-4, 10-5). The deceased was an adult male, twenty to twenty-five years old, laid on the back with knees bent, head oriented southeast, and hands stretched along the body. The grave inventory included eight ornamental circlets, about five to seven centimeters in diameter, placed on each side of the head (sixteen total); each circlet was made of white coral beads (422 beads on one side and 415 beads on the other). These might have been part of some kind of ornamented headband or cap (fig. 10-11). In addition, the grave contained a unique spear foreshaft (a detachable point), more than fifty centimeters long, with a point made of deer antler, a shaft made of wood, twenty-eight inset flint blades on the edges (fourteen on each side), and an antler attachment for the handle (fig. 10-12); one spear point made of deer antler with three gold tubular fittings for the shaft, about forty centimeters long (fig. 10-13); a third deer-antler spear point; one flint blade (fig. 10-8, bottom); one cylindrical polished

10-7. Two boar-tusk pendants, one perforated for the attachment of copper rings. Boar tusk, Suvorovo-Novodanilovka, Giurgiuleşti, Graves 3 (top) and 1 (bottom), 4500–4300 BC, MNAIM.

10-8. Conical core or nucleus and blade. Flint, Suvorovo-Novodanilovka, Giurgiuleşti, Graves 3 (top) and 4 (bottom), 4500–4300 BC, MNAIM.

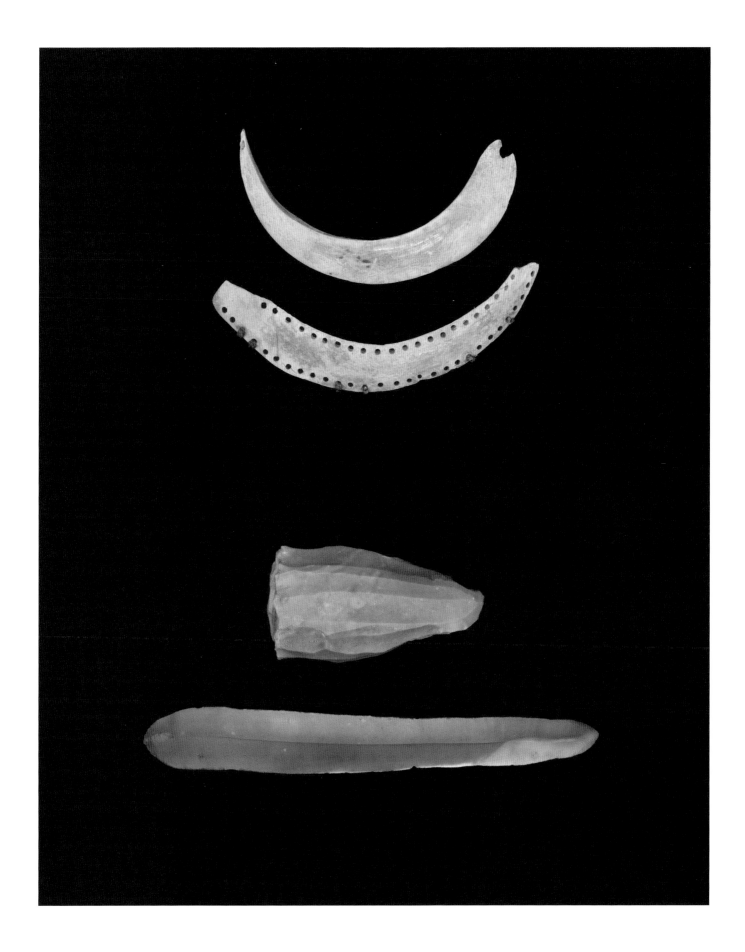

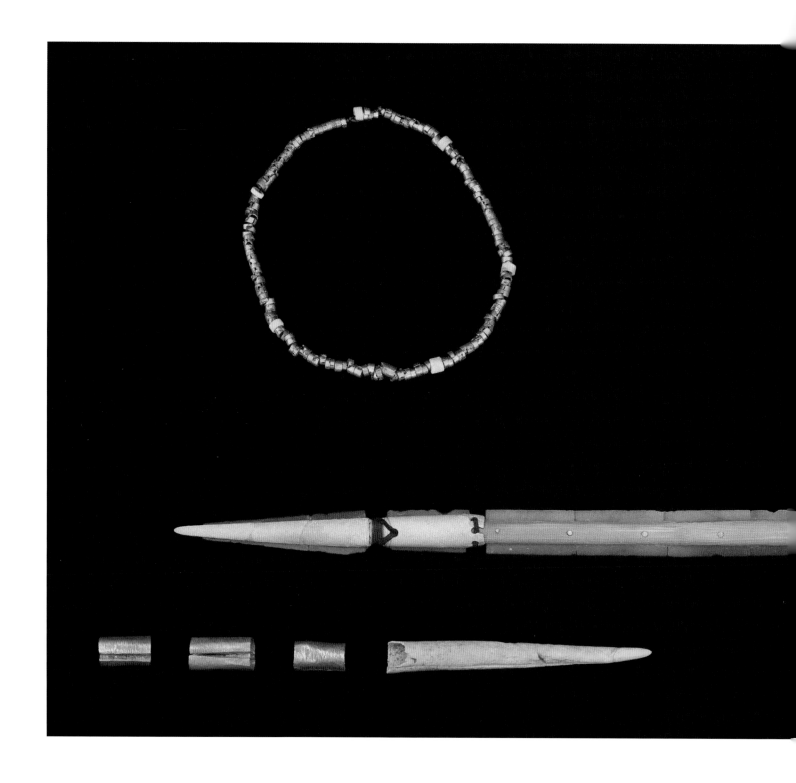

10-9 (top, left). Bead necklace. Copper and marble, Suvorovo-Novodanilovka, Giurgiuleşti, Grave 3, 4500–4300 BC, MNAIM.

10-10 (top, center). Bead necklace. Copper, Suvorovo-Novodanilovka, Giurgiuleşti, Grave 3, 4500–4300 BC, MNAIM.

10-11 (top, right). Circlets of white beads. Coral, Suvorovo-Novodanilovka, Giurgiuleşti, Grave 4, 4500–4300 BC, MNAIM.

10-12 (center). Spear foreshaft. Wood, antler, bone, and flint, Suvorovo-Novodanilovka, Giurgiuleşti, Grave 4, 4500–4300 BC, MNAIM.

10-13 (bottom, left). Spear point and tubular shaft fittings. Antler and gold, Suvorovo-Novodanilovka, Giurgiuleşti, Grave 4, 4500–4300 BC, MNAIM.

10-14 (bottom, right). Spiral ornaments. Gold, Suvorovo-Novodanilovka, Giurgiuleşti, Grave 4, 4500–4300 BC, MNAIM.

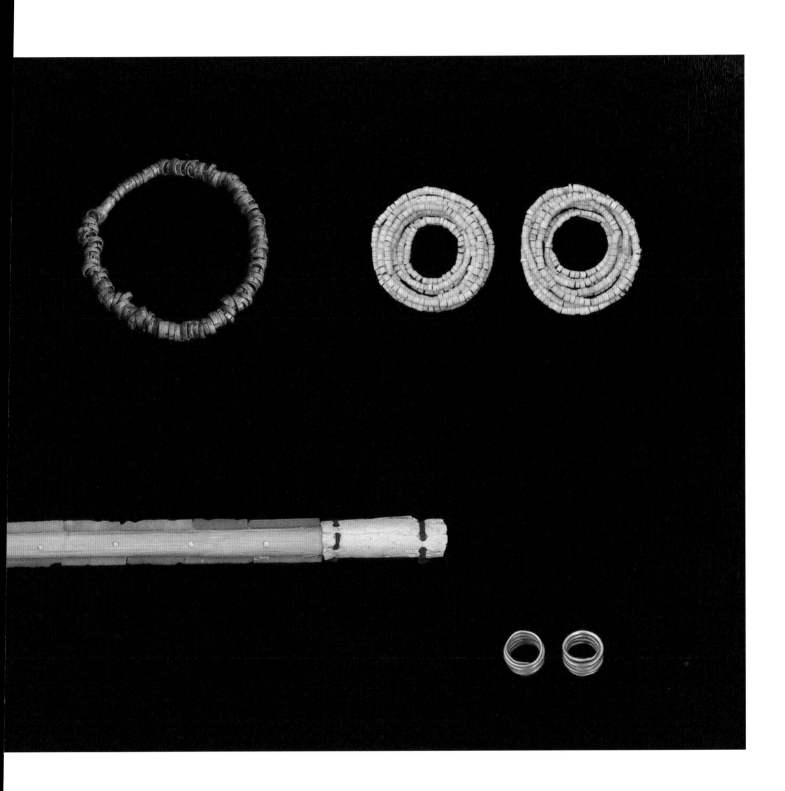

shell bead; one small bone plate; one deer-antler inlay; one deer-antler "phallus"; one small unworked piece of deer antler; one ovicaprine scapula with forty notches along one edge; two gold spiral ornaments (fig. 10-14); and a massive copper dagger.

Grave 5 was a deep pit of rectangular shape with roundish corners (fig. 10-6). The deceased was an adult, sex undetermined, laid on the back with knees bent, head oriented southeast, and hands stretched along the body. The grave inventory included one boar-tusk pendant; one shell pendant; four strands of copper beads containing 582 beads total (fig. 10-15); six strands of copper beads containing 506 beads total; and five copper bracelets (fig. 10-16).

The Causes and Targets of the Migrations

Winters began to get colder in the interior steppes after about 4300–4200 BC.[16] The marshlands of the Danube delta are the largest in Europe west of the Volga. Marshes of *Phragmites* reeds were the preferred winter refuge for nomadic pastoralists in the Black Sea steppes during recorded history because they offered good winter forage and cover for cattle. The Danube delta was richer in marsh resources than any other place on the Black Sea. The first Suvorovo-Novodanilovka herders who appeared on the northern edge of the Danube delta about 4300 BC might have brought some of their cattle south from the Dnieper steppes during a period of particularly cold winters.

Another attraction was the abundant copper that came from Old European towns. Copper was traded or gifted back into the steppes around the lower Dnieper River, probably by the migrants who were at the "front" of the contact with Tripol'ye B1, Cucuteni A3–A4, and late Gumelniţa settlements. Probably the first effect of the migration was the abandonment of the lake country north of the Danube delta by the agricultural communities who had lived there. The thirty settlements of the Bolgrad culture north of the Danube delta were abandoned and burned soon after the Suvorovo immigrants arrived. These small agricultural villages were composed of eight to ten semisubterranean houses with fired-clay hearths, benches, and large storage pots set in pits in the floor. Graphite-painted fine pottery and numerous

female figurines show a mixture of Gumelniţa (Aldeni II type) and Tripol'ye A traits. The villages were occupied mainly during Tripol'ye A, then were abandoned and burned during early Tripol'ye B1, probably about 4300–4200 BC. Most of the abandonments seem to have been planned, since almost everything was picked up. But at Vulcaneşti II, radiocarbon dated 4200–4100 BC (5300 ± 60 BP), abandonment was quick, leaving many whole pots to burn. This might date the arrival of the Suvorovo migrants, and the beginning of the end of Old Europe.[17] After this date, the new occupants of this region, including the chief buried at Suvorovo, left graves, but no settlements.

Translated by Iulia Postica

10-15. Bead necklace. Copper, Suvorovo-Novodanilovka, Giurgiuleşti, Grave 5, 4500-4300 BC, MNAIM.

10-16. Spiral bracelets. Copper, Suvorovo-Novodanilovka, Giurgiuleşti, Grave 5, 4500–4300 BC, MNAIM.

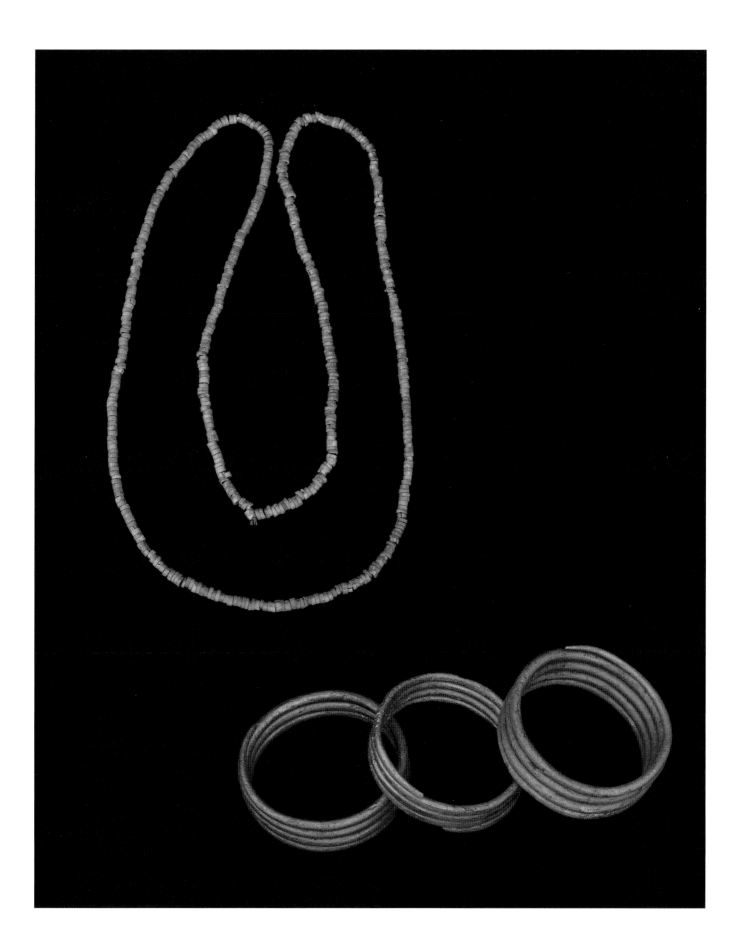

Notes

1 Haheu V., and S. Kurciatov, "Otchet o polevych issledovanyach Pruto-Dunayskoy novostroechnoy ekspedicii v 1991 godu," *Arhiva Arheologică a MNAIM* (Kishinev), no. 336, 1992: 55; Haheu, V., and S. Kurciatov, "Cimitirul plan eneolitic de lîngă satul Giurgiuleşti," *Revista Arkheologica* 1 (1993): 101–14.

2 In Romania and Moldova, the late fifth millennium BC is the end of the Early Copper Age, as above; but in the Bulgarian chronological system (Karanovo VI and Varna), this period was the end of the Late Copper Age.

3 Ivanov, I.S., *Sokroviscyata na varnenskya neoliten nekropolju* (Sofia: Septemvri, 1978); Chernykh, E.N., *Gornoje delo i metallurgija v drevnejsej Bolgarii* (Sofia: Arkheologicheskii Institut i Muzei Bolgarskoi Akademii Nauk, 1978); Todorova, H., *Eneolit Bolgarii* (Sofia, 1979): 116.

4 Chernykh, E.K., "Eneolit pravoberezhnoi ukrainy i moldavii," in *Eneolit SSSR*, ed. V.M. Masson and N.Y. Merpert: 166–320, Arkheologia SSSR 3 (Moskva: Nauka, 1982).

5 Gimbutas, M., *Civilizaţie şi cultură. Vestigii preistorice în sud-estul* (Bucureşti: Meridiane, 1989); see also Kotova, N.S., *Early Eneolithic in the Pontic Steppes*, trans. N.S. Makhortykh, British Archaeological Reports, International Series 1735 (Oxford: Archaeopress, 2008).

6 Alekseeva, I.L., "O drevneishhikh eneoliticheskikh pogrebeniyakh severo-zapadnogo prichernomor'ya," in *Materialy po Arkheologii Severnogo Prichernomor'ya* (Kiev) 8 (1976): 176–86. The Kopchak kurgan is described in: Beilekchi, V.S., "Raskopki kurgana 3 u s. Kopchak," *Arkheologicheskie Issledovaniya v Moldavii v 1985 g.*: 34–49 (Kishinev: Shtiintsa, 1985).

7 For the dating of these graves, see Tsvek, E.V., and Y. Rassamakin, "The Interactions between the Eastern Tripol'ye Culture and the Pontic Steppe Area: Some Aspects of the Problem," in *Cucuteni. 120 ans de recherches; Le temps du bilan/Cucuteni: 120 Years of Research; Time to Sum Up*: 173–92, Bibliotheca Memoriae Antiquitatis 16 (Piatra-Neamţ, 2005).

8 Rassamakin, Y., "The Eneolithic of the Black Sea Steppe: Dynamics of Cultural and Economic Development, 4500–2300 BC," in *Late Prehistoric Exploitation of the Eurasian Steppe*, ed. M. Levine, Rassamakin, A. Kislenko, and N. Tatarintseva: 59–182, McDonald Institute Monographs (Cambridge: McDonald Institute for Archaeological Research, 1999).

9 For the metals of the Novodanilovka group, see Ryndina, N.V., *Drevneishee metallo-obrabatyvaiushchee proizvodstvo Iugo-Vostochnoi Evropy* (Moscow: Editorial, 1998): 166–67. The Novodanilovka grave, which was isolated rather than being in a cemetery, is described in: Telegin, D.Y., *Seredno-Stogivs'ka kul'tura epokha midi* (Kiev: Dumka, 1927): 113. For descriptions of the graves at Petro-Svistunovo and Chapli, see Bodyans'kii, O.V., "Eneolitichnii mogil'nik bilya s. Petyro-Svistunovo," *Arkheologiya* (Kiev) 21 (1968): 117–25; and Dobrovol'skii, A.V., "Mogil'nik v s. Chapli," *Arkheologiya* (Kiev) 9 (1958): 106–18.

10 Located 150 kilometers northeast of Giurgiuleşti, in the floodplain of the Dniestr affluent Botna, at the southern border of the forest-steppe zone, thirteen kilometers east of the Precucuteni III settlement Carbuna, with its famous hoard of numerous copper and other objects.

11 Telegin, D.Y., A.N. Nechitailo, I.D. Potekhina, and Y.V. Panchenko, *Srednestogovskaya i novodanilovskaya kul'tury eneolita azovo-chernomorskogo regiona* (Lugansk: Shlyakh.Dergachev, 2001); Manzura, I., "Culturi eneolitice în zona de stepă," *Thraco-Dacia* 15, nos. 1–2 (1994): 93–101.

12 The metal of the Suvorovo-Novodanilovka complex is described in Ryndina, Drevneishee metallo-obrabatyvaiushchee proizvodstvo Iugo-Vostochnoi evropy (1998); see esp. 159–70 for the metallurgy of the "Novodanilovka tribe," as she called this complex. Ryndina examined copper objects from graves at Chapli, Giugiurleşti, Novodanilovka, Petro-Svistunovo, and Suvorovo. The copper of Varna and Gumelnitsa, but particularly Varna, is discussed in a long article by a well-known German metallurgical team: Pernicka, E.F., et al., "Prehistoric Copper in Bulgaria: Its Composition and Provenance," Eurasia Antiqua 3 (1997): 41–179. The authors document the end of the Balkan mines and the switch to Serbian ores about 4000 bc.

13 Radiocarbon dates from Kotova, *Early Eneolithic in the Pontic Steppes* (2008): 69.

14 Archaeozoological analysis by G. Cemyrtan and anatomical determination of human bones by I.D. Potekhina; see Manzura, I.V., "Arkheologia osnovnogo mifa," *Stratum. Structury i katastrofy [Sbornik simvolicheskoi indoevropeiskoi istorii]* (Sankt-Peterburg, 1997): 26–36.

15 After Dergachev, V., *Die äneolitishen und bronzezeitlichen Metallfunde aus Moldavien* (Stuttgart: Steiner, 2002): 19–21, Taffeln 10–15.

16 Leuschner, H.H., et al., "Subfossil European Bog Oaks: Population Dynamics and Long-Term Growth Depressions as Indicators of Changes in the Holocene Hydro-regime and Climate," *The Holocene* 12, no. 6 (2002): 695–706.

17 Subbotin, L.V., "O sinkhronizatsii pamyatnikov kul'tury Gumelnitsa v nizhnem Podunav'e," in *Arkheologicheskie issledovaniya severo-zapadnogo prichernomor'ya*, ed. V.N. Stanko (Kiev: Naukova Dumka, 1978): 29–41; and Subbotin, L.V., "Uglubennye zhilishcha kul'tury Gumelnitsa v nizhnem podunav'e," in *Rannezemledel'cheski poseleniya-giganty Tripol'skoi kul'tury na Ukraine*, ed. I.T. Chenyakov (Tal'yanki: Institut Arkheologii AN USSR, 1990): 177–82.

Republic of Bulgaria

Varna Museum Regionalen Istoricheski Muzey, Varna
Varna Regional Museum of History

Republic of Moldova

MNAIM Muzeul Naţional de Arheologie şi Istorie a Moldovei, Chişinău
The National Museum of Archaeology and History of Moldova, Chişinău

Romania

CMJMPN Complexul Muzeal Judeţean Neamţ, Piatra Neamţ
Neamţ County Museum Complex, Piatra Neamţ

CMNM Complexul Muzeal Naţional Moldova, Iaşi
Moldova National Museum Complex, Iaşi

IAI Institutul de Arheologie, Iaşi
The Institute of Archaeology, Iaşi

MB Muzeul Banatului, Timişoara
Museum of Banat, Timişoara

MBM Muzeul Banatului Montan, Reşiţa
Museum of Mountain Banat, Reşiţa

MBR Muzeul Brăilei, Brăila
Brăila Museum, Brăila

MDJ Muzeul Dunării de Jos, Călăraşi
Lower Danube Museum, Călăraşi

MIG Muzeul de Istorie Galaţi, Galaţi
Galaţi History Museum, Galaţi

MINAC Muzeul de Istorie Naţională şi Arheologie, Constanţa
National History and Archaeology Museum, Constanţa

MIR De Istorie Roman
Roman History Museum

MJBT Muzeul Judeţean Botoşani, Botoşani
Botoşani County Museum, Botoşani

MJIAZ Muzeul Judeţean de Istorie şi Artă, Zalău
County Museum of History and Art, Zalău

MJIBV Muzeul Judeţean de Istorie Braşov, Braşov
Braşov County History Museum, Braşov

MJITAGR Muzeul Judeţean de Istorie "Teohari Antonescu," Giurgiu
"Teohari Antonescu" History County Museum, Giurgiu

MJITR Muzeul Judeţean de Istorie Teleorman, Alexandria
Teleorman County History Museum, Alexandria

MJSMVS Muzeul Judeţean "Ştefan cel Mare" Vaslui, Vaslui
"Ştefan cel Mare" Vaslui County Museum, Vaslui

MNIR Muzeul Naţional de Istorie a României, Bucureşti
National History Museum of Romania, Bucharest

MO Muzeul Olteniei, Craiova
Museum of Oltenia, Craiova

MVPB Muzeul "Vasile Pârvan," Bârlad
"Vasile Pârvan" Museum, Bârlad

UAIC Universitatea "Alexandru Ioan Cuza," Iaşi
The Alexandru Ioan Cuza University of Iaşi

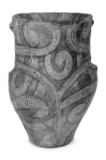

1. Anthropomorphic Vessel
Fired Clay
H. 24.2 cm; W. 17.5 cm
Cucuteni, Truşeşti
4200–4050 BC (Cucuteni A3)
CMNM: 602

2. Anthropomorphic Vessel
Fired Clay
H. 12.2 cm; D. 5.2 cm
Cucuteni, Scânteia
4200–4050 BC (Cucuteni A3)
IAI: 3027 (fig. 6-20)

3. Female Figurine
Fired Clay
H. 23 cm; W. 7 cm
Cucuteni, Drăguşeni
4050–3900 BC (Cucuteni A4)
MJBT: 7558 (p. 112, fig. 5-10)

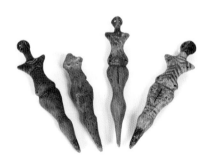

4. Female Figurine
Fired Clay
H. 21 cm; W. 4.8 cm
Cucuteni, Ghelăieşti-Nedeia
3700–3500 BC (Cucuteni B1)
CMJMPN: 4419

5. Female Figurine
Fired Clay
H. 18 cm; W. 3.6 cm
Cucuteni, Ghelăieşti-Nedeia
3700–3500 BC (Cucuteni B1)
CMJMPN: 4421

6. Female Figurine
Fired Clay
H. 24 cm; W. 3.6 cm
Cucuteni, Ghelăieşti-Nedeia
3700–3500 BC (Cucuteni B1)
CMJMPN: 4420

7. Female Figurine
Fired Clay
H. 22 cm; W. 5.2 cm
Cucuteni, Ghelăieşti-Nedeia
3700–3500 BC (Cucuteni B1)
CMJMPN: 4418

8. Female Figurine
Fired Clay
H. 11.5 cm; W. 4 cm
Cucuteni, Truşeşti
4200–4050 BC (Cucuteni A3)
MNIR: 81374 (fig. 5-7)

9. Female Figurine
Fired Clay
H. 17.5 cm; W. 3 cm
Cucuteni, Vânători-Rufeni
3700–3500 BC (Cucuteni B1)
MNIR: 81375 (fig. 1-14)

10. Figurine
Fired Clay
H. 8.5 cm; W. 2.5 cm
Cucuteni, Săveni
4200–4050 BC (Cucuteni A3)
MJBT: 17268 (fig. 1-12)

11. Figurine
Fired Clay
H. 13 cm; W. 4.5 cm
Cucuteni, Scânteia
4500–3900 BC (Cucuteni A)
IAI: 3039 (fig. 5-3)

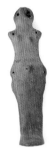

12. Figurine
Fired Clay
H. 23.5 cm; W. 6.1 cm
Cucuteni, Poduri-Dealul Ghindaru
3700–3500 BC (Cucuteni B1)
CMJMPN: 18344

13. Set of Twelve Figurines
Fired Clay
H. max. 21.5 cm; W. max. 6 cm
Cucuteni, Dumeşti
4200–4050 BC (Cucuteni A3)
MJSMVS: 15844–15855 (figs. 5-4a, b)

14. Set of Twenty-one Figurines and Thirteen
Chairs
Fired Clay
H. max. 8.6 cm; W. max. 4.7 cm
Cucuteni, Poduri-Dealul Ghindaru
4900–4750 BC (Pre-Cucuteni II)
CMJMPN: 10095–10128, 10703 (fig. 5-1)

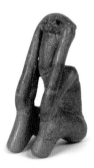

15. The "Thinker of Târpeşti" Figurine
Fired Clay
H. 7.5 cm; W. 4 cm
Cucuteni, Târpeşti
4750–4500 BC (Pre-Cucuteni III)
CMJMPN: 6618

16. Female Figurine
Fired Clay
H. 22 cm; W. 9.8 cm
Hamangia, Baïa
5000–4600 BC
MNIR: 11662 (fig. 1-6)

17. Female Figurine
Fired Clay
H. 15.5 cm; W. 5.5 cm
Hamangia, Cernavodă
5000–4600 BC
MNIR: 11663 (fig. 1-7)

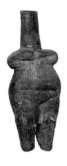

18. Female Figurine
Fired Clay
H. 19 cm; W. 8 cm
Hamangia, Baïa
5000–4600 BC
MNIR: 11655

19. Female Figurine
Fired Clay
H. 10.7 cm; W. 7.4 cm
Hamangia, Cernavodă
5000–4600 BC
MNIR: 11660

20. Female Figurine
Fired Clay
H. 11.5 cm; W. 5.4 cm
Hamangia, Cernavodă
5000–4600 BC
MNIR: 15907 (fig. 5-9)

21. The "Thinker from Cernavodă",
Male Figurine
Fired Clay
H. 11.5 cm; W. 7.5 cm
Hamangia, Cernavodă
5000–4600 BC
MNIR: 15906 (fig. 5-9)

22. Anthropomorphic Vessel
Fired Clay
H. 16.5; D. 22 cm
Gumelniţa, Gumelniţa
4600–3900 BC
MNIR: 13812

23. Anthropomorphic Vessel
Fired Clay
H. 32.3 cm; D. 18 cm
Gumelniţa, Sultana
4600–3900 BC
MNIR: 102326 (fig. 1-16)

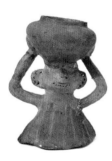

24. Anthropomorphic Vessel
Fired Clay
H. 22.5 cm; D. 20cm
Gumelniţa, Gumelniţa
4600–3900 BC
MNIR: 102312

25. Anthropomorphic Vessel with Lid
Fired Clay
H. 30 cm; D. 30 cm
Gumelniţa, Sultana
4600–3900 BC
MJITAGR: 2667–2668 (fig. 1-15)

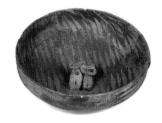

26. Bowl with Pair of Figurines
Fired Clay
H. 9.4 cm; D. 22.8 cm
Gumelniţa, Sultana
4600–3900 BC
MJITAGR: 6690

27. Female Figurine
Bone
H. 10.3 cm; W. 3 cm
Gumelniţa, Vităneşti
4600–3900 BC
MJITR: 24217 (fig. 1-11)

28. Female Figurine
Bone
H. 10.6 cm; W. 2.6 cm
Gumelniţa, Vităneşti
4600–3900 BC
MJITR: 24216 (fig. 5-6)

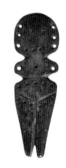

29. Female Figurine
Bone
H. 9.5 cm; W. 3 cm
Gumelniţa, Siliştea
4600–3900 BC
MJITR: 6349

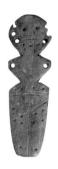

30. Female Figurine
Bone
H. 7 cm; W. 2.4 cm
Gumelniţa, Vităneşti
4600–3900 BC
MJITR: 25862

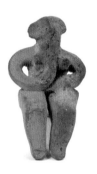

31. Female Figurine
Fired Clay
H. 8.5 cm; W. 4 cm
Gumelniţa, Căscioarele
4600–3900 BC
MNIR: 13726

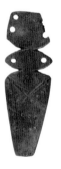

32. Female Figurine
H. 8.3 cm; W. 3 cm
Gumelniţa, Vităneşti
4600–3900 BC
MJITR: 25234

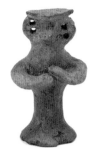

33. Figurine
Fired Clay
H. 5.4 cm; W. 4.3 cm
Gumelniţa, Brăiliţa
4600–3900 BC
MNIR: 73528

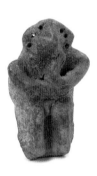

34. Figurine
Fired Clay
H.8 cm; W. 6 cm
Gumelniţa, Cernavodă
4600–3900 BC
MNIR: 32456

35. Head of Statuette
Fired Clay
H. 4.6 cm
Gumelniţa, Gărăgău
4600–3900 BC
MNIR: 176062

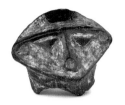

36. Head of Statuette
Fired Clay
H. 4.5 cm; W. 15 cm
Gumelniţa, Vidra
4600–3900 BC
MNIR: 32806

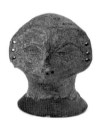

37. Head of Statuette
Fired Clay
H. 9.2 cm; W. 8 cm
Gumelniţa, Vidra
4600–3900 BC
MNIR: 32449

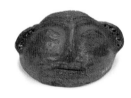

38. Lid in the Shape of a Human Head
Fired Clay
H. 5 cm; D. 9 cm
Gumelniţa, Sultana
4600–3900 BC
MJITAGR: 2766

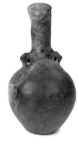

39. Anthropomorphic Vessel
Fired Clay
H. 18.3 cm; D. 10.4 cm
Vinča, Parţa
5000–4500 BC (Late Vinča)
MB: 26427

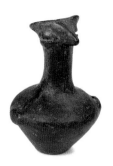

40. Anthropomorphic Vessel
Fired Clay
H. 11 cm; D. 8 cm
Vinča, Voivodina
5000–4500 BC (Late Vinča)
MB: 35921

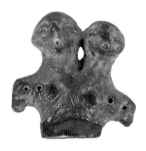

41. Double-headed Figurine
Fired Clay
H. 6.9 cm; W. 7.4 cm
Vinča, Rast
5000–4500 BC (Late Vinča)
MNIR: 12100

42. Figurine
Fired Clay
H. 11.8 cm; W. 9 cm
Vinča, Liubcova
5000–4500 BC (Late Vinča)
MBM: 339 (fig. 5-8)

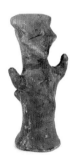

43. Figurine
Fired Clay
H. 12 cm; W. 6.5 cm
Vinča, Chişoda Veche
5000–4500 BC (Late Vinča)
MB: 8192

44. Figurine of a Woman Nursing a Child
Fired Clay
H. 12.4 cm; W. 7.6 cm
Vinča, Rast
5000–4500 BC (Late Vinča)
MNIR: 12104

45. Anthropomorphic Appliqué
Fired Clay
H. 12; W. 16.8 cm
Vădastra,Vădastra
5500–5000 BC
MO: 4984 (fig. 1-1)

46. Anthropomorphic Vessel
Fired Clay
H. 43 cm; W. 41 cm
Vădastra, Vădastra
5500–5000 BC
MNIR: 15908 (p. 90)

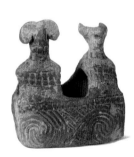

47. Double-headed Zoomorphic Vessel
Fired Clay
H. 15.7 cm; W. 15.3 cm
Vădastra, Vădastra
5500–5000 BC
MNIR: 15858

48. Anthropomorphic Vessel
Fired Clay
H. 21.5 cm; D. rim 13.2 cm; D. base 7.2 cm
Banat, Parţa
5300–5000 BC (Early Banat)
MNIR: 54748 (fig. 1-13)

49. Bear Statuette
Fired Clay
H. 6 cm; W. 4 cm
Cucuteni, Ripiceni
4500–3900 BC (Cucuteni A)
MJBT: 17216 (fig. 1-8)

50. Bowl with Handle in the Shape
of a Bull's Head
Fired Clay
H. 19.5 cm; D. 34.5 cm
Cucuteni, Poieneşti
4200–4050 BC (Cucuteni A3)
IAI: 3000 (fig. 6-15)

51. Fragmentary Zoomorphic Statuette
Fired Clay
H. 4.5 cm; W. 4 cm
Cucuteni, Epureni
4500–3900 BC (Cucuteni A)
MJSMVS: 71 (fig. 1-9)

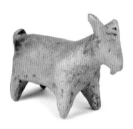

52. Goat Statuette
Fired Clay
H. 6.5 cm; W. 4.5 cm
Cucuteni, Ruginoasa
4500–3900 BC (Cucuteni A)
CMNM: 21876

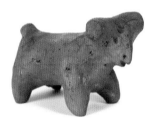

53. Ram Statuette
Clay
L. 7.5 cm; H. 4.5 cm; W. 3.5 cm
Cucuteni, Frumuşica
3700–3500 BC (Cucuteni B)
CMJMPN: 1283/86

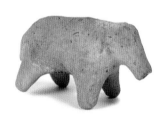

54. Zoomorphic Statuette
Clay
L. 9 cm; H. 5 cm; W. 4.5 cm
Cucuteni, Târpeşti
4750–4500 BC (Pre-Cucuteni III)
CMJMPN: 6653/1

55. Bull Statuette
Fired Clay
H. 10 cm; L. 14 cm
Vinča, Padea
5000–4500 BC (Late Vinča)
MO: 8359 (fig. 1-2)

56. Fragmentary Zoomorphic Statuette
Fired Clay
H. 8 cm; W. 5.5 cm
Vinča, Parţa
5000–4500 BC (Late Vinča)
MB: 21203

57. Bird Statuette
Fired Clay
H. 7.8 cm; W. 5 cm
Gumelniţa, Măriuţa
4600–3900 BC
MDJ: 53167

58. Fox Statuette
Fired Clay
L. 5.3 cm; W. 3.8 cm
Gumelniţa, Pietrele
4600–3900 BC
MNIR: 13724

59. Hedgehog Vessel
Fired Clay
D. 10.5 cm; W. 5.6 cm
Gumelniţa, Vînătorii Mici
4600–3900 BC
MNIR: 291169

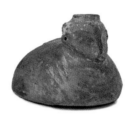

60. Zoomorphic Vessel
Fired Clay
H. 12.3 cm; L.18.4 cm
Gumelniţa, Gumelniţa
4600–3900 BC
MNIR: 13771

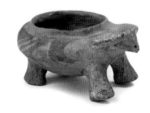

61. Zoomorphic Vessel
Fired Clay
H. 9.5 cm; L. 22.5
Gumelniţa, Calomfireşti
4600–3900 BC
MNIR: 13770

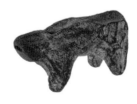

62. Zoomorphic Whistle
Fired Clay
H. 4.1 cm; L. 8.9 cm
Gumelniţa, Hîrşova
4600–3900 BC
MINAC: 39487

63. Architectural Model
Fired Clay
H. 27 cm; L. 51 cm; W. 13 cm
Gumelniţa, Căscioarele
4600–3900 BC
MNIR: 12156 (p. 74)

64. Architectural Model
Fired Clay
H.15.2 cm; W. 16.1 cm; L. 19.1 cm
Cucuteni, Poduri-Dealul Ghindaru
4750–4500 BC (Pre-Cucuteni III)
CMJMPN: 13184 (fig. 6-9)

65. Architectural Model with Seven Figurines
Fired Clay
Model: H.14.5 cm; D. max. 24.5 cm; D. base 11 cm
Cucuteni, Ghelăieşti
3700–3500 BC (Cucuteni B1)
CMJMPN: 12550–12552, 13209–13213 (fig. 5-5)

66. Offering Table
Fired Clay
H. 4.7 cm; L. 20.7 cm; W. 10.2 cm
Cucuteni, Drăguşeni
4050–3900 BC (Cucuteni A4)
MJBT: 17322 (fig. 6-18)

67. Offering Table
Fired Clay
H. 8 cm; L. 33 cm; W. 26 cm
Boïan-Vidra, Lişcoteanca
4900–4700 BC
MBR: 13371 (fig. 4-2)

68. Offering Table
Fired Clay
H. 5.5 cm; D. 16 cm
Starčevo-Criş, Cîrcea
6200–5500 BC
MO: 47473

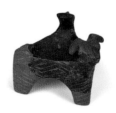

69. Offering Table
Fired Clay
H. 9 cm; D. 12 cm
Vinča, Gornea
5000–4500 BC (Late Vinča)
MBM: 412

70. Pot Stand
Fired Clay
H. 22 cm; L. 30 cm
Boïan-Vidra, Vidra
4900–4700 BC
MNIR: 32433

71. Biconical Vessel
Fired Clay
H. 34 cm; D. 44 cm
Cucuteni, Truşeşti
4200–4050 BC (Cucuteni A3)
CMNM: 547 (fig. 6-21)

72. Bitronconical Vessel
Fired Clay
H. 32.3 cm; D. max. 36.7 cm
Cucuteni, Dumeşti
4200–4050 BC (Cucuteni A3)
MJSMVS: 13802 (fig. 6-26)

73. Bitronconical Vessel
Fired Clay
H. 51 cm; D. max. 52.4 cm
Cucuteni, Drăguşeni-Botoşani
4050–3900 BC (Cucuteni A4)
MJBT: 799 (fig. 6-22)

74. Crater
Fired Clay
H. 29 cm; D. max. 30 cm
Cucuteni, Drăguşeni-Botoşani
4050–3900 BC (Cucuteni A4)
MJBT: 781 (fig. 6-16)

75. Cup
Fired Clay
H. 11 cm; D. max. 13 cm
Cucuteni, Bodeşti-Frumuşica
4200–4050 BC (Cucuteni A3)
CMJMPN: 998 (fig. 6-10)

76. Cup
Fired Clay
H. 10 cm; D. max. 11 cm
Cucuteni, Dumeşti
4200–4050 BC (Cucuteni A3)
MJSMVS: 16358 (fig. 6-11)

77. Globular Vessel with Lid
Fired Clay
H. max. 97.2 cm; D. max. 25 cm
Cucuteni, Scânteia
4200–4050 BC (Cucuteni A3)
CMNM: 17266, 19266 (p. 128)

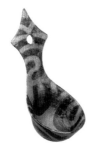

78. Ladle
Fired Clay
L. 23.5 cm; D. 10 cm
Cucuteni, Poduri-Dealul Ghindaru
4450–4200 BC (Cucuteni A2)
CMJMPN: 17935

79. Ladle
Fired Clay
L. 23.5 cm; D. 10 cm
Cucuteni, Truşeşti
4450–4200 BC (Cucuteni A2)
CMJMPN: 17936 (fig. 6-19)

80. Pot stand
Fired Clay
H. 36 cm; D. 25 cm
Cucuteni, Drăguşeni-Botoşani
4050–3900 BC (Cucuteni A4)
MJBT: 832 (fig. 6-13)

81. Stemmed Cup
Fired Clay
H. 35.3 cm; D. 15 cm
Cucuteni, Poduri-Dealul Ghindaru
4450–4200 BC (Cucuteni A2)
CMJMPN: 17473 (fig. 6-27)

82. Vessel
Fired Clay
H. 20 cm; D. max. 25 cm
Cucuteni, Drăguşeni
4050–3900 BC (Cucuteni A4)
MJBT: 17325 (fig. 6-17)

83. Amphora
Fired Clay
H. 30 cm; D. max. 28 cm
Cucuteni, Vorniceni
4050–3700 BC (Cucuteni A-B1)
MJBT: 17311 (fig. 6-32)

84. Biconical Vessel
Fired Clay
H. 58 cm; D. max. 64 cm
Cucuteni, Vorniceni
4050–3850 BC (Cucuteni A-B1)
MJBT: 17308 (fig. 6-36)

85. Bowl
Fired Clay
H. 20.5 cm; D. max. 44 cm
Cucuteni, Vorniceni
4050–3850 BC (Cucuteni A-B1)
MJBT: 17365 (fig. 6-28)

86. Crater
Fired Clay
H. 48 cm; D. max. 35 cm
Cucuteni, Traian
4050–3700 BC (Cucuteni A-B2)
MNIR: 13787 (fig. 6-35)

87. Double stand
Fired Clay
H. 22 cm; L. 27 cm
Cucuteni, Vorniceni
4050–3700 BC (Cucuteni A-B1)
MJBT: 17225 (fig. 6-33)

88. Lobate Vessel
Fired Clay
H. 16 cm; D. 18.5 cm
Cucuteni, Calu-Piatra Şoimului
3900–3700 BC (Cucuteni A-B2)
CMJMPN: 4450 (fig. 6-31)

89. Amphora
Fired Clay
H. 47cm; D. max. 38 cm
Cucuteni, Poduri-Dealul Ghindaru
3700–3500 BC (Cucuteni B1)
CMJMPN: 16422 (fig. 6-37)

90. Biconical Vessel
Fired Clay
H. 36 cm; D. max. 38 cm
Cucuteni, Şipeniţ
3700–3500 BC (Cucuteni B2)
MNIR: 15894 (fig. 6-43)

91. Biconical Vessel with Lid
Fired Clay
H. (with lid) 69 cm; D. max. 47.5 cm
Cucuteni, Ghelăieşti
3700–3500 BC (Cucuteni B1)
CMJMPN: 4282/1–2 (fig. 6-29)

92. Binocular Vessel
Fired Clay
H. 18 cm; W. 40 cm
Cucuteni, Ghelăieşti
3700–3500 BC (Cucuteni B1)
CMJMPN: 12173 (fig. 6-30)

93. Bitronconical Vessel
Fired Clay
H. 33.3 cm; D. max. 45.2 cm
Cucuteni, Valea Lupului
3700–3500 BC (Cucuteni B2)
CMNM: 706 (fig. 6-39)

94. Crater
Fired Clay
H. 34 cm; D. max. 50 cm
Cucuteni, Valea Lupului
3700–3500 BC (Cucuteni B2)
CMNM: 704 (fig. 6-42)

95. Crater
Fired Clay
H. 20 cm; D. 25.2 cm
Cucuteni, Târgu Ocna
3700–3500 BC (Cucuteni B2)
MNIR: 69638 (fig. 6-45)

96. Lid
Fired Clay
H. 13.5 cm; D. 30.5 cm
Gumelniţa, Sultana
4600–3900 BC
MJITAGR: 3074

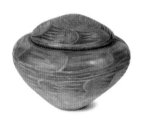

97. Vessel with Lid
Fired Clay
H. 22 cm; D. rim 21.6 cm; D. base 10.1 cm;
D. max. 35.9 cm
Gumelniţa, Sultana
4600–3900 BC
MJITAGR: 3063, 3072

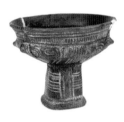

98. Stemmed Bowl
Fired Clay
H. 23 cm; D. 28.7 cm
Vădastra, Fărcarşele-Olt
5500–4800 BC
MO: I.8278

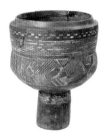

99. Stemmed Bowl
Fired Clay
H. 27.4 cm; D. 22.4 cm
Boïan-Vidra, Vidra-Măgura Tătarilor
4900–4700 BC
MNIR: 32435

100. Axe
Copper
L. 35.2 cm; W. 6 cm
Bodrogkeresztúr Culture, Sfârnaş
4000–3500 BC
MNIR: 15917 (fig. 4-1)

101. Axe
Copper
L. 20.5 cm; W. 4.7 cm
Bodrogkeresztúr Culture, Poiana
4000–3500 BC
MNIR: 15887 (fig. 7-8)

102. Axe
Copper
L. 25 cm; W. 6.1 cm
Cucuteni, Bogdăneşti
3700–3500 BC (Cucuteni B)
CMNM: 740 (fig. 7-6)

103. Axe
Copper
L. 16.5 cm; H. 2 cm; W. 4 cm
Gumelniţa, Glina
4600–3900 BC
MNIR: 14051 (fig. 7-4)

104. Axe
Stone
L. 18 cm; H. 10 cm; W. 7 cm
Cucuteni, Ciurea
3700–3500 BC (Cucuteni B)
CMNM: 643

105. Axe
Marble
L. 15.5 cm; H. 7 cm
Globular Culture, Scheia
3900–3600 BC
CMNM: 7081

106. Dagger
Copper
L. 15 cm; W. 3 cm
Cucuteni, Mereşti
4500–3900 BC (Cucuteni A)
MJIBV: 7060 (fig. 7-7)

107. Pintadera
Fired Clay
H. 4.9 cm; L. 5.9 cm
Cucuteni, Calu-Piatra Şoimului
4450–4200 BC (Cucuteni A2)
CMJMPN: 5646

108. Pintadera
Fired Clay
H. 4.1 cm; L. 4.5 cm
Cucuteni, Bodeşti-Frumuşica
4450–4200 BC (Cucuteni A2)
CMJMPN: 1227

109. Pintadera
Fired Clay
H. 2.3 cm; D. 4.2 cm
Cucuteni, Ruginoasa
4500–3900 BC (Cucuteni A)
CMNM: 21858 (fig. 1-3)

110. Pintadera
Fired Clay
H. 3.5 cm; D. 4.3 cm
Cucuteni, Igeşti
4500–3900 BC (Cucuteni A)
MJSMVS: 1752

111. Pintadera
Fired Clay
H. 5 cm; L. 7 cm
Starčevo-Criş, Poieneşti
6200–5500 BC
MJSMVS: 17479 (fig. 1-4)

112. Pintadera
Fired Clay
H. 4.7 cm; L. 5.2 cm
Starčevo-Criş, Bursuci
6200–5500 BC
MJSMVS: 923

113. Pintadera
Fired Clay
H. 2.6 cm; L. 5.3 cm
Starčevo-Criş, Perieni
6200–5500 BC
CMNM: 286

114. Pintadera
Fired Clay
H. 5 cm; D. 7.3 cm
Gumelniţa, Vadul Catagatei
4600–3900 BC
MBR: 6019

115. Pintadera
Fired Clay
H. 6.7 cm; D. 12 cm
Gumelniţa, Gradistea Ulmilor
4600–3900 BC
MDJ: 24806

116. Pintadera
Fired Clay
H. 4 cm; D. 6.2 cm
Gumelniţa, Brăiliţa
4600–3900 BC
MIG: 2847

117. Pintadera in the Shape of a Left Leg
Fired Clay
H. 6.6 cm; D. 3–6 cm
Starčevo-Criş, Zăuan
6200–5500 BC
MJIAZ: 25/1977 (fig. 1-5)

118. Anthropomorphic Appliqué
Gold
H. 9.7 cm; W. 7.3 cm
Bodrogkeresztúr Culture, Moigrad
4000–3500 BC
MNIR: 54572 (fig. 7-9)

119. Anthropomorphic Appliqué
Gold
H. 9.7cm; W. 7.3 cm
Bodrogkeresztúr Culture, Moigrad
4000–3500 BC
MNIR: 54573 (fig. 7-10)

120. Anthropomorphic Appliqué
Gold
H. 8.5cm; W. 8 cm
Bodrogkeresztúr Culture, Moigrad
4000–3500 BC
MNIR: 54571 (fig. 1-17)

121. Anthropomorphic Figure
Gold
H. 31.4 cm; W. 24.1 cm
Bodrogkeresztúr Culture, Moigrad
4000–3500 BC
MNIR: 54570 (p. 162)

122. Bracelet
Spondylus
D. 11.5 cm; Thickness 0.8 cm
Hamangia, Cernavodă
5000–4600 BC
MNIR: 11666 (p. 178)

123. Bracelet
Spondylus
D. 9.2 cm
Hamangia, Limanu
5000–4600 BC
MINAC: 4275 (p. 178)

124. Bracelet
Bone
Bead: L. 2.9–3.1 cm
Hamangia, Cernavodă
5000–4600 BC
MNIR: 11669–11673

125. Bracelet
Copper
D. max. 5.1 cm; D. thread 0.35 cm; H. 1.8 cm
Cucuteni, Hăbăşeşti
4500–3900 BC (Cucuteni A)
MNIR: 12171

126. Spiral Bracelet
Copper
D. max. 6.4 cm, D. thread 0.4 cm; H. 4.6 cm
Cucuteni, Hăbăşeşti
4500–3900 BC (Cucuteni A)
MNIR: 12166 (fig. 7-5)

127. Bracelet (26 Beads)
Shell
Bead: H. max. 1–1.5 cm; D. max. 1–1.4 cm
Cernavodă I, Vadul Catagatei
4000–3200 BC
MBR: 10528

128. Bracelet (63 Beads)
Copper, Glass
Bead: max. H. 0.4 cm; D. 0.6 cm
Cernavodă I, Vadul Catagatei
4000–3200 BC
MBR: 10533

129. Disk
Flint
D. 10.5 cm
Foltesti, Vadul Catagatei
4000–3900 BC
MBR: 10535

130. Necklace
Bone
Bead: H. 2–2.4 cm; W. 0.6–1 cm
Boïan, Andolina
5000–4500 BC
MDJ: 9165–9188

131. Necklace
Ankle Bone
L. 2.4–3.3 cm; W. 1.4 cm; H. 1.75–2.1 cm
Gumelniţa, Hîrşova
4600–3900 BC
MINAC: 39491

132. Necklace (156 Beads)
Spondylus
H. 0.4–0.6 cm; W. 0.8 cm; Thickness 0.3 cm
Foltesti, Vadul Catagatei
4000–3900 BC
MBR: 10525 (fig. 8-8)

133. Necklace (234 Beads)
Spondylus
Bead: L. 0.2–0.5 cm; D. 0.3–0.6 cm
Hamangia, Limanu
5000–4600 BC
MINAC: 5469 (fig. 8-9)

134. Necklace (24 Beads)
Malachite
D. 0.5–0.6 cm; Thickness 0.3 cm
Boïan-Vidra, Ciocăneşti
4900–4700 BC
MDJ: 1277–1300

135. Necklace (263 Beads)
Spondylus
Bead: max. L. 0.7; D. 0.6 cm
Hamangia, Limanu
5000–4600 BC
MINAC: 5468 (fig. 8-10)

136. Necklace (28 Beads)
Shell
L. 0.1–0.3 cm; D. 0.3–0.5 cm
Boïan-Vidra, Gradistea Ulmilor
4900–4700 BC
MDJ: 26728–26755

137. Necklace (93 Beads)
Spondylus and Copper
Bead: max. L. 0.5 cm; D. 0.5 cm
Gumelniţa, Brăiliţa
4600–3900 BC
MBR: 10524 (fig. 8-7)

138. Pendant
Bone
L. 6 cm; H. 3.5 cm
Vinča, Chişoda Veche
5000–4500 BC (Late Vinča)
MB: 8290

139. Pendant
Gold
L. 2.6 cm; W. 1.5 cm
Cucuteni, Traian
4050–3700 BC (Cucuteni A-B)
MNIR: 9025

140. Spiral Bracelet
Copper
L. 12.5 cm; D. 7 cm
Cucuteni, Ariuşd
4500–3900 BC (Cucuteni A)
MJIBV: 550 (fig. 7-3)

141. Amulets (7)
Gold
D. 1.7–2.0 cm; H. 1.8–2.2 cm
Varna, Varna, Grave 36
4400–4200 BC
Varna Museum: 1650–1656 (first and second rows)

142. Appliqués (2)
Gold
H. 0.8–1.6 cm; D. 3.3–3.5 cm
Varna, Varna, Grave 36
4400–4200 BC
Varna Museum: 1639, 1640 (second row, center)

143. Appliqués (10)
Gold
D. 2.1–2.3 cm
Varna, Varna, Grave 36
4400–4200 BC
Varna Museum: 1687, 1688, 1697, 1706, 1709, 1710, 1712, 1713, 1716, 1719 (third and fourth rows)

144. Animal-Head Appliqués (10)
Gold
L. 2.8–4.1 cm; H. 1.2–2.1 cm
Varna, Varna, Grave 36
4400–4200 BC
Varna Museum: 1658, 1659, 1664, 1668, 1669, 1673, 1677, 1679, 1680, 1682 (fig. 9-7)

145. Astragal
Gold
L. 1.9 cm; H. 0.9 cm
Varna, Varna, Grave 36
4400–4200 BC
Varna Museum: 1636 (fig. 9-5)

146. Axe
Copper
L. 15.5 cm; W. 3.1 cm
Varna, Varna, Grave 36
4400–4200 BC
Varna Museum: 1746 (fig. 9-16)

147. Axe
Copper
L. 15.5 cm; W. 2.3 cm
Varna, Varna, Grave 229
4400–4200 BC
Varna Museum: 2422 (fig. 9-16)

148. Axe
Copper
L. 11.2 cm; W. 2.1 cm
Varna, Varna, Grave 227
4400–4200 BC
Varna Museum: 2420 (fig. 9-16)

149. Axe
Stone
L. 15.6 cm; W. 3.9 cm
Varna, Varna, Grave 236
4400–4200 BC
Varna Museum: 2437

150. Axe
Copper
L. 12.9 cm; W. 3.1 cm
Varna, Varna, Grave 55
4400–4200 BC
Varna Museum: 2434

151. Beads (2,110)
Shell
L. 0.5–1.7 cm
Varna, Varna, Grave 36
4400–4200 BC
Varna Museum: 1751

152. Bracelets
Spondylus
H. 0.7 cm, 1.0 cm, 2.1 cm; D. 6.3 cm, 6.8 cm, 8.1 cm
Varna, Varna, Graves 97 and 158
4400–4200 BC
Varna Museum: 2965, 2967, 3326 (fig. 9-19)

153. Bracelets (2)
Gold
D. 6.8–6.9 cm; H. 2.7 cm
Varna, Varna, Grave 36
4400–4200 BC
Varna Museum: 1631, 1632 (fig. 9-6)

154. Chisel
Copper
L. 23.5 cm; W. 1 cm
Varna, Varna, Grave 151
4400–4200 BC
Varna Museum: 2674 (fig. 9-14)

155. Diadem
Gold
H. 3.4 cm; D. 4.3 cm
Varna, Varna, Grave 36
4400–4200 BC
Varna Museum: 1635 (fig. 9-9)

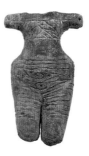

156. Dog Statuette
Clay
H. 8 cm; L. 19.2 cm; W. 6.1 cm
Varna, V. Golyamo Delchevo
4400–4200 BC
Varna Museum: 3632

157. Female Figurine
Clay
H. 11.3 cm; W. 6.3 cm
Varna, P.S. Strashimirovo
4400–4200 BC
Varna Museum: 1238-5

158. Idol Figurine
Bone
H. 21.2 cm; W. 8.5 cm
Varna, Varna, Grave 41
4400–4200 BC
Varna Museum: 2903 (fig. 9-2)

159. Implements (2)
Gold
Small: L. 5.5 cm; W. 8.8 cm.
Large: L. 17.1 cm; W. 14.2 cm
Varna, Varna, Grave 36
4400–4200 BC
Varna Museum: 1637, 1638 (fig. 9-4)

160. Lamella
Flint
L. 37.7 cm; W. 3.8 cm
Varna, Varna, Grave 63
4400–4200 BC
Varna Museum: 2740 (fig. 9-17)

161. Lamella
Flint
L. 22.6 cm; W. 3.1 cm
Varna, Varna, Grave 209
4400–4200 BC
Varna Museum: 2372 (fig. 9-17)

162. Necklace with Pendant
Quartz, Gold
Amulet: H. 3.6 cm; D. 3.2 cm.
Bead: D. 0.8–2.0 cm
Varna, Varna, Grave 97
4400–4200 BC
Varna Museum: 2271 (p. 192)

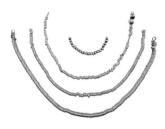

163. Necklaces (3 long, 1 short)
Gold
Bead: D. 0.3–1.1 cm
Varna, Varna, Grave 36
4400–4200 BC
Varna Museum: 1737–1739, 1741

164. Hair Pin
Copper
L. 16.9 cm; W. 4.5 cm
Varna, Varna, Grave 167
4400–4200 BC
Varna Museum: 2679 (fig. 9-15)

165. Rings (2 large, 4 small)
Gold
D. 1.8–32.5 cm
Varna, Varna, Grave 36
4400–4200 BC
Varna Museum: 1722, 1724, 1726, 1731, 1732, 1735

166. Scepter (9 elements)
Gold
L. 22.5 cm; W. 5.3 cm
Varna, Varna, Grave 36
4400–4200 BC
Varna Museum: 1641–1649 (fig. 9-3)

167. Spear Head
Copper
L. 25.8 cm; W. 3.1 cm
Varna, Varna, Grave 97
4400–4200 BC
Varna Museum: 2652 (fig. 9-13)

168. Strand of beads (66)
Carnelian
Bead: L. 0.7–0.9 cm; D. 0.5–0.7 cm
Varna, Varna, Grave 41
4400–4200 BC
Varna Museum: 3111 (fig. 9-21)

169. Vessel
Marble
H. 4 cm; D. 12.2 cm
Varna, Varna, Grave 209
4400–4200 BC
Varna Museum: 2374

170. Zoomorphic "Bull" Figurines (2)
Gold
H. 3.7–5.8 cm; L. 3.9–6.5 cm
Varna, Varna, Grave 36
4400–4200 BC
Varna Museum: 1633, 1634 (fig. 9-8)

171. Blade
Flint
L. 24 cm; W. 1.8–3.2 cm
Suvorovo-Novodanilovka, Giurgiuleşti, Grave 4
4500–4300 BC
MNAIM: FB-27571-2 (fig. 10-8, bottom)

172. Boar-Tusk Pendant
Boar tusk
L. 13 cm; W. 2.2 cm
Suvorovo-Novodanilovka, Giurgiuleşti, Grave 3
4500–4300 BC
MNAIM: FB-27571-40 (fig. 10-7, top)

173. Boar-Tusk Pendant with Perforations
Boar tusk
L. 16.6 cm; W. 2.7 ccm
Suvorovo-Novodanilovka, Giurgiuleşti, Grave 1
4500–4300 BC
MNAIM: FB-27571-4 (fig. 10-7, bottom)

174. Conical Core or Nucleus
Flint
H. 11.1 cm
Suvorovo-Novodanilovka, Giurgiuleşti, Grave 3
4500–4300 BC
MNAIM: FB-27571-42 (fig. 10-8, top)

175. Tubular Shaft Fittings (3)
Gold
L. 2.8–3.5 cm; D. 1.5–1.8 cm
Suvorovo-Novodanilovka, Giurgiuleşti, Grave 4
4500–4300 BC
MNAIM: FB-26256-26258 (fig. 10-13)

176. Necklace (129 Beads)
Copper
Bead: D. 1 cm
Suvorovo-Novodanilovka, Giurgiuleşti, Grave 3
4500–4300 BC
MNAIM: FB-27571-10 (fig. 10-7)

177. Necklace (154 Beads)
Copper and Marble
Bead: D. 0.5–0.7 cm
Suvorovo-Novodanilovka, Giurgiuleşti, Grave 3
4500–4300 BC
MNAIM: FB-27571-22 (fig. 10-6)

178. Necklace (35 Shells, 26 Beads)
Shell (Cardium edule, Mactra carolina)
Shell: 1.7–3 cm. Bead: 0.8–1.2 cm
Suvorovo-Novodanilovka, Giurgiuleşti, Grave 2
4500–4300 BC
MNAIM: FB-27571-9 (p. 212)

179. Necklace (420 Beads)
Copper
Bead: D. 0.5–0.7 cm
Suvorovo-Novodanilovka, Giurgiuleşti, Grave 5
4500–4300 BC
MNAIM: FB-27571-7 (fig. 10-15)

180. Spear Point
Antler
D. 0.4–1.8 cm; L. 14.6 cm
Suvorovo-Novodanilovka, Giurgiuleşti, Grave 4
4500–4300 BC
MNAIM: FB-27571-29 (fig. 10-13)

181. Spear Foreshaft
Wood, antler, bone, and flint
L. 59 cm; W. 2.1–2.5 cm
Suvorovo-Novodanilovka, Giurgiuleşti, Grave 4
4500–4300 BC
MNAIM: FB-27571-17 (fig. 10-12)

182. Spiral Bracelets (3)
Copper
D. 9.2–9.9 cm; W. 2.4–3.2 cm
Suvorovo-Novodanilovka, Giurgiuleşti, Grave 5
4500–4300 BC
MNAIM: FB-27571-12/13/14 (fig. 10-16)

183. Spiral Ornaments (2)
Gold
D. max. 1.7 cm
Suvorovo-Novodanilovka, Giurgiuleşti, Grave 4
4500–4300 BC
MNAIM: FB-26259/ FB-26260 (fig. 10-14)

184. Circlets of Beads (422 and 413 Beads)
Shell (Coral)
Bead: D. 2.5–4 cm
Suvorovo-Novodanilovka, Giurgiuleşti, Grave 4
4500–4300 BC
MNAIM: FB-27571-62/ FB-27571-63 (fig. 10-11)

185. Askos
Fired paste and splinters
H. 12 cm; D. 21 cm
Cucuteni, Brad
4200–4050 BC (Cucuteni A3)
MIR: 20276 (fig. 1-10)

186. Axe
Copper
L. 16 cm; W. 4 cm
Cucuteni, Brad
4200–4050 BC (Cucuteni A3)
MIR: 17575 (fig. 1-10)

187. Bracelet
Copper
D. 10 cm; W. 1.3 cm
Cucuteni, Brad
4200–4050 BC (Cucuteni A3)
MIR: 17576 (fig. 1-10)

188. Bracelet
Copper
D. 9 cm; W. 1.3 cm
Cucuteni, Brad
4200–4050 BC (Cucuteni A3)
MIR: 17577 (fig. 1-10)

189. Disks (2)
Gold
D. 4.8–6.3 cm; Thickness 0.5 cm
Cucuteni, Brad
4200–4050 BC (Cucuteni A3)
MIR: 17573–17574 (fig. 1-10)

190. Disks (3)
Copper
D. 2.9–5.2 cm
Cucuteni, Brad
4200–4050 BC (Cucuteni A3)
MIR: 17578–17580 (fig. 1-10)

191. Necklace (182 Beads)
Stag teeth
Tooth L. 1–1.5 cm
Cucuteni, Brad
4200–4050 BC (Cucuteni A3)
MIR: 22475–22656 (fig. 1-10)

192. Necklace (262 Beads)
Copper
Bead: D. 0.3 cm; W. 0.1–0.2 cm;
Thickness 0.1 cm
Cucuteni, Brad
4200–4050 BC (Cucuteni A3)
MIR: 22215–22474 (fig. 1-10)

193. Necklace (27 Beads)
12 Copper and 15 vitreous beads
Bead: D. 0.2–0.4 cm; L. 0.4–0.6 cm
Cucuteni, Brad
4200–4050 BC (Cucuteni A3)
MIR: 22181–22207 (fig. 1-10)

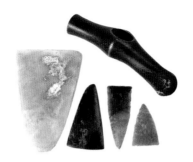

194. Lance
Flint
I l. 5 cm; L. 11.7 cm
Indo-European, Fălciu
4000 BC
MVPB: 7983

195. Axe
Flint
H. 3 cm; L. 7.3 cm
Indo-European, Fălciu
4000 BC
MVPB: 7985

196. Arrow Point
Flint
H. 3 cm; L. 7 cm
Indo-European, Fălciu
4000 BC
MVPB: 7986

197. Arrow Point
Flint
H. 3 cm; L. 4.7 cm
Indo-European, Fălciu
4000 BC
MVPB: 7987

198. Axe
Copper
H. 5 cm; L. 14 cm
Indo-European, Fălciu
4000 BC
MVPB: 7984

199. Beads (7)
Shell
Bead: D. 0.9–1.1 cm
Indo-European, Fălciu
4000 BC
MVPB: 7977–7983

200. Horse-Head Scepter
Stone
L. 17 cm; W. 7.5 cm
Indo-European, Casimcea
4000 BC
MNIR: 11650 (fig. 1-18)

201. Arrow Points (3)
Flint
H. 3.5–4.5 cm; L. 5.5–7.5 cm
Indo-European, Casimcea
4000 BC
MNIR: 11652–11654 (fig. 1-18)

202. Lances (2)
Flint
L. 12–13.5 cm; H. 6.5–6.8 cm
Indo-European, Casimcea
4000 BC
MNIR: 11647–11648 (fig. 1-18)

Akkermans, P., and M. Verhoeven. "An Image of Complexity: The Burnt Village at Late Neolithic Sabi Abyad, Siria." *American Journal of Archaeology* 99 (1995): 5–32.

Alaiba, R. "Olăritul în cultura Cucuteni." *Arheologia Moldovei* 28 (2005): 57–71.

Alekseeva, I. "O drevneishhikh eneoliticheskikh pogrebeniyakh severo-zapadnogo prichernomor'ya." *Materialy po Arkheologii Severnogo Prichernomor'ya* (Kiev) 8 (1976): 176–86.

Andrieşescu, I. "Contribuţii la Dacia înainte de romani." Ph.D. diss., Institutul de Arheologie Iaşi, 1912.

Angelov, N. "Selishtnata mogila pri s. Hotnitsa." In *Izsledvania v chest na akad. Dimitar Dechev po sluchai 80-godishninata mu*, edited by V. Beshevliev and V. Georgiev: 389–403. Sofia: Bulgarian Academy of Sciences Press, 1958.

———. "Zlatnoto sakrovishte ot Hotnitsa." *Arkheologia* 1, nos. 1–2 (1959): 38–46.

Angelova, I. "A Chalcolithic Cemetery Near the Town of Tărgovište." In *Die Kupferzeit als historische Epoche*, edited by J. Lichardus: vol. 1, 101–5. Saarbrücker Beitrage zur Altertumskunde 55. Bonn: Habelt, 1991.

Anghelinu, M. "The Magic of the Painted Pottery: The Cucutenian and the Romanian Prehistoric Archaeology." In *Cucuteni*, edited by Chapman et al. (2005): 29–38.

Anthony, D. *The Horse, the Wheel, and Language: How Bronze Age Riders from the Eurasian Steppes Shaped the Modern World*. Princeton, NJ: Princeton University Press, 2007.

———. "Nazi and Ecofeminist Prehistories: Ideology and Empiricism in Indo-European Archaeology." In *Nationalism, Politics, and the Practice of Archaeology*, edited by P. Kohl and C. Fawcett: 82–96. Cambridge: Cambridge University Press, 1995.

Antonović, D. "Copper Processing in Vinča: New Contributions to the Thesis about Metallurgical Character of Vinča Culture." Starinar 52 (2002): 27–45.

Antosyak, G., ed. Atlas Moldavskoy SSR. Moscow, 1978.

Apel, J., C. Hadevik, and L. Sundstrom. "Burning Down the House: The Transformation Use of Fire, and Other Aspects of an Early Neolithic TRB Site in Eastern Central Sweden. *Tor* (Uppsala) 29 (1997): 5–47.

Appadurai, A., ed. *The Social Life of Things: Commodities in Cultural Perspective*. Cambridge: Cambridge University Press, 1986.

Babeş, M. "Marile etape ale dezvoltării arheologiei în România." *Studii şi Cercetări de Istorie Veche şi Arheologie* 32, no. 3 (1981): 319–30.

Bailey, D. *Balkan Prehistory: Exclusion, Incorporation and Identity*. London: Routledge, 2000.

———. *Prehistoric Figurines: Representation and Corporeality in the Neolithic*. London: Routledge, 2005.

———, I. Panayotov, and S. Alexandrov, eds. *Prehistoric Bulgaria*. Monographs in World Archaeology 22. Madison, WI: Prehistory Press, 1995.

———, A. Whittle, and V. Cummings, eds. *(Un)settling the Neolithic*. Oxford: Oxbow, 2005.

———, A. Whittle, and D. Hofmann, eds. *Living Well Together: Sedentism and Mobility in the Balkan Neolithic*. Oxford: Oxbow, 2008.

———, et al. "Alluvial Landscapes in the Temperate Balkan Neolithic: Transitions to Tells." *Antiquity* 76 (2002): 349–55.

———, et al. "Expanding the Dimensions of Early Agricultural Tells: The Podgoritsa Archaeological Project, Bulgaria." *Journal of Field Archaeology* 25 (1998): 373–96.

Balabanov, I. "Holocene Sea-Level Changes of the Black Sea." In The Black Sea Flood Question, edited by Yanko-Hombach, Gilbert, Panin, and Dolukhanov (2007): 711–30.

———, D. Moise, and V. Radu. "Use of Bovine Traction in the Eneolithic of Romania: A Preliminary Approach." In *Cucuteni*, edited by Chapman et al. (2005): 277–83.

———, V. Radu, and D. Moise. *Omul şi mediul animal intre mileniile VII–IV i.e.n. la Dunarea de Jos*. Tărgovişte: Cetatea de Scaun, 2005.

Bălteanu, C., and P. Cantemir. "Contribuţii la cunoaşterea unor aspecte paleo-demografice la populaţia neolitică de la Chirnogi-Şuviţa Iorgulescu." *Studii şi Cercetări Antropologice* 28 (1991): 3–7.

Bánffy, E. "The Late Starčevo and the Earliest Linear Pottery Groups in Western Transdanubiana." *Documenta Praehistorica* 27 (2000):173–85.

———. "South-west Transdanubia as a Mediating Area: On the Cultural History of the Early and Middle Chalcolithic." In *Archaeology and Settlement History in the Hahót Basin, Southwest Hungary*, edited by B. Szóke: 157–96. Antaeus 22. Budapest: Archaeological Institute of the Hungarian Academy of Science, 1995.

Barford, P. "East Is East and West Is West? Power and Paradigm in European Archaeology." In *Archaeologies of Europe: History, Methods, and Theories*, edited by P. Biehl, A. Gramsch, and A. Marciniak: 78–97. Tübingen: Tübinger Archäologische Taschenbücher, 2002.

Bartosiewicz, L. "Mammalian Bone." In *The Early Neolithic on the Great Hungarian Plain: Investigations of the Koros Culture Site of Ecsegfalva 23, County Bekes*, edited by A. Whittle: 287–326. Varia Archaeologica Hungarica 21. Budapest: Archaeological Institute of the Hungarian Academy of Sciences; Cardiff: School of History and Archaeology, University of Cardiff, 2007.

Begemann, F., S. Schmitt-Strecker, and E. Pernicka. "The Metal Finds from Thermi III–V: A Chemical and Lead Isotope Study." *Studia Troica* 2 (1992): 219–39.

Beilekchi, V. "Raskopki kurgana 3 u s. Kopchak." In Arkheologicheskie Issledovaniya v Moldavii v 1985 g.: 34–49. Kishinev: Shtiintsa, 1985.

Beldiceanu, N. "Antichitățile de la Cucuteni." Iași: Institutul de Arheologie Iași, 1885.

Bem, C. *Traian-Dealul Fântânilor. Fenomenul Cucuteni A-B*. București: Muzeul National de Istorie a României, 2007.

———, et al. "Cercetări arheologice pe valea Neajlovului. Considerații generale asupra microzonei Bucșani." *Studii de Preistorie* 1 (2002): 131–45.

Benecke, N. "Archaeozoological Studies on the Transition from the Mesolithic to the Neolithic in the North Pontic Region." *Anthropozoologica* 25–26 (1997): 631–41.

Berciu, D. *Cultura Hamangia. Noi contribuții*. București: Institutul de Arheologiă al Academiei RPR, 1966.

———. *L'évolution de la civilisation de Cucuteni à la lumière des nouvelles fouilles archèologiques*. Florence, 1968.

Bicbaev, V. "Litsevye amfory kul'tury Kukuteni-Tripol'e-eneoliticheskie Model' Mira." Tezisy dokladov VIII mezhdunarodnoj konferentsii. *Mezdunarodnye otnoshennja v bassenye Chyornogo Mor'ya v drevnosti i srednie veka* (1996): 16–21.

Biehl, P. *Studien zum Symbolgut des Neolithikums und der Kupferzeit in Südosteuropa*. Saarbrücken: Habelt, 2003.

———. "Symbolic Communication Systems: Symbols on Anthropomorphic Figurines in Neolithic and Chalcolithic Southeast Europe." *Journal of European Archaeology* 4 (1996): 153–76.

———, and A. Marciniak. "The Construction of Hierarchy: Rethinking the Copper Age in Southeast Europe." In *Hierarchies in Action: Cui Bono?* edited by M. Diehl: 181–209. Occasional Paper 27. Carbondale, IL: Center for Archaeological Investigations, 2000.

Bodean, S. *Așezările culturii Precucuteni-Tripolie A din Republica Moldova*. Kishinev: Pontos, 2001.

Bodyans'kii, O. "Eneolitichnii mogil'nik bilya s. Petyro-Svistunovo." *Arkheologiya* (Kiev) 21 (1968): 117–25.

Boghian, D., and S. Ignătescu. "Quelques considérations sur un vase Cucuteni B aux représentations anthropomorphes peintes, découvert à Fetești-La Schit (Dép. de Suceava)." *Codrii Cosminului* 13, no. 23 (2007): 3–12.

———, and C. Mihai. "Le complexe de culte et le vase à décor ornithomorphe peint découverts à Buznea (Dep. de Iași)." In La civilisation de Cucuteni, edited by Petrescu-Dîmbovița, Ursulescu, Monah, and Chirica (1987): 313–23.

———, et al. "Târgu Frumos, Baza Pătule." In *Cronica cercetărilor arheologice din România. Campania 2001*: 314–16. București: CIMEC, 2002.

Bogucki, P. "The Spread of Early Farming in Europe." *American Scientist* 84, no. 3 (1996): 242–53.

Bolomey, Al. "Noi descoperiri de oase umane într-o așezare cucuteniană." *Cercetări Arheologice* (București) 8 (1983): 159–73.

———, and G. El Susi. "Animals Remains." In *Drăgușeni*, edited by Marinescu-Bîlcu and Bolomey (2000): 159–78.

Bond, G., et al. "Persistent Solar Influence on North Atlantic Climate During the Holocene." *Science* 294 (2001): 2130–36.

Boyadzhiev, Y. "Chalcolithic Stone Architecture from Bulgaria." *Archaeologia Bulgarica* 8, no. 1 (2004): 1–12.

———. "Chronology of Prehistoric Cultures in Bulgaria." In *Prehistoric Bulgaria*, edited by Bailey, Panayotov, and Alexandrov (1995): 149–91.

———. "Stone Architecture from the Chalcolithic Mound on Golemija Ostrov near Durankulak, Dobrich Region." *Starini* (2000–5): 63–74.

———. "Synchronization of the Stages of the Cucuteni Culture with the Eneolithic Cultures of the Territory of Bulgaria According to C14 Dates." In *Cucuteni*, edited by Chapman et al. (2005): 65–74.

Bradley, D., D. MacHugh, P. Cunningham, and R. Loftus. "Mitochondrial Diversity and the Origins of African and European Cattle." *Proceedings of the National Academy of Sciences* 93, no. 10 (1996): 5131–35.

Branigan, K. *Aegean Metalwork of the Early and Middle Bronze Age*. Oxford: Clarendon, 1974.

Bromberger, C. "Locuința." In *Dicționar de etnologie și antropologie*, edited by P. Bonte and M. Izard. Iași: Polirom, 1999.

———. "The Origins and Early Development of Mediterranean Maritime Activity." *Journal of Mediterranean Archaeology* 19, no. 2 (2006): 199–230.

———, and T. Strasser. "Migrant Farmers and the Colonization of Crete." *Antiquity* 65 (1991): 233–45.

Burdo, N. Sakral'nyi svit Trypil'skoi tsivilizatsii. Kiev: Nash Chas, 2008.

Burton, M., and T. Levy. "The Chalcolithic Radiocarbon Record and Its Use in Southern Levantine Archaeology." *Radiocarbon* 43, no. 3 (2001): 1223–46.

Bussy, M. "Le *spondylus* au Pérou et en Equateur à l'Époque préhispanique." Master's thesis, Université de Paris I Panthéon-Sorbonne, 1996–97.

Cameron, C., and S. Tomka, eds. *Abandonment of Settlements and Regions: Ethnoarchaeological and Archaeological Approaches*. Cambridge: Cambridge University Press, 1993.

Cantacuzino, G. "Morminte cu scheletele așezate pe torace din necropola neolitică de la Cernica și semnificația acestui ritual preistoric." *Muzeul Național* 2 (1975): 224–35.

———. "Un ritual funéraire exceptionnel de l'époque néolithique en Europe et en Afrique Septentrionale." *Dacia*, n.s., 19 (1975): 27–43.

———, and C. Fedorovici. "Morminte de femei decedate în timpul nașterii din necropola neolitică de la Cernica." *București* 8 (1971): 37–53.

Cârciumaru, M. *Paleobotanica. Studii în preistoria și protoistoria României*. Iași, 1996.

———, D. Popovici, M. Cosac, and R. Dincă. "Spectrographic Analysis of Neo-Eneolithic Obsidian Samples and Several Considerations about the Obsidian Supply Sources." *Analles d'Université Valachia, Târgoviște, Section d'Archéologie et d'Histoire* 2–3 (2000): 116–26.

Chapman, J. "The Creation of Social Arenas in the Neolithic and Copper Age of South East Europe: The Case of Varna." In *Sacred and Profane: Proceedings of a Conference on Archaeology, Ritual and Religion, Oxford, 1989*, edited by P. Garwood, R. Skeates, and J. Toms: 152–71. Oxford: Oxford Committee for Archaeology, 1991.

———. "Dark Burnished Ware as Sign: Ethnicity, Aesthetics and Categories in the Later Neolithic of the Central Balkans." In *Homage to Milutin Garašanin*, edited by Tasić and Grozdanov (2006): 295–308.

———. "Domesticating the Exotic: The Context of Cucuteni-Tripolye Exchange with Steppe and Forest-Steppe Communities." In *Ancient Interactions: East and West in Eurasia*, edited by K. Boyle, C. Renfrew, and M. Levine: 75–92. McDonald Institute Monongraphs. Cambridge: McDonald Institute for Archaeological Research, 2003.

———. "The Early Balkan Village." "Neolithic of Southeastern Europe and Its Near Eastern Connections," *Varia Archaeologica Hungarica* 2 (1989): 33–53.

———. "The Elaboration of an Aesthetic of Brilliance and Colour in the Climax Copper Age." In Stephanos Aristeios. Archäologische Forschungen zwischen Nil und Istros, edited by F. Lang, C. Reinholdt, and J. Weilhartner: 65–74. Vienna: Phoibos, 2007.

———. "Engaging with the Exotic: The Production of Early Farming Communities in South-East and Central Europe." In A Short Walk Through the Balkans: The First Farmers of the Carpathian Basin and Adjacent Regions, edited by M. Spataro and P. Biagi: 207–22. Trieste: Società per la Preistoria e Protostoria della Regione Friuli-Venezia Giulia Quaderno 12, 2007.

———. Fragmentation in Archaeology: People, Places and Broken Objects in the Prehistory of South Eastern Europe. London: Routledge, 2000.

———. "The Origins of Warfare in the Prehistory of Central and Eastern Europe." In Ancient Warfare, edited by J. Carman and A. Harding: 101–42. Stroud: Sutton, 1999.

———. "The Provision of Salt to Tripolye Megasites." In Tripolye Settlements-Giants, edited by Korvin-Piotorvsky, Kruts, and Rizhov (2003): 203–11.

———. "Social Inequality on Bulgarian Tells and the Varna Problem." In The Social Archaeology of Houses, edited by R. Samson: 49–98. Edinburgh: Edinburgh University Press, 1990.

———. "Spondylus bracelets: Fragmentation and Enchainment in the East Balkan Neolithic and Copper Age." Dobrudja 21 (2003): 63–87.

———. "Spondylus gaederopus/Glycymeris Exchange Networks in the European Neolithic and Chalcolithic." In Handbook of the European Neolithic, edited by D. Hoffman, C. Fowler, and J. Harding. London: Routledge, forthcoming.

———. The Vinča Culture of South East Europe: Studies in Chronology, Economy and Society. British Archaeological Reports, International Series 117. Oxford: Archaeopress, 1981.

———, and B. Gaydarska. Parts and Wholes: Fragmentation in Prehistoric Context. Oxford: Oxbow, 2007.

———, B. Gaydarska, and K. Hardy. "Does Enclosure Make a Difference? A View from the Balkans." In Enclosing the Past: Inside and Outside in Prehistory, edited by A. Harding, S. Sievers, and N. Varnaclová: 20–43. Sheffield Archaeological Monographs 15. London: Equinox, 2006.

———, and D. Monah. "A Seasonal Cucuteni Occupation at Siliște-Prohozești." In L'exploitation du sel à travers le temps, edited by D. Monah, G. Dumitroaia, O. Weller, and J. Chapman: 71–88. Bibliotheca Memoriae Antiquitatis 18. Piatra-Neamț, 2007.

———, et al., eds. Cucuteni. 120 ans de recherches; Le temps du bilan / Cucuteni: 120 Years of Research; Time to Sum Up. Bibliotheca Memoriae Antiquitatis 16. Piatra Neamț, 2005.

Chenu, J.-C. Illustrations conchyliologiques, ou Description et figures de toutes les coquilles connues vivantes et fossiles Paris: Franck, 1842.

Chernyakhov, I., ed. Rannezemledel'cheskie poseleniya-giganty Tripol'skoi kul'tury na Ukraine. Tal'yanki: Vinnitskii Pedagogicheskii Institut, 1990.

Chernykh, E. "Ai Bunar, a Balkan Copper Mine of the IVth Millennium BC." Proceedings of the Prehistoric Society 44 (1978): 203–18.

———. Ancient Metallurgy in the USSR: The Early Metal Age. Cambridge: Cambridge University Press, 1992.

———. "Eneolit pravoberezhnoi ukrainy i moldavii." In Eneolit SSSR, edited by V. Masson and N. Merpert: 166–320. Arkheologia SSSR 3. Moskva: Nauka, 1982.

———. Gornoje delo i metallurgija v drevnejsej Bolgarii. Sofia: Arkheologicheskii Institut i Muzei Bolgarskoi Akademii Nauk, 1978.

———. Istorija drevnejsej metallurgii vostocnoj Evropy. Materialy i issledovanija po arkheologii 132. Moskva and Leningrad: Akademii Nauk, 1966.

———. "O jugo-vostochnoj zone Balkano-Karpatskoj metallurgicheskoj provintsii épokhi éneolita." Studia Praehistorica (Sofia) 1–2 (1978): 170–81.

Chertier, B. "La sépulture danubienne de Vert-la-Gravelle (Marne), lieu-dit Le Bas des Vignes." Préhistoire et prohistoire en Champagne-Ardenne 12 (1988): 31–69.

Chilardi, S., L. Guzzardi, M. Iovino, and A. Rivoli. "The Evidence of Spondylus Ornamental Objects in the Central Mediterranean Sea: Two Case Studies; Sicily and Malta." In Archaeomalacology: Molluscs in Former Environments of Human Behaviour, edited by D. Bar-Yosef Mayer: 82–90. Procceedings of the 9th Conference of the International Council of Archaeozoology, Durham, August 2002. Oxford: Oxbow, 2005.

Childe, V.G. The Danube in Prehistory. Oxford: Clarendon, 1929.

———. The Dawn of European Civilization. 1925. Oxford: Taylor and Francis, 2005.

———. What Happened in History. 1942. Harmondsworth: Penguin, 1976.

Clottes, J., and D. Lewis-Williams. Les chamanes de la préhistoire. Paris: Roches, 2001.

Čochadžiev, S. "Untersuchungen des frühen Äneolithikums im südwestlichen Bulgarien." In Internationales Symposium über die Lengyel-Kultur: 45–52. Nitra: Archäologisches Institut der Slowakischen Akademie der Wissenschaften in Nitra, 1986.

Colledge, S., and J. Conolly. "The Neolithisation of the Balkans: A Review of the Archaeobotanical Evidence." In A Short Walk Through the Balkans: The First Farmers of the Carpathian Basin and Adjacent Regions, edited by M. Spataro and P. Biagi: 25–38. Trieste: Società per la Preistoria e Protostoria della Regione Friuli-Venezia Giulia Quaderno 12, 2007.

Comșa, E. "Așezarea neolitică de la Izvoarele (jud. Giurgiu)." Buletinul Muzeului "Teohari Antonescu" 5–6 (1999–2000): 103–4.

———. "Caracteristicile și însemnătatea cuptoarelor de ars oale din aria culturii Cucuteni-Ariușd." Studii și Cercetări de Istorie Veche și Arheologie 27, no. 1 (1976): 23–26.

———. Complexul neolitic de la Radovanu. Cultură și Civilizație la Dunărea de Jos 8. Călărași, 1990.

———. "Considérations sur le rite funéraire de la civilisation de Gumelnița." Dacia 4 (1960): 5–30.

———. "Contribuții la cunoașterea ritului funerar al purtătorilor culturii Gumelnița (Grupul de morminte de la Dridu)." Aluta 10–11 (1980): 23–32.

———. Istoria comunităților culturii Boian. București: Editura Academiei, 1974.

———. "Mormintele neolitice de la Radovanu." Studii și Cercetări de Istorie Veche și Arheologie 49, nos. 3–4 (1998): 265–76.

———. "Necropola gumelnițeană de la Vărăști." Analele Banatului 4, no. 1 (1995): 55–189.

———. Neoliticul pe teritoriul României. București: Considerații, 1987.

———. "Parures néolithiques en coquillages marins découvertes en territoire roumain." Dacia 17 (1973): 61–76.

———. "Quelques considerations sur la culture Gumelnița (l'agglomeration de Măgura Jilavei)." Dacia, n.s., 10 (1976): 105–27.

———. "Ritul și ritualurile funerare din epoca neolitică din Muntenia." Istorie și tradiție în spațiul românesc 4 (1998): 18–35.

———, and G. Cantacuzino. Necropola neolitică de la Cernica. București: Editura Academei Române, 2001.

Condurachi, E. Archéologie roumaine au XXe siècle. Bucharest: Académie RPR, 1963.

Cotiugă, V., and O. Cotoi. "Parcul arheologic experimental de la Cucuteni." In *Cucuteni-Cetăţuie*, edited by Petrescu-Dîmboviţa and Văleanu (2004): 337–50.

Craig, O., et al. "Did the First Farmers of Central and Eastern Europe Produce Dairy Foods?" *Antiquity* 79 (2005): 882–94.

Cucoş, Ş. "Un complex ritual descoperit la Ghelăieşti (jud. Neamţ). *Studii si cercetai de istorie veche si arheologie* 24, no. 2 (1973): 207–15.

———. "Cultura amforelor sferice din depresiunea subcarpatică a Moldovei." *Memoria Antiquitatis* 9–11 (1977–79): 141–61.

———. *Faza Cucuteni B în zona subcarpatică a Moldovei*. Bibliotheca Memoria Antiquitatis 6. Piatra Neamţ, 1999.

Daicoviciu, C. *Dacica. Studii şi articole privind istoria veche a pământului românesc*. Cluj, 1969.

———, and E. Condurachi. *Roumanie*. Archaeologia Mundi. Munich: Nagel, 1972.

Delong, A. "Phenomenological Space-Time: Toward an Experiential Relativity." *Science* 213, no. 4508 (7 August 1981): 681–82.

———. "Spatial Scale, Temporal Experience and Information Processing: An Empirical Examination of Experiential Reality." *Man-Environment Systems* 13 (1983): 77–86.

Dennell, R., and D. Webley. "Prehistoric Settlement and Land Use in Southern Bulgaria." In *Palaeoeconomy*, edited by E. Higgs: 97–110. Cambridge: Cambridge University Press, 1975.

Dergachev, V. *Die äneolitishen und bronzezeitlichen Metallfunde aus Moldavien*. Stuttgart: Steiner, 2002.

———. *Kerbunskii klad*. Chişinău: Tipografia Academiei de Ştiinţe, 1998.

———. "The Migration Theory of Marija Gimbutas." *Journal of Indo-European Studies* 28, nos. 3–4 (2000): 257–339.

———, A. Sherratt, and O. Larina. "Recent Results of Neolithic Research in Moldavia (USSR)." *Oxford Journal of Prehistory* 10, no. 1 (1991): 1–16.

Diaconescu, M. "Aşezarea cucuteniană de la Razima-Copalău din judeţul Botoşani." *Hierasus* (Botoşani) 9 (1994).

Dimitrijević, V., and C. Tripković. "Spondylus and Glycymeris Bracelets: Trade Reflections at Neolithic Vinča–Belo Brdo." Documenta Praehistorica 33 (2006): 1–16.

Dimitrov, K. *Mednata metalurgiya po Zapadnia briag na Cherno more (sredata na V–nachaloto na IV hil. pr. Hr.)*. Sofia: Autoreferat, 2007.

———. "Die Metallfunde aus den Gräberfeldern." In *Durankulak*, edited by Todorova (2002): 127–58.

Dimov, T. "Neolithic and Copper Age Sites in the North East Balkans (with Special Reference to Hamangia Culture). In *Early Symbolic Systems for Communication in Southeast Europe*, edited by L. Nikolova: vol. 2, 459–68. British Archaeological Reports, International Series 1339. Oxford: Archaeopress, 2003.

Dinu, M. "Contribuţii la problema Culturii Amforelor Sferice pe teritoriul Moldovei." *Arheologia Moldovei* 1 (1961): 43–59.

———. "Principalele rezultate ale cercetărilor arheologice de la Băiceni-Dâmbul Morii, com. Cucuteni (1961–1966)." In *Cucuteni*, edited by Ursulescu and Lazarovici (2006).

———. "Quelques remarques sur la continuité de la céramique peinte du type Cucuteni durant la civilisation Horodiştea-Erbiceni et Gorodsk." In *La civilisation de Cucuteni*, edited by Petrescu-Dîmboviţa, Ursulescu, Monah, and Chirica (1987): 133–40.

Dobrovol'skii, V. "Mogil'nik v s. Chapli." *Arkheologiya* (Kiev) 9 (1958): 106–18.

Draganov, V. "Submerged Coastal Settlements from the Final Eneolithic and the Early Bronze Age in the Sea around Sozopol and Urdoviza Bay near Kiten." In *Prehistoric Bulgaria*, edited by Bailey, Panayotov, and Alexandrov (1995): 225–41.

Dragomir, I. "Principalele rezultate ale săpăturilor arheologice de la Bereşti 'Dealul Bulgarului' (1981), judeţul Galaţi." *Memoria Antiquitatis* 9–11 (1985): 95.

———. *Eneoliticul din sud-estul României. Aspectul cultural Stoicani-Aldeni*. Biblioteca de Arheologie 42. Bucureşti: Academiei RSR, 1983.

Draşovean, Fl. *Cultura Vinča târzie (faza C) în Banat*. Timişoara: Mirton, 1996.

Dumitrescu, H. "Découvertes concernant un rite funéraire magique dans l'aire de la civilisation de la céramique peinte du type Cucuteni-Tripolie." *Dacia*, n.s., 1 (1957): 97–103.

———. "O descoperire în legătură cu ritul de înmormântare în cuprinsul culturii ceramicii pictate Cucuteni-Tripolie." *Studii şi Cercetări de Istorie Veche* 5, nos. 3–4 (1954): 399–429.

———. "Deux nouvelles tombes cucuténiennes à rite magique découvertes à Traian." Dacia, n.s., 2 (1958): 407–23.

Dumitrescu, Vl. *Arta culturii Cucuteni*. Bucureşti: Meridiane, 1979.

———. *Arta preistorică în România*. Bucureşti: Meridiane, 1974.

———. "Consideration et données nouvelles sur le problème du synchronisme des civilisations de Cucuteni et de Gumelniţa." *Dacia* 8 (1964): 53–66.

———. *Hăbăşeşti. Satul neolitic de pe Holm*. Bucureşti: Meridiane, 1967.

———. "În legătură cu periodizarea fazei Cucuteni A-B." *Studii şi Cercetări de Istorie Veche şi Arheologie* 23, no. 3 (1972): 441–47.

———. "A Late Neolithic Settlement on the Lower Danube." *Archaeology* (New York) 18, no. 1 (1965): 34–40.

———. "Originea şi evoluţia culturii Cucuteni-Tripolie." *Studii şi Cercetări de Istorie Veche şi Arheologie* 14, no. 1 (1963): 51–74; no. 2 (1963): 285–308.

———. "Principalele rezultate ale primelor două campanii de săpătură din aşezarea neolitică târzie de la Căscioarele." *Studii şi Cercetări de Istorie Veche şi Arheologie* 16, no. 2 (1965): 215–38.

———, et al. *Hăbăşeşti. Monografie arheologică*. Bucureşti: Academiei RPR, 1954.

Dumitroaia, G. *Comunităţi preistorice din nord-estul României. De la cultura Cucuteni până în bronzul mijlociu*. Biblioteca Memoria Antiquitatis 7. Piatra Neamţ, 2000.

———. "Depunerile neo-eneolitice de la Lunca şi Oglinzi, judeţul Neamţ." *Memoria Antiquitatis* 19 (1994): 7–82.

———. "La station archéologique de Lunca-Poiana Slatinii." In *La civilisation de Cucuteni*, edited by Petrescu-Dîmboviţa, Ursulescu, Monah, and Chirica (1987): 253–58.

———, and D. Monah, eds. *Cucuteni aujourd'hui. 110 ans depuis la découverte en 1884 du site eponyme*. Bibliotheca Memoriae Antiquitatis 2. Piatra-Neamţ, 1996.

Echt, R. *Drama-Merdžumekja: A Southeast Bulgarian Monument of the European Culture Heritage and Its Publication*. In *E-Learning Methodologies and Computer Applications in Archaeology*, edited by D. Politis: 229–51. Hershey, PA: IGI Global, 2008.

———, W.-R. Thiele, and I. Ivanov. "Varna—Untersuchungen zur kupferzeitlichen Goldverarbeitung." In Die Kupferzeit als historische Epoche, edited by Lichardus and Echt (1991): 633–91.

Ellis, L. "Analysis of Precucuteni Ceramics from Târgu Frumos, Romania." In Scripta praehistorica, edited by Spinei, Lazarovici, and Monah (2005): 262–70.

———. The Cucuteni-Tripolye Culture: A Study in Technology and the Origins of Complex Society. British Archaeological Reports, International Series 217. Oxford: Archaeopress, 1984.

Elster, E., and C. Renfrew, eds. Prehistoric Sitagroi: Excavations in Northeast Greece, 1968–1970. Vol. 2, The Final Report. Los Angeles: Cotsen Institute of Archaeology, University of California, 2003.

Fiedel, S., and D.W. Anthony. "Deerslayers, Pathfinders, and Icemen: Origins of the European Neolithic as Seen from the Frontier." In The Colonization of Unfamiliar Landscapes, edited by M. Rockman and J. Steele: 144–68. London: Routledge, 2003.

Filipova, M. "Palaeoecological Investigations of Lake Shabla-Ezeretz in North-eastern Bulgaria." Ecologica Mediterranea 1, no. 1 (1985): 147–58.

Filipova-Marinova, M. "Archaeological and Paleontological Evidence of Climate Dynamics, Sea-Level Change, and Coastline Migration in the Bulgarian Sector of the Circum-Pontic Region." In The Black Sea Flood Question, edited by Yanko-Holmbach, Gilbert, Panin, and Dolukhanov (2007): 453–81.

———. "Postglacial Vegetation Dynamics in the Coastal Part of the Strandza Mountains, South-eastern Bulgaria." In Aspects of Palynology and Palaeoecology: Festschrift in Honour of Elissaveta Bozilov, edited by S. Tonkov: 213–31. Sofia-Moscow: Pensoft, 2003.

Fletcher, R. The Limits to Settlement Growth. Cambridge: Cambridge University Press, 1996.

Florescu, A. "Observaţii asupra sistemului de fortificare al aşezărilor cucuteniene din Moldova." Arheologia Moldovei 4 (1966): 23–38.

———, and M. Florescu. "Şanţul de apărare." In Truşeşti, edited by Petrescu-Dîmboviţa, Florescu, and Florescu (1999): 222–30.

French, D. "Excavations at Can Hasan: First Preliminary Report, 1961." Anatolian Studies 12 (1962): 27–40.

Gale, N., et al. "Early Metallurgy in Bulgaria." In Mining and Metal Production Through the Ages, edited by P. Craddock and J. Lang: 122–73. London: British Museum Press, 2003.

———, et al. "Recent Studies of Eneolithic Copper Ores and Artefacts in Bulgaria." In Découverte du métal, edited by J. Mohen: 49–76. Paris: Picard, 1991.

Gaydarska, B. "Application of GIS in Settlement Archaeology: An Integrated Approach to Prehistoric Subsistence Strategies." In Tripolye Settlements-Giants, edited by Korvin-Piotorvsky, Kruts, and Rizhov (2003): 212–16.

———. "Preliminary Research on Prehistoric Salt Exploitation in Bulgaria." In "Todorova Festschrift," edited by V. Slavchev, Dobrudzha 21 (2004): 110–22.

———, et al. "Breaking, Making and Trading: The Omurtag Eneolithic Spondylus Hoard." Archaelogia Bulgarica 8 (2004): 11–34.

Georgieva, P. "Ethnocultural and Social-economic Changes during the Transitional Period from Eneolithic to Bronze Age in the Region of Lower Danube." Godišnjak na Akademija nauka i umetnosti Bosne i Hercegovine. Centar za balkanološka ispitivanja 28, no. 26 (1990): 239–45.

———. "Nadgrobna mogila krai gr. Shabla (problemi na hronologiyata i kulturnata prinadlezhnost)." Arkheologia 33, no. 1 (1991): 1–10.

———. "Za kraiya na eneolita v Zapadnoto Chernomorie." In Festschrift für Dr.habil. Henrieta Todorova, edited by V. Slavchev: 214–38. Sbornik Dobrudja 21. Varna: Sitronik, 2004.

———. "Za zoomorfnite skiptri i poslednite etapi na kasnoeneolitnite kulturi Varna, Kodzhadermen-Gumelnitsa-Karanovo VI i Krivodol-Salkutsa." In Stephanos Archaeologicos—In Honorem Professoris Ludmili Getov, edited by K. Rabadjievm: 144–67. Sofia: Sofia University Press, 2005.

Gheorgiu, D., and C. Schuste. "The Avatars of a Paradigm: A Short History of Romanian Archaeology." In P.F. Biehl, A. Gramsch, and A. Marciniak, eds. Archäologien Europas. Geschichte, Metoden und Theorien/Archaeologies of Europe: History, Methods and Theories: 289–301. Tübinger Archäologische Taschenbücher 3. Munster: Waxmann, 2002.

Ghetie, B., and C. Mateescu. "L'utilisation des bovines à la tracation dans le Neolithique Moyen." International Conference of Prehistoric and Protohistoric Sciences (Belgrade) 10 (1973): 454–61.

Gimbutas, M. Civilizaţie şi cultură. Vestigii preistorice în sud-estul. Bucureşti: Meridiane, 1989.

———. The Civilization of the Goddess: The World of Old Europe. San Francisco: Harper-Collins, 1991.

———. "The First Wave of Eurasian Steppe Pastoralists into Copper Age Europe." Journal of Indo-European Studies 5, no. 4 (1977): 277–338.

———. The Goddesses and Gods of Old Europe: Myths and Cult Images. London: Thames and Hudson, 1982.

———. The Goddesses and Gods of Old World Europe, 6500–3500 BC. London: Thames and Hudson, 1983.

———. The Gods and Goddesses of Old Europe, 6500–3500 BC: Myths and Cult Images. London: Thames and Hudson, 1974.

———. The Language of the Goddess. London: Thames and Hudson, 1989.

———, and M.R. Dexter. The Living Goddesses. Berkeley: University of California Press, 2001.

Glumac, P., and J. Todd. "Eneolithic Copper Smelting Slags from the Middle Danube Basin." In Archaeometry '90, edited by E. Pernicka and G. Wagner: 155–64. Basel: Birkhäuser, 1991.

———, and R. Tringham. "The Exploitation of Copper Minerals." In Selevac: A Neolithic Village in Yugoslavia, edited by Tringham and D. Krštić: 549–66. Los Angeles: Institute of Archaeology, University of California, 1990.

Golan, A. Prehistoric Religion: Mythology; Symbolism. Jerusalem, 2003.

Goren, Y. "The Location of Specialized Copper Production by the Lost Wax Technique in the Chalcolithic Southern Levant." Geoarchaeology 23, no. 3 (2008): 374–97.

Gotherstrom, A., et al. "Cattle Domestication in the Near East Was Followed by Hybridization with Aurochs Bulls in Europe." Proceedings of Biological Sciences 272, no. 1579 (2005): 2337–44.

Greenfield, H. "Preliminary Report on the 1992 Excavations at Foeni-Sălaş: An Early Neolithic Starčevo-Criş Settlement in the Romanian Banat." Analele Banatului 3 (1994): 45–93.

Haheu, V., and S. Kurciatov. "Cimitirul plan eneolitic de lingă satul Giurgiuleşti." Revistă Arheologică 1 (1993): 101–14.

———. "Otchet o polevych issledovanyach Pruto-Dunayskoy novostroechnoy ekspedicii v 1991 godu." Arhiva Arheologică a MNAIM (Kishinev), no. 336. 1992.

Haimovici, S. "Quelques problèmes d'archéo-zoologie concernant la culture de Cucuteni." In La civilisation de Cucuteni, edited by Petrescu-Dîmboviţa, Ursulescu, Monah, and Chirica (1987): 157–66.

Halstead, P. "Neighbours from Hell? The House-hold in Neolithic Greece." In Neolithic Society in Greece, edited by Halstead: 77–95. Sheffield Studies in Aegean Archaeology 2. Sheffield: Sheffield Academic Press, 1999.

Hansen, S. Bilder vom Menschen der Steinzeit: Untersuchungen zur anthropomorphen Plastik der Jungsteinzeit und Kupferzeit in Südosteuropa. Archäologie in Eurasien 20. Mainz: Philipp von Zabern, 2007.

———, et al. "Der kupferzeitliche Siedlungshugel Pietrele an der Unteren Donau. Bercht uber die Ausgrabungen in Sommer 2004." Eurasia Antiqua 11 (2005): 341–93.

———, et al. "Pietrele—Eine kupferzeitliche Siedlung an der Unteren Donau. Bericht über die Ausgrabungen in Sommer 2005." Eurasia Antiqua 12 (2006): 1–62.

Hartmann, A. Prähistorische Goldfunde aus Europa II. Studien zu den Anfängen der Metallurgie 5. Berlin: Mann, 1982.

Harțuche, N., and O. Bounegru. "Săpăturile arheologice de salvare de la Medgidia, jud. Constanța, 1957–1958." Pontica (Constanța) 30 (1997): 17–104.

Hasotti, P. Epocă neolitică în Dobrogea. Bibliotheca Tomitana 1. Constanta: Muzeul de Istorie Nationala si Arheologie, 1997.

Hauptmann, A., J. Lutz, E. Pernicka, and Ü. Yalçin. "Zur Technologie der frühesten Kupferverhüttung im östlichen Mittelmeerraum." In Between the Rivers and Over the Mountains, edited by M. Frangipane et al.: 541–72. Archaeologica Anatolica et Mesopotamica Alba Palmieri dedicata (Dip. Scienze Storiche Archeologiche e Antropologiche dell'Antichità). Rome: Universita di Roma La Sapienza, 1993.

Helms, M. "Long-Distance Contacts, Elite Aspirations, and the Age of Discovery." In Resources, Power, and Inter-regional Interaction, edited by E. Schortman and P. Urban: 157–74. New York: Plenum, 1992.

Higham, T., et al. "New Perspectives on the Varna Cemetery (Bulgaria)—AMS Dates and Social Implications." Antiquity 81 (2007): 640–54.

Hodder, I. The Domestication of Europe: Structure and Contingency in Neolithic Societies. Oxford: Blackwell, 1990.

Iercoșan, N. Cultura Tiszapolgár în vestul României. Cluj Napoca: Nereamia Napocae, 2002.

Ivanov, I. "À la question de la localisation et des études des sites submerges dans les lacs de Varna." Pontica 26 (1993): 19–26.

———. "Der Bestattungsritus in der chalkolitischen Nekropole in Varna." In Die Kupferzeit als historische Epoche, edited by Lichardus and Echt (1991): 125–50.

———. "Le chalcolithique en Bulgarie et dans la nécropole de Varna." In Ancient Bulgaria, edited by A. Poulter: vol. 1, 154–63. Nottingham: Nottingham University Press, 1983.

———. "Les fouilles archéologiques de la nécropole chalcolithique à Varna." Studia Praehistorica 1–2 (1978): 13–26.

———. "Das Gräberfeld von Varna." In Macht, Herrschaft und Gold. Das Gräberfeld von Varna (Bulgarien) und die Anfänge einer neuen europäischen Zivilisation, edited by A. Fol and J. Lichardus: 49–66. Saarbrücken: Moderne Galerie des Saarland-Museums, 1988.

———. "Nakolnite selishta—rezultati i problemi." FAR (1981): 268–91.

———. "Razkopki na varnenskija eneoliten nekropol prez 1972 godina." Izvestija na Narodnija Muzej Varna 11 (1975): 1–17.

———. Sokroviscyata na varnenskya neoliten nekropolju. Sofia: Septemvri, 1978.

———. "Spasitelni razkopki na rannoeneolitnioto selishte pri s. Suvorovo." Archeologicheski otkritia i razkopki prez 1983 29 (1984): 21–22.

———. "Varnenskiyat nekropol i negovoto myasto v praistoriyata na Iztochnoto Sredizemnomorie." In Balgaria v sveta ot drevnostta do nashi dni, edited by D. Kosev: vol. 1, 94–101. Sofia: Nauka i izkustvo, 1979.

———, and M. Avramova. Varna Necropolis: The Dawn of European Civilization. Sofia: Agatho, 2000.

Ivanov, T. Radingrad. Selishtna mogila i nekropol. Sofia: Septemvri, n.d.

Jockenhövel, A., and H. Popov. "Archaeometallurgical Surveys in the Eastern Rhodopes, 2004–2006: Results and Perspectives for Development." In Ancient Mining in Turkey and the Eastern Mediterranean: International Conference AMITEM 2008, June 15–22, edited by Ü. Yalçin, H. Özbal, and A. Pașamehmetoğlu: 251–70. Turkey Historical Research Applications and Research Center Publications 2. Ankara: Atılım University, 2008.

———. "B'lgaro-Nemski arkheometalurgichen proekt, 'Zhelyazo i Zlato'—A. po sledite na metalurgiyata ne drevna trakiya." In B'lgarska arkheologiya 2008. Katalog k'm izlozhba, edited by Z. Dimitrov: 31–33. Sofia.

Jovanovic, B. "Rudna Glava—ein Kupferbergwerk des frühen Eneolithikums in Ostserbien." Der Anschnitt 28 (1978): 150–57.

———. Rudna Glava. Najstarije rudarstvo bakra na Centralnom Balkanu. Bor: Museum für Bergbau- und Hüttenwesen; Beograd: Archäologisches Institut, 1982.

Junghans, S., E. Sangmeister, and M. Schröder. Kupfer und Bronze in der frühen Metallzeit Europas 1–3. Berlin, 1968.

Karmanski, S. Katalog antropomorfne i zoomorfne plastike iz okoline Odzaka. Odzaci: Arheoloska Zbirka, 1977.

Kharitidi, O. La chamane blanche. L'initiation d'un psychiatre à la médecine traditionnelle des âmes. Paris: Lattès, 1997.

Kienlin, T., and E. Pernicka. "Aspects of the Production of Copper Age Jászladány Type Axes." In Metals and Societies, edited by T. Kienlin and B. Roberts: 258–76. "Studies in Honour of Barbara S. Ottaway," Universitätsforschungen zur prähistorischen Archäologie 169. Bonn: Habelt, 2009.

Kogălniceanu, R. "Utilizarea testului X^2 în arheologie. Studiu de caz-necropola neolitică de la Cernica." Arheologia Moldovei 28 (2005): 288–95.

Kohl, P. The Making of Bronze Age Eurasia. Cambridge: Cambridge University Press, 2007.

Korvin-Piotorvsky, A., V. Kruts, and S. Rizhov, eds. Tripolye Settlements-Giants. Kiev: Institute of Archaeology, 2003.

Kotova, N. Early Eneolithic in the Pontic Steppes. Translated by N. Makhortykh. British Archaeological Reports, International Series 1735. Oxford: Archaeopress, 2008.

———. Neolithization in Ukraine. British Archaeological Reports, International Series 1109. Oxford: Archaeopress, 2003.

Kotsakis, K. "Across the Border: Unstable Dwellings and Fluid Landscapes in the Earliest Neolithic of Greece." In (Un)settling the Neolithic, edited by Bailey, Whittle, and Cummins: 8–16.

Kremenetskii, C. "Human Impact on the Holocene Vegetation of the South Russian Plain." In Landscapes in Flux: Central and Eastern Europe in Antiquity, edited by J. Chapman and P. Dolukhanov: 275–87. London: Oxbow, 1997.

Kruts, V. "Planirovka poseleniya u s. Tal'yanki i nekotorye voprosy Tripol'skogo domostroitel'stva." In Rannezemledel'skie poseleniya-giganty Tripol'skoi kul'tury na Ukraine: 43–47. Kiev: Institut Arkheologii AN USSR, 1990.

László, A. "Aşezări întărite ale culturii Ariuşd-Cucuteni în sud-estul Transilvaniei. Fortificarea aşezării de la Malnaş-Băi." Arheologia Moldovei 16 (1993): 33–50.

———. "Some Data on House-Building Techniques and Foundation Rites in the Ariuşd-Cucuteni Culture." Studi Antiqua et Archaeologica (Iaşi) 7: 245–52.

László, F. Ásatások az Erösdi östelepen. Sfântu Gheorghe, 1914.

———. "Ásatások az erösdi östelepen (1907–1912). Fouilles a station primitive de Erösd (1907–1912)." DolgCluj 5 (1914): 279–386.

Lazăr, C. "Date noi privind unele morminte gumelniţene." Cultură şi Civilizaţie la Dunărea de Jos 16–17 (2001): 173–83.

Lazăr, V. "Aşezarea Coţofeni de la Şincai (jud. Mureş)." Marisia 7 (1977): 17–56.

Lazarovici, C.-M. "Semne şi simboluri în cultura Cucuteni-Tripolie." In Cucuteni, edited by Ursulescu and Lazarovici (2006): 57–100.

———, D. Botezatu, L. Ellis, and S. Ţurcanu. "New Human Remains in the Cucutenian Settlement from Scânteia (1994–2003)." In Tripol'skoe poselenie-gigant Tal'ianki. Issledovaniia 2001 g., edited by V. Kruts, A. Korvin-Piotrovskiĭ, and S. Ryzhov. Kiev: In-t arkheologii NANU, 2001.

———, D. Botezatu, L. Ellis, and S. Ţurcanu. "Noi resturi de oase umane în aşezarea cucuteniană de la Scânteia (1994–2003)." Arheologia Moldovei 26 (2003): 297–306.

———, and G. Lazarovici. Neoliticul. Vol. 1, Arhitectura neoliticului şi epocii Cuprului din România, edited by V. Spinei and V. Mihailescu-Bîrliba. Bibliotheca Archaeologica Moldaviae 4. Iaşi: Trinitas, 2006.

———, and G. Lazarovici. Epoca Cuprului. Vol. 2, Arhitectura neoliticului şi epocii Cuprului din România. Edited by V. Spinei and V. Mihailescu-Bîrliba. Iaşi: Trinitas, 2007.

Lazarovici, G. "Principalele probleme ale culturii Tiszapolgár în România." Acta Musei Napocensis 20 (1983): 3–20.

———. "Über das neo-bis äneolithischer Befestigungen aus Rumänien." JahrMittDeutsch Vorgeschichte 73 (1990): 93–117.

———, F. Draşovean, and Z. Maxim. Parţa. Monografie arheologică. Bibliotheca Historica et Archaeologica Banatica 12. Timişoara: Mirton, 2001.

———, and C.-M. Lazarovici. "The Neo-Eneolithic Architecture in Banat, Transilvania and Moldova." In Recent Research in Prehistory of the Balkans, edited by D. Grammenos: 369–486. Publications of the Archaeological Institute of Northern Greece 3. Thessaloniki, 2003.

———, et al. "Balta Sărată. Campaniile 1992–2003 (I. Arhitectura)." Tibiscum 11 (2003): 143–98.

Leuschner, H., et al. "Subfossil European Bog Oaks: Population Dynamics and Long-Term Growth Depressions as Indicators of Changes in the Holocene Hydro-Regime and Climate." The Holocene 12, no. 6 (2002): 695–706.

Levi-Strauss, C. Histoire de lynx. Paris: Plon, 1991.

Leviţki, O., R. Alaiba, and V. Bubulici. "Raport asupra investigaţiilor arheologice efectuate în anii 1997–1998 la Trinca-Izvorul lui Luca, r. Edineţ, R. Moldova." Cercetări Arheologice în Aria Nord-Dacă (Bucureşti) 3 (1999): 16–116.

Lichardus, J. "Die Kupferzeit als historische Epoche. Eine forschungsgeschichtliche Einleitung." in Die Kupferzeit als historische Epoche, edited by Lichardus and Echt: 13–32.

———, and R. Echt, eds. Die Kupferzeit als historische Epoche. Saarbrücker Beiträge zur Altertumskunde 55. Bonn: Dr. Rudolf Habelt Verlag, 1991.

———, and M. Lichardus-Itten. "Nordpontische Beziehungen während der frühen Vorgeschichte Bulgariens." Thracia (Sofia) 11 (1995): 31–62.

Lichter, C. Untersuchungen zu den Bestattungssitten des Sudosteuropaeischen Neolithikums und Chalkolithikums. Mainz: Philip von Zabern, 2001.

Luca, S. Sfârşitul eneoliticului pe teritoriul intracarpatic al României—Cultura Bodrogkeresztúr. Bibliotheca Musei Apulensis 11. Alba Iulia, 1999.

Lutz, J. "Geochemische und mineralogische Aspekte der frühen Kupferverhüttung in Murgul/Nordost-Türkei." Ph.D. diss., Universität Heidelberg, 1990.

MacKendrick, P. The Dacian Stones Speak. Chapel Hill: University of North Carolina Press, 1975.

Malinowski, B. Argonauts of the Western Pacific. London: Routledge, 1922.

Mallory, J., and D. Adams. The Oxford Introduction to Proto-Indo-European and the Proto-Indo-European World. Oxford: Oxford University Press, 1997.

Măndescu, D. "Tellul gumelniţean de la Ziduri (com. Mozăceni, jud. Argeş)." Argessis 10 (2001): 7–20.

Manolakakis, L. Les industries lithiques énéolithiques de Bulgarie. Internationale Archäologie 88. Rahden/Westf.: Marie Leidorf, 2005.

Mantu, C.-M. "Cucuteni-Tripolye Cultural Complex: Relations and Synchronisms with Other Contemporaneous Cultures from the Black Sea Area." "In honorem Mircea Petrescu-Dâmboviţa et Marin Dinu," Studia Antiqua et Archaeologica (Universitatea Alexandru Ioan Cuza) 7 (2000): 267–84.

———. Cultura Cucuteni. Evoluţie, cronologie, legături. Bibliotheca Memoriae Antiquitatis 5. Piatra Neamţ, 1998.

———. "Plastica antropomorfă a aşezării Cucuteni A3 de la Scînteia." Arheologia Moldovei 16 (1993): 51–67.

———, and G. Dumitroaia. "Catalogue." In Cucuteni: The Last Great Chalcolithic Civilization of Europe, edited by Mantu, Dumitroaia, and A. Tsaravopoulos: 101–241. Thessaloniki: Athena, 1997.

———, and A. Scorţanu. "Date în legătură cu aşezarea Starčevo-Criş de la Poieneşti, jud. Vaslui." Studii şi Cercetări de Istorie Veche şi Arheologie 43, no. 2 (1992): 149–60.

———, M. Ştirbu, and N. Buzgar "Consideraţii privind obiectele din piatră, os şi corn de cerb din aşezarea cucuteniană de la Scânteia (1985–1990)." Arheologia Moldovei 18 (1995): 115–32.

———, A. Vlad, and G. Niculescu. "Painting Pigments for Ceramic Decoration in the Cucuteni-Tripolye Cultural Complex." In Festschrift für Gheorghe Lazarovici zon 60.Geburstag, edited by F. Draşovean: 191–210. Timişoara: Mirton, 2001.

———, et al. "Un mormânt dublu de înhumaţie din aşezarea cucuteniană de la Scânteia (jud. Iaşi)." Acta Musei Napocensis 31, no. 1 (1995): 87–103.

Manzura, I. "Arkheologia osnovnogo mifa " In Stratum. Structury i katastrofy [Sbornik simvolicheskoi indoevropeiskoi istorii]. Sankt-Peterburg, 1997.

———. "Culturi eneolitice în zona de stepă." Thraco-Dacia 15, nos. 1–2 (1994): 93–101.

———. "Steps to the Steppe, or How the North Pontic Region Was Colonized." Oxford Journal of Archaeology 24, no. 4 (2005): 313–38.

———. "Vladeyushie skipetrami." Stratum plus, no. 2 (2000): 237–95.

———, and E. Sava. "Interacţiuni 'est-vest' reflectate în culturile eneolitice şi ale epocii bronzului din zona de nord-vest a Mării Negre (schiţă cultural-istorică)." Memoria Antiquitatis 19 (1994): 143–92.

Marazov, I. "Grave No 36 from the Chalcolithic Cemetery in Varna—Myth, Ritual and Objects." In Die Kupferzeit als historische Epoche, edited by Lichardus and Echt (1991): 151–55.

Marchevici, V. Pozdnie Tripol'skie plemena severnoi Moldavii. Chișinău, 1981.

Mareș, I. Metalurgia aramei în neo-eneoliticul României. Suceava: Bucovina Istorică, 2002.

Marinescu, F. "Așezări fortificate neolitice din România." Studii și Comunicări Sibiu 14 (1969): 7–32.

Marinescu-Bîlcu, S. "Un 'atelier' néolithique pour la taille de haches en silex." Arheologia Moldovei 17 (1965): 48–53.

——. Cultura Precucuteni pe teritoriul României. București: Academiei RPR, 1974.

——. "Dwellings, Pits." In Drăgușeni, edited by Marinescu-Bîlcu and Bolomey (2000): 25–48.

——. "A Few Observations on the Internal Organization of Gumelnița Communities on Lake Cătălui Islet." In memoriam Vladimir Dumitrescu," Cultură și Civilizație la Dunărea de Jos 19 (2002): 149–50.

——. Tîrpești: From Prehistory to History in Eastern Romania. British Archaeological Reports, International Series 107 (1981).

——, and C. Bem. "Unde și cum s-a putut realiza trecerea de la faza Cucuteni A la Cucuteni A-B." In Scripta praehistorica, edited by Spinei, Lazarovici, and Monah (2005): 295–328.

——, and A. Bolomey. Drăgușeni: A Cucutenian Community. Bucharest: Enciclopedică, 2000.

——, A. Bolomey, M. Cârciumâru, and A. Muraru. "Ecological, Economic and Behavioral Aspects of the Cucuteni A4 Community at Dragușeni." Dacia 28, nos. 1–2 (1984): 41–46.

——, M. Cârciumaru, and A. Muraru. "Contributions to the Ecology of Pre- and Proto-historic Habitations at Tîrpești." Dacia 25 (1981): 7–31.

——, et al. "Cercetări arheologice la Bordușani-Popină (jud. Ialomița). Raport preliminar 1993–1994." Cercetări Arheologice 10 (1997): 35–39.

Marinov, G., and Y. Yordanov. "Preliminary Data from Studies of Bone Material from the Varna Chalcolithic Necropolis during the 1972–1975 Period." Studia Praehistorica 1–2 (1978): 60–67.

Marinova, E. "The New Pollen Core Lake Durankulak-3: The Vegetation History and Human Impact in Northeastern Bulgaria." In Aspects of Palynology and Paleontology, edited by S. Tonkov: 279–88. Sofia: Pensoft, 2003.

Marler, J., ed. The Danube Script: Neo-Eneolithic Writing in Southeastern Europe. Sebastopol, CA: Institute of Archaeomythology with the Brukenthal National Museum, Sibiu, Romania, 2008.

Marțian, I. "Archäologisch-prähistorisches Repertorium für Siebenbürgen." Mitteilungen der Anthropologischen Gesellschaft in Wien 39 (1909): 321–58.

Mateescu, C. "Remarks on Cattle Breeding and Agriculture in the Middle and Late Neolithic on the Lower Danube." Dacia, n.s., 19 (1981): 13–18.

Matsanova, V. "Intramiralni 'pogrebenia' ot kasnia halkolit v selishtnata mogila pri Yunatsite, Pazardzhishko." In Trakia i sasednite raioni prez neolita i halkolita, edited by V. Nikolov: 121–31. Sofia: Agatho, 2000.

Matthews, R., and H. Fazeli. "Copper and Complexity: Iran and Mesopotamia in the Fourth Millennium BC." Iran 42 (2004): 61–75.

Maxim-Alaibă, R. "Le complexe de culte de la phase Cucuteni A3 de Dumești (Dep. de Vaslui)." In La civilisation de Cucuteni, edited by Petrescu-Dîmbovița, Ursulescu, Monah, and Chirica (1987): 269–86.

——. "Locuința nr. 1 din așezarea Cucuteni A3 de la Dumești (Vaslui)." Acta Moldaviae Meridionalis 5–6 (1983–84): 99–148.

Maxim, Z. Neo-eneoliticul din Transilvania. Date arheologice și matematico-statistice. Bibliotheca Musei Napocensis 19. Cluj Napoca, 1999.

Merpert, N.Y. "Bulgaro-Russian Archaeological Investigations in the Balkans." Ancient Civilizations from Scythia to Siberia 2, no. 3 (1995): 364–83.

——, and R.M. Munchaev. "The Sovietskaya Arkheologiya or Sovietskaia Arkheologiia." Sovietskaja Arch. (1977): 154–63.

Meskell, L. "Twin Peaks: The Archaeologies of Çatal Höyük." In Ancient Goddesses: The Myths and the Evidence, edited by L. Goodison and C. Morris: 46–62. Madison: University of Wisconsin Press, 1998.

Mihăiescu, G., and A. Ilie. "Tellul gumelnițean de la Geangoești (com. Dragomirești, jud. Dâmbovița)." Ialomița 4 (2003–4).

Mihăilescu-Bîrliba, V. "Mormântul unei tinere căpetenii Mormantul unei tinere capetenii de la inceputul Epocii Bronzului (Mastacan, jud. Neamt–'Cultura Amforelor Sferice')." Memoria Antiquitatis 20 (2001): 157–217.

Monah, D. "Așezări." In Așezările culturii Cucuteni din România, edited by Monah and Cucoș (1985): 41–51.

——. "L'exploitation du sel dans les Carpates orientales et ses rapports avec la Culture de Cucuteni-Tripolye." In Le Paléolithique et le Néolithique de la Roumanie en contexte européen, edited by V. Chirica and D. Monah: 387–400. Bibliotheca Archaeologica Iassiensis 4. Iași, 1991.

——. "Istoricul cercetărilor." In Așezările culturii Cucuteni din România, edited by Monah and Cucoș (1985): 15–24.

——. Plastica antropomorfă a culturii Cucuteni-Tripolie. Bibliotheca Memoriae Antiquitatis 3. Piatra Neamț, 1997.

——. "Poduri-Dealul Ghindaru (com. Poduri, jud. Bacău)." In Cucuteni, un univers mereu inedit: 12–17. Iași: Documentis, 2006.

——, and Ș. Cucoș. Așezările culturii Cucuteni din România. Iași: Junimea, 1985.

——, and F. Monah, eds. "Cucuteni: The Last Great Chalcolithic Civilisation of Old Europe." In Cucuteni: The Last Great Chalcolithic Civilisation of Old Europe, edited by C.-M. Mantu, G. Dumitroaia, and A. Tsaravopoulos: 15–95. Bucharest: Athena, 1997.

——, et al. "Cercetările arheologice de la Poduri-Dealul Ghindaru." Cercetări Arheologice 6 (1983): 3–22.

——, et al. Poduri-Dealul Ghindaru. O Troie în Subcarpații Moldovei. Bibliotheca Memoriae Antiquitatis 8. Piatra Neamț, 2003.

——, et al. "Săpăturile arheologice din tell-ul cucutenian Dealul Ghindaru, com. Poduri, jud. Bacău." Cercetări arheologice 5 (1982): 9–18.

Monah, F., and D. Monah. Cercetări arheobotanice în tell-ul calcolitic Poduri-Dealul Ghindaru. Piatra Neamț, 2008.

Morintz, S. "Tipuri de așezări și sisteme de fortificație și de împrejmuire în cultura Gumelnița." Studii și Cercetări de Istorie Veche 13, no. 2 (1962): 273–84.

Much, M. Die Kupferzeit in Europa und ihr Verhältnis zur Cultur der Indogermanen. Wien, 1886.

Muhly, J. "Çayönü Tepesi and the Beginnings of Metallurgy in the Ancient World." In Old World Archaeometallurgy, edited by A. Hauptmann, E. Pernicka, and G. Wagner: 1–11. Der Anschnitt 7. Bochum: Deutsches Bergbau-Museum, 1989.

Nania, I. "Locuitorii gumelnițeni în lumina cercetărilor de la Teiu." Studii si Articole de Istorie 9 (1967): 7–23.

Neagu, M. "Comunitățile Bolintineanu în Câmpia Dunării." Istros 8 (1997): 9–23.

———. Neoliticul mijlociu la Dunărea de Jos. Călăraşi: Muzeul Dunării de Jos Călăraşi, 2003.

Necrasov, O. "Cercetări paleoantropologice privitoare la populaţiile de pe teritoriul României." Arheologia Moldovei 13 (1990): 182–85.

———. "Données anthropologiques concernant la population du complexe culturel Cucuteni-Ariuşd-Tripolie." In La civilization de Cucuteni, edited by Petrescu-Dîmboviţa, Ursulescu, Monah, and Chirica (1987): 145–56.

———, and M. Ştirbu. "The Chalcolithic Paleofauna from the Settlement of Tîrpeşti (Precucuteni and Cucuteni A1–A2 Cultures)." In Marinescu-Bîlcu, Tîrpeşti (1981): 174–87.

Nestor, I. "Der Stand der Vorgeschichtforschung in Rumänien." Ph.D. diss., Philipps-Universität Marburg, 1933.

———, and E. Zaharia. "Şantierul arheologic Sărata Monteoru." Studii şi Cercetări de Istorie Veche 6, nos. 3–4 (1955): 497–513.

Neuninger, H., R. Pittioni, and W. Siegl. "Frühkeramikzeitliche Kupfergewinnung in Anatolien." Arch. Austriaca 26 (1964): 52–66.

Nica, M. "Câteva date despre aşezarea neo-eneolitică de la Gârleşti (com. Mischi, jud. Dolj)." Arhivele Olteniei, n.s., 9 (1994): 3–24.

———. "Cîrcea, cea mai veche aşezare neolită de la sud de carpaţi." Studii şi Cercetări de Istore Veche şi Arheologie 27, no. 4 (1977): 435–63.

———. "Locuirea preistorică de la Sucidava-Celei din perioada de trecere de la neolitic la epoca bronzului." Oltenia 4 (1982): 15–37.

———, and Niţă A. "Les établissements néolithiques de Leu et Padea de la zone d'interférence des cultures Dudeşti et Vinča. Un nouvel aspect du Néolithique moyen d'Oltenie." Dacia, n.s., 23 (1979): 35–41.

Nicolăescu-Plopşor, C. "Un atelier neolitic pentru confecţionarea vârfurilor de săgeată. Gringul lui Iancu Muşat-Orlea." Studii şi Cercetări de Istorie Veche 11, no. 2 (1960).

Nikolova, L. "Social Transformations and Evolution in the Balkans in the Fourth and Third Millennia BC." In Analyzing the Bronze Age, edited by Nikolova: 1–8. Sofia: Prehistory Foundation 2000.

Niţu, A. "Criterii actuale pentru clasificarea complexelor ceramicii şi periodizarea etapelor culturii cucuteniene." Cercetări Istorice, n.s., 9–10 (1979): 93–162; 11 (1980): 135–222.

———. "Decorul zoomorf pictat pe ceramica Cucuteni-Tripolie." Arheologia Moldovei 8 (1975): 15–119.

———. Formarea şi clasificarea grupelor de stil AB şi B ale ceramicii pictate Cucuteni-Tripolie. Anuarul Institutului de Istorie şi Arheologie A.D. Xenopol 5. Iaşi, 1984.

Obobescu, A. Le trésor de Pétrossa. Historique; description; Étude sur l'orfèvrerie antique. 2 vols. in 3 bks. Paris: Rothschild, 1889–1900.

O'Brien, S.R., et al. "Complexity of Holocene Climate as Reconstructed from a Greenland Ice Core." Science 270 (1995): 1962–64.

Opriş, I. "Storia degli studi delle richerche archeologiche sulla cultura e civiltà dei daci." In I Daci, mostra della civiltà daco-getica in epoca classica: 19–22. Exh. cat. Rome: De Luca, 1979.

Ottaway, B.S. Prähistorische Archäometallurgie. Espelkamp: Marie Leidorf, 1994.

Ovcharov, D. "Eneoliten nekropol do s. Lilyak, Targovishko." Arkheologia 5, no. 1 (1963): 53–56.

Panayotov, I. Yamnata kultura v balgarskite zemi. Razkopki i prouchvaniya 21. Sofia: Bulgarian Academy of Sciences Press, 1989.

Pandrea, S. "Câteva observaţii referitoare la periodizarea culturii Boian." Istros 10 (2000): 36–57.

———. "Découvertes d'ossements humains dans les établissements Gumelnitsa situés au nord-est de la Plaine Roumaine." Acta Terrae Septemcastrensis 5, no. 1 (2006): 29–43.

Pântea, C. "Noi date privind tehnica picturală în cultura Cucuteni." Acta Moldaviae Meridionalis 5–6 (1983–84): 413–28.

Pârvan, V. Dacia: An Outline of Early Civilization of the Carpatho-Danubian Countries. Cambridge: Cambridge University Press, 1928.

———. Getica. Începuturile vieţii la gurile Dunării. Bucureşti, 1923.

Parzinger, H. "Hornstaad-Hlinskoe-Stollhof. Zur absoluten datierung eines vor-Baden-zeitlichen Horizontes." Germania 70 (1992): 241–50.

Passek, T. La ceramique tripolienne. Moscow: Académie de l'Histoire de la Culture Matérielle, 1935.

———. Periodizatsiya Tripol'skikh poselenii (III–II tysyachetiletie do n.e.). Materialy i issledovaniya po arkheologii SSSR 10. Moskva: Izdatel'stvo Akademii Nauk SSSR, 1949.

Patay, P. "Die hochkupferzeitliche Bodrogkeresztúr-Kultur." Bericht der Römisch-Germanisch Kommission 55 (1974): 1–71.

Paunescu, A. "Tardenoasianul din Dobrogea." Studii şi Cercetări de Istorie Veche şi Arheologie 38, no. 1 (1987): 3–22.

Pavuk, J. "Neolithisches Graberfeld in Nitra." Slovenska Archeológia 20 (1972): 5–105.

Perles, C. The Early Neolithic in Greece. Cambridge: Cambridge University Press, 2001.

Pernicka, E., F. Begemann, S. Schmitt-Strecker, and A.P. Grimanis. "On the Composition and Provenance of Metal Artefacts from Poliochni on Lemnos." Oxford Journal of Archaeology 9 (1990): 263–98.

———, F. Begemann, S. Schmitt-Strecker, and G.A. Wagner. "Eneolithic and Early Bronze Age Copper Artefacts from the Balkans and Their Relation to Serbian Copper Ores." Prähistorische Zeitschrift 68 (1993): 1–54.

—, et al. "Archäometallurgische Untersuchungen in Nordwestanatolien." Jahrbuch Romisch-Germanische Zentralmus 31 (1984): 533–99.

———, et al. "Prehistoric Copper in Bulgaria: Its Composition and Provenance." Eurasia Antiqua 3 (1997): 41–179.

Perry, C., and K. Hsu. "Geophysical, Archaeological, and Historical Evidence Support a Solar-Output Model for Climate Change." Proceedings of the National Academy of Sciences 7, no. 23 (2000): 12433–38.

Petrescu-Dîmboviţa, M. "Şanţurile de apărare." In Hăbăşeşti, by Dumitrescu et al. (1954): 203–23.

———, M. Florescu, and A. Florescu. Truşeşti. Monografie arheologică. Bucureşti-Iaşi: Editura Academiei Române, 1999.

———, N. Ursulescu, D. Monah, and V. Chirica, eds. La civilization de Cucuteni en contexte européen. Bibliotheca Archaeologica Iassiensis 1. Iaşi: Universitatea Alexandru Ioan Cuza, 1987.

———, and M. Văleanu. Cucuteni-Cetăţuie. Săpăturile din anii 1961–1966; Monografie arheologică. Biblioteca Memoria Antiquitatis 14. Piatra Neamţ, 2004.

Pogozheva, A.P. Antropomorfnaya Plastika Tripol''ya (Novosibirsk: Akademiia Nauk, Sibirskoe Otdelenie, 1983.

Popov, V. "The Ruse Tell Site Since James Gaul (Stratigraphy and Chronology)." In James Harvey Gaul—In Memoriam, edited by M. Stefanovich, H. Todorova, and H. Hauptman. Steps of James Harvey Gaul 1. Sofia: The James Harvey Gaul Foundation, 1998.

Popovici, D. "Area Organization, Arrangement and Use in the Cucuteni, Phase A Culture (I)." Cercetări Arheologice 12 (2003).

———. Cultura Cucuteni Faza A. Repertoriul aşezărilor (1). Bibliotheca Memoriae Antiquitatis 7. Piatra Neamţ, 2000.

———. "Exchanges during the Eneolithic Period: Case Study of the Cucuteni Culture." Analles d'Université Valachia, Târgoviște, Section d'Archéologie et d'Histoire 2–3 (2000): 87–99.

———. "Observations about the Cucutenian (Phase A) Communities Behavior Regarding the Human Body." Analles d'Université Valachia, Târgoviște, Section d'Archéologie et d'Histoire 1 (1999): 27–35.

———, B. Randoin, and Y. Rialland. "Le tell néolithique et chalcolithique d'Hârsova (Roumanie)." In Communautés villageoises du Proche-Orient à l'Atlantique (8000–2000 avant notre ère), edited by J. Guilaine: 119–52. Séminaire du Collège de France. Paris: Errance, 2001.

Radivojevic, M., et al. "The Beginnings of Metallurgy in Europe—Early Smelting Activities in the Vinča Culture." Paper presented at "Ancient and Medieval Metalworks: Archaeology-Numismatics-Nuclear Analyses," Second International Symposium, Bucharest, May 2008.

Radovanić, I. "Further Notes on Mesolithic-Neolithic Contacts in the Iron Gates Region and the Central Balkans." Documenta Praehistorica 33 (2006):107–24.

Radu, A. Cultura Sălcuța în Banat. Reșița: Banatica, 2002.

Raduntcheva, A. "Obshtestvenno-ikonomicheskiyat zhivot na Dobrudza i Zapadnoto Chernomorie prez Eneolita." Vekove 15, no. 1 (1986).

———. Vinitsa. Eneolitno selishte i nekropol. Razkopki i prouchvaniya 6. Sofia: Izdatelstvo na BAN, 1976.

Râmbu, N. Geografie fizică a Republicii Moldova. Manual pentru clasa a VIII-a. Chișinău, 2001.

Rassamakin, J. Die nordpontische Steppe in der Kupferzeit. Gräber aus Mitte des 5.Jts. bis des 4. Jts. v. Chr. 2 vols. Archäologie in Eurasien 17. Mainz: Zabern, 2004.

Rassamakin, Y. "The Eneolithic of the Black Sea Steppe: Dynamics of Cultural and Economic Development, 4500–2300 BC." In Late Prehistoric Exploitation of the Eurasian Steppe, edited by M. Levine, Rassamakin, A. Kislenko, and N. Tatarintseva: 59–182. McDonald Institute Monographs. Cambridge: McDonald Institute for Archaeological Research, 1999.

Renfrew, C. "The Autonomy of South-east European Copper Age." Proceedings of the Prehistoric Society 35 (1969): 12–47.

———. "Cycladic Metallurgy and the Aegean Early Bronze Age." American Journal of Archaeology 71 (1967): 2–26.

———. "Monuments, Mobilization and Social Organization in Neolithic Wessex." In The Explantation of Culture Change, edited by Renfrew: 539–58. Gloucester: Duckworth, 1973.

———. "Varna and the Emergence of Wealth in Prehistoric Europe." In The Social Life of Things, edited by Appadurai (1986): 141–68.

———. "Varna and the Social Context of Early Metallurgy." In Problems of European Prehistory, edited by Renfrew: 378–88. Edinburgh: Edinburgh University Press, 1979.

———, M. Gimbutas, and E. Elster, eds. Excavations at Sitagroi, a Prehistoric Village in Northeast Greece. Vol. 1. Los Angeles: Institute of Archaeology, University of California, Los Angeles, 1986.

Roman, P. "O așezare neolitică la Măgurele." Studii și Cercetări de Istorie Veche 13, no. 2 (1962): 259–71.

Rosetti, D.V., and S. Morintz. "Săpăturile de la Vidra." Materiale 7 (1960): 75–76.

Ryndina, N. Drevneishee metallo-obrabatyvaiushchee proizvodstvo Iugo-Vostochnoi Evropy. Moscow: Editorial, 1998.

Sagona, A., and P. Zimansky. Ancient Turkey. London: Routledge, 2009.

Schaeffer, G. "An Archaeomagnetic Study of a Wattle and Daub Building Collapse." Journal of Field Archaeology 20, no. 1 (Spring 1993): 59–75.

Schier, W. "Neolithic House Building and Ritual in the Late Vinca Tell Site of Uivar, Romania." In Homage to Milutin Garašanin, edited by Tasić and Grozdano (2006): 325–39.

Schmidt, H. Cucuteni in der oberen Moldau. Berlin-Leipzig: Gruyter, 1932.

Schuchhardt, C. Alteuropa, in seiner Kultur- und Stilenwicktlung. Strasburg: Trübner, 1919.

Séfériadès, M. "Note sur l'origine et la signification des objets en spondyle de Hongrie dans le cadre du Néolithique et de l'Enéolithique européens." In Morgenrot der Kulturen. Frühe Etappen der Menschheitsgeschichte in Mittel- und Südosteuropa; Festschrift für Nandor Kalicz zum 75 Geburtstag, edited by N. Kalicz, E. Jerem, and P. Raczky: 353–73. Budapest: Archaeolingua, 2003.

———. "Spondylus gaederopus: Some Observations on the Earliest European Long Distance Exchange System." In Karanovo III. Beitrage zum Neolithikum in Südosteuropa, edited by S. Hiller and V. Nikolov: 423–37. Vienna: Phoibos, 2000.

———. "Spondylus gaederopus: The Earliest European Long Distance Exchange System; A Symbolic and Structural Archaeological Approach to Neolithic Societies." Porocilo o raziskovanju paleolitika, neolitika in eneolitika v Sloveniji 22 (1995): 233–56.

Șerbănescu, D. "Căscioarele—D'aia parte." In Cronica cercetărilor arheologice din România. Campania 1997: 14. Călărași: CIMEC, 1998.

———. "Chirnogi-Terasa Rudarilor." In Situri Arheologice Cercetate în Perioada, 1983–1992. Brăila: Comisia Națională de Arheologie, Muzeul Brăilei, 1996.

———. "Necropola neolitică de la Popești, comuna Vasilați, jud. Călărași." In Civilizația Boian pe teritoriul României, edited by M. Neagu: 14–16. Călărași: Ministry of Culture, 1999.

———. "Observații preliminare asupra necropolei neolitice de la Sultana, județul Călărași." Cultură și Civilizație la Dunărea de Jos 19 (2002): 69–86.

———, A. Comșa, and L. Mecu. "Sultana, com. Mănăstirea, jud. Călărași. Punct: Valea Orbului." In Cronica cercetărilor arheologice din România. Campania 2006: 351–52, 473. Călărași: CIMeC, 2007.

Sergeev, G.P. "Rannetripol'skii klad u s. Karbuna." Sovetskaia arkheologiya 7, no. 1 (1963): 135–51.

Sherratt, A. "Plough and Pastoralism: Aspects of the Secondary Products Revolution." In Patterns of the Past, edited by G. Sieveking, I. Longworth, and K. Wilson: 261–305. Cambridge, 1983.

———. "V. Gordon Childe: Archaeology and Intellectual History." Past and Present 125 (1989): 151–86.

Siddall, M., et al. "Sea-Level Fluctuations During the Last Glacial Cycle." Nature 423 (2003): 853–58.

Slavchev, V. "Precucuteni Influences on Pottery of the Final Phase of Hamangia Culture." In Cucuteni, edited by Dumitroaia et al. (2005): 39–54.

———. "Prouchvane na selishtna mogila Kaleto v zemlishteto na s. Levski, obshtina Suvorovo, oblast Varna prez 2005 g." In Arkheologicheski otkritiya i razkopki prez 2005 g. XLV Natsionalna arkheologicheska konferentsia, edited by H. Popov. Sofia: Faber, 2006.

Šljivar, D. "The Eastern Settlement of the Vinča Culture at Pločnik: A Relationship of Its Stratigraphy to the Hoards of Copper Objects." Starinar 47 (1996): 85–97.

Solecki, R. "A Copper Mineral Pendant from Northern Iraq." Antiquity 43 (1969): 311–14.

Sorochin, V. Aspectul cucutenian Drăgușeni-Jura. Piatra Neamț, 2002.

———. "Culturile eneolitice din Moldova." *Thraco-Dacica* 15, nos. 1–2 (1994): 67–92.

———. "Locuințele așezărilor aspectului regional Drăgușeni-Jura." In *Cucuteni aujourd'hui*, edited by Dumitroaia and Monah (1996): 201–31.

———, V. "Modalitile de organizare a aezrilor complexului cultural Cucuteni-Tripolye." *Archaeologia Moldovei* 16 (1993): 69–86.

Spinei, V., C.-M. Lazarovici, and D. Monah, eds. *Miscellanea in honorem nonagenarii magistri Mircea Petrescu-Dîmbovița oblata. Scripta praehistorica*. Iași: Trinitas, 2005.

Stevanovic, M. "The Age of Clay: The Social Dynamics of House Destruction." *Journal of Anthropological Archaeology* 16 (1997): 334–95.

Subbotin, L. *Pamyatniki kultury Gumelnitsa Iugo-Zapada Ukrainy*. Kiev: Naukova Dumka, 1983.

———. "O sinkhronizatsii pamyatnikov kul'tury Gumelnitsa v nizhnem Podunav'e." In *Arkheologicheskie issledovaniya severo-zapadnogo prichernomor'ya*, edited by V. Stanko: 29–41. Kiev: Naukova Dumka, 1978.

———. "Uglubennye zhilishcha kul'tury Gumelnitsa v nizhnem podunav'e." In *Rannezemledel'cheski poseleniya-giganty Tripol'skoi kul'tury na Ukraine*, edited by I. Chenyakov: 177–82. Tal'yanki: Institut Arkheologii AN USSR, 1990.

Sztancsuj, S. "The Early Copper Age Hoard from Ariusd (Erosd)." In *Cucuteni*, edited by Chapman (2005): 85–106. Piatra Neamț, 2005.

Tadmor, M., et al. "The Nahal Mishmar Hoard from the Judean Desert: Technology, Composition, Provenance." *Atiqot* 27 (1995): 93–146.

Tasić, N., and C. Grozdano, eds. *Homage to Milutin Garašanin*. Belgrade: Serbische Akademie der Wissenschaften und Künste, 2006.

Telegin, D.Y. *Seredno-Stogivs'ka kul'tura epokha midi*. Kiev: Dumka, 1927.

———, A. Nechitailo, I. Potekhina, and Y. Panchenko. *Srednestogovskaya i novodanilovskaya kul'tury eneolita azovo-chernomorskogo regiona*. Lugansk: Shlyakh. Dergachev, 2001.

Tocilescu, G. *Dacia înainte de romani*. București, 1880.

Todorova, H. "Bemerkungen zum frühen Handelsverkehr während des Neolithikums und des Chalkolithikums im westlichen Schwarzmeerraum." In Handel, Tausch und Verkehr im bronze- und früheisenzeitlichen Südosteuropa, edited by B. Hänsel: 53–66. Prähistorische Archäologie in Südosteuropa 11. Munich: Südosteuropa-Gesellschaft, Seminar für Ur- und Frühgeschichte der Freien Universität, 1995.

———, ed. *Durankulak*. Vol. 2, *Die prähistorischen Gräberfelder von Durankulak*. Sofia-Berlin: Deutsches Archäologisches Institut, 2002.

———. *The Eneolithic Period in Bulgaria in the Fifth Millennium BC*. British Archaeological Reports, International Series 49. Oxford: Archaeopress, 1978.

———. "Die geographische Lage der Gräberfelder. Paläoklima, Strandverschiebungen und Umwelt der Dodrudscha im 6.–4. Jahrtausend v.Chr." In *Durankulak*, edited by Todorova (2002): 18–23.

———. *Kamenno-mednata epokha v Balgaria. Peto hilyadoletie predi novata era*. Sofia: Nauka i izkustvo, 1986.

———. *Die Kupferzeitliche Äxte und Beile in Bulgarien*. Prähistorische Bronzefunde 9 (14). Munich: Beck, 1981.

———. *Kupferzeitliche Siedlungen in Nordostbulgarien*. Materialien Zur Allgemeinen und Vergleichenden Archaologie 13. Munich: Beck, 1982.

———. "Die Nekropole bei Varna und die sozial-ökonomischen Probleme am Ende des Äneolithikums Bulgariens." *Zeitschrift für Archäulogie* 12 (1978): 87–97.

———. "The Neolithic, Eneolithic, and Transitional in Bulgarian Prehistory." In *Prehistoric Bulgaria*, edited by D. Bailey and I. Panayotov. Monographs in World Archaeology 22. Madison WI: Prehistory Press, 1995.

———. "Probleme der Umwelt der prähistorischen Kulturen zwischen 7000 und 100 v. Chr." In *Das Karpatenbecken und die osteuropäische Steppe. Nomadenbewegungen und Kulturaustausch in den vorchristlichen Metallzeiten (4000–500 v.Chr.)*, edited by B. Hänsel and J. Machnik: 65–70. Prähistorische Archäologie in Südosteuropa 12. Rahden: Marie Leidorf, 1998.

———. "Die Sepulkralkeramik aus den Gräbern von Durankulak." In *Durankulak*, edited by Todorova (2002): 81–116.

———. "Das Spätäneolithikum an der westichen Schwarzmeerküste." *Studia praehistorica* 1–2 (1978): 136–45.

———. "Tellsiedlung von Durankulak." *Fritz Thiessen Stiftung Jahresbericht 1995/96* (1997): 81–84.

———. "Der Übergang vom Äneolithikum zur Bronzezeit in Bulgarien. Die Ethnogenese der Thraker." In Dritter Internationaler Thrakologischer Kongress zu Ehren W. Tomascheks, edited by A. Peschew et al.: vol. 1, 117–20. Sofia: Swjat, 1984.

———. "Zur Frage der s.g. 'Symbolischen Gräber' des kupferzeitlichen Gräberfeldes Varna I." In *Hommage à Nikola Tasić à l'occasion de ses soixante ans*, edited by M. Garašanin and D. Srejović: 255–70. Balcanica 23. Belgrade: Academie Serbe des Sciences et des Arts, 1992.

———. and T. Dimov. "Ausgrabungen in Durankulak, 1974–1987." In *Neolithic of Southeastern Europe and Its Near Eastern Connections*. Varia Archaeologica Hungarica 2: 291–306. Budapest: Archaeological Institute of the Hungarian Academy of Sciences; Cardiff: School of History and Archaeology, University of Cardiff, 1989.

———, et al. *Selishtnata mogila pri Golyamo Delchevo*. Razkopki i prouchvaniya 5. Sofia: Izdatelstvo na BAN, 1975.

Todorova-Simeonova, H. "Kasnoeneolitniyat nekropol krai gr. Devnya." *Izvestiya na Narodniya Muzei—Varna* 7 (1971): 3–40.

Tringham, R., B. Brukner, and B. Voytek. "The Opovo Project: A Study of Socioeconomic Change in the Balkan Neolithic." *Journal of Field Archaeology* 12 (1985): 425–35.

———, and M. Conkey. "Rethinking Figurines: A Critical View from Archaeology of Gimbutas, the 'Goddess' and Popular Culture." In *Ancient Goddesses: The Myths and the Evidence*, edited by L. Goodison and C. Morris: 22–45. London: British Museum Press, 1998.

———, and D. Krstic, eds. *Selevac: A Neolithic Village in Yugoslavia*. Los Angeles: Institute of Archaeology, University of California, Los Angeles, 1990.

———, et al. "Excavations at Opovo, 1985–1987: Socioeconomic Change in the Balkan Neolithic." *Journal of Field Archaeology* 19 (1992): 351–86.

Troy, C., et al. "Genetic Evidence for Near-Eastern Origins of European Cattle." *Nature* 410, no. 6832 (2001): 1088–91.

Tsintsov, Z. "Unique Finds of Golden Articles in Alluvial Placers." *C.R. Acad. Bulg. Science* 45, no. 6 (1992): 59–61.

Tsvek, E. "On the Problem of Distinguishing Manufacturing Cults among Tripolyan Populations." In *Cucuteni*, edited by Chapman et al. (2005): 145–56.

———. "Structure of the Eastern Tripolye Culture." In *Cucuteni aujourd'hui*, edited by Dumitroaia and Monah (1996): 89–113.

———, and Y. Rassamakin. "The Interactions between the Eastern Tripolye Culture and the Pontic Steppe Area: Some Aspects of the Problem." In *Cucuteni*, edited by Chapman (2005): 173–92.

Tylecote, R. *A History of Metallurgy*. London: Metals Society, 1976.

———. *Metallurgy in Archaeology*. London: Edward Arnold, 1962.

Ucko, P. *Anthropomorphic Figurines of Predynastic Egypt and Neolithic Crete with Comparative Material from the Prehistoric Near East and Mainland Greece*. London: Szmidla, 1968.

Ursulescu, N. "Apariția înmormântărilor tumulare și a incinerației la est de Carpați." *Memoria Antiquitatis* 19 (1994): 193–99.

———. "Les commencements de l'utilisation du rite de l'incinération dans le monde proto-thrace du nord de la Moldavie." In *The Thracian World at the Crossroads of Civilizations*, edited by P. Roman: 447–64. Proceedings of the Seventh International Congress of Thracology, Constanța-Mangalia-Tulcea, 20–26 May 1996. Bucharest: Institut Român de Thracologie, 1997.

———. "Dovezi ale unei simbolistici a numerelor în cultura Pre-Cucuteni." *Memoria Antiquitatis* 22 (2001): 51–69.

———. "Exploatarea sării din saramură în neoliticul timpuriu, în lumina descoperirilor de la Solca (jud. Suceava)." *Studii și Cercetări de Istorie Veche și Arheologie* 28, no. 3 (1977): 307–18.

———. "Mormintele Criș de la Suceava-Platoul Cimitirului." *Anuarul Muzeului Județean Suceava* 5 (1978): 81–88.

———. "L'utilisation des sources salées dans le Néolithique de la Moldavie (Roumanie)." Nature et Culture 1, edited by M. Otte. Colloque de Liège, 13–17 December 1993. *ERAUL* (Liège) 68 (1995): 487–95.

———, D. Boghian, and V. Cotiugă. "L'autel peint de l'habitat de Târgu Frumos (dép. de Iași) appartenant à la civilisation Précucuteni (Énéolithique Ancien)." *Studia Antiqua et Archaeologica* 9 (2003): 27–40.

———, D. Boghian, and V. Cotiugă. "Locuințe de suprafață cu platformă din așezarea precucuzeniană de la Târgu Frumos–Baza Pătule." *Codrul Cosminului*, n.s., 12 (2006): 3–24.

———, D. Boghian, and V. Cotiugă. "Problèmes de la culture Précucuteni à la lumiére des recherches de Târgu Frumos, Romania." In Scripta praehistorica, edited by Spinei, Lazarovici, and Monah (2005): 217–60.

———, and S. Ignătescu. *Preutești-Haltă. O așezare cucuteniană de pe valea Șomuzului Mare*. Iași, 2003.

———, and C.-M. Lazarovici, eds. *Cucuteni 120–Valori universale. Lucrările simpozionului național, Iași 30 septembrie 2004*. Iași, 2006.

———, V. Merlan, and F. Tencariu. "Isaiia, com. Răducăneni, jud. Iași." In *Cronica Cercetărilor Arheologice. Campania 2000*: 110–11. București: CIMEC, 2001.

———, V. Merlan, F. Tencariu, and M. Vălean. "Isaiia, com. com. Răducăneni, jud. Iași." In *Cronica Cercetărilor Arheologice. Campania 2002*: 158–59. București: CIMEC, 2003.

———, and F. Tencariu. *Religie și magie la est de Carpați acum 7000 de ani. Tezaurul cu obiecte de cult de la Isaiia*. Iași: Demiurg, 2006.

———, et al. "Târgu Frumos, Baza Pătule." In *Cronica Cercetărilor Arheologice din România. Campania 2000*: 314–316. București: CIMEC, 2001.

Videiko, M. "Contours and Content of the Ghost: Trypillia Culture Proto-Cities." *Memoria Antiquitatis* 24 (2007): 251–76.

———, ed. *Entsiklopediya Tripil'skoi tsivilizatsii*. Kiev: Ukrpoligrafmedia, 2004.

———. "Die Grossiedlungen der Tripol'e-Kultur in der Ukraine." *Eurasia Antiqua* 1 (1996): 45–80.

———. "Looking for Trypillya Culture Proto-Cities." Illustrated pamphlet. 2005.

———. *Trypil's'ki protomista. Istoriia doslidzhen'*. Kiev: Tov. Kolo-Ra, 2002.

———. "Tripolye-Pastoral Contacts: Facts and Character of the Interactions, 4800–3200 BC." "Nomadism and Pastoralism in the Circle of Baltic-Pontic Early Agrarian Cultures, 5000–1650 BC," *Baltic Pontic Studies* 2 (1994): 5–28.

Von Pulszky, F. *Die Kupferzeit in Ungarn*. Budapest, 1884.

Vulpe, R. *Izvoare. Săpăturile din 1936–1948*. București: Academiei RPR, 1957.

Weller, O., R. Brigand, and M. Alexianu. "Cercetări sistematice asupra izvoarelor de apă sărată din Moldova." *Memoria Antiquitatis* 24 (2007): 121–90.

———, and G. Dumitroaia. "The Earliest Salt Production in the World: An Early Neolithic Exploitation in Poiana Slatinei-Lunca, Romania." Antiquity 79, no. 306 (2005): http://antiquity.ac.uk/projgall/weller.

———, et al. "Première exploitation de sel en Europe. Techniques et gestion de l'exploitation de la source salée de Poiana Slatinei à Lunca (Neamt, Roumanie)." In *Sel, eau et forêt. Hier et aujourd'hui*, edited by Weller, A. Dufraisse, and P. Pétrequin: 205–30. Actes du Colloque International, Saline Royale d'Arc-et-Senans, 3–5 October 2006, Cahiers de la MSH Ledoux 12 (coll. Homme et environnement 1). Besançon: Presses Universitaires de Franche-Comté, 2008.

Wertime, T. "The Beginning of Metallurgy: A New Look." *Science* 182 (1973): 875–86.

———. "Man's First Encounter with Metallurgy." *Science* 146 (1964): 1257.

Whittle, A. *Europe in the Neolithic: The Creation of New Worlds*. Cambridge: Cambridge University Press, 1996.

Willis, K. "The Vegetational History of the Balkans." *Quaternary Science Reviews* 13 (1994): 769–88.

Winn, S. *Pre-Writing in Southeastern Europe: The Sign System of the Vinča Culture, ca. 4000 BC*. Calgary: Western Publishers, 1981.

Wright, R. "Women's Labor and Pottery Production in Prehistory." In *Engendering Archaeology: Women and Prehistory*, edited by J. Gero and M. Cokey: 194–223. Oxford: Blackwell, 1991.

Yalçin, Ü. "Der Keulenkopf von Canhasan (TR). Naturwissenschaftliche Untersuchung und neue Interpretation." In *Metallurgica Antiqua*, edited by A. Hauptmann, J. Muhly, and T. Rehren: 279–89. Der Anschnitt 8. Bochum: Deutsches Bergbau-Museum: 1998.

———, and E. Pernicka. "Frühneolithische Metallbearbeitung am Aşıklı Höyük, Türkei." In *The Beginnings of Metallurgy*, edited by A. Hauptmann, Pernicka, T. Rehren, and Yalçin: 45–54. Der Anschnitt 9. Bochum: Deutsches Bergbau-Museum.

Yanko-Hombach, V., A. Gilbert, N. Panin, and P. Dolukhanov, eds. *The Black Sea Flood Question: Changes in Coastline, Climate, and Human Settlement*. Dordrecht: Springer, 2007.

Yener, K. *The Domestication of Metals: The Rise of Complex Metal Industries in Anatolia*. Leiden: Brill, 2000.

Yordanov, Y. "Anthropologic Study of Bone Remains from Persons Buried in the Varna Eneolithic Necropolis." Studia praehistorica 1–2 (1978): 50–59.

Zaharia, E., D. Galbenu, and Z. Székély. "Săpăturile arheologice de la Ariuşd, jud. Covasna." *Cercetări Arheologice* 5 (1981): 3–4.

Zavarei, A. *Monographie des Spondylidae actuels et fossiles*. Orsay: Centre d'Études et de Recherches de Paléontologie Biostratigraphique, 1973.

Zbenovič, V. *Siedlungen der frühen Tripol'e-Kultur zwischen Dnestr und Südlichem Bug*. Archäologie in Eurasien 1. Espelkamp: Marie Leidorf, 1996.

Zwicker, U. "Investigations on the Extractive Metallurgy of Cu/Sb/As Ore and Excavated Smelting Products from Norsun-Tepe (Keban) on the Upper Euphrates (3500–2800 BC)." In *Aspects of Early Metallurgy*, edited by W. Oddy: 13–26. Occasional Paper 17. London: British Museum, 1980.

Unless noted below, photography has been provided by the National History Museum of Romania, photographer Marius Amarie, the Varna Regional Museum of History, photographer Rumyana Kostadinova Ivanova, and the National Museum of Archaeology and History of Moldova, photographers Jurie Foca and Valery Hembaruc.

Maps: Inside cover, pages 26-27, figs. 7-1, 8-3

All base maps have been supplied by the Ancient World Mapping Center, University of North Carolina, Chapel Hill. Terrain depiction calculated from: "SRTM Shaded Relief," on *ESRI Data and Maps, 2006* (DVD-ROM, Redlands, CA: Environmental Systems Research Institute, 2006). Ancient physical data derived from: R. Talbert, ed., *Barrington Atlas of the Greek and Roman World* (Princeton, NJ: Princeton University Press, 2000). All other map information and final design: Dorcas Brown, David W. Anthony, and CoDe Communications and Design, New York.

Chapter 1
Page 28: C. Bem
Table 1-1: D. Brown, D. Anthony, and CoDe Communications and Design © ISAW

Chapter 2
Figs. 2-1–2-3: Archivs, Museum für Vor- und Fruehgeschichte, Staatliche Museen zu Berlin
Fig. 2-4: M. Vargha, Archiva Istorica, Muzeul Naţional Secuiesc
Figs. 2-5, 2-9: S. Marinescu-Bîlcu
Figs. 2-6–2-8, 2-13, page 58: Gh. Dumitroaia
Figs. 2-10–2-11: C. Bem
Fig. 2-12: C. Lazăr
Fig. 2-14: Gh. Dumitroaia and R. Munteanu
Table 2-1: I. Opriş and C. Bem

Chapter 3
Tables 3-1–3-3: D. Brown based on data from J. Chapman © ISAW
Figs. 3-1, 3-3: J. Chapman
Fig. 3-2. After H. Todorova (2002), Karte 4
Fig. 3-4. After H. Todorova (1982)
Fig. 3-5. D. Brown from D. Anthony (2007), fig. 12.7
Fig. 3-6. S. Marinescu-Bîlcu (1981), fig. 14
Fig. 3-7. M. Videiko (2007), fig. 4

Chapter 4
Fig. 4-3: M. Cernău
Fig. 4-4: V. Parnic
Fig. 4-5: E.-R. Munteanu
Figs. 4-6, 4-8–4-9, 4-11–4-14: D. Popovici
Fig. 4-7: After C.-M. Lazarovici and Gh. Lazarovici (2006)
Fig. 4-10: Fl. Draşovean

Chapter 5
Fig. 5-1: E-R. Munteanu, CMJMPN
Fig. 5-2: S. Odenie, Interdisciplinary Center of Archaeo-Historical Studies (CISA), UAIC
Fig. 5-4a: MJSCMV

Chapter 6
Figs. 6-1–6-3: C.-M. Lazarovici
Figs. 6-4–6-6, 6-34, 6-38, 6-40, 6-41, 6-44: I. Şerban and V. Popescu © Romeo Dumitrescu in N. Ursulescu, ed., *Cucuteni-Trypillia: A Great Civilization of Old Europe* (Bucuresti: Cucuteni pentru Mileniul III Foundation and Hers Consulting Group, 2008).
Figs. 6-7, 6-23–6-25: S. Odenie © CMJMPN, museum collections
Fig. 6-8: V. Spinei, C.-M. Lazarovici, and D. Monah (2005), fig. 16 © UAIC
Fig. 6-12, 6-14. S. Odenie © C.–M. Lazarovici collection
Fig. 6-42: CNMN, museum collections

Chapter 7
Fig. 7-2: Ü. Yalçın, Deutsches Bergbau-Museum, Bochum

Chapter 8
Fig. 8-1: Free Software Foundation, after J.-C. Chenu (1842)
Fig. 8-2: V. Dimitrijevic and C. Tripkovic (2006), fig. 2
Fig. 8-4: D. Vialou, Musée Nationale d'Histoire Naturelle, Paris
Figs. 8-5, 8-6: after H. Todorova and M. Avramova, National Museum of History, Sofia
Fig. 8-11: after E. Comşa (1973)
Fig. 8-12: Tibor Kádas, Archaeological Institute of the Hungarian Academy of Sciences, Archives
Fig. 8-13: after B. Chertier (1988)
Fig. 8-14: J. Pavuk, after J. Pavuk (1972)
Fig. 8-15: P. Biagi, after S. Karmanski (1977)

Chapter 9
Fig. 9-10: Vl. Slavchev
Fig. 9-12: K. Dimitrov

Chapter 10
Fig. 10-1. V. Bicbaev, The National Museum of Archaeology and History of Moldova
Fig. 10-2–10-4, 10-6: after Haheu and Kurciatov, 1993
Fig. 10-5: after Haheu and Kurciatov, 1992